Art and its global histories: a reader

Manchester University Press

The Open University

This Reader forms part of the series *Art and its Global Histories* published by Manchester University Press in association with The Open University. The other books in the series are:

European Art and the Wider World 1350–1550, edited by
Kathleen Christian and Leah R. Clark

Art, Commerce and Colonialism, 1600–1800, edited by
Emma Barker

Empire and Art: British India, edited by Renate Dohmen

Art after Empire: From Colonialism to Globalisation, edited by Warren
Carter

Art and its global histories: a reader

Edited by
Diana Newall, *with* Emma Barker,
Warren Carter, Kathleen Christian
and Renate Dohmen

Manchester University Press
in association with
The Open University

Published by Manchester University Press
Altrincham Street, Manchester M1 7JA
in association with
The Open University, Walton Hall, Milton Keynes MK7 6AA

www.manchesteruniversitypress.co.uk
www.open.ac.uk

This publication forms part of the Open University module 'Art and its Global Histories' (A344). Details of this and other Open University modules can be obtained from Student Recruitment, The Open University, PO Box 197, Milton Keynes MK7 6BJ, United Kingdom. (Tel. +44 (0) 300 303 5303, email general-enquiries@open.ac.uk).

British Library Cataloguing-in-Publication Data
A catalogue record for this book is available from the British Library

Library of Congress Cataloging-in-Publication Data applied for

ISBN 978 1 5261 1992 6 paperback

First published 2017

The publisher has no responsibility for the persistence or accuracy of URLs for any external or third-party internet websites referred to in this book, and does not guarantee that any content on such websites is, or will remain, accurate or appropriate.

Typeset
by Toppan Best-set Premedia Limited
Printed in Great Britain by
TJ International Ltd, Padstow, Cornwall

Cover illustration: Jan Jansz Mostaert, *Landscape with an Episode from the Conquest of America*, c. 1535, oil on panel, 87 × 153 cm. Rijksmuseum, Amsterdam

Contents

Contents

Contents

Figures

Acknowledgements

The first and most important debt of thanks in this anthology must go to the critics, theorists and historians who have generously allowed their work to be included and, in many cases, subject to editorial deletions. We are very grateful for their generosity. Equally important is the gratitude to the team at The Open University for their support and guidance through the process of compiling the book. Their diligence and generosity has helped considerably in the production of the manuscript under very tight circumstances. These include Emma Barker, Warren Carter, Amy Charlesworth, Kathleen Christian, Leah Clark, Renate Dohmen, Elizabeth McKellar, Gill Perry, Clare Taylor, Paul Wood and Kim Woods. The role of those members of the editorial and educational technology staff who participated in the discussion about, and selection of, the texts included in this book also needs to be given due credit. These colleagues will understand if the contribution to this book of Warren Carter and Kathleen Christian, the module chairs, are singled out for special recognition. Heather Kelly was the curriculum manager and her infinite kindness and endless competent support and guidance have made the completion of the manuscript very much easier. Gill Gowans of The Open University's LTS Development and Production Team and Liam Baldwin from the Visual Resources Unit were thorough and helpful at all stages of this project; many thanks to them also.

Introduction

Diana Newall

The *Art and its Global Histories* Reader, and the associated Open University module of the same name, offer an expansive approach to the history of western art in the context of global cross-cultural interactions. To this end, the Reader outlines and documents key issues, debates and perspectives which support such an approach. The Reader has five Sections of texts including an opening Section that presents a range of relevant theoretical texts followed by four case studies from the fourteenth to twenty-first centuries.

The Sections are as follows: Section 1, 'Confronting Art History: overviews, perspectives and reflections', edited by Diana Newall, introduces and explores the theoretical development of and issues associated with global approaches to art history. Section 2, 'European art and the wider world 1350–1550', edited by Kathleen Christian, considers the global artistic contexts produced by early European travel, trade and colonial encounter with Mexico, the Ottoman Empire, Asia and Africa. Section 3, 'Art, commerce and colonialism: 1600–1800', edited by Emma Barker, illuminates a period of growing global trade and colonial activity, accompanied by increasingly widespread European fascination with exotic luxury goods. Section 4, 'Empire and art: British India', edited by Renate Dohmen, explores the context of the British Empire in India in the nineteenth and early twentieth centuries and how colonial attitudes framed and controlled perceptions of Indian art, artefacts and architecture. Finally, Section 5, 'Art after empire: from colonialism to globalisation', edited by Warren Carter, takes the debate through the twentieth century from the context of Modernism and 'Primitivism' to issues and debates on globalised contemporary art and display.

The case studies explore cross-cultural and global relationships, connections and entanglements that have shaped the production and perception of western and non-western art. Extracts from primary sources offer

insights into contemporaneous artistic theory and practice while the associated critical texts present analytical and interpretative approaches. All of these texts, regardless of origin, are to a greater or lesser extent mediated through Eurocentric scholarly and pedagogic priorities and methodologies. Many of them directly address and challenge the issue of Eurocentrism in art history but they remain within its western framework. Central to this issue are the endeavours of European states to discover, trade with, colonise, exploit, scrutinise and control other parts of the world. Therefore, throughout this Reader, a key point of debate has to do with the broad range of consequences, in the past and the present, of European colonial and imperial hegemony.

Edward Said and Orientalism

The consequences of European colonialism and imperialism on societies and cultures within the western sphere and across the world have been the topic of intense scholarly debate for more than half a century. After the Second World War, the greater part of Europe's former colonial territories achieved independence. Many of them had experienced decades of unrest and war as they sought to challenge the injustices of imperial rule.[1] The theoretical framework which underpins consideration of the social and cultural implications of colonial rule is often seen to be rooted in Edward Said's (1935–2003) *Orientalism* (1978).[2] These issues had already been addressed by other writers including, most notably, Frantz Fanon (1925–1961), the Martiniquais-French psychologist, philosopher and writer who wrote in French colonial Algeria around the time of the Algerian War of Independence (1954–1962).[3] However, Said's work set out a robust polemic which has provided a foundation for critical debates within Postcolonial Studies ever since.

In *Orientalism*, Said analysed writings from European politics, scholarship and literature, from the classical period onwards, to reveal and

1 See for example, Dipesh Chakrabarty, *Provincializing Europe: Postcolonial Thought and Historical Difference* (Princeton, NJ: Princeton University Press, 2000); Bipan Chandra, Mridula Mukherjee, Aditya Mukherjee *et al.*, *India's Struggle for Independence* (New Delhi: Penguin, 1989); Peter Fryer, *Black People in the British Empire* (London: Pluto, 1988); James Rotberg and Ali Mazrui, *Protest and Power in Black Africa* (New York: Open University Press, 1970).
2 Edward W. Said, *Orientalism* (London: Penguin, 1978, 1995, 2003).
3 Earlier interventions include the poet Aimé Césaire, *Cahier d'un retour au pays natal (Notebook of a Return to the Native Land)* (1939), which explores African black cultural identity, and Frantz Fanon, who further explored the issues of black identity in *Black Skin, White Masks* (1952) and *The Wretched of the Earth* (1961).

interrogate the ways in which concepts of the 'east', the 'Orient' and Asia were created.[4] His central claim was that the imperial power ambitions pursued initially by Europe (primarily England and France), and later by the United States of America, entailed the conceptualisation the 'Orient' and the 'Oriental' as an inferior *other*. He argued that, rather than being based on geographical, political, social or cultural reality or empirical evidence, this ideological construct of inferiority functioned as a tool of power through which colonial rule was orchestrated (see Section 1).

Said identified Napoleon's invasion of Egypt at the start of the nineteenth century, accompanied by a group of scholars whose role was to study and document the country, as the radical moment of change in the relationship between Europe and the Orient, inaugurating Orientalist discourse.[5] Within the Reader, this moment is recognised by the changing perceptions of non-western art and culture from the vogue for the exotic in the seventeenth and eighteenth centuries in Section 3, to the denigration of Indian art under British rule from the nineteenth century, discussed in Section 4. Said also developed a critique of the discipline of Oriental Studies, with its origins in the scholarship initiated by Napoleon in Egypt, for the way in which it reinforced the conceptual framework of the inferior *other* through the power imbalances created by knowledge acquisition. His argument drew on Michel Foucault's theories in which knowledge functioned as power in society.[6] Said contended that in all aspects of the West's relationship with the 'Orient', the structures of European societies, politics, religion and culture kept those of non-European states in the Middle East and Asia in a permanent condition of exclusion and inferiority. This not only provided a justification of colonial rule (political and legal), Christian evangelisation and the imposition of western cultural values, but also constructed a framework in which the colonised seemingly accepted and participated in the colonial endeavour.[7]

Among the many scholars who have responded to Said's work have been numerous art historians. One of the earliest to do so was the American

4 See particularly, Said, 'The Scope of Orientalism', in *Orientalism*, pp. 31–110.
5 Said, *Orientalism*, p. 87.
6 Especially, Michel Foucault, *The Order of Things: An Archaeology of the Human Sciences* (New York: Pantheon Books, 1970), *The Archaeology of Knowledge and the Discourse on Language*, trans. A. M. Sheridan Smith and Rupert Sawyer (New York: Pantheon Books, 1972) and *Discipline and Punish: The Birth of the Prison*, trans. Alan Sheridan (New York: Pantheon Books, 1977).
7 Said developed his theories further in *Culture and Imperialism* (London: Chatto & Windus, 1993) where he analysed western culture, interrogating the colonial dynamics in works such as Joseph Conrad's *Heart of Darkness* (1899), Jane Austen's *Mansfield Park* (1814) and *Persuasion* (1817), and works on postcolonial issues by Salman Rushdie and V.S. Naipaul.

art historian Linda Nochlin. The prompt for her work came from the large body of so-called Orientalist painting produced during the nineteenth century, a period in which large swathes of North Africa and the Middle East came under European control, most notably work by French artists such as Eugène Delacroix and Jean-Léon Gérôme. The underlying stereotyping and denigration of the Oriental peoples, cultures and societies within these artworks, as Nochlin shows in her essay 'The Imaginary Orient' (Section 1), can be interpreted as another dimension to the colonial discourse critiqued by Said.

The scholarship on French Orientalist art since Nochlin is extensive. Some have challenged Said's and Nochlin's interpretation of Orientalism, among them John MacKenzie, who contended that Orientalist art was produced and functioned on a more respectful and positive level.[8] More recently, scholars have moved beyond the East–West binary construct of Orientalism at the centre of Said's hypothesis to a more nuanced reading of Orientalism as (in the words of Jill Beaulieu and Mary Roberts) 'an engagement with Orientalism as heterogeneous and contested'.[9]

Taking a different perspective, but also looking beyond the binary power dynamic implied by Said's Orientalism, Roger Benjamin has analysed closely the politics and imagery of colonialism, conceiving Orientalist art as products rather than drivers of colonialism.[10] Benjamin's work on the Orientalist art of French North Africa considers the beginning of the twentieth century up to 1930, thereby encompassing modernist artists' engagement with these cultures and situating them firmly within the context of French imperial hegemony in the region. The implication is that although the avant-garde developments of the early twentieth century and their appropriation of non-western artistic forms can be seen as progressive in western art terms, they are also part of the colonial hegemony (see Section 5). Section 5 also considers the debates on Primitivism and the ethnographic museums and collections in which many avant-garde artists first saw artworks from African and Oceania.

Scholarship on French Orientalist art, until recently, has tended to be much more extensive than consideration of British Imperialism. The Tate exhibition *Art and Empire: Facing Britain's Imperial Past* interrogated Britain's colonial and imperial history and legacies within a range of

8 John M. MacKenzie, *Orientalism: History, Theory and the Arts* (Manchester: Manchester University Press, 1995).

9 Jill Beaulieu and Mary Roberts (eds), *Orientalism's Interlocutors: Painting, Architecture, Photography* (Durham, NC: Duke University Press, 2002), p. 2.

10 Roger Benjamin, *Orientalist Aesthetics: Art, Colonialism, and French North Africa 1880–1930* (Berkeley, CA and Los Angeles: University of California Press, 2003).

artworks and objects.[11] Britain Imperialism in India is the focus of Section 4 and its approach forges new ground in studying, from a European perspective, the colonial encounter and its impact on perceptions of Indian art.

Postcolonialism and Subaltern Studies

Highly relevant to the issues explored in this Reader is the broader field of Postcolonial Studies. Postcolonialism and Postcolonial Studies engage with debates and concepts associated with the legacies of colonialism.[12] Postcolonial Studies traces its origins back to the works of Said, along with scholars and writers on colonialism such as Fanon, in their characterisations of the drivers and consequences of European hegemony across the world. Postcolonial scholarship is perhaps furthest developed in the sphere of literary studies, and is elucidated by literary scholars Bill Ashcroft, Gareth Griffiths and Helen Tiffin:

> Post-colonial theory involves discussion about experience of various kinds: migration, slavery, suppression, resistance, representation, difference, race, gender, place and responses to the influential master discourses of Imperial Europe such as history, philosophy and linguistics [...].[13]

Each of these different types of experience leaves a trace in the global cross-cultural interactions explored in this Reader. For example, slavery is part of the debates in Section 3; suppression, resistance and representation are explored in Section 4; difference is a key concept in Section 2 and place is considered in Section 1, to mention a few. Among the scholars who have contributed to the development of Postcolonial Studies are Homi K. Bhabha, whose work is included in Section 1, Stuart Hall, included in Section 5, and many others. Indeed, most of the critical

11 *Art and Empire: Facing Britain's Imperial Past* (25 November 2015–10 April 2016) (London; Tate Enterprises Ltd, 2015).

12 The term Post-Imperialism, on the other hand, has a more political and economic inflection associated with international development and multinational business. See for example, David G. Becker, Richard L. Sklar, Sayre P. Schatz and Jeff Frieden, *Postimperialism: International Capitalism and Development in the Late Twentieth Century* (Boulder, CO: Lynne Reiner Publishers, 1987). There are a wide range of introductions to Postcolonial theory including, for example, Leela Gandhi, *Postcolonial Theory: A Critical Introduction* (Edinburgh: Edinburgh University Press, 1998).

13 Bill Ashcroft, Gareth Griffiths and Helen Tiffin (eds), *The Post-Colonial Studies Reader*, 2nd edn (London and New York: Routledge, 1995, 2006), p. 2. See also on Postcolonial literary studies, Bill Ashcroft, Gareth Griffiths and Helen Tiffin, *The Empire Writes Back: Theory and Practice in Postcolonial Literatures*, 2nd edn (London and New York: Routledge, 1989, 2002).

approaches included in this Reader engage with the issues and debates of Postcolonialism in some way.

Postcolonialism is an interdisciplinary field which has permeated the humanities and social sciences, including literature, history, anthropology, archaeology, political studies and art history. The postcolonial theorist Robert J.C. Young summarises the key points of debate within the field in 'Ideologies of the Postcolonial' (1998), highlighting questions ranging from migrancy and dislocation; race, ethnicity and gender; connections to theories of Marxism and poststructuralism, to its impact on theories of aesthetics.[14] Postcolonialism is also concerned with concepts of *self* and *other*, objectification and exoticism of the *other*, the power imbalances of the colonial encounter, issues of language and translation across cultural boundaries and hybridity. It is concerned to interrogate and subvert the western knowledge systems which underpin all aspects of colonialism, and to a degree, the postcolonial discourse itself. There is recognition that the legacy of colonialism is not just in the past but has ongoing impacts in the contemporary globalised world; that the activities of western imperialism have not ended and that the contemporary globalised world is still negotiating the consequences of continuing western hegemony.[15]

Art historians who have explored postcolonial approaches within art history include James Clifford and Annie Coombes, who consider ways in which non-western art and culture have been framed within the hegemonic structures of colonialism and western art history.[16] A particular topic of concern for them is the role of the museum in representing and framing non-western art and culture. This issue is intrinsic to the watershed moment of the 1984 MoMA exhibition *'Primitivism' in 20th Century Art: Affinity of the Tribal and the Modern*, related to the material in Section 5. The exhibition was critiqued by Clifford in his essay 'Histories of the Tribal and the Modern' for its Modernist and Eurocentric approach to and presentation of 'Primitivist' art.[17]

14 Robert Young, 'Ideologies of the Postcolonial', *Interventions*, vol. 1, no. 1 (1998).

15 See for example, Michael Hardt and Antonio Negri, *Empire* (Cambridge, MA and London, Harvard University Press, 2000).

16 James Clifford, *The Predicament of Culture: Twentieth-Century Ethnography, Literature and Art* (Cambridge, MA: Harvard University Press, 1988); Annie Coombes, *Reinventing Africa: Museums, Material Culture and Popular Imagination in late Victorian and Edwardian England* (New Haven, CT and London: Yale University Press, 1994) and Annie Coombes, 'Inventing the Post-Colonial: Hybridity and Constituency in Contemporary Curating', *New Formations*, Winter (1992), 39–52.

17 James Clifford, 'Histories of the Tribal and the Modern', in *The Predicament of Culture*, pp. 189–214.

Particularly relevant to this Reader and the case study in Section 4 on India is the sub-discipline of Subaltern Studies, which applies many of the insights of the broader framework of Postcolonialism to the particular case of South Asia. Subaltern Studies is concerned to interrogate and address the circumstances and voice of the subaltern: the suppressed, marginalised colonial *other*. Most prominent in this field is the Indian scholar Gayatri Chakravorty Spivak, who, in her essay 'Can the Subaltern Speak?' explores the circumstances in which colonised people in India during British rule had their voices silenced by colonial policy, political subjectivity and cultural dominance.[18] She argues that the continuing domination of western knowledge systems and the legacies of colonialism mean that the subaltern still struggles to be heard.

Globalisation and Art History

As outlined above, Postcolonial Studies has had an impact on art-historical approaches and stimulated consideration of the consequences of globalisation. Globalisation broadly suggests that the world has become more closely interconnected through political, economic, business, social and technological developments. The idea that the discipline of art history might recognise and develop greater global interconnections has generated many initiatives over recent decades which have sought to respond to the challenges of Postcolonialism and explore more global strategies.[19]

18 Gayatri Chakravorty Spivak, 'Can the Subaltern Speak?', in Gayatri Chakravorty Spivak, Donna Landry and Gerald M. MacLean (eds), *The Spivak Reader: Selected Works of Gayatri Chakravorty Spivak* (New York and London: Routledge, 1996).
19 Partha Mitter, *Much Maligned Monsters: A History of European Reactions to Indian Art* (Oxford: Oxford University Press, 1977); Anthony D. King (ed.), *Culture, Globalization and the World-System: Current Debates in Art History* 3 (Binghamton, NY: Department of Art and Art History, State University of New York at Binghamton, 1991); David Summers, *Real Spaces: World Art History and the Rise of Western Modernism* (London: Phaidon, 2003); Clare Harris, 'The Buddha Goes Global: Some Thoughts Towards a Transnational Art History', *Art History*, vol. 29, no. 4 (2006), 689–720; James Elkins (ed.), *Is Art History Global?* (New York and Abingdon: Routledge, 2007); Partha Mitter, 'Decentring Modernism: Art History and Avant-Garde Art from the Periphery', *Art Bulletin*, vol. 90, no. 4 (2008), 531–548; Kitty Zijlmans and Wilfried van Damme (eds), *World Art Studies: Exploring Concepts and Approaches* (Amsterdam: Valiz, 2008); Jonathan Harris (ed.), *Globalization and Contemporary Art* (Malden, MA and Oxford: Wiley-Blackwell, 2011); Monica Juneja, *Die Universalität der Kunstgeschichte* (The Universality of Art History), Theme Issue, *kritische berichte, Zeitschrift für Kunst- und Kulturwissenschaften*, Heft 2, 2012 (edited with Matthias Bruhn and Elke Werner); Matthew Rampley, Thierry Lenain and Hubert Locher (eds), *Art History and Visual Studies in Europe: Transnational Discourses and National Frameworks* (Leiden: Brill, 2012); Jill Casid and Aruna D'Souza, *Art History in the Wake of the Global Turn* (New Haven, CT: Yale University Press, 2014).

However, many have recognised the limitations and constraints of Eurocentrism within the discipline and the challenges of developing methodologies and interconnectivity which is not rooted in the western tradition.

For art history, there has been substantial debate on how to address this challenge, some of which is presented in Section 1. Approaches to this challenge can broadly be categorised into two distinct alternatives. The first, which may broadly be termed Global Art History, has considered the question of how the discipline and its methodologies pursue closer integration. It has, however, proved difficult to escape its western origins. The extract in Section 1 by James Elkins sets out some of the different ways in which art history's methodologies, institutions and terms are rooted in a western discourse, in turn, shaped and compromised by colonial and imperial histories. Exemplary in this respect is the way that western art historians use terms such as 'space' in a way that privileges traditions of the artistic developments deriving from the Italian Renaissance. Some of the issues relating to perceptions of non-western art during the Renaissance are explored in Section 2.

The second approach, known as World Art Studies, offers a different strategy, one in which a looser network of art-historical interventions encompasses contributions from across the world without attempting to provide a unified disciplinary methodology for studying any and every work of art, regardless of their origin. With both approaches, however, there remains the problem that the driving force for these initiatives often comes from within the western discipline of art history.

A further consideration, addressed in Section 5, has to do with the circumstances of global contemporary art. Among the developments encompassed by this term is the growing popularity of world art fairs and biennales showcasing international contemporary art. Texts included in Section 5 consider to what extent the global art world continues to be driven by western artistic and market priorities. Bringing the debates up to the present, this section of the Reader questions whether or not the idea of the global remains simply another western construct.

Sections 2 to 5 of the Reader provide case studies for applying and testing the debates and perspectives outlined in this introduction. Although these case studies cannot step outside Art History's western methodologies, they aim to explore how, within each period, artistic practice and theory are shaped by and contribute to global cross-cultural interactions. The selection of case studies allows for consideration of a wide range of encounters extending over some seven hundred years. Starting with early exploration and initial contact from the fourteenth to sixteenth centuries, they move on through the flourishing of international European trade

and colonialism in the seventeenth and eighteenth centuries and take in the nineteenth-century era of Imperialism as exemplified by Britain in India. Finally, through a consideration of the artistic innovations and emancipatory politics of the twentieth century, the narrative comes up to date, raising the question of the continuing hegemony of western discourse in the contemporary art world.

I

Confronting Art History: overviews, perspectives and reflections

Diana Newall

Introduction

The texts in this section have been selected to foreground some of the key theoretical interventions relevant to an exploration of art and its global histories, since Edward Said published *Orientalism* in 1978, to frame the debates in the rest of the Reader. The selection has been made to foreground arguments that reflect the increasing degrees of questioning about the methodologies, disciplinary principles and possible future trajectories of art history within the context of globalisation.

The first pair of texts consider the legacy of past European colonial and imperial activities to illustrate the foundations of the colonial and postcolonial debates. The extract from the introduction to Said's *Orientalism* establishes the conceptual core of his arguments about the western construct of an inferior 'Orient'. Said analyses texts and literature in *Orientalism* but the relevance of his work to art-historical scholarship is demonstrated by the second text, Linda Nochlin's 'The Imaginary Orient' (1989), which discusses nineteenth-century French Orientalist art. Nochlin explores how this art, almost subliminally, constructed a stereotypical perception of the Middle East and the character of the inferior 'Oriental'.

The second set of extracts are taken from Homi K. Bhabha's *The Location of Culture* (1994), a collection of essays that interrogate concepts of *self* and *other* within the colonial relationship and challenge the idea of 'pure' cultural identity. He provides insights into the developing concepts within Postcolonialism which move beyond the issues of power imbalance, which Said identified. While Said analyses how European colonial and imperial discourse established the colonised identity as an inferior Oriental *other*, Bhabha interrogates relationships and interactions between coloniser and colonised to reveal ways in which the coloniser's hegemony is disrupted.

For Bhabha, *hybridity* at the interstice of the colonial relationship is the agent of disruption. In the first extract, from 'The Other Question: Stereotype, Discrimination and the Discourse of Colonialism', Bhabha suggests the differentiation of *otherness* in the colonial relationship is inherently unstable. In the second extract, from 'Articulating the Archaic: Cultural Difference and Colonial Nonsense', Bhabha interrogates British fiction of the Imperial era to further problematise the nature of the colonial relationship.

The remaining texts explore the challenges for art history within the current trend towards globalisation. They set out the different issues for a Eurocentric discipline in negotiating its position and methods as a globalised discourse, which many critical approaches in the Reader confront. Thomas DaCosta Kaufmann's text tracks the historiography of the changing ways in which art history has been structured geographically. The extract from James Elkins's 'Why Art History is Global' (2011) sets out key points of debate on the question of a global art history concerning the western-ness of its methodologies, institutions and terms. Although Elkins does not provide solutions, he sets out the challenges faced by a globalised art history.

Parul Dave Mukherji's 'Whither Art History in a Globalizing World' offers a perspective on the current position and future trajectory of art history from a South Asian perspective. She looks back on debates relating to a global art history and reveals the continuing problems of ethnocentricity. Mukherji, however, concludes with some optimism that in losing 'its connecting thread', art history may find a new and more expansive future.

Critical approaches

1.1 Orientalism

Edward W. Said (1935–2003) was born in Jerusalem, in the region of British Mandatory Palestine. He joined Columbia University in 1963 and held visiting professorships at other universities through his career, including Yale. He published extensively on colonial and imperial debates within literature. *Orientalism* emerged from early scholarship on works such as Joseph Conrad's *Heart of Darkness* (1899), and signified his strong sense of how the rich and diverse cultures of his experience in the Middle East had been negatively stereotyped. The extract from the introduction outlines the foundations of his hypothesis on Orientalism in European colonial initiatives, representations and power.

Linda Nochlin (b. 1931), is perhaps most well-known for her publications on feminist deconstructions of the western art-historical discourse. This extract builds directly from Said's hypotheses in analysing the artistic manifestation of Orientalism in the art of the nineteenth century. It analyses Jean-Léon Gérôme's *Snake Charmer* (late 1860s), one of several French Orientalist works discussed in the essay. Through analysis of the absences within the work she reveals a stereotyping of an inferior Orient which parallels Said's conclusions from the analysis of literature and texts. [Diana Newall]

a) Edward W. Said, 'Introduction – II', in *Orientalism* (London: Penguin, 1978, 1995, 2003), pp. 4–9

I have begun with the assumption that the Orient is not an inert fact of nature. It is not merely *there*, just as the Occident itself is not just *there* either. We must take seriously Vico's great observation that men make their own history, that what they can know is what they have made, and extend it to geography: as both geographical and cultural entities – to say nothing of historical entities – such locales, regions, geographical sectors as 'Orient' and 'Occident' are man-made. Therefore as much as the West itself, the Orient is an idea that has a history and a tradition of thought, imagery, and vocabulary that have given it reality and presence in and for the West. The two geographical entities thus support and to an extent reflect each other.

Having said that, one must go on to state a number of reasonable qualifications. In the first place, it would be wrong to conclude that the Orient was *essentially* an idea, or a creation with no corresponding reality. When Disraeli said in his novel *Tancred* that the East was a career, he meant that to be interested in the East was something bright young Westerners would find to be an all-consuming passion; he should not be interpreted as saying that the East was *only* a career for Westerners. There were – and are – cultures and nations whose location is in the East, and their lives, histories, and customs have a brute reality obviously greater than anything that could be said about them in the West. About that fact this study of Orientalism has very little to contribute, except to acknowledge it tacitly. But the phenomenon of Orientalism as I study it here deals principally, not with a correspondence between Orientalism and Orient, but with the internal consistency of Orientalism and its ideas about the Orient (the East as career) despite or beyond any correspondence, or lack thereof, with a 'real' Orient. My point is that Disraeli's statement about the East refers mainly to that created consistency, that regular

constellation of ideas as the pre-eminent thing about the Orient, and not to its mere being, as Wallace Stevens's phrase has it.

A second qualification is that ideas, cultures, and histories cannot seriously be understood or studied without their force, or more precisely their configurations of power, also being studied. To believe that the Orient was created – or, as I call it, 'Orientalized' – and to believe that such things happen simply as a necessity of the imagination, is to be disingenuous. The relationship between Occident and Orient is a relationship of power, of domination, of varying degrees of a complex hegemony, and is quite accurately indicated in the title of K.M. Panikkar's classic *Asia and Western Dominance.*[1] The Orient was Orientalized not only because it was discovered to be 'Oriental' in all those ways considered commonplace by an average nineteenth-century European, but also because it *could be* – that is, submitted to being – *made* Oriental. There is very little consent to be found, for example, in the fact that Flaubert's encounter with an Egyptian courtesan produced a widely influential model of the Oriental woman: she never spoke of herself, she never represented her emotions, presence, or history. *He* spoke for and represented her. He was foreign, comparatively wealthy, male, and these were historical facts of domination that allowed him not only to possess Kuchuk Hanem physically but to speak for her and tell his readers in what way she was 'typically Oriental'. My argument is that Flaubert's situation of strength in relation to Kuchuk Hanem was not an isolated instance. It fairly stands for the pattern of relative strength between East and West, and the discourse about the Orient that it enabled.

This brings us to a third qualification. One ought never to assume that the structure of Orientalism is nothing more than a structure of lies or of myths which, were the truth about them to be told, would simply blow away. I myself believe that Orientalism is more particularly valuable as a sign of European-Atlantic power over the Orient than it is a veridic discourse about the Orient (which is what, in its academic or scholarly form, it claims to be). Nevertheless, what we must respect and try to grasp is the sheer knitted-together strength of Orientalist discourse, its very close ties to the enabling socio-economic and political institutions, and its redoubtable durability. After all, any system of ideas that can remain unchanged as teachable wisdom (in academies, books, congresses, universities, foreign-service institutes) and from the period of Ernest Renan in the late 1840s until the present in the United States must be something more formidable than a mere collection of lies. Orientalism,

1 K.M. Panikkar, *Asia and Western Dominance* (London: George Allen & Unwin, 1959).

therefore, is not an airy European fantasy about the Orient, but a created body of theory and practice in which, for many generations, there has been a considerable material investment. Continued investment made Orientalism, as a system of knowledge about the Orient, an accepted grid for filtering through the Orient into Western consciousness, just as that same investment multiplied – indeed, made truly productive – the statements proliferating out from Orientalism into the general culture.

Gramsci has made the useful analytic distinction between civil and political society in which the former is made up of voluntary (or at least rational and noncoercive) affiliations like schools, families, and unions, the latter of state institutions (the army, the police, the central bureaucracy) whose role in the polity is direct domination. Culture, of course, is to be found operating within civil society, where the influence of ideas, of institutions, and of other persons works not through domination but by what Gramsci calls consent. In any society not totalitarian, then, certain cultural forms predominate over others, just as certain ideas are more influential than others; the form of this cultural leadership is what Gramsci has identified as *hegemony*, an indispensable concept for any understanding of cultural life in the industrial West. It is hegemony, or rather the result of cultural hegemony at work, that gives Orientalism the durability and the strength I have been speaking about so far. Orientalism is never far from what Denys Hay has called the idea of Europe,[2] a collective notion identifying 'us' Europeans as against all 'those' non-Europeans, and indeed it can be argued that the major component in European culture is precisely what made that culture hegemonic both in and outside Europe: the idea of European identity as a superior one in comparison with all the non-European people and cultures. There is in addition the hegemony of European ideas about the Orient, themselves reiterating European superiority over Oriental backwardness, usually overriding the possibility that a more independent, or more skeptical, thinker might have had different views on the matter.

In a quite constant way, Orientalism depends for its strategy on this flexible *positional* superiority, which puts the Westerner in a whole series of possible relationships with the Orient without ever losing him the relative upper hand. And why should it have been otherwise, especially during the period of extraordinary European ascendancy from the late Renaissance to the present? The scientist, the scholar, the missionary, the trader, or the soldier was in, or thought about, the Orient because

2 Denys Hay, *Europe: The Emergence of an Idea*, 2nd edn (Edinburgh: Edinburgh University Press, 1968).

he *could be there*, or could think about it, with very little resistance on the Orient's part. Under the general heading of knowledge of the Orient, and within the umbrella of Western hegemony over the Orient during the period from the end of the eighteenth century, there emerged a complex Orient suitable for study in the academy, for display in the museum, for reconstruction in the colonial office, for theoretical illustration in anthropological, biological, linguistic, racial, and historical theses about making and the universe, for instances of economic and sociological theories of development, revolution, cultural personality, national or religious character. Additionally, the imaginative examination of things Oriental was based more or less exclusively upon a sovereign Western consciousness out of whose unchallenged centrality an Oriental world emerged, first according to general ideas about who or what was an Oriental, then according to a detailed logic governed not simply by empirical reality but by a battery by desires, repressions, investments and projections. If we can point to great Orientalist works of genuine scholarship like Silvestre de Sacy's *Chrestomathie arabe* or Edward William Lane's *Account of the Manners and Customs of the Modern Egyptians*, we need also to note that Renan's and Gobineau's racial ideas came out of the same impulse, as did a great many Victorian pornographic novels (see the analysis by Steven Marcus of 'The Lustful Turk'[3]).

And yet, one must repeatedly ask oneself whether what matters in Orientalism is the general group of ideas overriding the mass of material – about which who could deny that they were shot through with doctrines of European superiority, various kinds of racism, imperialism, and the like, dogmatic views of 'the Oriental' as a kind of ideal and unchanging abstraction? – or the much more varied work produced by almost uncountable individual writers, whom one would take up as individual instances of authors dealing with the Orient. In a sense the two alternatives, general and particular, are really two perspectives on the same material: in both instances one would have to deal with pioneers in the field like William Jones, with great artists like Nerval or Flaubert. And why would it not be possible to employ both perspectives together, or one after the other? Isn't there an obvious danger of distortion (of precisely the kind that academic Orientalism has always been prone to) if either too general or too specific a level of description is maintained systematically?

3 Steven Marcus, *The Other Victorians: A Study of Sexuality and Pornography in Mid-Nineteenth Century England* (1966; reprint ed., New York: Bantam Books, 1967), pp. 200–219.

My two fears are distortion and inaccuracy, or rather the kind of inaccuracy produced by too dogmatic a generality and too positivistic a localized approach. In trying to deal with these problems I have tried to deal with three main aspects of my own contemporary reality that seem to me to point the way out of the methodological or perspectival difficulties I have been discussing, difficulties that might force one, in the first instance, into writing a coarse polemic on so unacceptably general a level of description as not to be worth the effort, or in the second instance, into writing so detailed and atomistic a series of analyses as to lose all track of the general lines to force informing the field, giving it its special cogency. How then to recognise individuality and to reconcile it with its intelligent, and by no means passive or merely dictatorial, general and hegemonic context?

b) Linda Nochlin, 'The Imaginary Orient', in *The Politics of Vision: Essays on Nineteenth-Century Art and Society* (New York: Harper & Row, 1989), pp. 34–39

[...]

What are we to make [...] of Jean-Léon Gérôme's *Snake Charmer*, painted in the late 1860s (now in the Clark Art Institute, Williamstown, Mass. (Figure 1.1))? Surely it may most profitably be considered as a visual document of nineteenth-century colonialist ideology, an iconic distillation of the Westerner's notion of the Oriental couched in the language of a would-be transparent naturalism. (No wonder Said used it as the dust jacket for his critical study of the phenomenon of Orientalism!)[1] The title, however, doesn't really tell the complete story; the painting should really be called *The Snake Charmer and His Audience,* for we are clearly meant to look at both performer and audience as parts of the same spectacle. We are not, as we so often are in Impressionist works of this period – works like Manet's or Degas's *Café Concerts,* for example, which are set in Paris – invited to identify with the audience. The watchers huddled against the ferociously detailed tiled wall in the background of Gérôme's painting are as resolutely alienated from us as is the act they watch with such childish, trancelike concentration. Our gaze is meant

1 The insights offered by Said's *Orientalism* (New York, 1978) are central to the arguments developed in this study. However, Said's book does not deal with the visual arts at all.

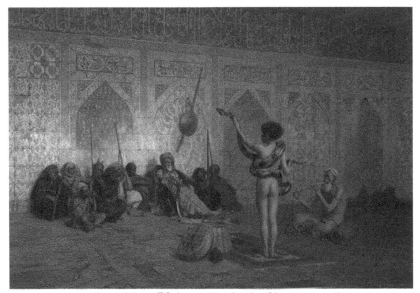

1.1 Jean-Léon Gérôme, *The Snake Charmer*, c. 1879

to include both the spectacle and its spectators as objects of picturesque delectation.

Clearly, these black and brown folk are mystified – but then again, so are we. Indeed, the defining mood of the painting is mystery, and it is created by a specific pictorial device. We are permitted only a beguiling rear view of the boy holding the snake. A full frontal view, which would reveal unambiguously both his sex and the fullness of his dangerous performance, is denied us. And the insistent, sexually charged mystery of the East itself, a standard topos of Orientalist ideology.

Despite, or perhaps because of, the insistent richness of the visual diet Gérôme offers – the manifest attractions of the young protagonist's rosy buttocks and muscular thighs; the wrinkles of the venerable snake charmer to his right; the varied delights offered by the picturesque crowd and the alluringly elaborate surfaces of the authentic Turkish tiles, carpet, and basket which serve as décor – we are haunted by certain *absences* in the painting. The absences are so conspicuous that, once we become aware of them, they begin to function as presences, in fact, as signs of a certain kind of conceptual deprivation.

One absence is the absence of history. Time stands still in Gérôme's painting, as it does in all imagery qualified as 'picturesque,' including nineteenth-century representations of peasants in France itself. Gérôme suggests that this Oriental world is a world without change, a world of

timeless, atemporal customs and rituals, untouched by the historical processes that were 'afflicting' or 'improving' but, at any rate, drastically altering Western societies at the time. Yet these were in fact years of violent and conspicuous change in the Near East as well, changes affected primarily by Western power – technological, military, economic, cultural – and specifically by the very French presence Gérôme so scrupulously avoids.

[...]

The absence of a sense of history, of temporal change, in Gérôme's painting is intimately related to another striking absence in the work: that of the telltale presence of Westerners. There are never any Europeans in 'picturesque' views of the Orient like these. Indeed, it might be said that one of the defining features of Orientalist painting is its dependence for its very existence on a presence that is always an absence: the Western colonial or touristic presence.

The white man, the Westerner, is of course always implicitly present in Orientalist painting like *Snake Charmer*, his is necessarily the controlling gaze, the gaze which brings the Oriental world into being, the gaze for which it is ultimately intended. And this leads us to still another absence. Part of the strategy of an Orientalist painter like Gérôme is to make his viewers forget that there was any 'bringing into being' at all, to convince them that works like these were simply 'reflections', scientific in their exactitude, of a pre-existing Oriental reality.

[...]

The strategies of 'realist' (or perhaps 'pseudo-realist,' 'authenticist,' or 'naturalist' would be better terms) mystification go hand in hand with those of Orientalist mystification. Hence, another absence which constitutes a significant presence in the painting: the absence – that is to say, the *apparent* absence – of art. As Leo Bersani has pointed out in his article on realism and the fear of desire, 'The "seriousness" of realist art is based on the absence of any reminder of the fact that it is really a question of art'.[2] No other artist has so inexorably eradicated all traces of the picture plane as Gérôme, denying us any clue to the art work as a literal flat surface.

If we compare a painting like Gérôme's *Street in Algiers* with its prototype, Delacroix's *Street in Meknes*, we immediately see that Gérôme, in the interest of 'artlessness', of innocent, Orientalist transparency, goes much farther than Delacroix in supplying picturesque data to the Western

2 Leo Bersani, 'Le Réalisme et la peur du désir', in *Littérature et réalité*, G. Genette and T. Todorov (eds.) (Paris, 1982), p. 59.

observer, and in veiling the fact that the image consists of paint on canvas. A 'naturalist' or 'authenticist' artist like Gérôme tries to make us forget that his art is really art, both by concealing the evidence of his touch, and, at the same time, by insisting on a plethora of authenticating details, especially on what might be called unnecessary ones. These include not merely the 'carefully executed Turkish tile patterns' that Richard Etting-hausen pointed out in his 1972 Gérôme catalogue; not merely the artist's renditions of Arabic inscriptions which Ettinghausen maintains, 'can be easily read';[3] but even the 'later repair' on the tile work, which, functioning at first sight rather like the barometer on the piano in Flaubert's description of Madame Aubain's drawing room in 'Un Coeur simple,' creates what Roland Barthes has called 'the reality effect' (*l'effet de réel*).[4]

[...]

Yet if we look again, we can see that the objectively described repairs in the tiles have still another function: a moralizing one which assumes meaning only within the apparently objectivized context of the scene as a whole. Neglected, ill-repaired architecture functions, in nineteenth-century Orientalist art, as a standard topos for commenting on the corruption of contemporary Islamic society. Kenneth Bendiner has collected striking examples of this device, in both paintings and the writings of nineteenth-century artists. For instance, the British painter David Roberts, documenting his *Holy Land* and *Egypt and Nubia*, wrote from Cairo in 1838 about 'splendid cities, once teeming with a busy population and embellished with ... edifices, the wonder of the world, now deserted and lonely, or reduced by mismanagement and the barbarism of the Moslem creed, to a state as savage as the wild animals by which they are surrounded'. At another time, explaining the existence of certain ruins in its environs, he declared that Cairo 'contains, I think, more idle people than any town its size in the world'.[5]

The vice of idleness was frequently commented upon by Western travellers to Islamic countries in the nineteenth century, and in relation to it, we can observe still another striking absence in the annals of Orientalist art: the absence of scenes of work and industry, despite the

3 Richard Ettinghausen in *Jean-Léon Gérôme (1824–1904)*, exhibition catalogue, Dayton Art Institute, 1972, p. 18. Edward Said has pointed out to me in conversation that most of the so-called writing on the back wall of the *Snake Charmer* is in fact unreadable.
4 Roland Barthes, 'L'effet de réel', in *Littérature et réalité*, pp. 81–90.
5 Cited by Kenneth Bendiner, 'The Portrayal of the Middle East in British Painting 1835–1860', Ph.D. Dissertation, Columbia University, 1979, pp. 110–111. Bendiner cites many other instances and has assembled visual representations of the theme as well.

fact that some Western observers commented on the Egyptian fellahin's long hours of back-breaking labor, and on the ceaseless work of Egyptian women engaged in the field and in domestic labor.[6]

When Gérôme's painting is seen within this context of supposed Near Eastern idleness and neglect, what might at first appear to be objectively described architectural fact turns out to be *architecture moralisée*. The lesson is subtle, perhaps, but still eminently available, given a context of similar topoi: these people – lazy, slothful, and childlike, if colourful – have let their own cultural treasures sink into decay. There is a clear allusion here, clothed in the language of objective reportage, not merely to the mystery of the East, but to the barbaric insouciance of Moslem peoples, who quite literally charm snakes while Constantinople falls into ruins.

What I am trying to get at, of course, is the obvious truth that in this painting Gérôme is not reflecting a ready-made reality but, like all artists, is producing meanings. If I seem to dwell on the issue of authenticating details, it is because not only Gérôme's contemporaries, but some present-day revisionist revivers of Gérôme, and of Orientalist painting in general, insist so strongly on the objectivity and creditability of Gérôme's view of the Near East, using this sort of detail as evidence of their claims.

1.2 Homi K. Bhabha, *The Location of Culture* (Abingdon: Routledge, 1994)

Homi K. Bhabha (b. 1949), born in Mumbai, has been Professor in English and American literature at Harvard University since 2001. His scholarship closely interrogates debates within post-colonial theory exploring the concepts of hybridity, ambivalence, cultural difference and the third space, to reveal ways in which colonised peoples can resist and destabilise the power of the coloniser. His focus on the space in which colonised and coloniser interact is reflected in the two extracts here. In the first he argues that, in the constant process of establishing and reinforcing other-ness on the colonised, there is an ambivalence – literally the coexistence of opposing emotional attitudes – which drives the colonial discourse.

In the second extract, he dissects and challenges the nature of culture difference in the colonial encounter. He discusses an

6 See, for example, Bayle St. John's *Village Life in Egypt*, originally published in 1852, reprinted 1973, I, pp. 13, 36, and passim.

episode from E. M. Forster's *A Passage to India* (1924), in which the Indian Dr Aziz is accused of sexual assault by the Englishwoman Adela Quested after visiting the Marabar Caves with her. Bhabha uses this narrative to reveal that at the centre of the colonial discourse, the reality of difference cannot be articulated coherently. [Diana Newall]

a) 'The Other Question: Stereotype, Discrimination and the Discourse of Colonialism', pp. 94–96

To concern oneself with the founding concepts of the entire history of philosophy, to deconstitute them, is not to undertake the work of the philologist or of the classic historian of philosophy. Despite appearances, it is probably the most daring way of making the beginnings of a step outside of philosophy.

<div align="right">Jacques Derrida, 'Structure, sign and play'[1]</div>

An important feature of colonial discourse is its dependence on the concept of 'fixity' in the ideological construction of otherness. Fixity, as the sign of cultural/historical/racial difference in the discourse of colonialism, is a paradoxical mode of representation: it connotes rigidity and an unchanging order as well as disorder, degeneracy and daemonic repetition. Likewise the stereotype, which is its major discursive strategy, is a form of knowledge and identification that vacillates between what is always 'in place', already known, and something that must be anxiously repeated … as if the essential duplicity of the Asiatic or the bestial sexual licence of the African that needs no proof, can never really, in discourse, be proved. It is this process of *ambivalence,* central to the stereotype, that this section explores as it constructs a theory of colonial discourse. For it is the force of ambivalence that gives the colonial stereotype its currency: ensures its repeatability in changing historical and discursive conjunctures; informs its strategies of individuation and marginalization; produces that effect of probabilistic truth and predictability which, for the stereotype, must always be in *excess* of what can be empirically proved or logically construed. Yet the function of ambivalence as one of the most significant discursive and psychical strategies of discriminatory power – whether racist or sexist, peripheral or metropolitan – remains to be charted.

The absence of such a perspective has its own history of political expediency. To recognize the stereotype as an ambivalent mode of

1 J. Derrida, 'Structure, sign and play in the discourse of the human sciences', in his *Writing* and *Difference,* Alan Bass (trans.) (Chicago: Chicago University Press, 1978), p. 284.

knowledge and power demands a theoretical and political response that challenges deterministic or functionalist modes of conceiving of the relationship between discourse and politics. The analytic of ambivalence questions dogmatic and moralistic positions on the meaning of oppression and discrimination. My reading of colonial discourse suggests that the point of intervention should shift from the ready recognition of images as positive or negative, to an understanding of the *processes of subjectification* made possible (and plausible) through stereotypical discourse. To judge the stereotyped image on the basis of a prior political normativity is to dismiss it, not to displace it, which is only possible by engaging with its *effectivity*; with the repertoire of positions of power and resistance, domination and dependence that constructs colonial identification subject (both colonizer and colonized). I do not intend to deconstruct the colonial discourse to reveal its ideological misconceptions or repressions, to exult in its self-reflexivity, or to indulge its liberatory 'excess'. In order to understand the productivity of colonial power it is crucial to construct its regime of truth, not to subject its representations to a normalizing judgement. Only then does it become possible to understand the *productive* ambivalence of the object of colonial discourse – that 'otherness' which is at once an object of desire and derision, an articulation of difference contained within the fantasy of origin and identity. What such a reading reveals are the boundaries of colonial discourse and it enables a transgression of these limits from the space of that otherness.

The construction of the colonial subject in discourse, and the exercise of colonial power through discourse, demands an articulation of forms of difference – racial and sexual. Such an articulation becomes crucial if it is held that the body is always simultaneously (if conflictually) inscribed in both the economy of pleasure and desire and the economy of discourse, domination and power. I do not wish to conflate, unproblematically, two forms of the marking – and splitting – of the subject nor to globalize two forms of representation. I want to suggest, however, that there is a theoretical space and a political place for such an *articulation* – in the sense in which that word itself denies an 'original' identity or a 'singularity' to objects of difference – sexual or racial. If such a view is taken, as Feuchtwang argues in a different context,[2] it follows that the epithets racial or sexual come to be seen as modes of differentiation, realized as multiple, cross-cutting determinations, polymorphous and

2 S. Feuchtwang, 'Socialist, feminist and anti-racist struggles', *m/f*, no. 4 (1980) p. 41.

perverse, always demanding a specific and strategic calculation of their effects. Such is, I believe, the moment of colonial discourse. It is a form of discourse crucial to the binding of a range of differences and discriminations that inform the discursive and political practices of racial and cultural hierarchization.

b) 'Articulating the Archaic: Cultural Difference and Colonial Nonsense', pp. 175–180

How can the mind take hold of such a country? Generations of invaders have tried, but they remain in exile. The important towns they build are only retreats, their quarrels the malaise of men who cannot find their way home. India knows of their trouble She calls 'Come' through her hundred mouths, through objects ridiculous and august. But come to what? She has never defined. She is not a promise, only an appeal.

E. M. Forster, *A Passage to India*[1]

The Fact that I have said that the effect of interpretation is to isolate in the subject a kernel, a *kern* to use Freud's own term, of *non-sense*, does not mean that interpretation is in itself nonsense.

Jacques Lacan, 'The field of the other'[2]

I

There is a conspiracy of silence around the colonial truth, whatever that might be. Around the turn of the century there emerges a mythic, masterful silence in the narratives of empire, what Sir Alfred Lyall called 'doing our Imperialism quietly', Carlyle celebrated as the 'wisdom of the Do-able – Behold ineloquent Brindley ... he has chained the seas together', and Kipling embodied, most eloquently in the figure of Cecil Rhodes – 'Nations not words he linked to prove/His faith before the crowd'.[3] Around the same time, from those dark corners of the earth, there comes another, more ominous silence that utters an archaic colonial 'otherness', that speaks in riddles, obliterating proper names and proper places. It is a silence that turns imperial triumphalism into the testimony of colonial

1 E. M. Forster, *A Passage to India* (Harmondsworth: Penguin, 1979), p. 135.
2 J. Lacan, *The Four Fundamental Concepts of Psychoanalysis* (Harmondsworth: Penguin, 1979), p. 250.
3 A. Lyall; Carlyle, *Essays*; R. Kipling, 'The burial', quoted in E. Stokes, *The Political Ideas of English Imperialism* (Oxford: Oxford University Press, 1960), p. 28. I am indebted to Stokes's suggestive remarks on the value of 'inarticulateness' attributed to the mission of colonial enterprise.

confusion and those who hear its echo lose their historic memories. This is the Voice of early modernist 'colonial' literature, the complex cultural memory of which is made in a fine tension between the melancholic homelessness of the modern novelist, and the wisdom of the sage-like storyteller whose craft takes him no further afield than his own people.[4] In Conrad's *Heart of Darkness*, Marlow seeks Kurtz's Voice, his words, 'a stream of light or the deceitful flow from the heart of an impenetrable darkness' and in that search he loses 'what is in the *work* – the chance to find yourself.[5] [...] And Aziz, in *A Passage to India*, who embarks jauntily, though no less desperately, on his Anglo-Indian picnic to the Marabar caves is cruelly undone by the echo of the Kawa Dol: 'Boum, ouboum is the sound as far as the human alphabet can express it ... if one spoke silences in that place or quoted lofty poetry, the comment would have been the same ou-boum'.[6]

As one silence uncannily repeats the other, the sign of identity and reality found in the work of empire is slowly undone. Eric Stokes, in *The Political Ideas of English Imperialism*,[7] describes the mission of work – that medium of recognition for the colonial subject – as a distinctive feature of the imperialist mind which, from the early nineteenth century, effected 'the transference of religious emotion to secular purposes'. But this transference of affect and object is never achieved 'without a disturbance, a displacement in the representation of empire's work itself. [...]

What emerges from the dispersal of work is the language of a colonial nonsense that displaces those dualities in which the colonial space is traditionally divided: nature/culture, chaos/civility. Ouboum or the owl's deathcall – the horror of these words! – are not naturalized or primitivistic descriptions of colonial 'otherness', they are the inscriptions of an uncertain colonial silence that mocks the social performance of language with their non-sense; that baffles the communicable verities of culture with their refusal to translate. These hybrid signifiers are the intimations of colonial otherness that Forster describes so well in the beckoning of India to the conquerors: 'She calls "Come" ... But come to what? She has never defined. She is not a promise, only an appeal'.[8] It is from such an uncertain

4 W. Benjamin, *Illuminations*, H. Zonh (trans.) (London: Cape, 1970), pp. 98–101.
5 J. Conrad, *Heart of Darkness*, R. Kimbrough (ed.) (New York: W. W. Norton & Co, 1963). p. 28.
6 Forster, *Passage to India*, p. 145.
7 E. Stokes, *The Political Ideas of English Imperialism* (Oxford: Oxford University Press, 1960), p. 29.
8 Forster, *Passage to India*, p. 135.

invitation to interpret, from such a question of desire, that the echo of another significant question can be dimly heard, Lacan's question of the alienation of the subject in the Other: 'He is saying this to me, but what does he want?[9]

[...]

The work of the word impedes the question of the transparent assimilation of cross-cultural meanings in a unitary sign of 'human' culture. In-between culture, at the point of its articulation of identity or distinctiveness, comes the question of signification. This is not simply a matter of language: it is the question of culture's representation of difference – manners, words, rituals, customs, time – inscribed *without* a transcendent subject that knows, outside of a mimetic social memory, and across the – ouboum – kernel of non-sense. What becomes of cultural identity, the ability to put the right word in the right place at the right time, when it crosses the colonial non-sense?

Such a question impedes the language of relativism in which cultural difference is usually disposed of as a kind of ethical naturalism, a matter of cultural diversity. 'A fully individual culture is at best a rare thing', Bernard Williams writes in his interesting work *Ethics and the Limits of Philosophy*.[10] Yet, he argues, the very structure of ethical thought seeks to apply its principles to the whole world. His concept of a 'relativism of distance', which is underwritten by an epistemological view of society as a given whole, seeks to inscribe the totality of other cultures in a realist and concrete narrative that must beware, he warns, the fantasy of projection. Surely, however, the very project of ethical naturalism or cultural relativism is spurred precisely by the repeated threat of the *loss* of a 'teleologically significant world', and it is the compensation of that loss in projection or introjection which then becomes the *basis* of its ethical judgement. From the margins of his text, Williams asks, in parenthesis, a question not dissimilar to Forster's India question or Lacan's question of the subject; 'What is this talk of projection [in the midst of naturalism] really saying? What is the screen?' He makes no answer.

The problematic enunciation of cultural difference becomes, in the discourse of relativism, the perspectival problem of temporal and spatial distance. The threatened 'loss' of meaningfulness in cross-cultural interpretation, which is as much a problem of the structure of the signifier

9 Lacan, *The Four Fundamental Concepts of Psychoanalysis*, p. 214.
10 B. Williams, *Ethics and the Limits of Philosophy* (London: Fontana, 1985).

as it is a question of cultural codes (the *experience* of other cultures), then becomes a hermeneutic project for the restoration of cultural 'essence' or authenticity. The issue of interpretation in colonial cultural discourse is not, however, an epistemological problem that emerges because colonial objects appear *before* (in both senses) the eye of the subject in a bewildering diversity. Nor is it simply a quarrel between preconstituted holistic cultures, that contain within themselves the codes by which they can legitimately be read. The question of cultural difference as I want to cast it, is not what Adela Quested quaintly identified as an 'Anglo-Indian difficulty', a problem caused by cultural plurality. And to which, in her view, the only response could be the sublation of cultural differentiation in an ethical universalism: 'That's why I want Akbar's "universal religion" or the equivalent to keep me decent and sensible'.[11] Cultural difference, as Adela experienced it, in the nonsense of the Marabar caves, is not the acquisition or accumulation of additional cultural knowledge; it is the momentous, if momentary, extinction of the recognizable object of culture in the disturbed artifice of its signification, at the edge of experience.

What happened in the Marabar caves? *There*, the loss of the narrative of cultural plurality; *there* the implausibility of conversation and commensurability: *there* the enactment of an undecidable, uncanny colonial present, an Anglo-Indian difficulty, which repeats but is never itself fully represented: 'Come ... But come to what?'; remember India's invocation. Aziz is uncurably inaccurate about the events, because he is sensitive, because Adela's question about polygamy has to be put from his mind. Adela, obsessively trying to think the incident out, somatizes the experience in repeated, hysterical narratives. Her body, Seba[s]tian-like, is covered in colonies of cactus spines, and her mind which attempts to disavow the body – hers, his – returns to it obsessively: 'Now, everything transferred to the surface of my body ... He never actually touched me once ... It all seems such nonsense ... a sort of shadow'. It is the echochamber of memory:

> 'What a handsome little oriental ... beauty, thick hair, a fine skin ... there was nothing of the vagrant in her blood ... he might attract women of his own race and rank: Have you one wife or many? ... Damn the English even at their best', he says ... 'I remember, remember scratching the wall with my finger-nail to start the echo ... ' she says ... And then the echo ... 'Ouboum'.[12]

11 Forster, *Passage to India*, p. 144.

12 This is a collage of words, phrases, statements made in/around the entry to the Marabar caves. They represent a fictional re-enactment of that crucial moment as an act of memory.

In this performance of the text, I have attempted to articulate the enunciatory disorder of the colonial present, the writing of cultural difference. It lies in the staging of the colonial signifier in the narrative uncertainty of culture's in-between: between sign and signifier, neither one nor the other, neither sexuality nor race, neither, simply, memory nor desire. [...]

1.3 New perspectives and approaches in Art History

The three texts presented here relate to ongoing debates and projects over the first two decades of the twenty-first century which have, in different ways, investigated the impact of globalisation on the structures and methodologies within the discipline of art history. The text by Thomas DaCosta Kaufmann (b. 1948) is a summary of his analysis of the geographical structuring of art history, developed within his *Toward a Geography of Art History* (2004). The essay was part of the initiative by Kitty Zijlmans and Wilfried van Damme to bring together articles which explore a global and multidisciplinary approach to world art studies. Kaufmann's text highlights issues within the concepts of place, identity, ethnicity, centre, periphery and diffusion that underpin the boundaries and categories used in art history.

James Elkins (b. 1955), E.C. Chadbourne Chair of art history, theory and criticism at the Art Institute, Chicago, has been a leading facilitator in exploring debates and issues of global art history. His text follows an Art Seminar round table held in 2005, published more fully in his *Is Art History Global?* (2007), and is part of a broader initiative and publication, edited by Jonathan Harris, *Globalization and Contemporary Art* (2011).

Parul Dave Mukherji, Professor in the School of Art and Aesthetics at Jawaharlal Nehru University, New Delhi, has written on issues of globalisation and art history, including *Towards a New Art History: Studies in Indian Art* (2003), with co-editors Shivaji K. Panikkar and Deeptha Achar and with co-editor Raminder Kaur, *Arts and Aesthetics in a Globalizing World* (2015). In this extract she analyses the concept of 'post-ethnic' surveying interventions which have sought to step outside the western-ness of art history. She argues that art history is still 'colonised' by western frameworks and the challenge faced by non-western art history (and by implication western art history as well) is how to break these constraints. [Diana Newall]

a) **Thomas DaCosta Kaufmann, 'The Geography of Art: Historiography, Issues, and Perspectives', in Kitty Zijlmans and Wilfried van Damme (eds),** *World Art Studies: Exploring Concepts and Approaches* **(Amsterdam: Valiz, 2008), pp. 167–182**

Historical methods deal with events or objects (including art and architecture) chronologically, considering their antecedents, causes, and effects. But explanations of human actions or the man-made may also concentrate on their spatial instead of their temporal aspects. Approaches that consider spaces, locations, or other environmental features including climate may be called geographical.

[...]

Since the beginning of the twentieth century a more specialized area of human geography has also developed. Human geography *(Anthropogeographie, géographie humaine)* considers the impact of the physical environment on, and in general its relation to, human beings. This approach specifically deals with the man-made, hence the relation to culture, which stands as a complement to nature. A field of cultural geography thus also came into being: it deals with the definition and spread of human cultures, however the term be understood, over the globe.

The conception of spread or diffusion implies a notion of a development that occurs in time as well as through space. Although critical reflection may distinguish between what Immanuel Kant deemed the basic categories of understanding (space and time), they are of course inseparable in existence; and an important school of cultural geography has indicated that considerations of geography can not be extricated from those of history. One of its founders already recognized that cultural geography was in effect cultural historical.[1] It can also be argued that cultural history (including art history) is inextricable from cultural geography.

[...]

In general, considerations of space may be regarded as fundamental to architecture and art. Buildings shape the space in which they exist; they relate directly to their environment, which they in turn form.[2] The pictorial and plastic arts often strive to create the illusion of space, and consequently these questions have engendered a large literature on perspective and on the psychology of visual representation, among other things. In the twentieth century a widely read aesthetics or poetics of

1 Carl Ortwin Sauer, *Land and life: A selection from the writings of Carl Ortwin Sauer,* John Leighly (ed.) (Berkeley, Los Angeles: University of California Press, 1963).
2 Vincent Scully, *Architecture: The natural and the manmade* (New York: St. Martin's Press, 1991).

space was also excogitated that related human sensory experience of space to the response to objects and environments.[3] Furthermore, a discourse on space in relation to art and architecture has recently been elaborated that stresses the distinctive character of the 'sacred space' created near and around holy objects and sites; a new field of 'hierotopy' has thus arisen.[4] A newly published theory of space has been even more fully elaborated which argues that a world history of art may be founded on the thesis that the visual arts are all essentially related to real spaces.[5]

However, these theories do not bear directly on issues of the geography of art as described here, because artistic geography entails considerations of place. Although both space and place are notoriously difficult to define, the concept of place represents something more specific. According to one recently formulated distinction, places considered in art history may be distinguished from spaces as 'definite areas distinguished from their surroundings by hominid construction'.[6] In any event, the geography of art treats places as distinctive locations in relation to art.

Along with conceptualizations of history, geographical notions are inherent in some of the most basic ideas that frame approaches to the history of art and architecture. Objects are usually categorized with terms such as 'baroque architecture' which relate them to historical epochs, whereby stylistic labels are utilized to designate particular periods. Yet they are also related either to specific (the School of Pont Aven) or to general locations (African art), indicating that geographical categories are also employed. Most often, of course, the two categories are conjoined (as in French Gothic). The idea that art is related to geography is implicit in such labels, whether or not they are explicitly analyzed. Throughout the historiography of art and architecture geographical ideas that have entered into these and many other assumptions about the place of art have indeed often been articulated, analyzed, and debated.

The geography of art may thus be related to cultural and human geography, and further defined. To restate some descriptions, the geography of art investigates how art results from or expresses a response to geographical circumstances, either directly, or in the way that such conditions

3 Gaston Bachelard, *The poetics of space*, Maria Jolas (trans.), foreword John R. Stilgoe, 1st ed. published 1964 (Boston: Beacon Press, 1994).

4 Alexei Lidov (ed.), *Hierotopy: Studies in the making of sacred spaces: Material from the international symposium* (Moscow: Radunitsa, 2004).

5 David Summers, *Real spaces: World art history and the rise of Western modernism* (London and New York: Phaidon, 2003).

6 Summers, *Real spaces*, p. 117.

have shaped human differences that have led to the production of distinctive kinds of objects.[7] It raises such questions as how art and architecture are related to, determined by, or determine, or are affected by or affect the place in which they are made; how art (and architecture) are identified with a people, culture, region, nation, or state; and how art or architecture in various places are to be interrelated, through spread, or contact. It involves concerns about how areas of study are to be delimited, spatially as well as chronologically, in relation to a particular place.[8]

[...]

Historiography

In the western (European and American) tradition, views of the relation of artifacts to their location have long been expressed in both proscriptive and descriptive terms. [...]

The descriptive tradition of topography [...] originated in antiquity. Topography is defined as the configuration of a surface including its relief and the position of its natural and man-made features, and as the accurate or detailed delineation or description of a particular place or places. Topography is thus clearly related to geography, and already in antiquity it touched upon discussions of works of art and architecture. The origins of these discussions are seen in writings such as the description *(periegesis)* of Greece by Pausanias, which describes works of art and architecture according to the places where they are found. Their heritage survives to the present in the form of guidebooks or surveys of monuments.

[...]

However, geography is to be distinguished from topography, in that it ascribes importance to the place of origin or location in its procedure of characterization, and assigns place a role in the determination of the existence or appearance of a work of art. [...]

Along with the topographic tradition (in the form of pilgrims' handbooks, for instance) geographical ideas connected with art – that climate influences the visual arts, and that buildings or types of objects are to be associated with particular peoples or places – were passed on through the middle ages. When some of the first statements which are usually identified with the origins of the modern historiography of art were

7 Thomas DaCosta Kaufmann, 'Introduction', in *Time and place: Essays in the geohistory of art*, Thomas DaCosta Kaufmann and Elizabeth Pilliod (eds.) (Aldershot and Burlington, VT: Ashgate, 2005), pp. 1–19: 1–2.

8 Thomas DaCosta Kaufmann, *Toward a geography of art* (Chicago and London: The University of Chicago Press, 2004), pp. 7–8.

formulated in sixteenth-century Italy, they also contained geographical notions. For a potential world art history it is noteworthy that even though the historiography of art has often subsequently taken on local dimensions, such views of art and its history, like other examples of early modern historiography, were also potentially global in their scope, in that they proposed a model of universal history which theoretically comprised all times and places. In his seminal *Vite*, as seen especially in the preface to this work, Giorgio Vasari thus outlined a universal history of the arts of *disegno*. Notoriously, however, Vasari distinguished the art of Tuscany and especially Florence from and above that of other centers; he treated the history of *disegno* largely as a narrative of the fate of the arts in Florence, often disparaging what was made in other places, most conspicuously that of the Germans.[9]

Vasari's geographical prejudice evoked reactions from subsequent writers, who, even if they at times adopted his model of universal history, shaped their treatments according to the place where they were writing (hence the origins of histories of the arts in Bologna, Genoa, Venice, etc.). In the seventeenth century writers on art also began to adopt Pliny's ideas of genera for the notion of local or regional schools,[10] and these ideas later became standard in art historical discourse. Geographical explanations were accordingly often called upon to account for local or regional differences. Moreover, cases continued to be made for the causal effect of climate and geography on human society and culture, and hence on art.

Thus were laid some of the foundations for Winckelmann's history of ancient art, a work which, though not the first of its kind as it claimed to be, helped mightily to establish the discourse and discipline of *Kunstgeschichte*, art history. Winckelmann argued that Greek art had been determined in good measure by the Greek environment, because of the effects of Greek climate on the Greeks' ability to see and imitate the (nude male) human form.[11] This sort of geographical presentation was also expressed elsewhere in later eighteenth-century discussions of art. The late eighteenth-century Swedish architect and author Carl August

9 See further Sonia Brough, *The Goths and the concept of Gothic in Germany from 1500 to 1750: Culture, language and architecture* (Frankfurt and New York: Peter Lang, 1985), pp. 103–131.

10 Denis Mahon, *Studies in seicento art and theory* (London: Warburg Institute, University of London, 1947), p. 245ff.

11 Johann Joachim Winckelmann, *Geschichte der Kunst des Alterthums*, 2 vols. (Dresden: In der Waltherischen Hof-Buchhandlung, 1764), pp. 19, 111.

Ehrensvard averred for instance that the nearer to Italy, and especially to Naples, the better art was, because Naples was closest to the qualities of Greek art, but the farther north one traveled, the uglier art and people became. Hence beautiful art was impossible in Sweden.[12]

While not all thinkers shared such opinions, when more structures were constructed for the discipline of art history in the nineteenth century, prejudices in favor of the classical norm were of course widespread, and, more than that, geographical ideas often formed the basis for further arguments. For instance, the idea that art expressed the spirit of a nation or people found in a particular place, or that there was a spirit of a place manifest in art, became commonplace. The study of national characteristics in art thus became a major concern for art history. This also happened because the era in which art history was institutionalized in the form of university chairs and museums was one in which many modern nation states were founded, and accordingly nationalism grew. Works of art and architecture were thus often invoked in efforts to define the identity of newly invented states.

In the nineteenth century nation was also by no means simply a neutral geographical concept. Besides being related to discussions of climate, and especially of the earth and its political or physical delimitations, ideas of nation were mingled with those of race. Hence along with geographical location race came to be counted among the determinants of human existence and culture: the two are combined for instance in the philosophy of Hippolyte Taine (as 'race, moment, milieu').[13]

Thus it was that when a self-conscious *Kunstgeographie* was articulated at the beginning of the twentieth century, many writers wove not only physical and cultural elements, but national, ethnic, and racial determinants into the discourse of the geography of art. *Kunstgeographie* drew from *Anthropogeographie,* as defined by Friedrich Ratzel (its counterparts are *géographie humaine* and human geography). Ratzel associated Darwinian notions of anthropology, such as the survival of the fittest and the struggle for existence, with geographical considerations of space. Ratzel also coined the idea of *Lebensraum.*[14]

Kunstgeographie of the earlier twentieth century often related the origins and spread of works of art to their physical circumstances as well as to

12 Carl August Ehrensvärd, *Skriften,* Svenska författare utgivna av Svenska Vitter-hetssamfundet, 10, Gunhild Bergh and Andrea Delen (ed.) (Stockholm, 1925).
13 Hippolyte Taine, *Philosophie de l'art: Voyage en Italie: Essais de critique et d'histoire,* Jean-Francois Revel (ed.) (Paris: Hermann, 1964).
14 Friedrich Ratzel, *Die Geographische Verbreitung des Menschen,* Vol. 2 of *Anthropo-geographie,* 2nd edn (Stuttgart: Engelhorns, 1912).

the ethnic origins of people who made them. For writers on the geography of art continued to believe that along with the physical features of the earth, ethnic origins determined the limits and spread of artistic traditions. Both sets of factors were thought to delimit or determine cultural phenomena. [...]

Many prominent scholars of the first half of the twentieth century, including Josef Strzygowski, Paul Frankl, Henri Focillon, and Dagobert Frey presented a variety of ideas or methods that may be associated with the geography of art. For many of them, as for other contemporaneous scholars, a basic concern of artistic geography was to determine the constants that existed in space over a long period of time, independent of history. These constants were associated with a city, region, state, or nation, and described as characteristic of a people (*Volk*), tribe (*Stamm*), landscape (*Landschaft*), or race. While not identifying themselves as geographers of art, many other thinkers, including several associated with the second Vienna school of art history, such as Karl Maria Swoboda, Otto Pächt, and Hans Sedlmayr, shared such views of national constants, and some of their students and followers continued to advance them.[15]

[...]

Although before the Second World War several scholars sharply criticized treatments of art in relation to race or nationality (even Pieper, while ultimately utilizing the concept of *Stamm*, also rejected racial explanations), they could do little to stem other tendencies of the time, which were overtly concerned with national expression (as is for instance indicated by the theme of the International Congress of the History of Art held in Stockholm in 1933). Nationalist movements and arguments and even more significantly beliefs such as the Nazi adaptation of the ideology of *Blut und Boden*, the Spenglerian thesis of blood and soil, tinged *Kunstgeographie* with an ideologically charged and often racist coloration. Disastrous consequences resulted, for much more than scholarship.

Despite the calamities of the Second World War, even afterwards many prominent scholars still continued to apply essentialist and racist notions of ethnicity in discussions of geographical questions. Among these, the nature of a continuing or constant national art continued to be paramount. Treatments of the Englishness of English art by émigré scholars like Nikolaus Pevsner or Erwin Panofsky in this regard bear remarkable resemblance to the continued and racist utterances of Dagobert

15 Kaufmann, *Toward a geography of art*, pp. 68–104.

Frey, who had been a Nazi propagandist and who was also reportedly involved in the destruction and despoiling of Polish monuments.[16]

Not until the later 1960's did a number of scholars including Rainer Hausherr, Horst Bredekamp, and Herbert Beck deliver a strong critique of *Kunstgeographie*. Pointing to the unhistorical and often racist assumptions that underlay them, they undermined the premises for previous premisses [*sic*] concerning stylistic or structural constants, unvarying climate, cultural landscape, and perpetual national or regional differences. They called instead for an understanding of geographical questions that would not project backward current national or political differences, but seek to explain the historic dimension and changing character of regions, and to find rational explanations for them. And in so doing they also called for a consideration of artistic centers and their involvement in the transmission of art, which occurred through workshops, the migration of artists, and the import and export of works of art.[17]

In the meantime, up through the mid-1960's George Kubler had been expressing a wide variety of ideas that also could have been potentially fruitful for the geography of art. Among the topics Kubler illuminated were questions of center versus periphery, of metropolis versus province, of city and region, of the difference between artistic and political regions, of artistic mixtures, and of the transfer of artistic ideas and personalities. Yet in his later work Kubler changed his focus. Until quite recently, moreover, Kubler's ideas have gone largely unheeded, except by a few scholars like Jan Bialostocki.[18]

[...]

Issues

These and other writings have left a legacy for the geography of art. Out of the plethora of potential issues, several questions in effect dominate

16 Nikolaus Pevsner, *The Englishness of English art* (London: Architectural Press, 1956); Erwin Panofsky, 'The ideological antecedents of the Rolls Royce radiator', *Proceedings of the American Philosophical Society* 107 (1963), pp. 273—288; Dagobert Frey, *Das englisches Wesen in der bildenden Kunst* (Stuttgart: Kohlhammer, 1942); Dagobert Frey, Kunstwissenschaftliche Grundfragen: Prologomena zu einer Kunstphilosophie (Vienna: Rohrer, 1946); Dagobert Frey, 'Geschichte und Probleme der Kultur- und Kunstgeographie', in *Archeologia Geographica* 4 (1955), pp. 90–105; Kaufmann, *Toward a geography of art*, pp. 86, 91ff.

17 Rainer Hausherr, 'Kunstgeographie: Aufgaben, Grenzen, Möglichkeiten', *Rheinische Vierteljahrsblätter* 34 (1970), pp. 158–171; Herbert Beck and Horst Bredekamp, 'Die mittelrheinische Kunst um 1400', in *Kunst um 1400 am Mittelrhein: ein Teil der Wirklichkeit*, Herbert Beck, Wolfgang Beeh, and Horst Bredekamp (eds.) (Frankfurt a. M.: Liebieghaus Museum alter Plastik, 1975), pp. 30–109.

18 See Kaufmann, *Toward a geography of art*, pp. 272–299.

recurrent discussions. Among these are notions of identity, regions, centers, metropolises, diffusion, circulation, and forms of exchange, or mixture.

One of the most debated is identity. A work of art or architecture may be said to obtain an identity when it is linked with a particular place, or time, or a particular artist. Identity is conceived geographically, when it is associated with a place, as in Venetian art. But this simple process also may become more elaborate, since it is also inherent in efforts to find geographical constants in art, cultural invariants that are to be associated with a location, a nation, or people. Much as the relatively unvarying features are said to characterize a landscape, so the characteristics that link a work with a place are often regarded as ahistorical or transhistorical.

Art historical literature continues to be haunted by such ghosts, among them the spirit of the place.[19] These may be found in the attempts to employ works of art as signs of a 'visual culture', which may be defined in national or ethnic terms.[20] Even if such conceptions occasionally assume historically specific characteristics, they still seem to depend from assumptions about a culture or ethnic group remaining identifiable independent of historical circumstances. Apart from inherent conceptual flaws, the history of the twentieth century should have sufficiently revealed the problems with such assumptions.

In any case, personality psychology and postmodern critiques have revealed problems with the notion of coherent identity. The term 'identity' should be used in the plural, and historical investigations also suggest as much. For example, even notions of popular identity may involve a sense of membership in a nation, a region, a town or village, a craft, and finally a class.[21] When identities are far from fixed or unchanging, to search for something as complicated and contradictory as national or even regional identity in art thus seems more than questionable. Many forms of artistic identity may exist in the same place and at the same time, making it difficult to define any single such identity.

[...]

Cities may also be considered as centers, or metropolises. In regional geography, which is closely related to cultural geography, such cities in

19 Christian Norberg-Schulz, *Genius loci: Towards a phenomenology of architecture* (New York: Rizzoli, 1979).

20 Svetlana Alpers, *The art of describing: Dutch art in the seventeenth century* (Chicago and London: The University of Chicago Press, 1983).

21 Peter Burke, 'We, the people: popular culture and popular identity in modern Europe', in *Modernity and identity*, Scott Lash and Jonathan Friedman (eds.) (Oxford and Cambridge, MA: Blackwell, 1992), pp. 293–308: 305.

turn define regions. A region may be defined as an area dominated *by* a metropolis or center. Regions may thus also be considered to be provinces, in the sense that they constitute a province in relation to a center, a core, or capital; centers also imply the existence of peripheries found towards the limits of their influence.

This argument has offered geographers a fruitful alternative to theories that explained cultural forms as determined by race, ethnicity, or nation, and it has accordingly also been productive for considerations of art. Notions of center and periphery or province are of course present in much art historical literature, where the importance of sites such as ancient Rome, Renaissance Florence, nineteenth-century Paris, or contemporary New York are deemed important, and other sites consequently ignored, disregarded as dependent on them or provincial, or dismissed as geographically peripheral.

Art historians utilize such ideas in discussions of centers and peripheries. Informed by geography, other social sciences, and historiography, Ginzburg and Castelnuovo provided a cogent definition of artistic metropolises as places of innovation, where paradigms were first created that would come to determine the course of art. Artists, workshops, academies, patrons, and information determined the fate of these cities as centers of innovation and production, which stood in contrast with their peripheries.[22]

A problem here is one of perspective. For what happens to areas outside of Europe, or even areas in eastern Europe, which do not belong to traditional art historical discourse? They may be condemned to neglect, or second-rate status, even remain hard to define as regions, and historical developments in them remain hard to study.[23] In any case, just as political borders around states and regions change, so do political, cultural, and artistic centers. Metropolises change with time, and many centers do not last long. Like any locality, metropolises must be considered in relation to historical circumstances, and historical change. Their function may often change, and the production of art in them, or its importance, accordingly.

The conception of centers also assumes ideas about artistic diffusion. Diffusion is defined as the 'spread of ideas or knowledge' from their origins to areas where they are adopted.[24] Applied to objects, diffusion

22 Enrico Castelnuovo and Carlo Ginzburg, 'Centro e periferia', in *Materiali e problemi*, Vol. I of *Storia dell'arte italiana: Questioni e metodi*, Giovanni Previtali (ed.) (Turin: Einaudi, 1979), pp. 285–352: 305–6.

23 Ján Bakoš, 'Peripherie und kunsthistorische Entwicklung', *Ars* I (1991), pp. 1–12.

24 Harm J. De Blij and Alexander B. Murphy, *Human geography: Culture, society, and space* (New York: Wiley, 1977), p. 12.

has long been a tool of the geography of art, and indeed has served art history as another way to express influence; as such it helps explain why in effect art does not remain constant, but changes in history. Art is said to be diffused from a center to its peripheries, as in the instance of Italian Renaissance art (and artists) abroad.

As art historians have increasingly recognized, however, concepts of diffusion may overlook several important factors. Diffusion does not account for local differences. That is because like the concept of influence the notion of diffusion concentrates on one side of the transaction, ignoring or underestimating the other. But reception is also involved in the process, and recipients are not simply passive. Cultural goods are assimilated in a variety of processes.[25]

One process affecting diffusion is circulation. [...] In artistic geography notions of circulation involve considerations not only of dissemination but of the assimilation of artistic and architectural forms, subjects, techniques, and materials. These are circulated by artists, travelers, objects themselves, reproductions, and collections. In this way itinerant masons in the Renaissance, medieval pilgrims, gifts of Netherlandish paintings, prints sent to Asia, and conversely collections such as the *Kunstkammer* all helped circulate a variety of forms and content of art and architecture in early modern Europe.

Just as they are not static, and just as the milieu in which something is assimilated is important, these processes are not one-sided, either. Art history and art geography have thus become increasingly concerned with issues of cultural transfer, or better, cultural exchange. And in the process in which goods and ideas are exchanged, travel does not occur just in one direction. Hence conceptions such as transculturation have come to replace ideas like acculturation that were earlier linked with diffusion: accordingly artistic ideas are not simply regarded as being transferred to the Americas in forms of churches or paintings, but transported back to Europe, in feather paintings and conch compositions, or seen in the Americas to take on distinctive forms in the often discussed, seemingly hybrid artistic creations called *tequitqui* or *mestizo* that are found in viceregal Mexico and Peru. The terms with which these phenomena are discussed and the processes involved in them have touched off a lively debate.[26]

25 Kaufmann, *Toward a geography of art*, pp. 187–216.
26 Kaufmann, *Toward a geography of art*, p. 272ff.

Perspectives

By the mid-1990s a broader revival of interest in questions of place and space had begun. [...]

These approaches point to a growing interest in the transregional or intercontinental aspects of global exchange. A large vocabulary has been created for them: negotiation, hybridization, accommodation, creolization, convergence.[27] And the products of cultural exchange, for which the evidence provided by Jesuit art and architecture throughout the world provides a particularly good example, have also been variously defined: as hybrids, mestizo forms, and much more.[28] Cultural transfer engenders a variety of reactions: they may be negative, in the form of resistance (as revealed in Japanese *fumi-e*[29]) or positive, in the form of adaptation seen in the creation of Chinese export porcelain. The end effects of such processes of transfer on a global scale have also been variously described: as resulting in counterglobalization, cultural bilingualism, cultural homogenization, and the creolization of world culture.[30] While the significance of all these ideas for cultural and hence artistic geography remains to be elaborated, in the end they suggest the existence of many new perspectives not only for the geography of art, but also for the foundation of a new world art history.

b) James Elkins, 'Why Art History is Global', in Jonathan Harris (ed.), *Globalization and Contemporary Art* (Malden, MA and Oxford: Wiley-Blackwell, 2011), pp. 375–386: 379–386

Two Arguments Regarding Art History

Some of those writing assessments in *Is Art History Global?* felt that the question itself presupposed western ways of thinking that rendered any possible answer unreliable.[1] Any kind of world art studies or global art history that might fairly be seen as a response to the kinds of questions that books like this one pose were taken, by those respondents, as inherently ideologically loaded. In his assessment, Craig Clunas describes his own

27 Peter Burke, *Hibridismo cultural*, Leila Souza Mendes (trans.) (São Leonardo: Editora Unisinos, 2003).
28 Gauvin Alexander Bailey, *Art on the Jesuit missions in Asia and Latin America 1542–1773* (Toronto, Buffalo and London: University of Toronto Press, 1999).
29 Kaufmann, *Toward a geography of art*, pp. 303–340.
30 Burke, *Hibridismo*.

1 James Elkins (ed.), *Is Art History Global?* (New York and Abingdon, Oxon: Routledge, 2007).

program, SOAS in London, in such a way that it appears that what counts as 'art history' might or might not appear along with many other interests and in many different contexts. Suman Gupta wrote an assessment, but he effectively declined to join the debate; he says instead that art history as it is constituted renders the kinds of questions we meant to ask at the round table inherently unanswerable or circular. My own position, which I do not articulate in *Is Art History Global?*, is close to theirs. Art history, as it currently is practised is itself an impediment to thinking about worldwide ways of telling art's history. The round table conversation in *Is Art History Global?* kept to questions recognizable as art history, but, as Clunas, Gupta, and others implied, or argued, some things can't be solved without thinking more widely. Art history can't diagnose its westernness without taking on other perspectives and without being willing to see itself dissolve.

It helps to dissect this problem into three parts: methodologies, institutions and leading terms.

The westernness of methodologies

We can certainly see beyond our interpretive agendas – our semiotics, deconstruction, literary theory, anthropology, linguistic theory, psychoanalysis – but it is not clear that we can recognize what we find beyond those limits as viable alternates to the interpretive methods we currently employ. In *Visual Studies: A Skeptical Introduction*, I argue that it would be an important step for visual studies to adopt as many new interpretive strategies as possible. Visual studies could experiment with avoiding Benjamin, Lacan, Foucault, Derrida, and the rest, and try taking indigenous texts as interpretive languages – Indian or Chinese texts, for example, or even 'unusual' western texts such as Leibniz, Vico, Bruno, Pico, Bayle, or any number of others. The idea would be to see what might happen to our concept of adequate or appropriate interpretation when the discourses are no longer familiar ones.

It is interesting how few scholars do this. Consider, for example, the fact that Gayatri Spivak, with her deep interests in Bengali language and culture, continues to employ a strictly faithful version of Derrida's philosophy in order to interpret Bengali culture. Or that Slavoj Žižek continues to alternate between Marxist and Lacanian models, no matter what subject matter he encounters. I have argued this elsewhere in a little more detail: what I want to register here is the fact that even the most reflective, multinational, multicultural writers do not move beyond western interpretive methods.[2] This is all the more true of art history.

2 James Elkins, *Visual Studies: A Skeptical Introduction* (London, Routledge, 2003).

The art of all nations continues to be interpreted using the toolbox of twentieth-century Western European and North American art history: structuralism, formalism, style analysis, iconography, patronage studies, and biography. I agree with Vinay Lal that an enormous challenge awaits a more adventurous historical practice, one that would try to explain artworks using indigenous, non-western texts.[3] Such an art history would risk seeming ineffectual, idiosyncratic, or misguided, and it is likely that it would not be perceived as an art history at all. Yet the risk is worth taking, if historical accounts of art are to finally pull free of the mire of westernness.

This isn't to say I am sanguine about the possibility of changing interpretive methods. I have myself experimented by using a sixteenth-century Persian text to interpret images, and I have also used pre-contact Chinese texts, and Indian texts including the one edited by Parul Mukherji.[4] The results, I think, are interesting, and they certainly sound unusual. But as far as I know, experiments like these have hardly been noticed, or have been taken as eccentric, artificial, or unhelpful.

The westernness of institutions

Part of Gupta's argument entails the observation that institutional structures of art history – its departments, seminar structures, refereed journals, examinations, essays and vivas, international conferences, visiting professorships, and archival protocols – are more pervasive than some of us in the round table imagined them to be. I agree with that, too, and I would say that the institutions of art history can make it nearly impossible to *recognize* a non-western interpretative practice as an instance of art history. I have only a little to say about this because virtually *all* contributions to the problem of globalism are written by scholars who work in western-style universities. We all (for once the 'we' is not contentious) attend conferences, publish in refereed journals, attend international conferences, and write according to international protocols. We are all of us inside that bubble. I know only two exceptions, both people who wrote assessments for our book. One is from Ghana, and the other Benin, and they work largely (but not completely) outside such structures.

3 My review of David Summers, *Real Spaces: World Art History and the Rise of Western Modernism* (New York: Phaidon Press, 2003), quotes Lal and develops this idea.

4 In the chapter 'Different Horizons for the Concept of the Image', in *On Pictures and the Words That Fail Them* (Cambridge: Cambridge University Press, 1998). An earlier version is in *Zeitschrift für Ästhetik und allgemeine Kunstwissenschaft*, 43(1) (1998), pp. 26–46, and the ideas are reviewed in my *Stories of Art* (New York: Routledge, 2002).

Disappointingly, then, they do not engage these problems: instead they write in ways that open the question of difference between art history and criticism (as in my first point). So if rethinking art history for world art involves a critique of institutions, I am afraid we are all stuck.

The westernness of terms

This was an object of protracted debate throughout *Is Art History Global?* The central issue was this: Should art historians continue to use western terms such as space and form, or should it be the business of historians to learn the relevant languages and adopt their critical terms? Very approximately speaking, David Summers's *Real Spaces* suggests that an optimal way to address the full range of art-making practices across different cultures is to attend to the fundamental terms that structure embodied human experience, terms like *space, axis,* and *center.* His book is a monumental rethinking of those terms, most of them classical and many originally Greek or Latin, so that they can be made flexible and open enough to address works made outside of western traditions. In my review of his book, I noted that most postcolonial theory goes in a different direction: it avoids western terms wherever they seem to be in play, and it opts for local concepts, taken from indigenous – and often non-western – languages. In our round table conversation, Summers became increasingly unhappy about this possibility.

I am still undecided on the question because both sides have compelling arguments in their favour: but I am more interested in looking at unusual, non-western terms than I am in revisiting the oldest western concepts. That bias came out in the round table, although we ended on a conciliatory and indecisive note in order to make way for the people who would write the assessments. They, in turn, mostly doubted the project of finding 'new', non-western terms to describe non-western artworks; but – to sum up an enormous variety of responses, hints, and even evasions – they also kept their distance from Summers's approach. There are some brilliant assessments on this question, most especially one by the Japanese scholar Shigemi Inaga, who proposes a complex 'elliptical' model of translations that involves three languages rather than the usual two. For many scholars, the question is solved, effectively, by deferring it: my sense of the assessments as a whole is that most scholars do not see non-western terms and western terms *as a choice:* rather they take a mixed, local, and opportunistic attitude, hoping to find the best terms in any given context. I am not convinced that a coherent position, especially given that any practice that mixes discourses has to assume that concepts can be safely excerpted from traditions that might well be inherently, deeply immiscible. (How can *space,* to name just one example, be disentangled from western

41

metaphysics?) The issue looms over any future art history that continues to grant a place to discourses identified as western, and those seen as somehow outside that tradition.

Kitty Zijlmans's Assessment in *Is Art History Global?* advocates an 'intercultural perspective' formed in part by the development of several key themes, including a rethinking of center and periphery, frames and contexts, and the concept of multiple cultures. Her project is to found a 'multidisciplinary study of art, as a panhuman phenomenon'. Her terms are the culture's broadest and deepest terms, including 'culture' itself, and her purpose is to find common ground, and to develop a broad, open-ended sense of ideas that bind artmaking around the world. Her approach is, from that perspective, allied to Summers's. My skepticism, then, comes from the westernness of the terms, but also from the sense that those terms are not sufficiently capacious or malleable to embrace world art production. My sense of the words 'space', 'form', and 'culture' is that they are moored in the deep waters of the recent western past, and that our confidence in their capacity to shift and metamorphose and rediscover themselves in new settings is itself a symptomatic overconfidence that has been built into western metaphysics since Plato.

[...]

Conclusion

Why is the coherence of art history pertinent to this book, especially since I began by saying that contemporary international art requires disciplines other than art history? Because art history, theory, and criticism provide the crucial terms of the discourse about contemporary art. Twentieth-century art history created a majority of the formative ideas whose unseen continuation (or whose public repudiation) continues to direct our understanding of art. For example, contemporary art discourse rejects the idea of importance of medium, which is assigned to modernism: but the current confusions about media stem directly from modernist conceptualizations. Contemporary criticism rejects the old-fashioned modernist idea of the avant-garde, as it is found in Theodor Adorno: but every artist I know wishes to be in *some* avant-garde. Contemporary art writing still uncritically worships complexity, difficulty, and ambiguity, which were also leading concepts for the modernists. Contemporary art writing rejects the ideal of the great artist, the unitary masterpiece, and the act of inspiration: but writing on contemporary art uses all those ideas uncritically. Contemporary exhibition catalogues prefer to leave the Old Masters behind and talk about young artists: but the ghosts of the past are not that easily forgotten, and the current exhibition literature is deeply dependent on all the putatively irrelevant names. We are not

as contemporary as we think, or as free of the past as the freedom and euphoria of current art writing implies.

That is why I think the globalisation of art history is crucial, and why I think that it must come before local, empirical inquiries. It may well happen that the discipline of art history melts away, and that we start to see it as an ideological fossil, the way modernist artists saw the old academies. But if that happens, and I hope and expect that it will, we will still be chained to the old art history. We will be shackled to identifiably art historical assumptions about the significance of art and its history, to received ideas about how certain objects are expressive and why they matter, and to immovable convictions about the significance and capaciousness of concepts like 'space' and 'form'. We will still be addicted to scholarship, academies, culture, value, art, and the writing of art's history. We need to go backwards, into our own past, in order to see why we are so optimistic about the idea that we can escape our own histories by looking into the future. It is not that we will be doomed to repeat that past unless we know it better: it is that we will not be able to understand our present.

c) Parul Dave Mukherji, 'Whither Art History in a Globalizing World', *Art Bulletin,* **no. 2 (June 2014), vol. 96, pp. 151–155**

'Whither Art History?' is a question that, potentially, the discipline, like every other discipline, is capable of raising in a moment of self-critical reflection. But what marks this question raised today, around the end of the first decade of the twenty-first century, as different is the very directionality that it poses. 'Whither art history' addresses as much the future scope of the discipline as the past from which it emerges. Perhaps it is a sign of contemporaneity that today it is impossible to separate these two questions about art history's future as well as its present.

With many art histories and many art practices in the south gaining visibility, not only the sense of where we are going but also who 'we' encompass become germane to our discussion. Many terms have been coined to register this growing plurality of practices, such as 'posthistorical', 'postcolonial', 'postracial', and 'postethnic', all of which have gone hand in hand with the proliferation of new disciplinary terrains, such as world art studies, world art history, and global art history.[1]

1 On the recent expansion of art history into a global discipline, see Kitty Zijlmans and Wilfried van Damme, eds., *World Art Studies: Exploring Concepts and Approaches* (Amsterdam: Valiz, 2008); Hans Belting and Andrea Buddensieg, eds., *The Global Art World: Audiences, Markets, and Museums* (Ostfildern: Hatje Cantz, 2009); James Elkins, ed., *Is Art History Global?* (London: Routledge, 2007); and James Elkins, Zhivka Valiavicharska, and Alice Kim, eds., *Art and Globalization* (University Park: Pennsylvania State University Press, 2010).

My point of entry into the debate will be through one of the salient terms used to theorize contemporaneity: postethnic. I aim to problematize developments leading up to the notion of a global art history, which, however well-meaning, is caught in an insidious ethnocentrism. In the abundance of terms that get yoked with 'post-', 'postethnic' posits itself as a new term to capture the contemporary dynamics of the art world and seems to pose key questions about the future of art history as it reflects on its past. Bereft of its 'post-', ethnic art history would signify the period in art history in the West when a clear distinction was believed to have existed between the art museums devoted to modern and contemporary art trends as opposed to the ethnographic museums that primarily housed artifacts from non-Western cultures, more as objects of curiosity than of aesthetic significance. The distinction was created by the West for the West, for its consumption.

There are a plethora of reasons why the gap between these two sites of modernity—the art museum and the ethnographic museum—closes or is viewed with suspicion. Apart from the broader shifts within academia following Edward Said's *Orientalism*[2] and, more directly, the postcolonial turn in art history following Partha Mitter's *Much Maligned Monsters*[3] and the subsequent rise of postcolonial studies, some art events themselves signal the need for a new paradigm to grasp the changes that have occurred on the ground, with the Cold War drawing to a close and a new world order coming into existence by the early 1990s.

The landmark exhibition *'Primitivism' in 20th Century Art: Affinity of the Tribal and the Modern*, organized by William Rubin at the Museum of Modern Art, New York, in 1984 provoked what we would today call a postcolonial critique, as it reduced non-Western art to a primitive source for the metropolitan West's fashioning of the modern. To complicate the East-West binary, Jean-Hubert Martin's pathbreaking exhibition *Magiciens de la Terre*, at the Centre Pompidou in Paris, 1989, counteracted the representation of the non-Western artist as a silent other. Considering that this exhibition drew a wide range of responses from acute dismissal to ardent admiration for such an unprecedented move, it was apparent

2 Edward Said, *Orientalism: Western Conceptions of the Orient* (London: Routledge and Kegan Paul, 1978). It should be noted that this influential work, which was published a year after Partha Mitter's *Much Maligned Monsters*, focused primarily on travel literature and literary representation, whereas Mitter's main thrust was on visual representation.

3 Partha Mitter, *Much Maligned Monsters: A History of European Reactions to Indian Art* (Oxford: Oxford University Press, 1977). This work continues to remain salient in the way it anticipated the main thrust of postcolonial art history around the question of imperial power and cultural representation.

that the curator had touched the pulse of the art world. Rasheed Ar[a]een's curated show at London's Hayward Gallery in 1989, *The Other Story*, was another landmark event that brought into visibility doubly marginalized immigrant artists, who until then were overlooked as much by their 'home' country as by the country they settled in.

We are told that the 'postethnic' moment arrives when those who were considered incapable of self-representation acquire agency in fashioning their own identity.[4] This involves not just taking agency in fashioning one's identity but doing so self-consciously, with its constructedness kept in view. 'Postethnic' is envisaged as an empowering term that marks the arrival of the Third World artist and, by extension, art historian within the horizon of contemporary art and art history. Perhaps from the postcolonial perspective and my location in India, I am expected to embrace this term as liberating us from the stranglehold of the past, as it is well known that art history, like many other disciplines, arrived in the colonized world under the aegis of colonial modernity.

[...]

The Global Turn in Western Art History and Its Implication for Art History in India

My chancing on Elkins's *Stories of Art* in a bookshop in Oxford in 2004 occasioned an epiphany.[5] As someone whose undergraduate training was shaped by E. H. Gombrich's *The Story of Art*, I was used to relativizing Indian art as one more branch on the gigantic tree of world art. I later learned that the book, which was considered a bible for undergraduates in India, was in fact a high-school textbook in the United Kingdom. Given such inequity in knowledge circulation and consumption, the multiple 'Stories' and Elkins's claim to address a multicultural moment seemed like a major corrective.

The section on non-Western art history in this book captured my attention, as the author was exploring a new terrain of non-Western art histories and making sense of other art histories in an admirable attempt at stepping outside 'the self portrait of Western art history'. *Stories of Art* was thus an unprecedented enterprise that stressed the need to familiarize

4 Hans Belting coined this term, which, however problematic, is critical in capturing the politics of representation in the contemporary art world. Belting and Buddensieg, *The Global Art World*, p. 58.

5 James Elkins, *Stories of Art* (New York: Routledge, 2002). As I regard Elkins's contribution to global art history as comprehensive and sustained over more than a decade, I will concentrate on his intervention, which has helped shape this emerging field in Euro-American academia.

Western readers with non-Western aesthetic texts as a framework for non-Western artworks. Despite the fact that this was a commendable move within Western art history, reliance on fragments of texts from 'native discourse' – and not necessarily the most reliable editions – has had the potential of creating misunderstanding more than illuminating the questions of visual representation. The very act of culling out a fraction of a text and making it emblematic of a tradition at large is mired in an asymmetry of forms of knowledge in the West and non-West and ultimately leads to an asymmetry of interpretative efforts by each side.

What Elkins's intervention enables is the recognition of the gap between live and dominant discourses of art theory in the West that set out to make sense of the other intellectual traditions and the dead concepts of premodern Indian art that are consigned to history and antiquarian interest. While in the West certain key terms like 'mimesis' or 'catharsis' from Greek and Roman art theory function as live terms and continue to participate in the discourse on visual representation that has been constructed as a continuous intellectual enterprise, these premodern categories in the Indian context, once part of a rigorous theoretical lineage, now exist primarily as practice-oriented concepts. Seldom does a South Asian art historian engage with these concepts as resources for critical thought for the present. And when one ventures into this territory, one is met with complete incomprehension and lack of interpretative effort.

David Summers's *Real Spaces: World Art History and the Rise of Western Modernism* constitutes another major attempt to write a non-Eurocentric account of world art by focusing attention on different types of spatiality that shape art in different civilizations.[6] I could continue to add more such publications to demonstrate how earnest the move has been in recent years to include the others.[7] Mobility and travel have marked the lifestyle of many Western art historians in recent years, as they undertake field trips to far-flung countries outside Europe and the United States to gain a better grasp of other art histories. Such travel is no longer the preserve of Western art historians, as it is increasingly embraced by art historians from non-Western societies, although by many fewer. This inequality of mobility, almost symptomatic of uneven access to resources and institutional support, leads to a situation where tokenism flourishes and the burden to represent native art history and culture falls on select shoulders.

6 David Summers, *Real Spaces: World Art History and the Rise of Western Modernism* (New York: Phaidon Press, 2003).
7 David Carrier, *A World Art History and Its Objects* (University Park: Pennsylvania State University Press, 2008).

In such a situation, ethnicity is raising its head in new ways. In many global forums where I have participated in group discussions, the question posed to me has been: 'For too long, we in the West have been using concepts and tools created by us, and now we have reached a point of exhaustion. What tools can you provide us to rejuvenate the discipline?' As we turn to the second decade of the twenty-first century, should we really attach ethnicity to the tools of thinking and move toward this intellectual essentialism? Its more recent reiteration is again by Elkins, in his interrogation 'Why Art History Is Global':

> The art of all nations continues to be interpreted using the toolbox of twentieth-century Western European and North American art history: structuralism, formalism, style analysis, iconography, patronage studies, biography ... an enormous challenge awaits a more adventurous historical practice, one that would try to explain artworks using indigenous, non-Western texts.[8]

For me, such a proposition makes me question the use of the 'postethnic' and the Western interlocutors' historical amnesia of two hundred years of colonialism that preceded Indian independence in 1947 from the British rule. It also signals essentialism in the way it expects that a radically different method of thinking must prevail in India, from which authentic Indian discourse must emerge. Any claim to an 'Indian' interpretative system is as fraught with reductionism as the 'Western' intellectual tradition, as ideas that circulate and cross-fertilize over a long period of time and space do not respect ethnic or geographic boundaries. This adherence to ethnicity goes hand in hand with the misunderstanding of postcolonial theory as the validation of 'local concepts, taken from indigenous – often non-western languages'.[9]

We are far from the situation where the 'postethnic' can circulate as a relevant category, just as another term, 'postracial,' coined by Paul Gilroy to decenter ethnicity, also has not received sufficient engagement.[10] While globalization is leading us to think of the 'postnational', it takes something like a Venice Biennale to remind us of the persistence of national identity. It will be a while before art historians can identify themselves as world citizens and become freed from the burden of ethnic identity. Until then, tokenism will color the field of global art history, a field that many of us from the Third World had hoped was becoming

8 James Elkins, 'Why Art History Is Global,' in *Globalization and Contemporary Art*, ed. Jonathan Harris (Chichester, U.K.: Wiley-Blackwell, 2011), 380.

9 Ibid., 381. [...]

10 Paul Gilroy, *Against Race: Imagining Political Culture beyond the Color Line* (Cambridge, Mass.: Belknap Press of Harvard University Press, 2000).

more equitable through the effects of globalization. So where are 'we' going? Is it to the formation of a new 'us' and 'them' binary – between those of us who have invented (a dominant) art history and those of us who duplicate interpretative tools and are shackled in a derivative discourse as a perpetual condition?[11]

The burning question in studies in global art history has been whether non-Western art history can be studied through native intellectual frameworks.[12] It is possible to plot various answers to this question between the two poles of using only non-Western terminology while retaining the basic structure from Western art history to letting the other framework radically disturb the Eurocentric assumptions of the discipline. In this sense, global art history is an impossible project if it implies studying art objects not only from culturally disparate contexts but also through the interpretative frameworks drawn from 'native' aesthetic theories. For it to happen, unfamiliar terrains have to be charted, risking incomprehension and even encountering a cacophony of voices and languages. It cannot emerge as an insular discourse that only the cultural insiders can access but must be translatable if it is to enable a dialogue across languages and disciplines.

The 'where' in 'Whither art history?' is no longer located in a future of semantic plenitude and universal lucidity but involves traversing uncharted territories from the past, when experiments with art history took place outside its mainstream. It could be anywhere, in South Africa, Latin America, the former Soviet bloc, or India. One such experiment occurred in India at Santiniketan in the 1930s, when Nandalal Bose, an artist pedagogue, who undertook a postcolonial project (in colonial times) of creating an alternative art historical reference for contemporary art practice, designed a student dormitory that came to be called the Black House.[13] If André Malraux dreamed of a museum without walls, Bose cited sculptural reliefs from world art – ancient Mesopotamia, Egypt, and Japan (strategically bypassing the classical Greco-Roman legacy enshrined in colonial art schools) – on the outer walls of the students' dormitory. If its interiors composed the living quarters of students, its

11 See Monica Juneja, 'Global Art History and the "Burden of Representation,"' in *Global Studies: Mapping Contemporary Art and Culture*, ed. Hans Belting, Jakob Birken, and Andrea Buddensieg (Stuttgart: Hatje Cantz, 2011), 274–97 [...].

12 Frederick M. Asher, 'The Shape of Indian Art History,' in *Asian Art History in the Twenty-First Century*, ed. Vishakha N. Desai, Clark Studies in the Visual Arts (New Haven: Yale University Press, 2007).

13 Parvez Kabir, 'Copies before Originals: Notes on a Few Black House Reliefs at Santiniketan,' in *The Black House: Texts and Contexts*, ed. Sanjoy Mallik (Santiniketan: Visva Bharati Publication, forthcoming).

outer wall worked as a curated museum with sculpture reliefs and served art pedagogy. In the discourses that were in circulation, an alternative way of theorizing visual representation and similitude was being developed, and these debates were often published in Bengali, a language in which modern art theories and art criticism came to be formulated during colonialism.

If global art history abandons its overarching story of progress and canonization and turns its gaze on the non-Western and postcolonial archive and its overlooked sites,[14] it will have much to gain from a local and regional focus, which can be best conducted as case studies. For a new theory to emerge, it will have to consider these overlooked histories and sites of experimentation in which space will have a new primacy and become a source of new temporality: not the temporality of homogeneous time, but temporality as a construct that acquires coherence within a specific, located spatiality.

The 'whither' may go hither and thither, but perhaps in the crisscrossing of space and time, art history, though it lose its connecting thread, may gain in its conceptual amplitude.

14 See Partha Mitter, 'Decentering Modernism: Art History and Avant-Garde Art from the Periphery,' *Art Bulletin* 90, no. 4 (2008): 531–48, 568–74 [...].

2

European art and the wider world 1350–1550

Kathleen Christian

Introduction

This selection of texts presented in this section reflect upon cultural connections in an era usually referred to as 'the Renaissance', a time of technological innovation and the flourishing of the visual arts in Europe. In many ways, however, art historians have questioned the nineteenth-century characterisation of this period as a heroic step in Europe's seemingly inevitable, self-propelled path towards modernity and hegemony. Global art history has presented one of the most substantial challenges to this narrative.

Increasingly art historians have, for example, accounted for the cultural efflorescence associated with this era in terms of Europe's improved integration with the wider world. The revival of trade in the Mediterranean which began around the eleventh to twelfth centuries gave Europe greater access to the global networks that had long brought prosperity, knowledge and creative insights to other parts of the world, setting the stage for significant advances in commerce and manufacturing between the twelfth and fifteenth centuries. In 1492, Columbus sailed west to the Americas, and in 1498 Portugal gained direct entry into the 'spice' and luxury markets of Asia when Vasco da Gama rounded the Cape of Good Hope, reaching Calicut. From the European perspective, journeys to previously unknown parts of Africa, Asia and America brought contact with 'new' cultures and peoples, leading to an influx of ideas, cultural perceptions and material goods.

The first selection of primary texts below was written by Europeans coming to terms with novelty and cultural difference by assessing the skills of Amerindian artists. European observers express admiration for the artistry of Mexican featherwork, yet ultimately document how Amerindians became the agents of their own colonisation when they

were taught to depict Christian subjects using indigenous techniques as a means of proving their own 'humanity'. The loss or radical transformation of indigenous traditions and cultures brought by the European conquest of the Americas is never far in the background of these narratives.

Art historians engaged with the global have sought alternatives to the usual focus on national cultures (particularly Italian and Netherlandish) and their internal histories, preferring instead to stress contacts, diverse interests and connectivities. One of the most-discussed examples of the artistic dialogue between Europe and the Islamic world has been Sultan Mehmet II's invitation to Gentile Bellini to his court in Constantinople; several texts included here relate to invitations from other Ottoman Sultans to the quintessential Renaissance artists Leonardo and Michelangelo. Cultural and material exchange was at the time guaranteed by trade, and accounts of navigators and merchants from the sixteenth century are often quite narrowly focused on the products one could acquire in different parts of the world: the selections gathered together here describe what could be found in the ports of America, Africa and Asia, which were seen as sources of vast wealth. The age-old tradition of diplomatic gift-giving was another means of global circulation, as is detailed in texts describing the tent, vases, perfumes and animals (including a much-admired giraffe) which the Mamluk Sultan sent to Florence in 1487.

Four secondary texts chosen for this section present some of the most engaging points of view that have shaped recent debates. They treat several of the themes brought out by global perspectives on the art of this period. The first by Claire Farago argues that the inherent structures of Renaissance art history presuppose the 'radical unity' of works of art: interpretation has long had as its goal the discovery of a single, correct meaning, which has limited our ability to account for multiplicity, cultural diversity or 'hybridity'. Another by the historian of Islamic art Avinoam Shalem considers the implications of the recent focus on Islamic culture as the primary agent of the 'global' for historians of European art. This tendency has prompted strong reactions amongst Islamicists, including the sentiment that Europeanists are recolonising the globe, imposing their canons, methodologies and interests on an Islamic 'other'.

An essay by Luca Molà and Marta Ajmar-Wollheim draws upon varied examples of material culture to illustrate the increasing integration of global markets, designs and techniques, as can be seen in the trade of ceramics, metalwork, textiles and carpets. Finally, a selection from a book by the anthropologist Jack Goody questions whether 'the Renaissance' is a sociological phenomenon that can be traced in non-European cultures. His goal is to detach the concept from its traditional role, as a manifestation of Europe's supposed superiority over other places in the world.

Primary source texts

2.1 Europeans describing Amerindian artists in Mexico

These sources were written by men with first-hand experience of the New World. Francesco Allé (born c. 1490) was a Franciscan friar working in the New World. Bartolomé de las Casas (1474–1566), who completed *The Apologetic History* around 1559, was a Dominican friar and apologist for the Amerindian people, who spent over 50 years in the New World. Conquistador Bernal Díaz (c. 1492–1584) accompanied Hernán Cortés on his 1519 expedition to Mexico. His book *The True History of the Conquest of New Spain* was finished in 1568.

Cortés's strategy of leaving statues of the Virgin and Child as visual reminders of the Christian missionary message suggests he embarked on his expedition with a supply of sculptures on board ship. Of the three post-conquest Amerindian artists that he names, Marcos de Aquino may have been the painter responsible for the image of Our Lady of Guadalupe, later a major shrine. Las Casas and Francesco Allé detailed how indigenous feather art was diverted to make religious pictures and as a substitute for embroidery in ecclesiastical vestments. Allé's letter likely refers to the shipment of the feather mosaic to Paul III now in the Musée des Jacobins in Auch (Figure 2.2). Both writers stress the ease with which Indian craftsmen could copy European techniques. Renaissance values favoured invention and downgraded 'mere' imitation, however, and read like this, the texts unintentionally excluded indigenous practitioners from the highest artistic status. [Kim Woods]

a) Allé, Francesco da Bologna, Letter of c. 1514 sent from Mexico to Padre Clemente Dolera da Moneglia, head of the Order of Conventual Franciscans in Bologna, and other friars of the order, in P. Colla and P.L. Crovetto (eds), *Nuovo mondo: Gli italiani 1492–1565* (Milan: Mondadori, 2011), pp. 431–442 [translation Kathleen Christian]

[...] [Before] they weren't literate and didn't know how to paint, but they had a prodigious memory, and made beautiful figures with the feathers of different animals, and with coloured stones. Now, they can paint better than you can, and they make figures of saints with feathers. I have seen two of these, which the friars who came through here took

to bring to Rome to our Holy Father Pope Paul III: they are more beautiful than if they had been made in gold or silver. The Indians are also sending to the pope three cases of precious stones with some of these figures and also two beautiful hangings.

b) Bernal Díaz, *The Conquest of New Spain*, translated with an introduction by J.M. Cohen (London: Penguin Books, 1963), pp. 81, 83, 176–177, 230

[...]

Another thing that Cortes asked of them was that they should abandon their idols and sacrifices, which they promised to do. He expounded to them as best he could the principles of our holy faith, telling them that we were Christians and worshipped one true God. He then showed them a most sacred image of Our Lady with Her precious Son in her arms, and declared to them that we worshipped it because it was the image of the Mother of our Lord God, who was in heaven. The *Caciques*[1] answered that they liked this great *tececiguata* which is the name they give to great ladies in their country – and asked for it to be given to them to keep in their town. Cortes agreed to their request, and told them to build a fine altar for it, which they did. Next morning he ordered two of our carpenters, Alonso Yañez and Alvar Lopez, to make a very tall cross.

[...]

[p. 81]

[...]

Cortes then ordered the Caciques to come to the altar with their women and children very early next day, which was Palm Sunday, to worship the holy image of Our Lady and the cross. He also told them to send six Indian carpenters to go with our carpenters to the town of Cintla, where our lord God had granted us the victory in the battle I have described, there to cut a cross on a great tree that they call a silk-cotton tree, which grew there. This they did, and it was stood there a long time, for each time the bark is renewed the cross stands out afresh.

[...]

[p. 83]

[...]

Cortes expressed his thanks, and with a cheerful expression answered that he accepted the maidens and took them for his and ours, but that for the present they must remain in their fathers' care. The old Caciques then asked why he did not take them now, and Cortes replied that he wished first to do the will of our lord God, in whom we believe and

1 Here *Caciques* means local elders.

whom we worship, and to perform the task for which our lord and King had sent us; which was to make them give up their idols and cease to kill and sacrifice human beings, also cease the other abominations which they practised, and believe as we believed in the one true God. He told them much more about our holy faith, and in truth he expounded it very well, for Doña Marina and Aguilar were so practised that they could explain it very clearly. Cortes showed them an image of Our Lady with her precious child in her arms, and explained to them that this image was a likeness of the Blessed Mary, who dwells in the high heavens and is the mother of our Lord, the Child Jesus, whom she holds in her arms and whom she conceived by grace of the Holy Spirit, being a virgin before, during, and after His birth. He told them how this great Lady prays for us to her precious Son who is our Lord and God, and said other fitting things about our holy faith. He then went on to state that if they wished to be our brothers and live on terms of true friendship with us, and if they really wanted us to take their daughters for our wives, as they proposed, they must immediately give up their wicked idols and accept and worship Our Lord God, as we did. They would see, he told them, how things would prosper for them, and when they died their souls would go to heaven to enjoy everlasting glory. But if they went on making their customary sacrifices to their idols, which were devils, they would be taken to hell, where they would burn for ever in living flames. He said no more about their forsaking their idols, since he had stressed the matter sufficiently in his previous addresses.

Their reply to his statement was as follows: 'Malinche,[1] we have heard from you before, and certainly believe that your God and this great Lady are very good. But remember that you have only just come to our land. In the course of time we shall do what is right. But can you ask us to give up our *Teules*, whom our ancestors have held to be gods for many years, worshipping them and paying them sacrifices? Even if we old men were to do so in order to please you, would not all our *papas* and our neighbours, our youths and children throughout the province, rise against us?

[...]

[pp. 176–177]

[...]

I must now speak of the skilled workmen whom Montezuma[2] employed in all the crafts they practised, beginning with the jewellers and workers in silver and gold and various kinds of hollowed objects, which excited the admiration of our great silversmiths at home. Many of the best of

1 Cortes's interpreter.
2 Ruler of Mexico, now usually referred to as Moctezuma.

them lived in a town called Atzcapotzalco, three miles from Mexico. There were other skilled craftsmen who worked with precious stones and *chalchihuites*, and specialists in feather-work, and very fine painters and carvers. We can form some judgment of what they did then from what we see of their work today. There are three Indians now living in the city of Mexico, named Marcos de Aquino, Juan de la Cruz, and El Crespillo, who are such magnificent painters and carvers that, had they lived in the age of the Apelles of old, or of Michael Angelo, or Berruguete in our day, they would be counted in the same rank.

[...]

[p. 230]

c) Bartolomé de las Casas, 'Indian Houses, Featherwork and Silverwork', in George Sanderlin (trans. and ed.), *A Selection of His Writings* (New York: Alfred A. Knopf, 1971), pp. 128–132

[...]

But what appears without doubt to exceed all human genius [...] is the art which those Mexican peoples have so perfectly mastered, of making from natural feathers, fixed in position with their own natural colors, anything that they or any other first-class painters can paint with brushes. They were accustomed to make many things out of feathers, such as animals, birds, men, capes or blankets to cover themselves, vestments for their priests, crowns or mitres, shields, flies, and a thousand other sorts of objects which they fancy.

These feathers were green, red or gold, purple, bright red, yellow, blue or pale green, black, white, and all the other colors, blended and pure, not dyed by human ingenuity but all natural, taken from various birds. Therefore they placed a high value on every species of birds, because they made use of all. They preserved the color hues of even the smallest birds that could be found on land or in the air, so that certain hues would harmonize with others, and they might adorn their work as much as and more fittingly than, any painter in the world.

They would seat this feather on cotton cloth, or on a board, and on that would add little feathers of all colors, which they kept in small individual boxes or vessels, just as they would have taken prepared paints from shells or small saucers with paint brushes. If they wished to make a man's face, the form of an animal, or some other object which they had decided on and for which a white feather was needed, they selected one from the whites; if a green was required, they took one from the greens; if a red, from the reds; and they attached it very delicately, with a certain paste. Thus for the eyes in the face of a man or animal, requiring black and white and the pupil, they made, and continue to make, the

different parts of feathers, with the delicacy of a greater painter using a very fine brush – and surely this is a marvel.

And granted that before we Christians entered there they made perfect and wonderful things by this art such as a tree, a rose, grass, a flower, an animal, a man, a bird, a dainty butterfly, a forest and a stone or rock, so skilfully that the object appeared alive or natural, [...] yet after the Spaniards went there and they saw our statues and other things, they had, beyond comparison, abundant material and an excellent opportunity to show the liveliness of their intellects, the integrity and disengagement of their powers or interior and exterior senses, and their great talent. For since our statues and altar-pieces are large and painted in divers colors, they had occasion to branch out, to practice, and to distinguish themselves in that new and delicate art of theirs, seeking to imitate our objects.

One of the great beauties they achieve in what they make – a canopy, cloak, vestment, or anything else especially large – is to place the feather in such a way that seen from one direction it appears gilded, although it lacks gold; from another, it seems iridescent; from another, it has a green luster, without being chiefly green; from another, viewed crossways, it has still another beautiful tint [...] and similarly from many other angles, all lustrous colors of marvellous attractiveness. Hence it is that one of their craftsmen is accustomed to go without food and drink for a whole day, arranging and removing feathers according to how in his view the hues best harmonize, and so that the work will produce greater diversity of colors and more beauty. He observes it, as I said, from one direction and then another; one time in sunlight, other times in shade, at night, during the day or when it is almost night, under much or little light, crossways or from the opposite side.

To sum up, out of feathers they have made and still make, every day, statues, altar-pieces, and many other things of ours; they also interpose bits of gold at suitable places, making the work more beautiful and charming so that the whole world may wonder at it. They have made trimming for chasubles and mantles, covers or silk cases for crosses, for processions and for divine service, and mitres for bishops. And certainly, with no exaggeration, if these had been of gold or silver brocade, three thicknesses on rich crimson, or embroidered richly with gold or silver thread, with rubies, emeralds, and other precious stones, they would not have been more beautiful or more pleasing to look on. The craftsmen who surpass everyone in New Spain in this art are those of the province of Mechuacán.

[...]

Although the featherwork craftsmen are unquestionably excellent and demonstrate their great talent, the silversmiths of New Spain are not

unworthy of our admiration for their delicate, outstanding work. They have made, and still make, unusual pieces, of a fineness very different from that of silverwork in any part of our Europe. What makes the pieces more admirable is that the silversmiths form and shape them only by means of fire, and with stone and flint, without any iron tool or anything that can help them produce that nicety and beauty. They made birds, animals, men, idols, vessels of various shapes, arms for war, beads or rosaries, necklaces, bracelets, earrings, and many other jewels worn by men and women.

[...] They made other excellent things, thousands more, while they were pagan, but now they make many more of our things, such as crosses, chalices, monstrances, wine vessels for Mass, vessels for the altar, and many other delicate things.

In the beginning, there would be an Indian, all wrapped up in a blanket, in their fashion, with only his eyes showing; he would be at some distance from the shop of one of our silversmiths, dissembling and pretending to observe nothing. The silversmith would be shaping some gold or silver articles, very delicate and of great craftsmanship. And the Indian, simply from seeing him make some part of the article, would go off to his house, make it himself as well or better, and soon carry it from there in his hand to sell to whoever would buy it.

[...]

2.2 Albrecht Dürer, 'Part II: Diary of a Journey the Netherlands (July, 1520–July, 1521)', *Memoirs of Journeys Venice and the Low Countries* (eBooks@Adelaide, University of Adelaide, South Australia) [https://ebooks.adelaide.edu.au/d/durer/albrecht/journeys/part2.html, last updated 27 March 2016, accessed 27 October 2016]

The German artist Albrecht Dürer (1471–1528) kept a log, mainly a record of financial transactions, when he travelled in Western Germany, the Netherlands and Venice in 1520–1521. The excerpts from the diary provide a rich insight into the places he visited, the people he met, and significantly the gifts he exchanged and the types of goods he acquired during his travels. What is particularly remarkable is the sheer variety of objects he saw or procured, reflecting his interests in both the natural world and artistic creations – from the fish bone he marvelled at in Brussels, to the Chinese porcelain he received from a Portuguese factor [agent], to the live monkey he also acquired. Dürer's entries,

however, also expose his meagre understanding of the world and its geography. His references to objects from 'Calicut', for example, confuse goods that came from Africa, the Americas and India. The passages highlight how artists and others who did not travel to the far corners of the earth could still gain access to objects and artefacts from around the globe. [Leah Clark]

Anno 1520: Visit to Brussels

[...]

Also I have seen the things which they have brought to the King out of the new land of gold: a sun all of gold, a whole fathom broad, and a moon, too, of silver, of the same size, also two rooms full of armour, and the people there with all manner of wondrous weapons, harness, darts, wonderful shields, extraordinary clothing, beds, and all kinds of wonderful things for human use, much finer to look at than prodigies. These things are all so precious that they are valued at 100,000 gulden, and all the days of my life I have seen nothing that reaches my heart so much as these, for among them I have seen wonderfully artistic things and have admired the subtle ingenuity of men in foreign lands; indeed, I don't know how to express what I there found.

I also saw many other beautiful things at Brussels, and especially a great fish bone there, as vast as if it had been built up of square stones; it was a fathom long, very thick, weighs up to 1 cwt. (15 centner), and it has the form as is here drawn; it stood behind on the fish's head.

[...]

At Antwerp (September 3–October 4, 1520)

I breakfasted with the Portuguese factor, who gave me three porcelain dishes, and Rodrigo gave me some Calicut feathers.

[...]

At Antwerp (December, 1520–April, 1521)

[...] The factor of Portugal has given me a brown velvet bag and a box of good electuary; I gave his boy 3 stivers for wages. I gave 1 Horn florin for two little panels, but they gave me back 6 stivers. I bought a little monkey for 4 gulden, and gave 14 stivers for five fish.

[...]

[...] Rodrigo, the Portuguese secretary, has given me two Calicut cloths, one of them is silk, and he has given me an ornamented cap and a green jug with myrobalans, and a branch of cedar tree, worth 10 florins altogether.

[...]

[...] I sold two reams and four books of Schauflein's prints for 3 florins. Have given 3 florins for two ivory salt-cellars from Calicut. Have taken 2 florins for prints; have changed 1 florin for expenses. Rudiger von Gelern gave me a snail shell, together with coins of gold and silver, with an ort. I gave him in return the three large books and an engraved 'Knight;' have taken 11 stivers for prints.

[...]

2.3 Sources on proposed work by Leonardo and Michelangelo for the Ottoman Sultans

The Ottoman Sultan Mehmed II (r. 1444–1446/1451–1481) hosted Venetian artist Gentile Bellini at his court in Constantinople, as well as other European painters, architects and sculptors. His son and successor Sultan Bayezid II (r. 1481–1512) may have been less receptive towards European art but invited both Leonardo da Vinci and Michelangelo – rival artists who were then working in Florence – to design a new bridge across the Golden Horn that would connect Europe and Asia. Leonardo made a sketch for this bridge in one of his notebooks (MS L in Paris). The letter from Leonardo to the Sultan describing his plans for the bridge and other works survives in a Turkish translation, though the details it gives about his proposed projects are murky and the translation may be quite distant from the original. It seems he had in mind a bridge with a single arch which would span the length of the Golden Horn, and which would have required very substantial pylons.

In 1553 Ascanio Condivi published his *Life of Michelangelo*, an 'authorised biography' of the artist written in close collaboration with Michelangelo himself. Here Condivi comments on the Sultan's invitation, which Michelangelo threatened to accept to avoid returning to Rome and the demands of his patron, Pope Julius II. Tommaso di Tolfo's letter of 1519, discovered amongst Michelangelo's papers at the Casa Buonarroti in Florence, remembers this earlier invitation and also reports that Bayezid II's successor Sultan Selim I (r. 1512–1520) was open to European figural art. He had just purchased a statue of a female nude and wished to lure Michelangelo or other outstanding Italian artists to his court in Edirne. Tommaso shows little concern for cultural differences between Italy and the Ottoman realm and is focused instead on the profit Michelangelo could make from the trip. [Kathleen Christian]

a) **Leonardo da Vinci, undated letter to Sultan Bayezid II in a Turkish translation discovered in the archives of the Topkapi Palace, Istanbul. The text below is taken with slight amendments from C. Pedretti, *The Literary Works of Leonardo da Vinci*, vol. 1 (Berkeley and Los Angeles: University of California Press, 1977), pp. 212–214, a translation of the Italian version of the original Turkish given in F. Babinger, 'Un inedito di Leonardo da Vinci: Leonardo e la Corte del Sultano', *Il nuovo corriere*, 22 March 1952, p. 3**

Copy of a letter that the infidel by the name of Leonardo has sent from Genoa. I, your servant, having thought for some time about the matter of the mill, with the help of God, have found a solution, so that, with an artifice, I will build a mill which works without water, but only by the wind in a way that it will take less than a mill at sea; and not only would it be more convenient to the people, but it would also be suitable to any place.

Furthermore, God (may he be exalted!) has granted me to find a way of extracting the water from ships without ropes or cables, but with a self-operating hydraulic machine.

I, your servant, have heard about your intention to build a bridge from Istanbul to Galatea, and that you have not done it because no man can be found who would be able to plan it. I, your servant, know how. I would raise it to the height of a building, so that, on account of its height, no one will be allowed to go through it. But I have thought of making an obstruction so as to make it possible to drive piles after having removed the water. I would make it possible that a ship may pass underneath it even with its sails up. I would have a drawbridge so that, when one wishes, one can pass on to the Anatolia coast. However, since water moves through continuously, the banks may be consumed. Thus I may find a system of guiding the flow of the water, and keep it at the bottom so as not to affect the banks. The sultans, your successors, will be able to do it at little expense. May God make you believe these words and may you consider this servant of yours always at your service.

This letter was written the 3rd of July. It is four months old.

b) **Tommaso di Tolfo in Edirne (in Ottoman Turkey) to Michelangelo in Florence, in P. Barocchi and R. Ristori (eds), *Il Carteggio di Michelangelo*, vol. 2 (Florence: Sansoni, 1967), pp. 176–177 [translation Kathleen Christian]**

To the honourable Michelangelo Buonarroti in Florence.

1 April 1519

My dear, esteemed Michelangelo, in the past I hadn't written to you because there was nothing to report, and the reason for this letter is that about 15 years ago now I sometimes spent time in conversation with you at the house of Gianozzo Salviati, and if I remember correctly, your wish was to come and see this place, but you were dissuaded from the idea since in those times there was a ruler [Sultan] who did not like figurative representations of any sort; indeed, he held them in loathing. At the moment, however, our illustrious Lord is very much the opposite. And in recent days he acquired a statue, a female nude reclining and holding her head up with her arm, and from what I hear he is very satisfied with it. Baldinacio degli Allesandri had this figure here in his house, and I don't know where he found it, yet this figure in my opinion is something rather ordinary.

My point is this: that if you are still of the same mind that you were then, I would recommend that you come here immediately, and you would be regarded well here and it would not bring you any loss; rather it would bring you much profit. And you can believe me in this; if I thought otherwise I wouldn't write it. And if you are thinking of coming you should not hesitate, and when you receive this letter you should set out as soon as you can, through Ragusa, which is the easiest way. And I would pledge to send, before you arrive in Ragusa, a letter of introduction from this Lord, so that his representative in Chocia [Foča] can arrange for a good escort to accompany you to here, and also I would arrange for a letter that allows you to go and stay at your leisure. If you still aren't quite convinced, I would urge you by any means to come, because I know you will earn more than you might imagine, and I wouldn't say this without reason. And since it may be that you will need some ducats for your expenses for the costs of the journey, I have written to my patrons the Gondi in Florence, so that they can provide you with everything you need, and I know that this is just spare change for them, since they are not lacking in money. But I did it with good intentions, and because I know that your stay here will not be without large profit.

And in case you aren't of the mind or the inclination to come to these parts, I pray you that you look for another painter who is one of the best painters you can find in Christendom, and try by all measures to make him come as quickly as you can. And if he comes it would be good if he brought with him some of his better works. And I want you to understand this: that the person who gave that figure to the Sultan received 400 gold ducats and a promotion, and he was a secretary of the ports for this Lord and as I told you, that figure wasn't very special. You can trust me in this: whether it is you or someone else who comes, they will not lose the grace of God, I have faith in that. I have put my faith in

you, thinking that if you come you could live with me and if you didn't come and sent someone else instead, it would be likewise. And I have nothing else to say except I put myself in your hands, and may God protect you from harm always and watch over you.

Your Tommaso di Tolfo in Adrianapoli [Edirne]

c) Ascanio Condivi, 'Life of Michelangelo', translation by A. Sedgwick Wohl, in H. Wohl (ed.), *The Life of Michelangelo* (Oxford: Phaidon, 1976), pp. 35–37

[...] he went on to Florence where, in the three months that he stayed there, three briefs were sent to the Signoria, full of threats, to the effect that they should send him back by fair means or foul. Piero Soderini, who was then *gonfaloniere* [holder of a high civic office] for life of [Florence], had previously let him go to Rome against [Soderini's] will, as he was planning to employ him in painting the Sala del Consiglio; thus when the first letter came he did not force Michelangelo to return, hoping that the pope's anger would pass; but, when the second and the third came, he sent for Michelangelo and said to him, 'You have tried the pope as a king of France would not have done. However, he is not to be kept begging any longer. We do not want to go to war with him over you and place our state in jeopardy. Therefore, make ready to return.' Then Michelangelo, seeing that it had come to this and fearing the wrath of the pope, thought of going away to the Levant, chiefly as the Turk sought after him with most generous promises through the intermediary of certain Franciscan friars, because he wanted to employ him in building a bridge from Constantinople to Pera and in other works. But, when the *gonfaloniere* heard of this, he sent for him and dissuaded him from this idea, saying that he should prefer to die going to the pope than to live going to the Turk; and that anyway he should not be afraid of this because the pope was benevolent and was recalling him because he loved him and not in order to harm him; and that, if he was still afraid, the *Signoria* would send him with the title of ambassador, because it is not customary to commit violence against public persons without its applying to those who send them. On account of these and other words, Michelangelo prepared to return.

[...]

2.4 Gifts to Lorenzo de' Medici in Florence from Qaytbay, the Mamluk Sultan in Cairo

In the 1480s the Mamluk Sultan Qaytbay, eager to solidify commercial connections with Italy and to rival the European trade

relationships established by the Ottoman Empire, exchanged ambassadors and diplomatic gifts with Lorenzo de' Medici, de facto ruler of Florence. The Sultan's ambassador arrived in Florence in November 1487 amid great public interest and fanfare. His gifts included a giraffe, which would become a favourite subject for poets and painters (such as Domenico Ghirlandaio and Piero di Cosimo). By this time sending exotic animals as diplomatic gifts was a well-established tradition in many different cultures.

Paolo Giovio collected portraits of famous men and women and published a series of 'elogies' describing their great deeds. His book about military leaders included a portrait and elegy of Qaytbay. He also mentions Qaytbay's gift to the Duke of Milan of a giraffe and elephant and the frescoes of these animals in the Duke's Castle; the painting of the elephant still survives. [Kathleen Christian]

a) L. Landucci, *Diario fiorentino dal 1450 al 1516, continuato da un anonimo fino al 1542*, I. Del Badia (ed.) (Florence, Sansoni, 1883), pp. 52–53 [translation Kathleen Christian]
[…] And on the 11th of November, certain animals arrived here which it was said were sent by the Sultan […]. The animals were these: a very large giraffe which was very beautiful and gentle; one can get a sense of its appearance from paintings found in many different places in Florence. And it lived here many years. And a large lion, and goats and horses which were very strange [antelopes or buffaloes?].

[…]

And on the 18th of November 1487, the abovementioned ambassador of the Sultan presented to the Signoria [Florentine government] the abovementioned giraffe, lion, and other animals, and they went to sit in the Signoria, on the *ringhiera* of the Signori [the platform in front of the Palazzo della Signoria], speaking and thanking each other by means of an interpreter. A large crowd had gathered that morning in the piazza to witness such an event taking place. The platform was decorated with banners and carpets, and all the principal citizens were seated there. The ambassador stayed here many months. He made many purchases and gave gifts.

And on the 25 of November 1487 the said ambassador presented Lorenzo de' Medici with certain aromatics in beautiful vases in Moorish style, and jars filled with balsam, and a beautiful and large striped tent in the Moorish manner that opens up, which I saw.

b) Paolo Giovio, *Gli elogi. Vite brevemente scritte d'huomini illustri di guerra, antichi et moderni* (Florence, 1590), pp. 199–200 [translation Kathleen Christian]

[...] After these deeds were done Qaytbay emerged full of glory, and was famous in our country not least for his virtue but also his fame that exceeded that of other Sultans. Among them it was he who wanted to develop friendships with foreigners, and to promote his name he sent a giraffe as a gift to Lorenzo de' Medici. This animal had very high front legs, and very low shoulders and short back legs, and the head of a deer with a straight, unbendable neck, and two little horns. Its back was furthermore marvellously patterned with scattered white and red spots, and it never caused displeasure; it was for a long time a marvellous spectacle not only in Tuscany but also in all of Italy, of the sort that had not been seen in Italy since the time of the Romans, since [these animals] are captured only with great difficulty in the distant reaches of Ethiopia on the banks of the Nile. He also a short time before as a similarly magnificent gesture sent as a gift to Duke Galeazzo Sforza a tamed elephant and a tiger marked with long black stripes, which was terribly fierce by nature, and these beasts can be seen today in paintings of good quality in the Castello of Milan.
[...]

2.5 Travel narratives

These extracts of travel narratives describe overseas voyages in America, Africa and Asia, highlighting the goods and products available in different places, while also sometimes making observations about local peoples and customs. While these were written by the travellers themselves, they report not only on first-hand observations, but also outdated beliefs and hearsay. Giovanni da Empoli, for example, refers to the 'Great Khan' who ruled over China from Quanzhou, yet the Ming dynasty had long ago replaced the Mongol 'Khans', and Quanzhou was a major port for foreign traders rather than the capital. Despite such inaccuracies, however, these sources represent a turning point, when different parts of the world were coming into direct contact and observing each other for the first time.

Vasco da Gama (c. 1469–1524) is most famous for the navigation of a sea route to India in 1497–1498 which provided the Portuguese unmediated access to Asian markets. This excerpt recording da Gama's journey down the coast of Africa observes the interaction between Christians and Muslims and pays special attention to

dress. Da Gama has heard of an almost mythic abundance of spices and jewels that could be obtained further along the route, but this information was acquired only second-hand. The next except is taken from the letters of the Florentine merchant Giovanni da Empoli, who sailed on several lengthy expeditions on behalf of Florentine investment firms in Bruges. Da Empoli also served Alfonso di Albuquerque in India, participating in the sieges of Goa in 1510 and Malacca in 1511. The text is taken from a letter to his father describing a voyage of 1510–1514 from Lisbon to Malacca and back. The third extract is from a travel book written by the Portuguese adventurer Duarte Barbosa (c. 1480–1521) who served as an officer and translator in South India, having learned to speak Malayalam. It records his time in South-East Asia during the second decade of the sixteenth century. Soon after writing it, Barbosa was killed in the Philippines while sailing on Magellan's expedition to circumnavigate the globe. [Kathleen Christian and Leah Clark]

a) **Vasco da Gama, *A Journal of the First Voyage of Vasco da Gama 1497–1499*, E.G. Ravenstein (trans.) (London: The Hakluyt Society, 1898), pp. 22–31, in Peter C. Mancall (ed.), *Travel Narratives from the Age of Discovery: An Anthology* (Oxford: Oxford University Press, 2006), p. 62**

[...]

The people of this country are of a ruddy complexion and well made. They are Mohameddans [Muslims], and their language is the same as that of the Moors. Their dresses are of fine linen or cotton stuffs, with variously colored stripes, and of rich and elaborate workmanship. They all wear *toucas* [hats] with borders of silk embroidered in gold. They are merchants, and have transactions with the white Moors, four of whose vessels were at the time in port, laden with gold, silver, cloves, pepper, ginger, and silver rings, as also with quantities of pearls, jewels, and rubies, all of which articles are used by the people of this country. We understood them to say that all these things, with the exception of gold, were brought thither by these Moors; that further on, where we were going to, they abounded, and that precious stones, pearls and spices were so plentiful that there was no need to purchase them as they could be collected in baskets. All this we learned through a sailor the captain-major had with him, and who, having formerly been a prisoner among the Moors, understood their language.

[...]

b) Duarte de Sande, 'An Excellent Treatise of the Kingdom of China (1590)', in Richard Hakluyt, *The Principal Navigations, Voyages, Traffiques and Discoveries of the English Nation*, 3 vols (London, 1589–1600), vol. 2: pp. 88–98, in Peter C. Mancall (ed.), *Travel Narratives from the Age of Discovery. An Anthology* (Oxford: Oxford University Press, 2006), pp. 168–170

[...] But the kingdom of China is, in this regard, so highly extolled, because there is not any region in the East parts that aboundeth so with merchandise, and from whence so much traffic is sent abroad. For whereas this kingdom is most large & full of navigable rivers, so that commodities may easily be conveyed out of one province into another, the Portuguese do find such abundance of wares within one and the same City (which perhaps is the greatest Mart throughout the whole kingdom) that they are verily persuaded, that the same region, of all others, most aboundeth with merchandise: which notwithstanding is to be understood of the Oriental regions: albeit there are some kinds of merchandise, wherewith the land of China is better stored than any other kingdom. The region affordeth especially many sundry kinds of metals, of which the chief, both in excellency & in abundance, is gold, whereof so many Pezoes are brought from China to India, and to our country of Japan, that I heard say, that in one and the same ship, this present year, 2000 such pieces consisting of massie gold, as the Portuguese commonly call golden loaves, were brought unto us for merchandise: and one of these loaves is worth almost 100 ducats. Hence it is that in the kingdom of China so many things are adorned with gold, as for example, beds, tables, pictures, images, litters wherein nice and dainty dames are carried upon their servants' backs. Neither are these golden loaves only brought by the Portuguese, but also great plenty of gold-twine and leaves of gold: for the Chinese can very cunningly heat and extenuate gold into places and leaves. There is also great store of silver, whereof (that I may omit other arguments) it is no small demonstration, that every year there are brought in to the city commonly called Cantam by the Portugal merchants to buy wares, at the least 400 Sestertium thereof, and yet nothing in a manner is conveyed out of the Chinese kingdom: because the people of China abounding with all necessaries, are not greatly inquisitive or desirous of any merchandise from other kingdoms. I do here omit the Silver mines whereof there are great numbers in China, albeit there is much circumspection used in digging the silver thereout: for the king standeth much in fear least it may be an occasion to stir up the covetous and greedy humor of many. Now their silver, which they put to uses, is for the most part passing fine, and purified from all dross, and therefore in trying it they use great diligence. What should I speak of their iron, copper, lead, tin,

and other metals, and also of their quick-silver: of all which in the realm of China there is great abundance, and from thence they are transported into divers countries. Hereunto may be added the wonderful store of pearls, which, at the Isle of Hainan, are found in shell-fishes taken very cunningly by certain Divers, and do much enlarge the king's revenues. But now let us proceed unto the Silk or Bombycine [silken] fleece, whereof there is great plenty in China: so that even as the husbandmen labor in manuring the earth, and in sowing of Rice; so likewise the women do employ a great part of their time in preserving of silk-worms, and in keeming [combing] and weaving of Silk. Hence it is that every year the King and Queen with great solemnity come forth in to a public place, the one of them touching a plough, and the other a mulberry tree, with the leaves whereof Silk-worms are nourished: and both of them by this ceremony encouraging both men and women unto their vocation and labor: whereas otherwise, all the whole year throughout, no man besides the principal magistrates, may once attain to the sight of the king. Of this Silk or Bombycine fleece there is such abundance, that three ships for the most part coming out of India to the port of Macao, & at the least one every year coming unto us, are laden especially with this freight, and it is used not only in India, but carried even unto Portugal. Neither is the Fleet it self only transported thence, but also divers & sundry stuffs woven thereof, for the Chinese do greatly excel in the Art of weaving, and do very much resemble our weavers of Europe. Moreover the kingdom of China aboundeth with most costly spices & odors, and especially with cinnamon [albeit not comparable to the cinnamon of Zeilan [Ceylon?] with camfer also & musk, which is very principal & good. Musk deriveth his name fro[m] a beast of the same name (which beast resembleth a Beaver) fro[m] the parts whereof bruised & putrefied proceedeth a most delicate & fragrant smell which the Portuguese highly esteem, co[m]monly calling those parts of the foresaid beasts (because they are like unto the gorges of fouls) Papos, & convey great plenty of them into India, & to us of Japan. But who would believe, that there were so much gossipine or cotton-wool in China; whereof such variety of clothes are made like unto linen; which we ourselves do so often use, & which also is conveyed by sea into so many regions: Let us now entreat of that earthen or pliable manner commonly called porcelain, which is pure white, & is to be esteemed the best stuff of that kind in the whole world: whereof vessels of all kinds are curiously framed. I say, it is the best earthen matter in all the world, for three qualities; namely, the cleanness, the beauty, & the strength thereof. There is indeed other matter to be found more glorious, and most costly, but none so free from uncleanness, and so durable: this I add, in regard of glass, which indeed

is immaculate and clean, but may easily be broken in pieces. This matter is digged, not throughout the whole region of China, but only in one of the fifteen provinces called Quiansi, wherein continually very many artificers are employed about the same matter: neither do they only frame thereof smaller vessels, as dishes, platters, salt-sellers, ewers, and such like, but also certain huge tunnes and vessels of great quantity, being very finely and cunningly wrought, which, by reason of the danger and difficulty of carriage, are not transported out of the realm, but are used only within it, and especially in the king's court. The beauty of this matter is much augmented by variety of picture, which is laid in certain colors upon it, while it is yet new, gold also being added thereunto, which maketh the foresaid vessels to appear more beautiful. It is wonderful how highly the Portuguese do esteem thereof, seeing they do, with great difficulty, transport the same, not only to us of Japan and into India, but also into sundry provinces of Europe. [...]

c) **Giovanni da Empoli, extract of a letter to his father, 2 July, 1514 in *Giovanni da Empoli: un mercante fiorentino nell'Asia portoghese*, M. Spallanzani (ed.) (Florence, Studio Per Edizioni Scelte, 1999), pp. 159–207 [translation Kathleen Christian]**

[...] I already described to you on another occasion that Cap-Vert called Bissichicci [the Bay of Dakar, called the 'Angra de Bezeguiche'] is the principal place and capital of lower Ethiopia. They are gentiles, don't worship idols but are bestial like Epicureans; a little bit further along certain rivers you find Christian populations; these people are rather skilled and every day more so, because of the constant conversations they have with sailors passing through. Exports from this land include slaves, gold, iron, malagueta pepper, tailed pepper [cubeb], rice, ivory and other goods and palm textiles.

Navigating further, from here we went across to arrive at Terra di Santa Croce called Brazil, which is not yet well known. The Antilles of the King of Castile, and likewise the Terra di Corte Reale [the Atlantic coast near the Hudson Bay, named after the Portuguese explorer Gaspar Corte-Real] are thought to be joined together with Malacca, because the people, the animals, and all other things are so similar; but the distance, location and the cold temperatures don't allow it to be navigated or discovered. The people in these parts are very bestial and natural Epicureans; they don't possess any personal property; they wage wars against each other to eat one another; they decorate the piercings they make on their bodies and faces with stones and various parrot feathers. They use bows and arrows as weapons. As of yet nothing is found there

except for brazilwood and furs. In the Antilles of Castile, you find gold, as I have told you.

The Cape of Good Hope, whose people I have described to you, extends up to Zofalla [Sofala in Mozambique]; they are industrious people, and most of them are Moors who live in the city of Zofalla. You can find gold in abundance here, and they sell Cambay cloth [from India], gold and very good cotton fabrics. And these people extend up to Mozambique, Malindi, Mogadishu, Brava [Barawa in Somalia], Chilva [Kilwa in Tanzania], and Mombasa, which are all walled cities on the mainland, with streets and houses like ours, except Mozambique, which is an *aldea* [a Portuguese term for a village without city walls], that is, a villa. On the island just like on the mainland there is also a large fortress there, and many very good Portuguese outposts.

Moving on to India, as you already know and as I have told you, these are gentiles, that is, idol-worshippers and natural men of the earth who worship Mars as their primary god. Nevertheless, they know and believe that there is one great God, because 'the sound [of the heavens praising God] hath gone forth into all the earth', etc.[1] There are foreigners there (who rule over the natives) and various sorts of Moors, who follow the law of Muhammad, whom we call 'Mechomet', except those of the sect of Shah Isma'il [1487–1524], that is the Soffi who believe in Ali, the son-in-law of Mohammed. In the land of India called Malibar, the territory that begins with Goa and goes up to Cavo Comedi [Kanyakumari], they produce pepper and ginger, and goods which you already know about. Moving beyond Cavo Comedi there are gentiles, and there one finds Gael [Kayalpatnam], where they fish for pearls, and the body of Saint Thomas the Apostle is found here. Moving further between the land and the sea you find the Island of Ceylon, where they produce cinnamon, saffron and Asian rubies in great abundance. This is a very beautiful, well populated and well situated land.

Returning to the mainland, and to Gael, you find Coromandel [the Coromandel Coast], where all the rice exported to Malacca comes from; and it is a land greatly abundant in merchandise of all sorts. Then there comes Bengal, also gentiles, where they make cotton cloths of all varieties, very fine ones, called *brattiglie, barracano, sultanpuri* [different types of cloth], and other sorts of very fine cotton cloths. They also have preserved green ginger, which is excellent, and all other types also preserved, and great quantities of fine cane sugar and white sugar as refined as that of Valencia.

1 A quote from Psalm 19.4.

Then a bit further you find Martaban [Mottama in Myanmar], which is also populated by gentiles, men who are great merchants and knowledgeable in all things, and who are experts of accounting; the best in the world. They write out their accounts in books just as we do. In this land you find large quantities of lacquer, cloth, merchandise and other things. Then Tanazzari [Tenasserim] and Sarnau [Siam] where they make very fine white benzoin resin, storax gum and lacquer which is finer than that of Martaban and Scale [unidentified location], and where the Chinese go to sell their goods, that is, rhubarb, musk, silk damask, brocades, white silk, raw silk in all colours and Chinese pearls. Here you find all sorts of spices which the Chinese buy and bring back to their country. Then there is Pegu [Bago, Myanmar], which is well-populated with horses and noble people, where you find mines of [unintelligible] and perfect rubies, in great abundance. These are very beautiful men, tall and broad; they seem a race of giants. They are accustomed to wearing on their male members six or seven very big bells, the size of chestnuts, which they put under their foreskins, and because it is something unseemly to write about, let's put this topic aside and laugh about it during a pleasant moment when we can speak in person, and I will send one of these bells to you with this ship so that you can see it. It seems incredible, but it is very much true, and in Malacca we have encountered more than 200 people wearing these; some of them wear nine at a time, and some of them wear ones made of gold or silver.

Beyond Malacca, they don't make anything and they are natural people of the earth and gentiles, and the others are Moors of several generations. Moving further, you come to the land of Java where they produce nutmeg and mace, cubeb [tailed pepper or Java pepper], turpeth, galangal [a plant related to ginger], camphor of two varieties, aloes and an infinite number of other medicines. One type of tree produces both nutmeg and mace. I'm sending you on this ship a specimen which is still green.

And further on is Timor, where white and yellow sandalwood come from, and further on are the Moluccas, where cloves are produced. I am sending you the bark of these trees, which is excellent, as are the flowers.

Going towards the North are the lands of the Chinese, called China, Lechi [Ryukyu islands] and Gori [Vietnam]; that is like saying Flanders, Germany and the Brabant. They have very wide rivers that run inland and, from what we have heard about them, beautiful cities and castles on either side of these rivers. You would sail three months up one of these rivers before you arrived at the capital city, called Zerum [Quanzhou, formerly called Zaytun] where the King of the Chinese lives, who is called the Great Khan of Cathay. Whatever land lies beyond this territory, if someone ever fully discovers it, would be enormous.

Returning toward the south is Sumatra, also called Trapobana, and as I have told you there are idolatrous gentiles there.

Coming back to Goa, going from there along the coast as far as the kingdom of Cambay [Khambhat] there is the city of Dacon [an unidentified location], where diamonds come from: and then there is Diu, Dabul [Daibul], Chaul, Zurrati [Surat] and other most noble ports and cities of infinite wealth and a great deal of merchandise. Then Hormuz, a beautiful place, then Giulfar [Julfar], where you find large pearls in great abundance, as well as small ones. Then next is Stava and Alegi [unidentified locations, whose names refer to two varieties of silk] where they make the silks that go to Chosagli [unidentified location].

Believe me, his Highness the King of Portugal is the lord of great conquests, and lands, and principalities, but even more of the sea, and of riches of all sorts; one might even say he is lord of the world.

[...]

d) Duarte Barbosa, 'The Great City of Bisnagua', in Mansel Longworth Dames (trans., ed. and annotated), *The Book of Duarte Barbosa* (London: The Hakluyt Society, 1918), vol. 1, pp. 200–204

Forty Leagues (of this country) further inland there is a very great city called Bisnagua.

[...]

Here there is a diamond-mine as there is also in the kingdom of Daquem, whence are obtained many good diamonds; all other precious stones are brought hither for sale from Peguu and Ceilam, and from Ormus [and Cael] they bring pearls and seed-pearls. These precious stones circulate here more freely than elsewhere, because of the great esteem in which they are held [for they deck their persons with them, for which reason they collect here in great quantities]. Here also is used great store of the brocades of poorer quality brought for sale from China [and Alexandria], [and much cloth dyed scarlet-in-grain and other colours and coral worked into paternosters and in branches], 'also metals both wrought and unwrought,' copper in abundance, quicksilver, vermilion, saffron, rosewater, great store of opium, sanders-wood, aloes-wood, camphor, musk (of which a great quantity is consumed yearly, as they use to anoint themselves therewith), and scented materials. Likewise much pepper is used here and everywhere throughout the kingdom, which they bring hither from Malabar on asses and pack-cattle.

All this merchandise is bought and sold by *pardaos*, [the gold coin, which they call *pardao* is worth three hundred *maravedis*] which are made in certain towns of this kingdom, [and over the whole of India they make

use of this coin, which is current in all these kingdoms. The gold is rather base.] [...]

Critical approaches

2.6 Claire Farago, 'Reframing the Renaissance Problem Today: Developing a Pluralistic Historical Vision', in Jaynie Anderson (ed.), *Crossing Cultures: Conflict/Migration/Convergence, 32nd Congress of the International Committee of the History of Art* (Melbourne: University of Melbourne Press, 2009), pp. 227–232

Claire Farago is a leading figure in Renaissance art history and historiography. In this essay she assesses the over-privileging of Italian Renaissance humanism and the revival of antiquity, which has produced a single vision of the period rather than a pluralistic one. Through their partiality towards one understanding of the Renaissance, major figures from generations past have left behind 'undigested projections' that continue in the present. On the level of the individual object, the assumption of the 'radical unity' of the work of art has blinded art historians to the possibility that art emerges out of heterogeneous or connected cultures. As examples she cites Afro-Portuguese ivories, a Mexican featherwork painting made for Pope Paul III (Fig. 2.2), and colonial religious art. Farago ends by suggesting that the concept of 'rebirth' in the Renaissance might be extended to include a theme frequently evoked in orations delivered at the papal court: the goal of converting the whole world to Christianity. [Kathleen Christian]

[...]

We are now in the process of conceptualising the interaction of different representational conventions across cultural boundaries in terms other than aesthetic considerations grounded in Western styles of representation, and we are also required to interrogate what are meant by 'cultural boundaries' themselves. We need strategies for studying the contributions of fluctuating sixteenth-century senses of 'art' to later ideas about cultural identity and aesthetic sensibility – strategies that undercut anachronistic categories that interfere with our ability to see the complexity of artistic and cultural interactions during the early modern period. The fundamental responsibility for historians today is to recognise the undigested projections of past generations in our present-day theoretical extensions of existing scholarship. My approach will chart the peripatetic histories of several

strategically chosen categories of objects along the entire trajectory of cultural exchange.

The visual sign does not necessarily 'reveal' its meaning – the visual hides as much as it shows. I open with a series of questions:

What happens when the pictorial systems of unrelated cultures are conflated?

Neither the artist nor the artist's audience necessarily attaches the same meaning to an appropriated motif or convention that it had for its previous audience in a different context. Nor can it be assumed that all viewers attach the same meaning to a motif, especially when it is inserted into a new representational system. How do artistic images convey culturally shared meanings to a heterogeneous audience? And what can be recovered from the surviving record in which diverse artistic traditions have interacted for generations and even centuries?

Whether the term 'hybridity' itself, or others like it, will endure matters less than our understanding of the conditions that 'cultural hybridity' attempts to describe: in societies in which the authority of texts and other forms of artistic representation are destabilised by multiple viewing perspectives, 'identity' itself is always dynamic, incomplete.

How do we deal with cultural productions that we do not fully understand, and cannot understand, because their cultural significance is beyond our grasp?

The kind of art historical practice I would like to see in Renaissance studies goes all over the world, and deals with all kinds of practices, representational systems and cultural conditions, not only at the level of social history, but at deeper epistemological levels. What happens when the readability of the art changes because of contact, when people's ability to live changes because of their altered material culture?

Who owns the past?

One of our most deeply rooted forms of art historical thought is the assumption, based in neo-Aristotelian, Christian theories of images, that an artwork has a radical unity that reconciles (harmonises, synthesises) any surface contradictions. This radical unity purportedly stems from the conscious or unconscious intention of the author, who is imagined to be singular and unified, and in turn accounts for the work's power to communicate to audiences. The conditions of production and use of art in heterogeneous societies, or societies viewed in transnational terms, call into question the assumed connections between artistic intention, unified meaning and communicative power. Pace Panofsky, there appears to be no way to resolve the meaning of certain works of art into a single,

stable reading, any more than there appears to be a resolution to the complex agencies involved in their production and use.

What is our responsibility to society as intellectuals?

This question deserves to be driving our research agendas. Our work can seem apolitical when we produce it, but at the same time it excludes other work from taking place or relegates that work to the margins. Left with a magnificent but inert treasury of inherited objects, art historians who do not stray from their inherited categories are consequently unlikely to articulate complex questions of self-other relationships that produced these storehouses in the first place. Nor are they likely to develop an interest in the marginal position of the culturally dispossessed and the politically disempowered who leave no provenances of ownership or even their names in the historical record.

The evolving definition of art in early modern European thought is only one thread in a complex weave of changing attitudes towards human knowledge, but perhaps a concrete example can suggest what a sixteenth-century understanding of art meant for non-European cultures (see Figure 2.1).[1] A humanist collector would have appreciated this extraordinary object very differently from the Sapi artists commissioned by Portuguese slave traders. For the inhabitants of Sierra Leone, as Suzanne Blier has shown, the severed heads and the main figure's seated position can be connected specifically with Sapi burial traditions.[2] By contrast the same scene is likely to have encouraged European fantasies of decapitation and cannibalism among 'savages'. The lack of documentation, which is characteristic of the entire class of fifteenth- and sixteenth-century African-Portuguese ivories, further suggests that these hybrid cultural products were valued primarily as exotic collectors' items. Such *grotteschi* and similar artistic inventions signified in a double-handed way, moreover. On one hand, they stood for the artists' freedom and capacity to invent images out of their imagination that nature could never create; on the other hand, and for the same reasons, *grotteschi* were associated with irrational mental activity, the active imagination unrestrained by human reason.

My second category of objects comes from a society completely unrelated to the Sapi people in the sixteenth century, yet their artistic

1 The first example is drawn from Farago, *Reframing the Renaissance: Visual Culture in Europe and Latin America 1450–1650* (London and New Haven: Yale University Press, 1995), pp. 9–12, in which the argument is developed further with full documentation.
2 Suzanne Blier, 'Imagining Otherness in Ivory: African Portrayals of the Portuguese c. 1492', *Art Bulletin*, no. 75, 1993, pp. 375–397.

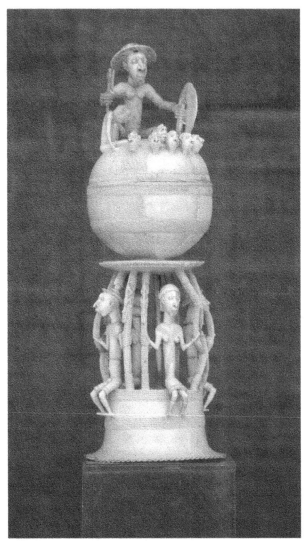

2.1 Unknown artist (Sapi-Portuguese), Saltcellar, c. 1490–1530

production might have been viewed similarly by the European collectors who sought them out. Mexican featherwork made into ceremonial objects, such as shields, capes and fans, was the most highly prized form of artistic production in the Aztec Empire (this name itself, designating a complex political alliance of three cultures, is problematic). At the time of the Spanish conquest, the technique was immediately utilised by missionaries to produce objects with Christian imagery. Both pre-Columbian and colonial featherwork objects straightaway became highly prized in Europe.

A Latin epigraph dates this remarkably well-preserved feather mosaic (*amantecayotl*) to 1539, making it the earliest dated work of art surviving from New Spain (see Figure 2.2).[3] The inscription states that the object was made in Mexico City under the supervision of Pedro de Gante (1486–1572), the Franciscan lay brother who in 1524 established the famous mission school of San José de los Naturales, at which the mechanical and liberal arts were taught to Native Americans. According to the inscription, Don Diego de Alvarado Huantzin, Aztec royalty and the ranking native government official in the Republic of Indians, offered this extraordinary gift to Paul III, the pope who had recently published a series of declarations protecting the rights of Native Americans. Only two years earlier, on 9 June 1537, Pope Paul III had issued the bull *Sublimis Deus*, against enslaving the Native Americans and seizing their property, pronouncing 'Indians and all other people who may later be discovered by Christians' to be endowed with the 'nature and faculties' necessary to receive the Christian faith solely by 'preaching of the word of God and by the example of good and holy living'.[4]

It is within this politicised, ideologically freighted frame of reference that the significance of this particular *Mass of Saint Gregory* must be sought. In 1539, an assimilated, Christianised government official of noble

3 The inscription, in Roman capitals, bordering the image reads:

 PAVLO III PONTIFICI MAXIMA
 EN MAGNA INDIARV[M] VRBE MEXICO
 CO[M]POSITA D[OMI]NO DIDACO GVBERNA
 TORE CVRA FR[ATR]IS PETRI A GANTE MINORITAE AD 1539

 ('Made for His Excellency Pope Paul III in the great city of the Indies, Mexico, during the governorship of Don Diego [?], under the supervision of the Minorite Brother Peter of Ghent, 1539 AD'). See also Claire Farago, 'Catalogue no. 1, *Mass of Saint Gregory*, featherwork mosaic'; and Elena Isabel E. de Gerlero & Donna Pierce, 'Catalogue no. 1, *Mass of Saint Gregory*, featherwork mosaic', in Donna Pierce et al., *Painting a New World*, exhibition catalogue, Denver Art Museum, Denver, CO, and University of Texas Press, Austin, TX, 2004, pp. 98–102.

 The iconography of the Gregorian mass includes the arms of Christ, a favourite devotion of the earliest Franciscans in Mexico and a motif that can be associated with a utopian concept of the universal Christian Church. For further discussion, see Donna Pierce, *Mexico: Splendors of Thirty Centuries*, exhibition catalogue, introduction by Octavio Paz, Metropolitan Museum of Art, New York, and Little, Brown, Boston, MA, 1990, pp. 260–263.

4 *Sublimis Deus*, cited in Lewis Hanke, 'Pope Paul III and the American Indians', *Harvard Theological Review*, no. 30, 1947, pp. 72–73, translation in Francis MacNutt, *Bartholomew de Las Casas*, AH Clark, Cleveland, OH, 1909, pp. 427–431. News of the decree reached Mexico in 1539. Hanke notes that the pope rescinded the penalty of excommunication the following year, but apparently this was not widely reported in New Spain.

2.2 Mass of Saint Gregory, 1539

Aztec descent like Don Diego might have felt optimistic about the future, and deeply grateful to a pope who recognised the intelligence of the Native American peoples. The imagery on this featherwork painting was directly derived from a European print similar to an engraving by Israel van Meckenem, c. 1480–85.[5] A Latin inscription below the image in the

5 Max Lehrs, *Engraving and Etching: A Handbook for the Use of Students and Print Collectors*, Scribner, New York, 1906, IX.288.353. See Alan Shestack, *Fifteenth-Century Engravings of Northern Europe*, exhibition catalogue, National Gallery of Art, Washington, DC, 1968, catalogue no. 214. A similar engraving by the same artist is catalogued as no. 215.

engraving indicates that the sheet was intended as an indulgence granted to whoever recites the requisite prayers to the instruments of Christ's Passion. Saint Gregory the Great, a sixth-century pope, famously defended the religious use of images because they functioned as a 'Bible for the illiterate'.[6] There are significant differences, however, between an inexpensive broadsheet issued to pilgrims and a unique gift of state crafted in precious, exotic materials, intended for the chief representative of Christ on earth. Given the timing of the gift, the choice of subject suggests that Pope Paul III was to be praised as a latter-day Saint Gregory, no doubt for his strong defence of the Native Americans' fully human capacities. Viewed in this context, this featherwork painting is a magnanimous gesture, eloquently rendered in a medium well established in pre-Columbian times as a form of tribute, that both the Native Americans and their European conquerors considered the most elevated form of Mexican art.[7]

The choice of subject was strategic on several levels. De Gante and other missionaries used visual images extensively during the early years of the conquest, when language was an extreme barrier to communication, as is known from numerous sources including the 1579 Italian publication in Latin of an important pedagogical text, *De rhetorica christiana*, written and illustrated by Diego Valadés, De Gante's pupil. Valadés introduced a sort of pictographic syllabary involving signs in the shape of sacred hearts, a symbol with connotations on both sides of the cultural and linguistic divide.[8] Some of Valadés's heart signs include recognisable

6 For his defence of images, see Gregory the Great, letter to Sernus, c. 600 AD, in Epistolae, 11.4, 13, in J-P. Migne, *Patrologia Latina*, vol. 78, col. 1128, translation in Georges Didi-Huberman, *Fra Angelico: Dissemblance and Figuration*, trans. Jane Marie Todd, University of Chicago Press, Chicago, IL, and London, 1995, p. 25: 'It is one thing to adore a painting, but quite another to learn, through the story the painting recounts, what ought to be adored ... [for painting is made for] idiots and illiterates, for *ignorantes* who must be content to find in images what they cannot read in texts'.

7 For descriptions and illustrations of featherwork techniques compiled in the second half of the sixteenth century, see Fra Bernardino de Sahagun, *Historia general de las cosas de Nueva España*, vol. 10. The modern edition is Arthur J.O. Anderson & Charles E. Dibbie (trans.), *The Florentine Codex: A General History of the Things of New Spain*, 12 vols, School of American Research, Santa Fe, NM, and Salt Lake City, UT, 1950–81.

8 Diego Valadés, *De rhetorica christiana*, Perugia, 1579. In describing and illustrating the basic tenets of medieval faculty psychology, Valadés focused on the role played by the art of memory in teaching sacred doctrine to neophytes at San José de los Naturales, where images were placed in strategic locations along liturgical procession routes.

elements from Nahuatl pictograms. Although their exact meaning has never been deciphered, the manner in which they function in his text makes the important point that they are a culturally hybrid means of communication.

The mnemonic devices in both Valadés's book and the featherwork mosaic attest to the mental capacity of their users to 'recollect', that is to remember the central mysteries of the Christian faith by contemplating the mnemonic signs that refer to them. In the feather mosaic, the conventional setting in a church interior has been eliminated in favour of an undifferentiated blue background that might indicate the outdoor settings used to instruct neophytes in Mexico. The blue aids the beholder perceptually, by isolating each sign against a brilliantly coloured ground, making it easier to remember the images, as European treatises devoted to training memory recommended. The mental capacity to draw a series of inferences, as Aristotle and his commentators defined the human faculty of memory as distinct from the retentive memory of animals, was both directly cited and indirectly implied throughout sixteenth-century discussions of Native Americans' mental capacities. Don Diego's erudite gift was offered by a bicultural colonial subject in the language of the conqueror, in a medium prized by the coloniser, as evidence of his own humanness. It is perhaps not overstated to claim that, by 1539, the terms on which the Native Americans' mental capacities were judged were part of an international, transcultural discourse in which the culturally dispossessed also participated – at least to the limited extent of a few assimilated members of the Native American elite.

My final example takes a diachronic view of the Renaissance. Many of the stylistic conventions associated with the Italianate classicising style we call 'Renaissance art' continued to be used for centuries, in Europe and throughout the colonial world. Conventional histories of art relegate these artistic productions to the periphery, if they are considered at all, with dismissive labels such as 'belated', 'provincial', 'marginal' or 'regional' variants, whereas the 'originality' of Italian inventions is taken as the standard of judgment. Part of the challenge currently facing art historians is to devise less ethnocentric ways to think about cultural production. Alternatively, to draw an example from my own research, the distinctive qualities that identify locally produced New Mexican religious imagery as products of the region can be described in terms of elaborating framing devices, including geometric patterns and other motifs derived from both Indigenous artistic traditions and imported materials, prominent landscape settings and bold graphic compositions often with exuberant drawing

also found in Pueblo pottery by artists largely untrained in European academic methods [...].[9]

How do we account for the culturally determined predispositions of different spectators in front of the same objects and images without falling back on discredited assumptions of cultural coherence or of individual free will? Ultimately, all three case studies involve 'style' in questions of what it means to be human. In addressing the Renaissance problem in an expanded field, one possible course of action would be to consider how the metaphor of rebirth developed historically in a religious context. John O'Malley, who studied over 160 sacred and secular orations dealing with the theme of *renovatio mundi* composed at the papal court, emphasises that this genre of oratory is intimately tied to the humanist revival of classical rhetoric.[10] One of the recurring themes of the sermons is the need to wage a successful war against the Turks, this being a precondition for constituting the world as 'one flock' under one universal pastor. Another is the conversion of Gentiles, Jews and Greek Christians. Reconsidering the metaphor of rebirth in its historically concrete political, religious and ideological context would yield an understanding of 'Renaissance' radically different from any yet developed. Have we even recognised the blinders that the association of metaphors of rebirth with hierarchical, religious binaries implicit in subdisciplinary formations such as Italian Renaissance, Byzantine and Islamic art history – and operating in both the Mediterranean world and in the global network of trade that succeeded it – impose on our historical vision?

2.7 Avinoam Shalem, 'Dangerous Claims: on the "Othering" of Islamic Art History and How it Operates within Global Art History', *kritische berichte: Zeitschrift für Kunst- und Kulturwissenschaften,* vol. 40.2 (2012), pp. 69–86

This extract is taken from a lengthier article in which Avinoam Shalem, a historian of Islamic art, addresses the question of how Islamic art is represented in the new global art history – Islamic

9 Space constraints prevent me from further summarising the argument presented at the CIHA, but see Claire Farago & Donna Pierce, *Transforming Images: New Mexican Santos in between Worlds*, Pennsylvania State University Press, University Park, PA, 2006, esp. ch. 11, pp. 194–212.

10 John O'Malley, *Praise and Blame in Renaissance Rome: Rhetoric, Doctrine, and Reform in the Sacred Orators of the Papal Court, c. 1450–1521*, Duke University Press, Durham, NC, 1979. I will develop the following argument in a forthcoming study, provisionally entitled *The Promise of Art*.

art has long played a peripheral role in Western art history, where it has been brought in to 'explain' the development of European art at select moments in its history, then dismissed. Now global and cross-cultural art history has produced a new surge of interest in Islamic art amongst European specialists. This essay examines the implications for Islamicists and questions whether what has resulted is a form of colonisation by historians of Western art who continue to maintain a Eurocentric perspective. The author challenges and historicises the tendency among Renaissance specialists to make the Islamic societies bordering Europe on the Mediterranean the sole agents of 'the global' in this period. He also questions the comparison of cultures in the practice of 'world art history', stressing instead the need to find connections between artistic traditions.

This extract has been shortened from the original essay and most of the author's extensive references and notes have been removed. [Kathleen Christian]

To a question I was recently asked by an Indian journalist from *Delhi Time Out* magazine about the specific place that Islamic art has in art history, I answered immediately, and without further thought: 'Islamic history is art history.' Of course, my answer was no less provocative than her question. But both her question and my answer touch upon the broad and complicated issue of making Islamic art a foreign field within the realm of art history, namely the 'Othering' of Islamic art history. Both art historians and historians of Islamic art are trapped in this setting, which has its roots in the Eurocentric history of the discipline called art history.[1] Moreover, the emergence of a new paradigmatic model for global art history in the last decade has sharpened the question posed by the Indian journalist and brought about a crisis for both art historians and those who specialize in Islamic alike.

'Anxious' Islamic art historians are in fear that the recent developments in the field of art history and the wish to make it global might both inflict and weaken the hegemony that they (historians of Islamic art) to this

1 On this subject see mainly Robert S. Nelson, 'The Map of Art History', *The Art Bulletin* 79, 1, 1997, pp. 28–40 [...]; Sheila S. Blair and Jonathan M. Bloom, 'The Mirage of Islamic Art: Reflections on the Study of an Unwieldy Field', *The Art Bulletin* 85, 1, 2003, pp. 152–184; Finbarr Barry Flood, 'From the Prophet to Post-modernism? New World Orders and the end of Islamic Art', in Elizabeth Mansfield ed., *Making Art History: A Changing Discipline and Its Institutions,* London, 2007, pp. 31–53; Avinoam Shalem, 'Über die Notwendigkeit, zeitgenössisch zu sein: Die islamische Kunst im Schatten der europäischen Kunstgeschichte', in Burkhard Schepel, Gunnar Brands, and Hanne Schönig (eds), *Orient – Orientalistik – Orientalismus,* Bielefeld, 2011, pp. 245–264.

day have enjoyed as the sole authoritative voices in their specific field.[2] Trying vehemently to distinguish themselves from the numerous new 'Globalists', who write, publish, and talk about subjects that were just a few years ago in their (the Islamists') domain, they accuse these newcomers of being essentialists, even neo-colonialists. And, in order to demarcate borders of different identities, namely to tell apart the Islamic art historians from the 'new' global ones, the field of Islamic art history rapidly and vigorously excretes essentialist terminologies such as 'Islam' and 'the Orient' from its own academic jargon. The result is a constant search for new subtle and ancillary terms of differentiation, such as 'Islamicate', or the attempt to break up the field of 'Islam' into subfields, of which the debate on the new definition for the Islamic Art Gallery in the Metropolitan Museum of Art in academic journals and media reports bears witness.[3] Moreover, the 'Against-Essentialism' position taken today by scholars in the field of Islam, has forced those who see themselves as art historians of 'Islam' to abandon their common operating model of 'Diversity in Unity.' Since the idea of unity can no longer be taken for granted, they are left with only the notion of diversity. This means that the whole field of Islamic art history has now been deconstructed, as if in a postmodern manner, and that its present fragmentary character poses crucial questions about how to deal with these bits and pieces of the, for example, medieval 'Islamic' arts, which stretch from Cordoba to Karakorum.

The 'other' art historians, who till yesterday were occupied with the so-called Eurocentric and Western art history, appear as hungry, devouring animals seeking to conquer these new territories in the East. Like the colonial powers of the nineteenth century, they see in this moment of globalization an opportunity to widen their horizons, to revise and reframe the borders of their scholarly interests. Art history expands. It re-conquers South America, Asia, and South Asia, reaches beyond North Africa into the center of the 'Black Continent' and even casts its gaze in the direction of the Far East, towards Japan and Australia. But beyond geographical expansion across the globe the Western art historian remains, as always, armed with classical canons and aesthetic judgements secured by Western methodologies and norms. Like an Orientalist, he collects during his journeys in these new academic territories souvenirs and trophies, namely new monuments of art, which in fact tell the most private story of his

2 The use of the word 'anxious' refers to the workshop *Anxious Historiographies of 'Islamic' Art* held at the Getty Research Institute on March 11, 2009 [...].

3 See Nasser Rabbat, 'What's in a Name.' *Artforum*, January 2012; Michael J. Lewis, 'Islam: by Any Other Name.' *The New Criterion* 30 (December 2011), p. 13 [...].

psyche rather than mirror the visual cultures of the other in non-Western spaces. Back at his desk, he immediately and often in an undigested manner incorporates these artifacts into his reframed research agenda, a process somewhat reminiscent of the display of exotic Oriental objects on the mantelpiece of a nineteenth-century European drawing room.

The picture I draw seems bleak. But why and how did it reach this state? In fact, what went wrong? And why should the widening of scholarly horizons and the – we must admit – positive tendency to look globally at artistic and aesthetic issues result in a crisis?

[…]

In this article I will try to illuminate the query 'what went wrong', and, to this end, […] [focus] on 'dangerous claims.' These comprise the aims and aspirations that global art history declares as part of its new agenda. However, I would like to clarify that by dubbing these claims as dangerous I am not adopting a patronizing attitude and presuming that I am able to distinguish between right and wrong. My use of the adjective 'dangerous' in this context refers to the critical thought embraced by positions which speak for 'the world': my aim is not to define or impose, rather to disclose.

It is well known, and several recent articles on the history of Islamic art have drawn our attention to the issue, that the art of the Other, and especially that of Islamic production, appears to have been accepted into the *longue dureé* of the history of art, usually from the Eurocentric point of view, where it surfaces at intervals. This means that Islamic art and Islamic objects were chosen to illustrate a specific era or were integrated into the discussion about the development of Western art history only at specific moments in history. These objects of Islamic manufacture, usually defined at the very beginning of the 20th century by art historians as masterpieces and artworks of high quality, then appeared in and disappeared from the history of European art. They were used to explain in a more intricate and, one might say today, global context the production of art in the West. For example, objects of cast metal from the Fatimid period, like the famous griffin of Pisa, were used to explain the interest in casting monumental and 'minor' metalwork in the second half of the eleventh century in Europe; and I mainly refer to the emergence of the production of bronze doors and aquamaniles in the Romanesque period. The enamelled works from Al-Andalus were then considered as forerunners to the famous enamels of Limoges. Fatimid carved rock crystals demonstrating the highest level of crystal carving technique were a source of fascination and provided an impulse for the founding of a western center of carved rock crystal, be it in Paris or in Burgundy, in the High Middle Ages, and were thus integrated, so to speak, into the history of carving

rock crystals in the West. In addition, Islamic and Byzantine textiles, which were widely traded all over the Mediterranean Basin during the Middle Ages, are usually accepted as the main agents for fostering the appearance of secular motifs, mainly of combatant, intertwined animals and other fantastic creatures within the aesthetic language of the medieval Latin West.

[...]

These exotic objects appeared in [...] the era of the world under the global hegemony of Alexander the Great, who ruled the universe from one end to the other [...]; the Golden Age, so to speak, of Mediterranean trade around the year 1000, in which port cities like Amalfi and Salerno played a major role in connecting the histories of the eastern and western, as well as northern and southern, shores of the Mediterranean Basin; the era of the Crusades which, beyond the animosity that spread in Europe and Asia to mobilize human forces to fight each other for the sake of the right religion and god, in fact enjoyed moments of fruitful interaction between Eastern and Western cultures; and of course the Renaissance, in which the transmission of lost classical knowledge in the West found its way back through the translated writings of mainly Arab scholars and the migration of luxury goods, all of which promoted the birth of new techniques and aesthetics. Modern Times in Europe, and I mainly refer to the century that follows the French conquest of Egypt by Napoleon in 1798, namely the nineteenth century – the age of Orientalism – witnessed a continuing interest in the art of the Near Eastern Orient and especially of that of North Africa and the Levant and prompted the rediscovery of Islamic art.

And yet, as I mentioned before, these moments were and are seen as short intervals in the history of European art. The artistic interest in the high art products of the Orient, admirable as this art was regarded and as seriously as it was reflected upon, always appears as a temporary vector that found its end as soon as a new aesthetic era was seen to emerge in the West.[4]

[...]

In the spring of 2002, as I first took up the position of professor for the history of Islamic art in the department of art history at the Ludwig Maximilian University in Munich, one of the first problems I was faced with were resources. In the first place, the main concern of the art history department was the acquisition of books that would cover this new field

4 See my publication cited in note 1. In this article I suggest that the major moments or turning points in the history of Western culture, namely the Renaissance and the age of modernism, cast a shadow on the history of Islamic art.

within the curiculum. The euphoria created by the prospect of establishing for the first time in the history of German art history a professorship for the study of Islamic art in an art history department – in Germany Islamic art has been always an adjunct branch linked to Oriental or Islamic studies departments – died away as soon as I was told that the newly acquired books on Islamic arts would be placed in the institute library in a specific space, in fact in one of the corners of the so-called Italia Room. A niche was made for Islamic art, I thought. After several discussions and much planning, my request for integrating the books on Islamic art within the entire library system was accepted. This anecdote illustrates the major problem that art history departments still face vis-à-vis the field of Islamic art history. Like Chinese or Japanese arts, this field is regarded as a sort of extra, bonus area that students, whose main interest is clearly anchored in European art, can explore. It seems that, from a Eurocentric point of view, Islamic art has clear geographical borders that define its history as wholly detached and fully independent from the rest of world art history. Misconceptions of this kind are common in departments of art history elsewhere. It could be argued that this bibliographical organization makes life easier for students. Students taking courses on Islamic art can find books on the subject with little difficulty. But the importance of integrating books on Islamic art within the whole system is, to me, ideological in nature, and equally serves those students whose focus is in fact Western art. For example, while searching for books on medieval European textiles, glass, or ivory, students are also confronted with the medieval Islamic objects in these materials. The possibility of encountering these artifacts also enables students to broaden their knowledge, to encourage comparative thinking and studies which seek to trace processes of artistic interaction. Integrating Islamic art books in the library system also avoids the absurd situation in which books on Islamic art are both secluded and, in geographical areas like Norman Sicily, also included on the shelves of the Italia Room. The same could be said for the shelves designed for Spain, Malta, Cyprus, Sicily, Anatolia, Armenia, etc. The specific books on Islamic art that were chosen to make the 'move' from their Islamic 'ghetto' to these intercultural spaces might then have been regarded as privileged. In fact, the integration of these selected books into the narratives of European or Christian art illustrates the Eurocentric approach towards the arts of Islam and the use of this art in selected intervals that, from a European point of view, are useful for the narrative of European civilization. Mistakes such as these should be avoided. And again, by using the word 'mistake' I would like to avoid any judgment that simplifies or acts as an evaluative parameter for right or wrong. My understanding here of the word 'mistake' involves an

act that might be made unconsciously or due to a lack of knowledge, or that might involve the inadvertent exploitation of a subject that is completely new.

At the same time, I would like to put this anecdote in its art historical context. Early in 2002, art history departments in Germany were less concerned with placing art history in a global frame. [...] But soon after, the 'Global Turn' entered the art-historical space, or rather conquered it, and, as in any battle, both produced casualties and celebrated triumphs. There were martyrs and heroes. Islamic art appears as one of the great heroes of global art history in pre-modern times, the age that precedes the discovery of the Americas. In medieval and late medieval times civilizations were formed in large part through cultural interactions between Asia and Europe, and to some extent with several parts of Africa, the history of which begs further research and scholarship. However, the axis Asia-Europe, namely the old thesis that claims that ancient and medieval interactions kept going between East and West, again sheds new light on the intermediating areas of the Near East and Central Asia. These areas appear as the zones of activity for the East-West dialogues, and one could detect in them a plethora of migrating ideas and motifs. Islam, which occupied these zones of contact from very early in the seventh century AD, becomes visible and emerges as an important field of research for any art historian. Islamic art acquires then a central position in the global history of art in the pre-modern age and enters the story of art. But – and here lies the 'mistake' previously alluded to – it is no more the extra, adjunct field – the enrichment course – of art history. Moreover, one cannot merely 'cast a glance' eastwards. [...]

The newly discovered phenomenon of Islamic art as *the* crucial sphere for writing global history actually engenders a further 'mistake.' As a matter of fact, this tendency is the cryptic Orientalist approach, because it still looks at the Muslim Near East and Central Asia as the sole ambassadors of global art. Similar to Orientalist artists and travelers of the nineteenth century that wished to find in the Orient the particular space that would provide them with the missing impulse for new ideas and fantasies and rescue them from the decadence of the West, here the art historians are again searching to revitalize their field of research by looking at these Muslim geographies. The Renaissance is reframed. European masterpieces, like the works of Pisanello, the Bellinis, Dürer, and Titian, just to name a few, are revisited, and the depicted Islamic designs, motifs, and artifacts are now being addressed. The Globalists, or perhaps better yet Neo-Orientalists, of art history concentrate in their comparative studies on the known Orient, the Orient that lies next to the European border,

mainly North Africa and the Levant, and which became familiar to us today through the expeditions of artists like Delacroix and Gérôme and writers like Nerval and Flaubert.

Another current outcome of the Neo-Orientalist approach, with their strong focus on the visual world of Islam, involves the excessive interest in the Mediterranean Basin as a cultural phenomenon and as a paradigmatic model for global art. It is true that the Mediterranean Sea delimits a specific zone capable of binding together different religions and cultures and, at a given moment, impelled a new *ultra maris* aesthetic dubbed the medieval international Mediterranean style. Part of the Mediterranean success is undoubtedly deeply rooted in the idea of collective time shared by the citizens of the whole Mediterranean zone. [...] The inhabitants of the Mediterranean region, regardless of religious identity, all share the same monotheistic sense of time. This time was based on the Biblical knowledge of man. It has its genesis in the story of the Creation of Adam and Eve, and ends in the eschatological conviction of Heaven and Hell and even, to some extent, in the idea of Resurrection. This systematization of time creates a similar framed structure of time for understanding each other.

But the Mediterranean Sea is not the only active cross-cultural space. There are many other seas that tell similar stories. Moreover, as far as global history is concerned, the Mediterranean Sea is not located in the center of all terrae, as its name alludes. The 'shifting' of its location, or rather importance, into the very center of European cultural geography is a historical product of the nineteenth-century desire to write history with a clear Eurocentric agenda, in which this sea takes the role of the connecting and mediating factor between the rise and fall of cultures, all of which narrate the story of European civilisation. No less revealing is the history of the Indian Ocean, mediating between the Swahili and Gujarati coasts and binding, economically and culturally, East Africa and Western India. Or the Arabian and Red Seas in the classical medieval age with their specific seaports like Basra, Siraf, Aden and Ayla (Eilat/Aqaba), which were the maritime playgrounds for transferring merchandise to the Near East and the Mediterranean from places as far as China, Central Asia, and Africa. And, again, by comparing these other 'Mediterranean' spheres to the Mediterranean Basin, I do not mean to transfer the same model of thinking about and interpretations applied to the study of Mediterranean cultures, such as that of Fernand Braudel, who proclaimed the unity of cultural and geographical spheres by the movements of people across water. But breaking the homogeneity or unity of these spaces and trying to define diversities and distinctions between maritime and land cultures might be very useful, especially for drawing

up a more complex picture and defining varied appearances of 'glocals' within the study of global art history. It should be emphasized that the term 'glocal' as used here does not limit complexity, as between the classification of Global and Local there is wide spectrum of cultural spheres. Thus, the glocal should be further differentiated.

The next point that I would like to discuss involves the view or belief that global art history stands for world art history [...]. This false belief must be explained. Art historians and museum curators today are proud to present the specific curricula of their departments or the wide range of their museums' collections as global. It is true that the first step toward creating an educational program for global art should involve the hiring of experts in the art histories of the varied cultures of the globe. This need is understandable. Only through filling new positions in the field of what one calls 'non-European art' [...] can one hope to have a complete, global extension. Museums that proclaim their global character should convince the audience that their collections aim at covering as much of as many different visual cultures as possible, temporally and geographically speaking. And yet, global art cannot be reduced and simplified to an encyclopedic system. The overall coverage of art productions of the universe, or one should rather say polyverse, does not make the collection global. The same should be said about art history departments. The inclusion of experts of Islamic, Chinese, Japanese, African, and Latin American art does not assure that the students will be educated as global art historians. The accumulation of knowledge is only the first step of the scholarly process. It is rather its organization and presentation that is the crucial point, because here the systematization of knowledge is addressed and hierarchies assigned. The bestselling book by Neil MacGregor illustrates this delicate problem.[5] It is true that the one hundred objects, as MacGregor says, were carefully chosen and researched in order to tell a universal story of art. Their extensive coverage of areas and eras ensure that the book is as comprehensive as possible. But the main point, as MacGregor also emphasizes, is that each of these objects will be able to tell only the global history that contributed to its production. This point, which could be termed as the global connectivity component, lies at the core of the idea of global art and global art history. There is no reason to offer students courses in Islamic art if this field is not taught in a manner that binds and connects this aesthetic phenomenon with the arts of other cultures, such as, for example, China and the Latin West. If the story of Islamic or Chinese art is taught as a closed

5 Neil MacGregor, *A History of the World in 100 Objects*, London/New York, 2010.

art-historical narrative and the focus of investigation is on creating autonomous and independent identities that produce self-supporting works of art, then [...] only 'brief glances', to use Gombrich's phrase, will be directed westward. Moreover, this rather accumulative tendency of global art today recalls the nature and spirit of the Kunstkammern and Wunderkammern [universalising collections] of the late Renaissance and Baroque. Thus, the universal art-historical curriculum will be no more than a Sammelsurium. In fact, in several papers delivered at conferences and workshops I have recently attended, a specific encyclopedic trend can be detected. Scholars aiming at writing global art history find comparative iconographies an attractive method. Lectures on the long history of the image of the dragon in West and East or the image of Madonna and Child or that of Alexander the Great in a global context present manifold similar images collected from all over the world, without any chronological system or order that could point to or, at least, suggest connectivity. This methodology can be termed as the encyclopedic album of images. Of course, one is reminded of Aby Warburg's *Mnemosyne Atlas*. But it should be emphasized that in comparison to the aforementioned papers on the global aspects of images, Warburg's Atlas was a tool and not regarded as the final aim or goal of research.

The principal effort should be in defining new cross sections and linkages between aesthetic notions and motifs in different spaces rather than accumulating similar motifs. The artistic network should be revealed and, like routes of trade, be explored in order to shed new light on the linkages in the history of art. One also speaks of parallel narratives and corresponding artistic innovations, or, more importantly, on looking at artworks from different times and spaces from the same 'eye level' [...].[6] These tendencies will force us, art historians, to rethink the writing of art history and to look for other aspects and themes through which specific eras in the history of the world could be presented and discussed. Similarly, curators will be asked to reorganize their permanent collections in the future and exhibit artifacts in a different order of things.

The reassessment and reconsideration of the Eurocentric vision of the world that art history [is] occupied with should prepare art historians to change views and methods of examination. It is true that many art historians and museum directors follow the steps of Dipesh Chakrabarty in his famous book *Provincializing Europe*. Furthermore, it seems that this notion of changing one's point of view, and the wish to look at the story of art from other angles, impels new ideas and novel interpretations

6 I mainly refer to [Hans Belting, *Florence and Baghdad: Renaissance Art and Arab Science*, Cambridge, MA: Harvard University Press, 2011]. [...]

for art historians' narrative traditions. Books such as *Mighty Opposites* by Zhang Longxi and *Global History: A View from the South* by Samir Amin illustrate this positive notion and present historians and art historians with new modes of thinking. But the counter-research theme of Occidentalism, which aims at creating a balanced and critical voice for East–West histories and directly addresses the issue of Orientalism, is no less important. It should be noted, however, that Occidentalism, if not critically addressed, could also be regarded as another Eurocentric approach. The obsessive interest of art historians in the image of Europe in non-European spheres could again lead us to a strong Eurocentric and self-interested art history. Another danger awaiting an insufficiently critical or careful study of global art stems from the circumstance that some art historians who have joined this discourse and teach global art studies still apply Western paradigms and criteria for evaluating global art. This is a crucial error. For example, terms such as iconoclasm and *Bilderverbot* are still employed by art historians when discussing Islamic art. This tendency derives from the Western canon of art of the rendering of nature and mimesis, a canon that dictates the evolution of art in the West. One should be careful in applying it to the arts of Asia, in which parameters other than mimesis were used for defining high art.[7] The same could apply to art historians' discussions of the relationship between 'Word' and 'Image' in art. When applying this Western model of examination, the ancient Orient just might be profoundly mistreated, as it developed another approach for understanding and reading word-and-image compositions.

The last point is not critical but rather seeks to open a door for further possibilities for understanding and working within the frame of global art today. It focuses on the idea of contact zones and spaces of interaction. As mentioned above, these sites play a major role in the new global approach. They are bound to specific geographical regions, like the Silk Road, public urban spaces, or specific architectural buildings that serve these cultural interactive occurrences. But the digital revolution creates another, virtual, yet no less important space. Facebook and Twitter shape another space of communication that has tremendous impact on the transmission of knowledge and accelerates the transfer and migration of ideas and ideology. It is true that real space – be it Tahrir Square in Cairo or the public spaces in Sidi Bouzid, Tunisia where the Jasmine Revolution

7 On this and other parameters of Western art and their use for writing the history of Islamic art, [see Avinoam Shalem, 'What Do We Mean When We Say 'Islamic Art'? A Plea for a Critical Rewriting of the History of the Arts of Islam', *Journal of Art Historiography*, vol. 6, 2012, pp. 1–18].

started – is stamped in our collective memory as the space in which the impact of cultural globalization and global politics become visible. But the virtual space that exists through digital media and the computerization of our world is no less important than the gathering of thousands of people in these places. We face then the process of the immaterialization of the real and tangible spaces. The virtual spaces are additional connective spaces of important cognitive merit. They create another form of network that runs and intersects with the old veins, through which art became a global phenomenon – a complexity.

In sum, this article has assumed a provocative perspective in discussing the ramifications of the global turn in the context of art history and especially as related to the field of Islamic art history. As a historian of art who has been occupied for the last twenty odd years in the study of art production in the *worlds of Islam,* I have confronted, every now and then, the specific conjunctures in time in which the history of Islamic art met with other histories of art. I was astonished to discover, time and again, a repeating pattern within the response of art historians when explaining these moments in history. The global turn we witness in the last ten or so years has formed and shaped politics, social structures, and art practices, it has also affected the academic sphere. It forces us, art historians, *nolens volens,* to revise our interpretive models and modify our structures of thinking while discussing major turning points in the great narrative of 'European' or rather Eurocentric, art history; crucial moments such as: the birth of the concept, and I emphasize the word 'concept', of medieval time; the Renaissance; the Age of Enlightenment; and even modernity. In the present era, at the end of the first decade of the twenty-first century, in a period that I would like to label as 'Changing Times', politicians, intellectuals, and the general populace are all well aware of the need to include within the history of the West the immediate 'Other', namely the world of Islam. Of course this notion is part of globalization, a new model of connectivity that aims in the first place to create a larger, world-wide network for capitalism, namely free trade, investment, and marketing. The birth of this global notion has come in the wake of the collapse of the Soviet Union, culminating in the fall of the Berlin Wall in 1989, and the departure from ideology of the Communist social utopia. But the global turn was no less inflicted by another eclipse: the attack on the World Trade Center in New York on September 11 – a traumatic experience that the Western world is still trying to 'digest' and recover from. It is therefore a complex and intricate affair, and art historians should be aware of all the subtleties of this global concern. While my intention to address this issue by pointing towards several 'dangerous errors', or I should rather say 'failures of notice', might be considered

too harsh or aggressive, I should again stress that I have chosen provocation as a method of encouraging, I hope, critical thinking. [...]

2.8 Luca Molà and Marta Ajmar-Wollheim, 'The Global Renaissance: Cross-Cultural Objects in the Early Modern Period', in Glenn Adamson, Giorgio Riello and Sarah Teasley (eds), *Global Design History* (London: Routledge, 2011), pp. 11–20

This essay brings together two researchers interested in art, material culture, economic history and trade who are both focused on the movement of objects and technologies around the globe in the Renaissance. They argue that designs, techniques and raw materials (silk cloth, for example, or fabric dyes) imported from Africa, Asia and America greatly enriched the production of commodities and artworks in Europe. Global connections brought foreign objects westward, which in turn stimulated the creation within Europe of 'cross-cultural' goods meant to appeal to both local and foreign consumers. The authors consider glass, ceramics and Oriental carpets, as well as a ewer (pitcher) made in Northern Europe and sent to Syria or Egypt to be ornamented ('damascened') with silver and lacquer inlay. Their aims are to open up the overlooked, yet vital role of global trade in this era and to underscore the fact that designs, techniques and materials were widely shared by different cultures around the world. [Kathleen Christian]

In his advice book aimed at the gentleman, first published in 1546, the Italian friar and scholar Sabba da Castiglione outlines the ornaments suitable for the interior:

Others furnish and adorn their rooms with tapestries and textiles from Flanders with figures, foliage and greenery; some with Turkish and Syrian carpets and bed covers; ... some with ingeniously wrought leather hangings from Spain; and others with new, fantastic and bizarre, but ingenious things from the Levant or Germany ... And all these ornaments I recommend and praise, because they sharpen one's intellect, politeness, civility and courtesy.[1]

The international range of the furnishings listed is dazzling, and at odds with a notion of the Italian Renaissance object-scape as the quintessential expression of a predominant and self-contained culture. If we compare

1 Sabba da Castiglione (1561) *Ricordi ovvero ammaestramenti*, 1561, f. 118v.

Sabba's description with contemporary inventories and account books, we can see that his is not just an aspirational list compiled in the tradition of humanistic rhetoric, but an accurate reflection of current practice. As this text also makes clear, the display of foreign goods is not a purely aesthetic exercise, but an activity at the core of early modern self-fashioning strategies. What does 'the Renaissance' have to do with this globalized view of material culture and, in turn, what does material globalization have to do with current conceptualizations of 'the Renaissance'?[2]

The 'Global Renaissance' is an ongoing research project aimed at exploring for the first time through objects, pictures and texts the impact that the European Renaissance had on the rest of the world and, in turn, how this period, generally presented as a quintessentially Western phenomenon, was in fact widely informed by cultures from around the globe. Spanning the centuries between 1300 and 1700, the project aims at setting European material culture against the global background of intensifying cultural and economic connections. It also questions traditional views of this period, dominated by narratives of the emergence of European nation states and a growing divide between 'the West' and the rest of the world.[3] Instead, by looking at the relationship between Europe, the Islamic world, sub-Saharan Africa, India, China, Japan and America, it transcends narrow geographical boundaries and explores through material, visual and written culture how Renaissance Europe informed and responded to the rest of the world. Tapping into a growing interest by scholars in global connections, the project intends to offer a fresh perspective on the Renaissance.

The notion of a 'Global Renaissance' is seemingly a paradox, although it is intriguing to observe, with a Jakob Burckhardt's hat on, how many civilizations around the world – from the Ottomans to the Mughals, from the Italians to the Ming – experienced some kind of 'efflorences' between the fourteenth and the seventeenth centuries.[4] It is not, however, the

2 On the current debate on the concept of the Renaissance see Luca Molà (2008) 'Rinascimento', in Marcello Fantoni and Amedeo Quondam (eds) (2008) *Le parole che noi usiamo. Categorie storiografiche e interpretative dell'Europa moderna*, Rome: Bulzoni, pp. 11–31.

3 For a reassessment of this view see Kenneth Pomeranz (2001) *The Great Divergence: Europe, China and the Making of the Modern World Economy*, Princeton: Princeton University Press; and Kenneth Pomeranz and Steven Topik (1999) *The World that Trade Created: Culture, Society, and the World Economy, 1400–The Present*, Armonk, NY and London: M.E. Sharpe.

4 For the concept of 'efflorences' see Jack Goldstone (2002) 'Efflorences and Economic Growth in World History: Rethinking the "Rise of the West" and the Industrial Revolution', *Journal of World History*, 13, pp. 323–389. For the Renaissance seen in a global context see Jack Goody (2010) *Renaissances: The One or the Many?*, Cambridge: Cambridge University Press.

conventional meaning of 'Renaissance' as essentially a 'movement' limited to the sphere of high culture that we intend to explore.[5] In this limited perspective, it would be undoubtedly absurd to suggest that the whole world experienced a process of cultural 'rebirth' closely comparable to that of Europe. Our approach, by contrast, aims to consider the implications that the revival of antiquity and the diffusion of humanism – with its positive appreciation for the classical notions of 'magnificence' and 'splendour' – had for the emergence of new models of consumption, at first among Italian elites and then throughout the continent, creating a distinctive Renaissance material culture that in various degrees informed all aspects of European societies.[6] If we, therefore, understand the Renaissance as primarily an all-embracing phenomenon based on a distinctive and innovative way of using objects as social and cultural signifiers with an inner civilizing dynamic, then the process of global exchange and the complex system of interconnections that developed during the fourteenth to seventeenth centuries would have enabled some aspects of the Renaissance, particularly those embedded within material culture, to have a genuinely global reach. It is thus not so far-fetched to assert that the cultural and material vitality of the Renaissance was not a 'local', if pan-European, phenomenon, but instead the result of a network of impulses that went far beyond Europe or even the Middle East, encompassing China and the New World. Moreover, this approach will allow us to detect the development of an ecumenical visual and material language on a global scale, and the emergence of an international community of taste.[7]

The growing integration of global markets in the early modern period opened up new possibilities and provided a fundamental stimulus for the production in Europe of goods that were meant to cross cultural divides. Among the industrial artefacts with a global dimension, glass is

5 See Peter Burke (2007) 'Decentring the Renaissance: The Challenge of Postmodernism', in Stephen J. Milner (ed.) *At the Margins: Minority Groups in Premodern Italy*, Minneapolis and London: University of Minnesota Press, pp. 36–49.

6 Richard A. Goldthwaite (1987) 'The Empire of Things: Consumer Demand in Renaissance Italy', in Francis W. Kent and Patricia Simons (eds) *Patronage, Art, and Society in Renaissance Italy*, Oxford: Clarendon Press, pp. 153–175; Richard A. Goldthwaite (1993) *Wealth and the Demand for Art in Italy 1300–1600*, Baltimore and London: Johns Hopkins University Press; Evelyn Welch (2002) 'Public Magnificence and Private Display: Pontano's *De splendore* and the Domestic Arts', *Journal of Design History*, 15, pp. 211–227.

7 Robert Finlay (1998) 'The Pilgrim Art: The Culture of Porcelain in World History', *Journal of World History*, 9, pp. 141–187; Rosamond E. Mack (2000) *Bazaar to Piazza. Islamic Trade and Italian Art, 1300–1600*, Berkeley, Los Angeles and London: University of California Press.

certainly one of the most interesting and less studied. The skilled glass-makers of Murano were able to devise and produce a variety of different objects aimed at the growing Renaissance global market.[8] If the full-size enamelled and bejewelled set of armour for parade made entirely of crystal glass and complete with a glass scimitar and saddle – based on an original metal armour brought from Syria – that Venetian merchants planned to commission from a famous workshop in Murano in 1512 remains a unique piece of inventiveness,[9] the production and exportation of vases and mosque lamps with Islamic inscriptions for the markets of Cairo, Damascus and Istanbul was a common occurrence. Pilgrims going to the Holy Land on board Venetian galleys mention them already in the late fifteenth century, and drawings with precise specifications and measures were sent to Murano by Venetian diplomats residing in the Ottoman Empire during the late sixteenth century.[10]

[...]

Silk fabrics, too, were one of the most important global commodities during the Renaissance, being highly appreciated and frequently craved by the elites and 'middling sorts' in all continents. A piece of brocaded silk velvet with a crimson colour produced in Venice around the middle of the sixteenth century provides us with one of the best examples of a 'virtual' Renaissance global object, which could have been made – and probably was made – by processing and assembling together raw and semi-finished materials coming from all the known corners of the world. Indeed, for heavy fabrics such as brocades, Venetians commonly employed silk threads originating in different parts of Asia, where local reelers – usually women – joined together smaller or greater numbers of cocoons' filaments in order to obtain a thread with variable degrees of thickness. Caravans loaded with thick silk produced in the regions around the Caspian Sea arrived from Persia to the eastern Mediterranean shores, where they were joined by hundreds of parcels of thinner Syrian threads and then carried on board ships to Venice. Here the two different types of silks were mixed together to form the warp and weft of luxury textiles such as our brocaded velvet. The pigments employed for dyeing these silks in crimson – the most valuable and noble of all colours – had also

8 On the import of Venetian glass in China see Emily Byrne Curtis (2009) *Glass Exchange Between Europe and China, 1550–1800: Diplomatic, Mercantile and Technological Interactions*, Aldershot: Ashgate.

9 G. Dalla Santa (1916–1917) 'Commerci, vita privata e notizie politiche dei giorni della lega di Cambrai (da lettere del mercante veneziano Martino Merlini)', *Atti del Reale Istituto Veneto di Scienze, Lettere ed Arti*, 76, pp. 1566–1568.

10 Deborah Howard (2000) *Venice & The East: The Impact of the Islamic World on Venetian Architecture 1100–1500*, New Haven and London: Yale University Press.

for a long time been supplied by the Asian continent. In the early 1540s, however, a new red dye arrived for the first time in Venice from the New World and quickly conquered the greatest share of the market. This was Mexican cochineal, a material obtained from the parasites of a particular species of cactus that was produced in New Spain by native peasants under the control of Spanish colonial landowners, and then massively exported across the Atlantic to Europe with the annual Royal Fleet. Cochineal had the same chemical composition of traditional kermes but had a much higher colouring power and fastness, all qualities that made this dye immediately popular among silk cloth producers.[11] The Asian silks dyed with American pigments, and treated with Turkish or Italian alum as mordent, were then enriched for the weaving of brocades with metal thread made with strips of beaten gold, which by the middle of the sixteenth century was still reaching Venice from the mines of sub-Saharan Africa thanks to the intermediation of Muslim and Portuguese merchants.[12] Finally, all these global materials were processed and then woven by Venetian artisans into a brocade with a typical Renaissance design (in its turn mutated and modified through the centuries from original Oriental and Middle Eastern flower patterns), using Italian know-how in combination with techniques that had originated in different parts of the world – velvet making, for instance, seems to have arrived in Italy in the early fourteenth century from China via Persia,[13] while the application of cochineal to silk was first discovered by a Spanish immigrant to Mexico in 1537.[14] The global trading connections that had acted as a centripetal force for the concentration in Venice of all these goods were afterwards converted into a centrifugal motion that disseminated Venetian silk fabrics for the consumption of elite customers across the globe.

The complex unfolding of this process of visual, material and technological globalization can be explored in greater detail by looking at

11 Luca Molà (2000) *The Silk Industry of Renaissance Venice*, Baltimore and London: Johns Hopkins University Press, pp. 55–137.
12 Ugo Tucci (1981) 'Le emissioni monetarie di Venezia e i movimenti internazionali dell'oro', in Ugo Tucci, *Mercanti, navi, monete nel Cinquecento veneziano*, Bologna: Il Mulino, pp. 275–316; Philip D. Curtin (1983) 'Africa and the Wider Monetary World', in John F. Richards (ed.) *Precious Metals in the Later Medieval and Early Modern Worlds*, Durham, NC: Carolina Academic Press, pp. 231–268.
13 Sophie Desrosiers (2000) 'Sur l'origine d'un tissu qui a participé à la fortune de Venise: le velours de soie', in Luca Molà, Reinhold C. Mueller, and Claudio Zanier (eds), *La seta in Italia dal Medioevo al Seicento. Dal baco al drappo*, Venice: Marsilio, pp. 35–61.
14 Woodrow Borah (1943) *Silk Raising in Colonial Mexico*, Berkeley and Los Angeles: University of California Press, p. 10.

three types of non-European commodities that participated in different ways to the creation within Europe of a shared object-scape: carpets, metalwork and ceramics. What happened to the look and meaning of these objects as they moved across cultures?

Carpets provide a useful starting point in assessing the impact of global objects on Renaissance Europe. Generally purchased on the markets of Syria, Egypt or the Ottoman Empire, from the early fifteenth century carpets became a popular furnishing within wealthy Italian domestic interiors, where they were used to cover all kinds of surfaces, from tables to chests, from writing desks to day-beds (*lettucci*).[15] However, in spite of their pervasiveness, they provide an intriguing example of resistance to naturalization, in terms of both manufacture and consumption. It is clear that although the European demand increased considerably during the course of the Renaissance, generally speaking carpets did not change significantly in design, shape, technique or other aspects of manufacture to fit Western requirements better. There is a sense, for example, that the range of different designs available was quite limited, prompting some Italian customers to specify exactly what type of carpets they did not want to purchase.[16] Other methods of customization dear to the Italian market, such as the application of armorial devices, provide another indication of how reluctantly the carpets industry engaged with European demands. A letter from the Florentine consul in Constantinople, Carlo Baroncelli, to Lorenzo the Magnificent in Florence in 1473 apologizes for the fact that the Turkish carpet that he is sending lacks the Medici arms because the manufacturing process of an armorial carpet is punishingly slow.[17] A marked resistance to customization is also visible in the shapes available, which only rarely were intended specifically for Western furniture, as with table carpets made in Turkey or Egypt, with the cruciform design conceived especially to fit the high-legged tables of Western Europe (see Figure 2.3).

The location and uses of carpets within European households seemingly confirm this picture of physical and semantic displacement. Not only

15 Donald King and David Sylvester (eds) (1983) *The Eastern Carpet in the Western World*, London: Arts Council of Great Britain; Serare Yetkin (1981) *Historical Turkish Carpets*, Istanbul: Türkiye iş Bankası Cultural Publications; Jennifer Mary Wearden (2003) *Oriental Carpets and their Structure: Highlights from the V&A Collection*, London: V&A Publications; J. Mills (1983) 'The Coming of the Carpet to the West', in King and Sylvester (eds) *Eastern Carpet*, pp. 10–23; Giovanni Curatola (1983) *Oriental Carpets*, London: Souvenir; Marco Spallanzani (2007) *Oriental Rugs in Renaissance Florence*, Florence: SPES.

16 Marco Spallanzani (2007) *Oriental Rugs in Renaissance Florence*, Florence: SPES, pp. 104–105, doc. 78.

17 Ibid., p. 105, doc. 80.

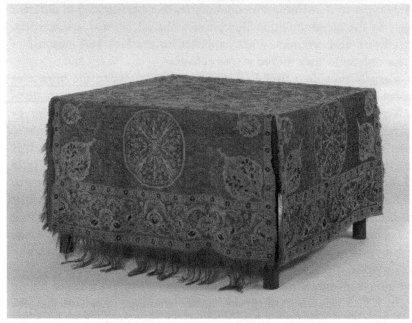

2.3 Table carpet, Egypt, mid-sixteenth century

did the carpets' original placement on the floor not find much currency in Europe, where their status and value would demand a more prestigious location, but their meaning as objects closely associated with prayer was largely lost within secular Western environments. [...] On the whole, although carpets enjoyed a remarkable popularity during the Renaissance, the geographical and cultural disconnection between production and consumption meant that as a commodity they remained an object of unilateral exchange situated at the periphery of European Renaissance material culture, generating neither indigenous imitations nor other material responses.

The process of interconnection becomes more dynamic with another type of global commodity that was highly appreciated by European consumers in the fifteenth century: Islamic damascened metalwork. Produced in Syria or Egypt in significant quantities by Islamic craftsmen, it included a wide variety of fine household objects ranging from inkstands to boxes, from fruit bowls to candlesticks. The network of production responsible for the manufacture of these objects is remarkably cross-cultural. The itinerary that we know was performed by the Molino ewer (see Figure 2.4) – an object owing its name to the Venetian family whose arms are inscribed on the lid – suggests an extraordinarily multilayered

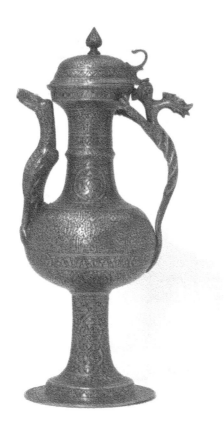

2.4 Ewer, possibly Flanders or Germany and possibly decorated in
Egypt or Syria, 1450–1500

biography.[18] If we look at the first stages of manufacture, the ewer would
qualify as a Northern European object. Made in Germany or Flanders
between 1450 and 1500, it was originally a serially-produced plain brass
ewer bearing a characteristically late-gothic elongated shape and zoo-
morphic handle. If we look at its decoration it would qualify as Islamic,
as this object would have been shipped from Northern Europe over to
Syria or Egypt to be inlaid in silver by local Muslim craftsmen with

18 Anna Contadini (1999) 'Artistic Contacts and Future Tasks', in Charles Burnett
and Anna Contadini (eds) *Islam and the Italian Reinassance, Colloquia 5, The Warburg
Institute*, London: The Warburg Institute, University of London, pp. 1–65; Anna
Contadini (2006) 'Middle-Eastern Objects', in Marta Ajmar-Wollheim and Flora
Dennis (eds) *At Home in Renaissance Italy*, London: V&A Publications, pp. 308–321.

elaborate geometric and vegetal Mamluk ornament. After this transformative decoration was applied, the piece was then sent to Italy, where it would have been customized through the application of the family's coat of arms. Therefore, when we take into account its customization and consumption, an Italian claim can be added to the chorus. We are thus looking at an object whose production and consumption is the direct result of an interconnected network of manufacture, trade and supply operating on a truly international scale. Its palimpsest-like identity is reflected in the naming of objects such as this within Renaissance written records. In his *Venetia città nobilissima* of 1581, Francesco Sansovino refers to them as 'bronzi lavorati all'azimina', which we can translate as 'bronzes wrought in an Arabic fashion'.[19] Within domestic inventories they are often listed as objects 'alla damaschina', hinting at their supposed provenance from Damascus. In the inventories of the Venetian community in Damascus, however, these objects acquire a more ethnic meaning, as they are often labelled as 'alla morescha', thus alluding to their Moorish origins.[20]

It is with ceramics, however, that the evidence for global matrixes at work in the early modern period is striking. Focusing on sixteenth-century Italian tin-glazed earthenware, generally known as maiolica, is enlightening. Maiolica is rightly perceived by scholarship as the quintessential Renaissance medium – in the conventional, 'humanistic' sense of the word – combining as it does a low intrinsic, monetary value with a high added value provided by its extraordinary variety and multiplicity of shapes, decorations and iconographic themes – what Richard Goldthwaite has termed 'the value of culture'.[21] Widely appreciated by the elites across Europe – from scholars to princes – because of its high intellectual cache, Italian maiolica embodied the Renaissance idea of the culturally charged artefact and was enthusiastically collected. Because of its unparalleled creative receptivity, maiolica can also be seen as an excellent indicator and agent of design transmission across the globe.

If we look at the European production, one of the first examples of global ceramics is sixteenth-century maiolica made in the Ligurian city of Genoa, then a newly established centre of ceramic production. Most

19 Francesco Sansovino (1581) *Venetia città nobilissima*, Venice, p. 142: 'Le credentiere d'argento, et gli altri fornimenti di porcellane, di peltri, et di rami, ò bronzi lavorati all'azimina, sono senza fine'.

20 Francesco Bianchi and Deborah Howard (2003) 'Life and Death in Damascus: The Material Culture of Venetians in the Syrian Capital in the Mid-Fifteenth Century', *Studi Veneziani*, 46, pp. 233–300.

21 Richard Goldthwaite (1989) 'The Economic and Social World of Italian Renaissance Maiolica', *Renaissance Quarterly*, 42, pp. 1–32.

contemporary Italian maiolica was largely inspired by classical motifs; complying with a Western notion of *disegno* and sometimes aspiring to naturalism. Genoese maiolica was distinctive for its rejection of all of these visual conventions. Instead, relying almost exclusively on white-and-blue decoration, it imitated its contemporary Asian counterparts, either Turkish Iznikware or Ming porcelain.[22] Indeed, in a seminal article on the culture of porcelain in world history, Robert Finlay charts the emergence in the sixteenth century of 'global patterns of trade which fostered the recycling of cultural fantasies, the creation of hybrid wares, and the emergence of a common visual language'.[23] Finlay's analysis generates, as he admits, 'a certain vertigo' as he traces the global connections at the root of the success of ceramics worldwide.

Being much cheaper than its Chinese counterpart, in the course of the sixteenth century Genoese maiolica flooded the markets worldwide. Distributed via Antwerp to Northern Europe, by 1550 it had also become prominent among glazed earthenware exported via Spain to the American market. Its appearance and popularity were coincident with the peaking of Genoese influence in Spain, a time when the bankers of Genoa repeatedly rescued the financially troubled Spanish monarchy and when Ligurians infiltrated all social levels of the Iberian peninsula. Archaeological excavations in Mexico have confirmed the popularity of Genoese pottery in the New World, where potsherds have been found in considerable quantities, and which are most often associated with late sixteenth-century Ming porcelains, coming into Mexico on annual galleons from Manila.[...]

There is no pretence, obviously, that our investigation into the material aspects of this 'Global Renaissance' will substitute the current notions of that period held by cultural and art historians. But unlike other scholars, who consider the production, exchange and consumption of the objects we have been talking about as inhabiting 'the margins of the Renaissance' (coherently with a view of the phenomenon as a restricted and elitist 'movement' animated by a small group of humanists interested mainly in the Greek and Roman classics),[24] we believe that a full understanding

22 Federico Marzinot (1979) *Ceramica e ceramisti di Liguria*, Genova: Sagep; Federico Marzinot (ed.) (1989) *La ceramica*, Genova; Carlo Varaldo (1994) 'Maiolica ligure: contributo della ricerca archeologica alla conoscenza delle tipologie decorative del vasellame', *Albisola*, 27, pp. 171–193.
23 Finlay, 'The Pilgrim Art', p. 146; John Carswell (1985) *Blue and White: Chinese Porcelain and its Impact on the Western World*, Exhibition Catalogue, Chicago: David and Alfred Smart Gallery and University of Chicago.
24 Peter Burke (2005) 'Renaissance Europe and the World', in Jonathan Woolfson (ed.) *Palgrave Advances in Renaissance Historiography*, Houndmills and New York: Palgrave Macmillan, pp. 52–70.

of the European Renaissance cannot be achieved without taking into consideration the complex processes of exchange, cross-fertilization and hybridization with other civilizations across the world. It is, therefore, the beginning of a progressively more globally integrated material culture that we want to explore, in the conviction that this process began much earlier than is generally thought, and that it was crucial in informing, and in many ways defining, what we today understand as 'the Renaissance'.

Since our research is just at the beginning, much still remains to be done. We would need to assess, for instance, the role of different cross-cultural agents – such as trading minorities or diplomats – in disseminating design patterns and suggesting new consumption habits; the ways in which technologies of production were acquired, adapted and transformed, and what were the implications and impacts for different material cultures locally; the shifting meanings and uses of objects according to the changing cultural and social milieux in which they moved; and also the conflicts and resistance that such movements created. These are no small tasks, such that only a globally-disseminated team of scholars with a multicultural range of specializations can dream of accomplishing them. But this is the challenge of modern scholarship: global questions require global enterprises.

2.9 Jack Goody, 'The Idea of the Renaissance' in *Renaissances: The One or the Many?* (Cambridge: Cambridge University Press, 2010), pp. 7–42

This text is extracted from a book by anthropologist Jack Goody which poses the question of whether non-European cultures had 'Renaissances'. He argues that in many different societies which preserve their knowledge in written form, cultural efflorescences occur when these societies look to the past. Certain conditions tend to produce these periods of advancement, such as when backward-looking occurs during times of peace, secularisation and prosperity. The European Renaissance was one such instance, amongst others. At the end of the book Goody concludes however that the European Renaissance was uniquely strong, since it occurred after a uniquely formidable break with the past – other cultures had not lost their past knowledge or been limited by religion to the same degree – and because the pagan texts of Europe's antiquity were so invigorating, given their stark difference from Christian religious texts. Through its Renaissance, Europe

was able to catch up with parts of the world which were in many aspects more advanced.

In the chapter extracted below he argues that 'Abrahamistic' religious texts (of Judaism, Christianity and Islam) had a chilling effect on individual creativity and the figural arts in Europe. Yet looking back to classical knowledge in the Renaissance brought renewal, which was particularly vivid in the arts and music, since input from Arab sources had limited the same degree of loss in other fields (for example, medicine). Goody also assesses how contact with the wider world helped to stimulate the Renaissance in Europe, and open new horizons.

Goody's goal is to detract from the Eurocentric idea that the European Renaissance was the only phenomenon of its type by considering the 'Renaissance' as a sociological pattern that can occur elsewhere. Critics of his book have, however, questioned both his conception of the medieval era in Europe as a dark age when classical knowledge was fully lost, and his application of a European historiographic model to the analysis of non-European cultures. [Kathleen Christian]

The idea of a renaissance

Beginning with the 'first lights' (*primi lumi*) of the fourteenth century, the Italian Renaissance has often been seen as the critical moment in the development of 'modernity', in terms not only both of the arts and of the sciences, but from the point of view of economic development also of the advent of capitalism. That this was certainly an important moment in history, even world history, there can be no doubt. But how unique was it in a general way? There is a specific historical problem as well as a general sociological one. All societies in stasis require some kind of rebirth to get them moving again, and that may involve a looking back to a previous era (Antiquity in the European case) or it may involve another type of efflorescence.

My own polemical background is this. I do not view the Italian Renaissance as the key to modernity and to capitalism. This seems to me a claim that has been made by teleologically inclined Europeans. In my opinion its origins were to be found more widely, not only in Arabic knowledge but in influential borrowings from India and China. What we speak of as capitalism had its roots in a wider Eurasian literate culture that had developed rapidly since the Bronze Age, exchanging goods, exchanging information. The fact of literacy was important because it permitted the growth of knowledge as well as of the economies that would exchange their products. As distinct from purely oral communication,

literacy made language visible; it made language into a material object, which could pass between cultures and which existed over time in the same form. Consequently, all written cultures could at times look back and revive past knowledge, as was the case with the humanists in Europe, and possibly lead onto cultural efflorescence, that is, to a definite burst forward.

[...]

This gradual awakening followed a Dark Age, an idea that has been challenged but, in my opinion, ineffectively so. For if there had been a rebirth there must also have been a death, in this case the death of the classical civilization which is today held to be so central to European culture. That death occurred with the fall of the Roman empire, partly causing a decline in the European urban economy and the cultural life that took place there. But cultural life also suffered from the spread of the Abrahamistic religions that not only forbade forms of representation such as theatre and the visual arts (except later in Catholic Christianity for religious purposes) but to some extent music and dance as well as other forms of play including cards, encouraging puritanical activity more generally, around sex for example. For Augustine (354–430 CE), man was born in sin and needed a prince to guide him. Moreover, his religion also inhibited scientific enquiry into the natural world by insisting that God was already omniscient, knowing all. In all these spheres Christianity required its own literature, not that of the pagans of Rome and Greece. Reading this was not intended to widen the mind so much as to confirm beliefs.

[...]

The role of the monotheistic religions in holding back knowledge is interesting, for they are often assumed to represent the vanguard of civilization, mainly because they come from Europe and the Near East. We need to be reminded, as classicist Vernant[1] has indeed done, that there is no universal rule whereby religions progress or evolve from the polytheistic to the monotheistic. The very 'rational' Greeks were polytheistic; so too the Chinese; some would even claim that Catholics have become so. For the differences are in some aspects not all that great. Generally, polytheistic religions too have the notion of a creator god, a supreme being, so that the possibility of monotheism is buried in polytheistic beliefs, as the history of Egyptian religion makes clear.[2] Far from being the most 'rational' form of religion, the monotheistic ones were in practice

1 J-P. Vernant, *Religions, histoires, raisons* (Paris: La Découverte, 2006 [1979]).
2 J. Assman, *The Search for God in Ancient Egypt*, trans. D. Lorton (Ithaca, NY: Cornell University Press, 2001 [1984]).

the most hegemonic, allowing less room not only for alternative versions of the 'truth' but also for independent enquiry and in the Abrahamistic ones, for the most part, for the development of the representational arts.
[...]
As mentioned, in the post-classical period the representative arts, like the sciences, also suffered. Naturalistic representation was restricted, especially figurative. The role of the Abrahamistic God as creator was a monopolistic one. Consequently many of the creative arts suffered. So looking back to the pagan period in European history meant a certain freeing of the mind. We have to draw a sharp line between the artistic accomplishments of the Renaissance and those in the sciences, in the widest sense. In the arts, you could go back to Roman and Greek architecture, sculpture, theatre, and start from there. But there had been a radical discontinuity, with only a small contribution from other cultures. The same with music, fiction, and, to a lesser extent, poetry. The 'puritanical complex' meant that these activities were abandoned. Neighbouring religious cultures were equally ambivalent. However, in the knowledge 'industries', some continuity has been maintained partly through the Arab connection, the contents of which fed back into the west at various points in time, though here too objections were raised to what did not have transcendental backing.

This freedom is not always how the progress of art has been portrayed. Berenson, the art critic, wrote, 'the thousand years that elapsed between the triumph of Christianity and the middle of the fourteenth century have been not inaptly compared to the first fifteen and sixteen years in the life of the individual'.[3] That statement presumes Europe grew continuously from the coming of Christianity, the moment of 'triumph'. But that religion meant the introduction of Semitic notions of iconophobia, and only later allowed, in the Roman Church or in the Byzantine icon, the development of art as long as it was confined to religious themes. In earlier classical Greece or Rome matters had been very different; a secular art was encouraged, for example at Pompeii where sex was a prominent topic in a way that was scarcely possible in Christendom at most periods, especially with a celibate priesthood and a puritanical ideology. Of course, as time went on, religious art increasingly included a secular background (as well as sex in the literature of Chaucer and Bocaccio); but it was virtually not until the Renaissance that completely secular painting was legitimated. That had partly to do with ideological shifts but was also a

3 B. Berenson, *Italian Painters of the Renaissance* (London: Phaidon Press, 1952), p. 4.

matter of patronage, which was increasingly neither of the church nor of the court but of the bourgeoisie, involving the rebirth of the city and of urban life. The result is clear in the attention now given to nature. Most '[p]ainters of the early Renaissance were aware of landscape elements in a way altogether unknown to painters of the Gothic past, when landscape was treated symbolically'.[4] Landscape had of course long formed an essential aspect of Chinese painting. But that came much later in Europe; it was Dürer who produced not only the self-portrait[5] but dwelt on the visual aspects of small creatures. And soon after, in the 1510s and 1520s, the artists of the Danube school, especially Albrecht Altdorfer and Wolf Hüber, 'started, for the first time in Europe, to treat figureless landscape studies on panel or paper as an independent speciality'.[6] The Renaissance broke with the past. 'While Christian themes and representations, with the Madonna and child always popular and ubiquitous, continued to dominate the interest of Renaissance painters, there was a proliferation of purely lay art and sometimes pagan subject matter.'[7] It was only possible for historians of art, like Berenson, to draw a continuous line in its development from earlier times because they saw the 'triumph' of Christianity as the beginning of things, continuing down to the Renaissance. In fact, continuity never existed and therefore the problem needs looking at again, in a comparative way.

In this context there was also the question of the status of the painter. During the Middle Ages, he was an artisan who carried out the instructions of his patron-employer to the best of his abilities; art did not require independent invention. An art market gradually emerged in the Renaissance, where each prince or republic wanted the best artist. And with the increasing laicization of the subject matter, more scope was given to imagination and innovation. That market reached its peak in the Low Countries, where the bourgeoisification of patronage was more pronounced; in Italy the process was always caught up with the aristocracy of the city, even in republics such as Florence or Venice. If demand was sufficient, the artisan could establish an atelier, a shop, where he would train and employ apprentices and would supervise their work. Then the painter was free to choose his subject, as in genre painting, without having as an artisan a prearranged position as a member of a *famiglia*. But much portrait painting still today implies a designated patron.

4 J. H. Beck, *Italian Renaissance Painting* (Cologne: Konemann, 1999), p. 10.
5 Other Italians had already done so.
6 J. Bell, *Mirror of the World: a New History of Art* (London: Thames & Hudson, 2007), p. 186.
7 Beck, *Italian Renaissance Painting*, p. 7.

Portrait painting was very much part of the view of the Renaissance as the progenitor of modernism, the notion that it represented the beginning of individualism. That quality is seen as characteristic of capitalism (via the entrepreneur) and is especially evident in painting, especially in the large-scale portraits (and sculptures) of particular individuals, particularly lay ones. This view was critical to the still influential work of the mid-nineteenth-century historian Jacob Burckhardt in *The Civilization of the Renaissance in Italy*,[8] where Florence is seen to have 'torn the veil that enveloped medieval minds with a tissue of faith and prejudices' and to have allowed man to be a spiritual individual. This was supposed to be one of the major themes of the Italian Renaissance: 'the development of the individual'.[9] And its particular manifestation is the growth of (realistic) portrait painting and of the autobiography. But leaving aside for the moment the growth of the autobiography, this scenario, so beloved by European historians of the Renaissance, is most unhistorical. Portraits existed in Antiquity; they existed in Buddhist and other paintings in China; there is nothing new (modern) in the Renaissance portrait except when it is viewed against the background of the restrictions of medieval Christian art which in some respects held to the iconoclastic tradition of Abrahamistic religions.

[...]

My own interest in the comparative study of the Renaissance clearly has a political dimension. Contemporary leaders continually refer to the contributions made to the modern world by Judaeo-Christian civiliza-tion. Islam is set aside although it belongs very firmly to the trilogy of major religions based upon some of the same sacred texts, going back to classical knowledge, and having many of the same values. But not only is Islam often excluded from the European account of the Renais-sance but so too are India and China, some of whose achievements reached Europe through an Islam that stretched from southern Spain to the Far East. And their achievements were very considerable. In the latter case, Joseph Needham has argued that until the sixteenth century, Chinese science was in many cases in advance of Europe. And in the economic sphere, anthropologist Francesca Bray has described the country as the major exporter of manufactured goods in the world before the nineteenth century and only then, according to the sinologist Kenneth

8 J. Burckhardt, *The Civilization of the Renaissance in Italy* (New York: Penguin, 1990 [1860]), p. 63.
9 E. Crouzet-Pavan, *Renaissances Italiennes 1380–1500* (Paris: Albin Michel, 2007), p. 346.

Pomeranz,[10] did the Great Divergence occur. India too was ahead of Europe in some respects, for example, in the use and production of cotton before the Industrial Revolution and intellectually with its 'Arabic' numerals and mathematics. These cultures were not simply sitting back, waiting to be overtaken by a renascent Europe. They made their own contribution to scientific, technological and economic advance, contributing to the European Renaissance in the process. But the result of drawing and emphasizing an exclusive Antiquity-Renaissance line has been to exclude non-European cultures from the growth of civilization. I will not speak further of the political implications except to argue that at times this exclusion, thought or unthought, encourages an almost racist fallacy of superiority towards the rest of the world. Some such feelings are doubtless justified since the nineteenth century, some would argue since the Renaissance. Islam and other societies may argue for a moral superiority but in the nineteenth century the west outstripped all others in economic and military might, as well as in education. What is quite illegitimate, and calls forth the epithet 'racist', is, on a quasi-genetic basis, to project this superiority backwards into earlier periods for which the evidence is lacking.

This problem of ethnocentric history did not start with the Renaissance, nor yet with the classical civilizations. For Antiquity was conceived as a period different from the Bronze or even the Iron Age, quite distinctively European and separate from Asia, a period that started Europe off on the unique path to modernization. No one else had an Antiquity, no one else had democracy (Greece invented it!), just we Europeans. But was that actually the case? The Phoenicians in Tyre had a democratic system; they also invented our alphabet. So too had Carthage, a colony of Tyre. But Carthage, a Mediterranean rival to Greece and Rome, has been largely written out of the Antiquity script. I do not want to go all the way with the thesis of the cultural historian Martin Bernal's *Black Athena*, but the manner in which the Semitic-speakers have been excluded from western history does seem to have parallels with the treatment of the Arab contributions to the Renaissance. The Asian input to communication in the form of the Semitic (consonantal) alphabet (even though with this 'literacy' it provided Christian Europe with its scriptures) has been set aside, as has democracy in Tyre, Carthage and elsewhere. The whole weight of classical, humanistic, learning was concentrated upon the Greek and Roman societies which created Antiquity, European Antiquity, as a form of civilization which had to be differentiated from the Bronze Age

10 K. Pomeranz, *The Great Divergence: China, Europe and the Making of the Modern World Economy* (Princeton, NJ: Princeton University Press, 2000).

cultures of the Near East and Asia in view of developments, and which was revived in the Renaissance.

They were of course different from Egypt and the Near East but the attempt to cut this off in a radical way, as Europeanists have often done, has been disputed by scholars like Bernal and in fact by the very Judaeo-Christian tradition, although it is reinforced by the contemporary inclusion of Israel in Europe for many purposes.

It would be more accurate to see a flowering of the Bronze Age in the whole ancient world around the Mediterranean, including the Near East, a flowering which received a drastic setback with the fall of the Roman empire, and in some respects with the advent of all the Abrahamistic religions, although both the negative and the positive aspects have to be balanced out. The eastern Mediterranean always kept its commercial and intellectual links with east and with central Asia. Moreover Europe itself revived again economically after contact with the Levant which had never lost its urban culture, its Asian trade and its tradition of learning in quite the same way, although there too were many setbacks. Part of our study of the Renaissance means reviewing these other traditions of development.

Should we then see the European Renaissance as part of a wider rebirth of culture and knowledge that included the Islamic world from the ninth century when they were translating Greek texts in Baghdad, then producing paper and establishing a large library in the city that is now the locus of so much civil and military strife? As Fernand Braudel emphasized, the inland sea, the Mediterranean, became a node of communication once again, beginning with Venice's early revival in the eighth century. The mortal remains of St Mark were acquired from Alexandria in the ninth, the bronze horses decorating his church came from the Hippodrome of Constantinople during the devastation caused by the Fourth Crusade of 1204. But trade meant the exchange of knowledge, of 'culture', as well as of goods (and sometimes of stolen goods, as in the case of St Mark). The bringing of his remains to Venice 'represented a great boost to the city's ability to expand its trade in the eastern and southern Mediterranean, to become an important point of departure for pilgrimage to the Holy Land, and to establish herself as ... the "hinge" between Europe and the East'.[11]

Certainly we have to view the Mediterranean as a lake, in the manner of the historian Braudel. Its banks were intercommunicating even in

11 S. Carboni, 'Moments of vision: Venice and the Islamic world, 828–1797', in S. Carboni (ed.), *Venice and the Islamic World, 828–1797* (New Haven, CT: Yale University Press, 2007), p. 15.

ancient times. It is not a problem of whether a specific feature or particular object was transmitted between ancient Egypt and Greece, between one part of the coast and another, but given the seafaring peoples on its shores, what was impossible? Grain, olive oil, African red ware, all were traded. The fields of the south supplied the towns of the north. Why should the same societies not have been exchanging information? European Greece was not cut off from what is now Asiatic Turkey. Indeed, it possessed many important cities on the Ionian coast, such as Miletus, Ephesus, Halicarnassus and others, and it exercised much influence in Persia, central Asia and in northern India. They were also communicating with what are now the Syrian and Lebanese cities to the south, inhabited by Semitic-speaking Phoenicians whose settlements stretched from Ugarit to Tyre and further south to Canaan and Israel and on to Egypt and present-day Tunisia and Spain. Too often we think of Greece and Phoenicia as cultural units. So in a sense they were, but not in any self-enclosed way. These were seafaring peoples with their backs to the mountains, whose natural movement was often over the water. Exchange was in their blood. They wanted metals, European metals, which remained important for the east, as for all societies after the coming of the ages of Copper and Bronze. For these they travelled widely and would be well aware of each other's institutions so that the knowledge of particular modes of government and representation constituted a common pool. Hence we should see the distribution of the particular types of democratic government around the Mediterranean as part of an interacting system of goods, institutions and ideas.

But the Mediterranean itself was clearly not self-enclosed. There was no boundary with the Near East, with Iraq and Persia. And the Islamic religion stretched right across central Asia to China, just as China traded to the Near East and established settlements along the way. So too of course Christian (Nestorian) and Jewish communities existed all along the Silk Road, which was later used by Italian traders. So Chinese culture touched upon the Mediterranean in a variety of ways. Muslims themselves recognized the importance of this link for knowledge as well as for trade. The Hadith has a saying, 'Pursue learning (*ilm*) from the cradle to the grave even as far away as China.' The Chinese had their own trading quarter in Baghdad, the founder of which city, al-Mansur, also exchanged embassies to the west with Charlemagne. Then there were other links of the Near East with India, both overland through Iran and by sea from Egypt, Ethiopia and Arabia. One thinks of the Indian sailor shipwrecked in Egypt whose story Ghosh traced from the Geniza documents in his book *In an Antique Land,* and of the Roman establishments at Arikamedu and Musaris in southern India, connected with the spice trade. Then

there was the arrival of Semitic-speakers from the Mediterranean area, all of trading stock, with the monophysitic Christians supposedly led by St Thomas,[12] with the Muslims who settled on the west coast, with the Jewish inhabitants in Cochin and further north whose activities are so vividly portrayed in the documents found in Cairo.[13]

So, yet wider networks affect the cultural shifts, the wide-ranging Muslim sphere stretching from Spain to Canton and the northern borders of China that transmitted paper, porcelain, gunpowder, silk and other commodities, as well as information (in astronomy for example), and the Indian Ocean one that shipped pepper, spices, cotton goods and knowledge such as Indian ('Arabic') numerals, which Needham considers may even have originated in China (at least the concept of zero). The notion of a purely European Renaissance has recently been criticized by Brotton, in *The Renaissance Bazaar*, where he writes 'once we begin to understand the impact of eastern cultures upon mainland Europe (c.1400–1600), then this traditional understanding of the European Renaissance collapses'.[14] His own enquiries have been towards specifying the contribution of the Near East to events in Europe, a point that is certainly well taken. But it is not only a question of *their* contribution to *our* Renaissance but whether similar rebirths occurred elsewhere.

Alongside communication and the flow of goods and ideas between networks of exchanging cultures, there were of course parallel developments (the *commenda*, for example, a method whereby merchants shared risks and profits) some of which arose out of the internal elaboration of distinct merchant societies, as they distanced themselves from court and religious hierarchies. Particularly intriguing are the parallels in bourgeois society that appear in Clunas's discussion of written materials on connoisseurship in China which appeared at about the same time as this activity was developing in Europe, undoubtedly an independent development. It was similar with the secular theatre which made its reappearance in early Tudor Britain a little before *kabuki* theatre emerged among Japanese merchants in the seventeenth century (both the No plays of Japan and of classical theatre Kalidasa in India were of course earlier). An elaborate haute cuisine and culture of flowers were found in China earlier than similar developments in Europe and the Near East; they were not borrowed

12 These Christians of south India were Nestorians who were condemned as heretics by their fellows in the fifth century and may have fled to India as early as the sixth.
13 S. D. Goitein, 'Letters and documents on the India trade in medieval times', in *Islamic Culture* (1963), 37: 96.
14 J. Brotton, *The Renaissance Bazaar* (London: Oxford University Press, 2002), p. 3.

but were manifestations, first of a differentiated elite culture, then one mainly consisting of the bourgeoisie, largely merchant, in both areas. Sociologically the practices had their roots in similar conditions.

The Renaissance and the Reformation are clearly European events, and ones that have been given iconic status in the development of modern society. My present interest is directed not to eliminating their significance in Europe, nor to proposing that their origins lay partly overseas (though some elements certainly did), but to querying their uniqueness and hence the position given to them in world, as distinct from European, history. The uniqueness of the Reformation is a minor theme for present purposes. It is the Renaissance that lies at the centre of my concerns, and here I want to confine my attention to similar activities outside Europe, their comparative neglect and what that implies for European historiography.

[...]

3

Art, commerce and colonialism
1600–1800

Emma Barker

Introduction

The texts in this section have been selected to illuminate the nexus of art, commerce and colonialism between the late sixteenth century and the end of the eighteenth. During this period, the dominant powers of the previous phase of European expansion, Portugal and Spain, lost ground to the Dutch, who rapidly became the world's leading commercial power before being supplanted in their turn by the British from the late seventeenth century onwards. The initial moment of transition is represented by the first source text, an extract from a travel narrative by a Dutchman, whose book encouraged his compatriots to wrest control of the lucrative Asian trade from the Portuguese, as well as providing advice as to how to do so. The endpoint of this period is represented by the final source text, an extract from a work by one of the 'founding fathers' of the United States, which documents Britain's loss of most of its North American colonies, a loss all the more significant in view of the greatly increased importance of the Atlantic economy over the previous two centuries. This period is distinguished from the imperial era that followed by the limited involvement of national governments in the colonising project.

The source texts included here attest to some of the ways in which commerce and colonialism helped to shape European art and architecture, along with their visual and material culture, both at home and overseas. The first shows how Europeans asserted their authority in a colonial context through a mixture of their own artistic traditions, such as the series of official portraits, and indigenous customs, such as the parasol held by slaves. As the group of texts relating to Latin America reveal, religious art and architecture were widely deployed for this purpose in colonies ruled by Roman Catholic powers. By contrast, the Dutch adopted a more narrowly commercial approach in their dealings with the

non-European world, with spectacular success, as shown by a German traveller's description of Amsterdam. The impact on European material culture of the large-scale importation of artefacts and commodities from the East is exemplified by a pair of texts that respectively evoke a real and a fictional British woman's domestic furnishings. The final text discusses the importation of classical architectural principles from Europe into the colonial context of North America.

This group of source texts also testifies to the way that European artistic and cultural traditions informed attitudes towards the peoples and cultures of other parts of the world. Thus, for example, religious images and practices native to Asia and the Americas are dismissed as idols and devil-worship by a Dutch traveller and a Spanish priest respectively. A similarly damning assessment underlies the fictional account of a British domestic interior, in which the vogue for luxury goods from Asia is associated with the abandonment of classical principles of good taste and good sense. In the case of human beings, physical appearances judged 'ugly' by European standards are associated with supposed mental and moral debasement. A Spanish viceroy in colonial Peru articulates the belief that skin colour and other features characteristic of descent from 'Indians and blacks' entail a person having related tendencies and qualities. Likewise, a slave-owning future president of the United States contends that blacks are inferior to whites 'in the endowments both of body and mind'. Both texts provide evidence of the way that colonial interests encouraged the development of racist stereotypes.

The four modern scholarly texts included here as 'critical approaches' each offer a different framework for grappling with the complexities of artistic and cultural exchange and diffusion during this period. Thomas DaCosta Kaufmann is primarily concerned with the Hispanic world, but emphasises the global scope of the diverse influences that shaped artistic production there. He offers as a theoretical model the notion of the cultural field which intersects or overlaps with others. By contrast, Benjamin Schmidt examines Dutch representations of the 'exotic world', showing how they were disseminated across Europe. Schmidt's conception of exoticism differs markedly from Orientalism, as theorised by Edward Said for the period post-1800. David Porter discusses the aesthetics of exoticism with reference to the vogue for Chinese goods in eighteenth-century Britain, where, as he shows, fears of female autonomy played a significant role in denying the Chinese style legitimacy as an alternative to European artistic traditions centred on classicism. Both classicism and gender recur as themes in Daniel Maudlin and Bernard Herman's discussion of architecture in the British Atlantic World, which, like Kaufmann's analysis, challenges older models of one-way diffusion from

metropolis to colony, instead proposing a 'model of overlapping spheres of influence'.

Overall, the texts in this section demonstrate how the nexus of art, commerce and colonialism differed from country to country and between continents. It is worth noting that the selection does not include any relating to France, also a leading colonial power during this period, with a dominant role in the Atlantic economy. Nevertheless, on the basis of the texts gathered here, it can be argued that, as the countries of Western Europe competed with each other across the globe for trade and territory, they helped to forge a supposedly separate and superior 'white' identity, which underlay the subsequent development of imperialism.

Emma Barker

Primary source texts

3.1 Johan Huyghen van Linschoten on Goa, from *Iohn Huighen van Linschoten. his discours of voyages into ye Easte & West Indies Deuided into foure books* (London: John Wolfe, 1598), vol. 1., pp. 13, 51–52, 56, 62–65 (vol. 1 first published in Dutch in 1596). (English translation of Dutch work originally published in 1598; spelling modernised by Emma Barker)

The *Itinerario* of Jan Huyghen van Linschoten (1563–1611) is one of the great travel narratives of the early modern period. Linschoten, a Dutchman who sailed for India in 1583 as secretary to the Archbishop of the Portuguese colony of Goa, fascinated readers with his detailed account of the sights and customs of the East. The book's appeal was enhanced by its many illustrations, supposedly drawn by Linschoten himself. It was also instrumental in launching the Netherlands as a global economic power, thanks to the sea charts, navigational advice and other mercantile information that it included. The extracts here are drawn from Linschoten's description of the culture and society of colonial Goa, which he characterised as excessively formal and even decadent. Nevertheless, such elements as the gallery of official portraits and the parasol held up by slaves were later adopted by the Dutch in their colonial capital, Batavia, in Java. Linschoten's account of the use of images by the local Hindu population betrays his European prejudices about the pagan worship of 'idols'. The text printed here is the original English translation, but the spelling has been modernised for ease of reading. [Emma Barker]

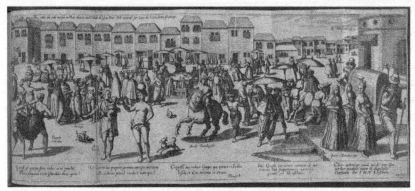

3.1 Johannes van Doetecum after Johan Huyghen van Linschoten, 'View of the Market in Goa', 1598

I stayed with my master in India certain years to learn the manners and customs of the said lands, people, fruits, wares and merchandises, with other things which when time serves I will in truth set down, as I myself for the most part have seen with my own eyes and of credible persons, both Indians and other inhabitants of those Countries learned and required to know [...]

The City of Goa, is the Metropolitan or chief City of all the Oriental Indies, where the Portuguese have their traffic, where also the Viceroy, the Archbishop, the King's Counsel, and Chancery have their residence, and from thence are all places in the Oriental Indies, governed and ruled. There is likewise the staple for all Indian commodities, whether all sorts of Merchants do resort, coming thither both to buy and sell, as out of Arabia, Armenia, Persia, Cambaia,[1] Bengal, Pegu,[2] Siam,[3] Malacca, Java, Molucca, China, &c. [...]

The Portuguese in India, are many of them married with the natural born women of the country, and the children proceeding of them are called Mestizos, that is, half countrymen [...]

The Portuguese, Mestizos, and Christians keep worshipful and bountiful houses, having commonly (as it is said before) five, six, ten, twenty, some more, some less slaves, both men and women, in their houses every man according to his estate and quality ... The Portuguese are commonly served with great gravity, without any difference between the Gentleman & the common Citizen, townsman or soldier, and in their going, curtsies, and conversations, common in all things: when they go in the streets

1 Gujarat.
2 In present-day Myanmar.
3 Thailand.

they step very softly and slowly forwards, with a great pride and vainglorious majesty, with a slave that carries a great hat or veil over their heads,[4] to keep the sun and rain from them. Also when it rains they commonly have a boy that bears a cloak of Scarlet or of some other cloth after them, to cast over them: and if it be before noon, he carries a cushion for his master to kneel on when he hears Mass, and their Rapier is most commonly carried after them by a boy, that it may not trouble them as they walk, nor hinder their gravities [...]

Every 3 years there is a new Viceroy sent into India, and some time they stay longer, as it pleases the King, but very few of them, he continues in Goa (which is the chief City of India) where he has his house and continual residence, ... In the hall of his Palace stand the Guard, and in the great hall, where his Council sit, are painted all the Viceroys, that have governed in India, since the first discovery and conquest thereof, and as they new come, their pictures are likewise placed there. Also in the entry of the Palace are painted all the ships, that since the first discovery of India, ever came out of Portugal into those countries, every year by itself, and the names and surnames of their Captains, with a note over every ship which was cast away, or had any mischance, all lively set forth, for a perpetual memory, and every year as any ship comes thither, they are set by the rest.

The Viceroys in the last year of their government, do use to visit the Forts lying round about the country, fifty, sixty, or eighty miles long, on the North and South side of Goa, to see how they are governed, they look well unto them, but commonly another supplies their place, and if they do it themselves, it is more to fill their purses, and to get presents, then to further the commonwealth, these Viceroys have great revenues, they may spend, give, and keep the King's treasure, which is very much, and do with it what pleases them, for it is in their choice, having full and absolute power from the King, in such sort, that they gather and hoard up a mighty quantity of treasure, for that besides their great allowance from the King, they have great presents & gifts, bestowed upon them. For it is the custom in those countries, when any Viceroy comes newly over, that all the Kings bordering about Goa, and that have peace and friendship with the Portuguese, do then send their Ambassadors unto him, to confirm their leagues with great and rich presents, therewith likewise to bid the Viceroy welcome, which amounts to a great mass of treasure.

4 That is, a parasol (the English translator is evidently at a loss to know what is being described in the original Dutch).

In the town and land of Goa, are resident many Heathens ... But they have Idols and Images, which they call Pagods, cut and formed most ugly, and like monstrous Devils, to whom daily they offer, and say, that those holy men have been living among them, whereof they tell so many miracles, as it is wonderful, and say that they are intercessors between them and God. The Devil often times answers them out of those Images, whom they likewise know, and do him great honour by offering unto him, to keep friendships with him, and that he should not hurt them.

[...] The heathenish Indians that dwell in Goa are very rich Merchants, and traffic much, there is one street within the town, that is full of shops kept by those Heathenish Indians, that not only sell all kinds of Silks, Satins, Damasks, and curious works of Porcelain from China and other places, but all manner of wares of Velvet, Silk, Satin and such like, brought out of Portugal, which by means of their Brokers they buy by the great, and sell them again by the piece or ells, wherein they are very cunning, and naturally subtle. There are in the same street on the other side, that have all kinds of linen, and shirts, with other clothes ready made for all sorts of persons, as well slaves as Portuguese, and of all other linen work that may be desired. There are Heathens that sell all kinds of women's clothes, and such like wares, with a thousand sorts of clothes and cottons, which are like Canvas for sails and sacks. There is also another street where the Banyans of Cambaia dwell, that have all kinds of wares out of Cambaia, and all sorts of precious stones, and are very subtle and cunning to bore and make holes in all kinds of stones, pearls, and corals, on the other side of the same street dwell other heathens, which sell all sorts of bedsteads, stools, and such like stuff, very cunningly covered over with Lacquer, most pleasant to behold, and they can turn the Lacquer into any colour that you will desire. There is also a street full of gold and Silver Smiths that are Heathens, which make all kind of works, also divers other handicrafts men, as Coppersmiths, Carpenters, and such like occupations, which are all heathens, and every one a street by themselves.

3.2 Art, religion and race in colonial Latin America

This group of texts has been selected to illuminate the relationship between art, religion and race in colonial Latin America. The first two were both written by Roman Catholic clerics endeavouring to convert the indigenous population of the Viceroyalty of Peru (one of two viceroyalties into which the Spanish Empire was divided, the other being New Spain, which centred on Mexico).

The first text provides evidence of large-scale church building carried out by the colonial authorities in new settlements, in which indigenous people were forced to live, from the mid-sixteenth century onwards. The second text, which was written by a Jesuit priest working in the former Inca capital, Cusco, around 1600, attests to the role of music and painting in missionary endeavour. The third text discusses a secular type of picture that emerged in both viceroyalties in the early eighteenth century, though all but one of the surviving examples were made in New Spain; known as Casta paintings, they depicted the ethnically diverse population of the colonies according to an elaborate racial hierarchy. The fourth text originated as a caption by the Mexican painter Diego Rivera (1886–1957) for a picture commemorating the inauguration of a newly built Dominican convent in New Spain (Figure 3.2). Rivera's analysis highlights the painting's significance as a document of a racially divided colonial society, contradicting its intended message about the unifying and civilising effects of the Christian faith. Rivera's text itself functions as a source text for the history of twentieth-century Mexican realism. Compare Section 5, 5.2. [Emma Barker]

a) Extract from the First Provincial Council in Lima 1551–1552, K. Donahue-Wallace, *Art and Architecture of Viceregal Latin America, 1521–1821* (Albuquerque, University of New Mexico Press, 2008), p. 24

Second Constitution – That churches shall be constructed in Indian towns, and the manner in which to do so.

Furthermore, because, for the goodness and mercy of God our Father, in most Indian towns and provinces there are many Christians, and each day there will be more; and for this reason there shall be temples and churches where God our Father will be honored, and they will celebrate the divine offices and administer the sacraments, and the Indians will attend to hear the preaching and doctrine: *Sancta Sínodo aprobante* we order that the priests in the Indian doctrinas[1] in the Indian towns give and procure with diligence as in each *repartimiento*,[2] in the principal town where the principal cacique[3] lives [...] to make a church, according to the number of people in the town, in which shall be administered all the

1 doctrina – mission centre.
2 *repartimiento* – unit of forced labour.
3 cacique – indigenous leader.

sacraments, except in cases of necessity. And said priest shall procure to adorn it [...] the art needed for the site's dignity and so that it is done, helping the people understand that that place is dedicated to God and to the faith and divine offices, and where we attend to ask God to forgive our sins, and in which are not to be done other illicit things, not to give a place for those things. And in the other small towns in which it is not possible to make a church, make a small house, like a hermitage, and put an altar in it adorned with an image or images, in the best manner possible. [...]

Third Constitution – That the huacas[4] shall be torn down, and in their place, if it is decent, shall be made churches.

Furthermore, because [the priests] are not just to make houses and buildings where our Father shall be honored, but to tear down those that are made in honor of and devotion to the devil, for being counter to natural law, it [the indigenous temple] is a great prejudice and incentive for the Christianized [Indians] to return to ancient rites because they are together with infidel fathers and brothers, and to the same infidels it is a great obstacle to their Christianization. As such, *Sancta Sínodo aprobante* we order that all the idols and shrines that are in towns where there are Christian Indians be burned and torn down; and if the place is decent for them, that churches be built there, or at least put a cross there.

– From Rubén Vargas Ugarte, *Concilios limenes (1551–1772)*, vol. 1 (Lima: n.p., 1951), 8–9. (Translation [K. Donahue-Wallace])

b) Extract from Padre Antonio de Vega Loaiza, *Historia del Colegio y Universidad de San Ignacio de Loyola en la Ciudad de Cusco*, Rubén Vargas Ugarte (ed.) (Lima 1948), p. 43 [translation Piers Baker-Bates]

Chapter XI— Confraternity of the Child Jesus of the Indians in this College

Here, they [the Indian members of the Confraternity] hold their spiritual discussion every Wednesday and Friday of the year, their Holy Week celebrations and Communion on many feast days, here too every weekday the blind and the poor read and chant Christian doctrine, with other pious verses and motets, which has aroused and still arouses wonder. Some of them are skilled in music, without having studied it but only listened, and, being blind, sing from memory the responses and Epistles

4 huaca – sacred site.

of Saint Paul on their feast days and at Masses for the dead. Every Saturday, the litany of the Blessed Virgin Mary is sung in the chapel, with organ accompaniment, and here on those days, as on their feast days and processions, and in those of our College, the players of this Confraternity strike up skilfully on their orlos, flutes, shawms and trumpets.[1]

Here, finally, the Indians have attained many graces and indulgences and have themselves catechized, for the sake of their sins and our own, Indians who have come from far afield to confess and to learn Christian doctrine and there have been notable transformations and conversions of Indians through the contemplation of the judgement and glory [of the blessed] and punishments of the condemned, which are all painted on the walls of this chapel, particularly the pain and chastisement meted out to the vices and the sins of the Indians in Hell, which are here well enough depicted, in all their variety, because the Indians are greatly moved by paintings, much more so than by sermons. The duty and purpose of this Confraternity is that the Indian men and women of this Confraternity set a good example for all, so that those who are members of the Confraternity should shun drunkenness and fornication and other sins, should at least three times a week confess and take communion, recite the rosary of Our lady, listen to sermons and spiritual conversation [...]

c) Letter from the Viceroy of Peru Manuel Amat y Junyent to Crown official Julián de Arriaga accompanying a shipment of Casta paintings to the collection of the Royal Cabinet of Natural History 1770, from K. Donahue-Wallace, *Art and Architecture of Viceregal Latin America, 1521–1821* (Albuquerque, University of New Mexico Press, 2008), p. 221

Your Excellency,

Ardently desiring to contribute to the formation of the Cabinet of Natural History which His Most Serene Prince of Asturias has begun, what I offer will contribute but little to his enlightenment but is one of the principal examples of the rare products found in these parts, the notable mutation of appearance, figure, and color that results from the successive generations of the mixture of Indians and Blacks, which are usually accompanied proportionally by inclinations and properties. With this idea, I ordered copied and sent twenty canvases, described in the

1 Orlo and shawm – types of wind instrument.

accompanying registry; and I will continue urging the completion of these combinations until they are finished, if it is that this humble product of my humility finds some acceptance by Our Prince and Lord by way of Your Excellency's hand. For better understanding, the order of the descendants are graduated by numbers; it should serve as key that the son or daughter of the first couple is, according to his or her sex, father or mother in the next: and that of the next couple in the third, and so on until the end of those which are now copied.

May God preserve Your Excellency for many years.

Lima 13 May 1770 … Sr. D. Manuel de Amat

– Pilar Romero de Tejada y Picatoste, 'Los cuadros de mestizaje del virrey Amat', in *Los cuadros de mestizaje del virrey Amat: La representación etnográfica en el Perú colonial* (Lima: Museo de Arte de Lima, 2000), 22. [Translation K. Donahue-Wallace]

d) Picture caption by Diego Rivera, from Joseph J. Rishel with Suzanne Stratton-Pruitt (eds), *The Arts in Latin America 1492–1820* **(New Haven, CT and London: Yale University Press; Philadelphia: Philadelphia Museum of Art, 2006)**

A community of nuns moving to their new convent.

I find that this painting representing a procession on the principal street of Valladolid (today Morelia) is of great interest in the history of Mexican painting, because it brings together the following characteristics:

a) It is a rare case of realistic painting, during its time, 1738, related to a concrete social event, relating with plastic veracity the period and place in which it occurs.

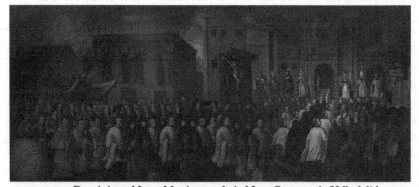

3.2 *Dominican Nuns Moving to their New Convent in Valladolid* (now Morelia), 1738

b) It is of doubtless social value, for the public spectacle in the painting shows a truthful slice of the colonial society with all of its divisions into classes and castes.

c) Ethnographically, it is important because since the painting is the truthful collection of portraits, it powerfully emphasises the differences in the racial components of the personages.

d) Historically, it constitutes an important document with respect to clothing, customs, and the architectural character of the place painted.

e) Finally, considered solely as a painting, it is of strong character, fluidity of execution, and of the composition that is bold in its realism.

Diego Rivera

3.3 Johann Albrecht von Mandelslo on Amsterdam, from Adam Olearius, *The voyages and travells of the ambassadors sent by Frederick, Duke of Holstein, to the Great Duke of Muscovy and the King of Persia ... Whereto are added the Travels of John Albert de Mandelslo (a gentleman belonging to the embassy) from Persia into the East-Indies ... Faithfully rendred into English, by John Davies, of Kidwelly* (London, 1669), pp. 239–232

Johan Albrecht von Mandelslo (1616–1644) travelled to Russia and Persia as a member of a German diplomatic mission between 1633 and 1637, after which he continued on to India on his own initiative, returning to Europe in December 1639. Mandelslo's journal of his travels was published after his death by his friend Adam Olearius (1599–1671), who had been a member of the same diplomatic mission, as a supplement to his own travel narrative. Subsequent editions, including the English translation from which this extract is taken, were augmented with material from other sources; this extract purports to be Mandelslo's account of the city of Amsterdam, through which he passed on his return home. Whoever wrote it, the account is of interest for its description of how Amsterdam had been enriched and embellished as a result of Dutch commercial expansion across the globe; the writer remarks particularly on the wealth and power in evidence at the headquarters of the Dutch East India Company. English readers would no doubt have taken note of this passage, as their own East India Company was then engaged in fierce competition with its Dutch counterpart in Persia, India and the East Indies. [Emma Barker]

I left Haerlem, about six in the Evening, and came at nine the same night, to Amsterdam. Of this place I had heard so much, even in the Indies, that I had framed to my self, a certain Idea of its greatness: but what the more surprised me, was, That going out of my Lodging the next morning, I had much ado to get through the throng of people / walking up and down the Streets, in such numbers, as if there had been some Faire. All the other parts of the World seem'd to have sent their Factours thither, and that the East and North had brought thither all their Commodities; whereof there were in the shops but the Patterns, whereas the main Stock was disposed into Store-houses, publick Weighing-places, upon sledges in the streets, upon the Kayes, in the flat-bottomed boats, which unload the great Ships, and others which serve for Store-houses for the Wheat.

It was at some loss, which I should rather admire in that great City whether the Commerce of it, which is greater than that of all the other Cities of the Low-Countries put together; the neatness of its Streets, especially that of the New City; the sweetness and cleanliness of its house, the Magnificence of its publick and private Structures; the abundance of Ships and Barks, which come thither, and go thence every day; the largeness of its Port, wherein there are at all times seven or eight hundred Ships; or the Order and Policy observed by the Magistrate, in all things relating to the quiet of the City, the well-fare of its Inhabitants, and the improvement of Trade, by which only the City subsists, and causes to subsist that powerful State, whereof it is a considerable part.

As to its Commerce there is no City in the world; where the Inhabitants of *Amsterdam* have not their Factors and correspondents. All the maritime towns of England, France, Spain, and Italy, are full of them, as are also those of the *Baltick-Sea*, and *Muscovy* it self. It is in a manner impossible to number the Ships it sends away every year to Archangel, to *Reueul*[1], *Riga, Konigsberg, Dantizick*,[2] to the Coasts of *Pomerania*, and into *Norway* where they put off their Spices and Silk, and Woolen stuffs; for Wheat, Timber, Pitch, Furs, and other things they stand in need of, either for the building of their, ships and houses, or the carrying on of their Trade in the other parts of the world. [...]

Though a man should consider only the House belonging to the *East-India* Company, he would be forc'd to confess, that every Trade were enough to enrich all its Inhabitants. I have seen some Ships loaden at *Surat*, but when I saw the Store-houses, and Magazeens reaching at

1 Reval, modern Tallinn.
2 Danzig, modern Dansk.

a great distance, from the East-India House, full of Spices, Silk, Stuffs and Purcelane, and whatever China and the Indies afford that is most rare, I thought that *Ceylon* had sent thither all its Cinamon, the *Moluccas* all their Cloves; the Islands of *Sumatra* and *Java* all their Spices, *China* all its rich stuffs; *Japan* its excellent works of several kinds, and the rest of the Indies its Pepper and Silk. Nay, it may be said this Company is a kind of particular Common-wealth in that little world; since its Magistrates, Officers, Armies, Fleets, Generals, Governours of Provinces and Cities, and its subjects, seem to have no other dependance on this City, then a particular State hath on the Universe. [...]

It were impossible to imagine any thing more delightful, or more regularly disposed then the Streets, Water-channels, and Houses of this City. All the Rivulets are bordered with lime-trees, and the Quays pav'd at the extremities with Brick, and in the middest with Flint. The Houses, especially those of the new City, are so many Palaces; so neat without, that painting could add nothing thereto, and so well furnish'd within, that there are some, whereof only the Pictures were enough to enrich a man. But what most speaks the cost imploy'd about them is least seen: For all the Houses being built on piles, it must be confessed, the foundations are no less precious then the rest of the Structure, and that there is not so noble a Forrest in the World as that which the City of *Amsterdam* hath under its houses.

3.4 Texts on Chinoiserie in Britain

This pair of texts attests to the taste for imported luxury goods in eighteenth-century Britain and to the criticism this taste elicited. The first consists of extracts from the sale catalogue drawn up following the death of the Duchess of Kingston, Elizabeth Chudleigh (1721–88). The furnishings of the bedchambers and dressing rooms of her residence, Thoresby Hall in in Nottinghamshire, reflect up to-the-minute taste for the 1770s. Hung with Chinese wallpaper and Indian chintz, these rooms also contain moveable objects signalling this taste, such as furniture in mahogany imported from the Caribbean, both real and imitation ('japanned') lacquerwork and tea wares. The second is taken from a series of fictional letters from a Chinese Philosopher by Oliver Goldsmith (1730–74). It describes an imaginary encounter between Lien-Chi Altangi, who has travelled from China, and 'a lady of distinction' whose apartment he visits, as described in a letter home addressed to Fum-Hoam. Goldsmith's purpose is

to mock what he sees as a superficial fashion for things Chinese in furnishings, dress and tea-drinking, which he portrays as part of a generalised and misconceived taste for the exotic that confuses an Egyptian pyramid with a Chinese temple. None of these are any match for the works of classical philosophy, which the lady claims guide her through life, themselves signalling the alternative to Chinese taste. [Clare Taylor]

a) *A catalogue of all the rich and elegant household furniture, ... late the property of Her Grace the Duchess of Kingston, deceased ... at Thorseby Park ... Which will be sold by auction, by Mr. Christie ... on Wednesday, 10th June 1789* (British Library, Eighteenth Century Collections Online Gale Document Reference number: CW3307960949)

No. XVI *Green India Paper*[1] *Room.*

88. A French couch bedstead with crimson mixed damask furniture and 2 pair ditto window curtains and rods

[...]

91. *A pair of inlaid walnut commodes* as fixed in the window recess's

92 A square pier glass 24 inches by 31 in gilt frame and a mahogany Pembroke table

93 A shaped dressing glass in a Japanned[2] frame and a ditto quadrille box

94 A mahogany shaving stand with glass, & c.

95 A settee and 4 armed chairs

96 Green baize to cover the floor, a Leghorn matt and the inside of a kitchen in a gilt frame

[...]

No. XXVIII *Chintz Bed Chamber and Two Dressing Rooms adjoining* ...

[16]

12. A *pair of mahogany drawers* as fixed in the windows

13 a very large japanned linen chest

14 Sundry India paper, odd articles in the chest and a chintz palampo[3]

15 A bergier and cushion, with cotton cases

16 Fourteen mock Bamboo chairs, with cane seats

1 Wallpaper imported from China.
2 Either a reference to genuine lacquer, imported from Asia, or the imitation of Asian lacquer in Europe, a technique known as japanning.
3 An abbreviation of palampore, a rectangular panel from a set of chintz bed hangings or bed cover.

17 A set of honey-comb chimney ornaments, a pair of flower vases and a pair of blue glass bottles

18 Green baize planned to the room, about 40 yards

19 A tent couch bedstead, with chintz furniture lined [...]

20 A *pair of mahogany drawers and cupboards* as fixed in the recesses

21 Cotton throw-over furniture for a field bedstead

22 A mahogany square table, a ditto candlestand, 2 swing glass, a folding tin fender, shovel, poker and tin stand

23 A square chimney glass 19 by 25

24 Two Chinese figures,[4] 2 blue and white mango cups, 3 odd cups and saucers

25 A *Japan cabinet* on a frame

26 Green baize planned to the floor [...]

27 A square chimney glass 24 by 28

28 A *pair of fine brown china hawks*

29 A couch canopy bedstead, with chintz furniture lined, a counterpane to match and 2 brass cranes to ditto

[...]

32 A *mahogany press as fixed in the window*

33 A mahogany table with 2 drawers, a swing glass, 3 Japan toilette boxes and 2 stands

34 Green baize to the floor

No. XXIX CHINA, *Blue and White*

35 Twenty three half pint basons, 24 plates and 6 tea pots

36 Nineteen breakfast cups, 12 saucers, 6 cream ewers and 4 red tea pots[5]

[...]

b) Oliver Goldsmith, on Chinoiserie 'Letter XIV', in *The Citizen of the World; or Letters from a Chinese philosopher, residing in London, to his friends in the East* (London, 1762), vol. 1, pp. 48–45

I WAS some days ago agreeably surprised by a message from a lady of distinction, who sent me word, that she most passionately desired the pleasure of my acquaintance; and with the utmost impatience, expected an interview. I will not deny, my dear Fum Hoam, but that my vanity was raised at such an invitation. I flattered myself that she had seen me

4 Chinese standing figures were usually supplied in pairs.
5 A reference to Chinese red stoneware with applied decoration (*Yixing* ware) which provided models for Staffordshire manufacturers.

in some public place, and had conceived an affection for my person, which thus induced her to deviate from the usual decorums of the sex. My imagination painted her in all the bloom of youth and beauty. I fancied her attended by the loves and graces, and I set out with the most pleasing expectations of seeing the conquest I had made.

When I was introduced into her apartment, my expectations were quickly at an end; I perceived a little shrivelled figure indolently reclined on a sofa, who nodded by way of approbation at my approach. This, as I was afterwards informed, was the lady herself, a woman equally distinguished for rank, politeness, taste, and understanding. As I was dressed after the fashion of Europe, she had taken me for an Englishman, and consequently saluted me in her ordinary manner; but when the footman informed her grace that I was the gentleman from China, she instantly lifted herself from the couch, while her eyes sparkled with unusual vivacity. 'Bless me! can this be the gentleman that was born so far from home? What an unusual share of *somethingness* in his whole appearance. Lord how I am charmed with the outlandish cut of his face; how bewitching the exotic breadth of his forehead. I would give the world to see him in his own country dress. Pray turn about, Sir, and let me see you behind. There! there's a travell'd air for you. You that attend there, bring up a plate of beef cut into small pieces; I have a violent passion to see him eat. Pray, Sir, have you got your chop sticks about you? It will be so pretty to see the meat carried to the mouth with a jerk. Pray speak a little Chinese: I have learned some of the language myself. Lord, have you nothing pretty from China about you; something that one does not know what to do with? I have got twenty things from China that are of no use in the world. Look at those jars, they are of the right pea green: these are the furniture'. *Dear madam,* said I, *those, though they may appear fine in your eyes, are but paltry to a Chinese; but, as they are useful utensils, it is proper they should have a place in every apartment.* Useful! Sir, replied the lady; sure you mistake, they are of no use in the world. *What! are they not filled with an infusion of tea as in China?* replied I. Quite empty and useless upon my honour, Sir. *Then they are the most cumbrous and clumsy furniture in the world, as nothing is truly elegant but what unites use with beauty.* I protest, says the lady, I shall begin to suspect thee of being an actual barbarian. I suppose also you hold my two beautiful pagods in contempt. *What!* cried I, *has Fohi spread his gross superstitions here also? Pagods of all kinds are my aversion.* A Chinese, a traveller, and want taste! it surprises me. Pray, sir, examine the beauties of that Chinese temple which you see at the end of the garden. Is there any thing in China more beautiful? *Where I stand I see*

nothing, madam, at the end of the garden that may not as well be called an Egyptian pyramid as a Chinese temple; for that little building in view is as like the one as other. What! Sir, is not that a Chinese temple? you must surely be mistaken. Mr. Freeze, who designed it calls it one, and nobody disputes his pretensions to taste. I now found it vain to contradict the lady in any thing she thought fit to advance: so was resolved rather to act the disciple than the instructor. She took me through several rooms all furnished, as she told me, in the Chinese manner; sprawling dragons, squatting pagods, and clumsy mandarines, were stuck upon every shelf: In turning round one must have used caution not to demolish a part of the precarious furniture.

In a house like this, thought I, one must live continually upon the watch; the inhabitant must resemble a knight in an enchanted castle, who expects to meet an adventure at every turning. *But, Madam,* said I, *do no accidents ever happen to all this finery?* Man, Sir, replied the lady, is born to misfortunes, and 'tis but fit I should have a share. Three weeks ago, a careless servant snapp'd off the head of a favourite mandarine: I had scarce done grieving for that, when a monkey broke a beautiful jar; this I took the more to heart, as the injury was done me by a friend: however, I survived the calamity; when yesterday crash went half a dozen dragons upon the marble hearth stone; and yet I live; I survive it all: you can't conceive what comfort I find under afflictions from philosophy. There is Seneca, and Bolingbroke, and some others, who guide me through life, and teach me to support its calamities. — I could not but smile at a woman who makes her own misfortunes, and then deplores the miseries of her situation. Wherefore tired of acting with dissimulation, and willing to indulge my meditations in solitude, I took leave just as the servant was bringing in a plate of beef, pursuant to the directions of his mistress.

Adieu.

3.5 Thomas Jefferson, *Notes on the State of Virginia* (London, 1787), pp. 229–240, 253–258

Thomas Jefferson (1743–1826), a major figure in the American Revolution, was the third President of the United States (1801–1809). These Notes originated as a response to a series of questions posed by a French diplomat in 1780. Jefferson continued to revise and expand the text until 1787. The first extract reflects the tension between his Enlightenment commitment

to liberty, as a signatory to the Declaration of Independence of 1776, and crude racial prejudice, in which he was invested as a slave-owner himself. Although supportive of the emancipation of the slave population long-term, he advocated deporting the freed slaves to an unspecified location. It is notable that he attributes greater artistic and intellectual qualities to the indigenous population of America who, by contrast, he considered part of the new nation. The second extract discusses the architecture of Williamsburg, the capital of Virginia from 1699 to 1780. Jefferson laments the ignorance of classical architecture revealed by its early eighteenth-century buildings, laying the blame on a lack of skilled craftsmen and the inadequacies of the education system. In the final paragraph Jefferson weaves his aesthetic preference for masonry buildings of stone or brick, on the European model, into universal claims for architectural permanence and national significance. [Elizabeth McKellar]

a) 14 Laws

[...] The first difference which strikes us is that of colour. – Whether the black of the negro resides in the reticular membrane between the skin and scarf-skin, or in the scarf-skin itself; whether it proceeds from the colour of the blood, the colour of the bile, or from that of some other secretion, the difference is fixed in nature, and is as real as if its seat and cause were better known to us. And is this difference of no importance? Is it not the foundation of a greater or less share of beauty in the two races? Are not the fine mixtures of red and white, the expressions of every passion by greater or less suffusions of colour in the one, preferable to that eternal monotony, which reigns in the countenances, that immovable veil of black which covers all the emotions of the other race? Add to these, flowing hair, a more elegant symmetry of form, their own judgment in favour of the whites, declared by their preference of them, as uniformly as is the preference of the Oranootan for the black women over those of his own species. The circumstance of Superior beauty, is thought worthy attention in the propagation of our horses, dogs, and other domestic animals; why not in that of man? [...]

Comparing them by their faculties of memory, reason, and imagination, it appears to me that in memory they are equal to the whites; in reason much inferior, as I think one could scarcely be found capable of tracing and comprehending the investigations of Euclid; and that in imagination they are dull, tasteless, and anomalous. It would be unfair to follow them to Africa for this investigation. We will consider them here, on the same

stage with the whites, and where the facts are not apocryphal on which a judgment is to be formed. It will be right to make great allowances for the difference of condition, of education, of conversation, of the sphere in which they move. Many millions of them have been brought to, and born in America. Most of them indeed have been confined to tillage, to their own homes, and their own society: yet many have been so situated, that they might have availed themselves of the conversation of their masters; many have been brought up to the handicraft arts, and from that circumstance have always been associated with the whites. Some have been liberally educated, and all have lived in countries where the arts and sciences are cultivated to a considerable degree, and have had before their eyes samples of the best works from abroad.

The Indians, with no advantages of this kind, will often carve figures on their pipes not destitute of design and merit. They will crayon out an animal, a plant, or a country, so as to prove the existence of a germ in their minds which only wants cultivation. They astonish you with strokes of the most sublime oratory; such as prove their reason and sentiment strong, their imagination glowing and elevated. But never yet could I find that a black had uttered a thought above the level of plain narration; never saw even an elementary trait of painting or sculpture. In music they are more generally gifted than the whites with accurate ears for tune and time, and they have been found capable of imagining a small catch. Whether they will be equal to the composition of a more extensive run of melody, or of complicated harmony, is yet to be proved. Misery is often the parent of the most affecting touches in poetry. Among the blacks is misery enough, God knows, but no poetry. [...]

[...] To our reproach it must be said, that though for a century and a half we have had under our eyes the races of black and of red men, they have never yet been viewed by us as subjects of natural history. I advance it therefore as a suspicion only, that the blacks, whether originally a distinct race, or made distinct by time and circumstances, are inferior to the whites in the endowments both of body and mind. It is not against experience to suppose, that different Species of the same genus, or varieties of the same species, may possess different qualifications. Will not a lover of natural history then, one who views the gradations in all the races of animals with the eye of philosophy, excuse an effort to keep those in the department of man as distinct as nature has formed them?

This unfortunate difference of colour, and perhaps of faculty, is a powerful obstacle to the emancipation of these people. Many of their advocates, while they wish to vindicate the liberty of human nature are anxious also to preserve its dignity and beauty. Some of these, embarrassed

by the question 'What further is to be done with them?' join themselves in opposition with those who are actuated by sordid avarice only. Among the Romans emancipation required but one effort. The slave, when made free, might mix with, without staining the blood of his master. But with us a second is necessary, unknown to history. When freed, he is to be removed beyond the reach of mixture.

[pp. 229–240]

b) 19 Colleges, Buildings, Roads, &c

The college of William and Mary is the only public seminary of learning in this state. It was founded in the time of king William and queen Mary, who granted to it 20,000 acres of land, and a penny a pound duty on certain tobaccoes exported from Virginia and Maryland, which had been levied by the statute of 25 Car. 2. The assembly also gave it, by temporary laws, a duty on liquors imported, and skins and firs exported. From these resources it received upwards of 3000 l. communibus annis. The buildings are of brick, sufficient for an indifferent accommodation of perhaps an hundred students. By its charter it was to be under the government of twenty visitors, who were to be its legislators, and to have a president and six professors, who were incorporated. It was allowed a representative in the general assembly. Under this charter, a professorship of the Greek and Latin languages, a professorship of mathematics, one of moral philosophy, and two of divinity, were established. To these were annexed, for a sixth professorship, a considerable donation by Mr. Boyle of England, for the instruction of the Indians, and their conversion to Christianity. [...]

The private buildings are very rarely constructed of stone or brick; much the greatest proportion being of scantling and boards, plaistered with lime. It is impossible to devise things more ugly, uncomfortable, and happily more perishable. There are two or three plans, on one of which, according to its size, most of the houses in the state are built. The poorest people build huts of logs, laid horizontally in pens, stopping the interstices with mud. These are warmer in winter, and cooler in summer, than the more expensive constructions of scantling and plank. The wealthy are attentive to the raising of vegetables, but very little so to fruits. The poorer people attend to neither, living principally on milk and animal diet. This is the more inexcusable, as the climate requires indispensably a free use of vegetable food, for health as well as comfort, and is very friendly to the raising of fruits. [...]

The only public buildings worthy mention are the Capitol, the Palace, the College, and the Hospital for Lunatics, all of them in Williamsburg,

132

heretofore the seat of our government. The Capitol is a light and airy structure, with a portico in front of two orders, the lower of which, being Doric, is tolerably just in its proportions and ornaments, save only that the intercolonnations are too large. The upper is Ionic, much too small for that on which it is mounted, its ornaments not proper to the order, nor proportioned within themselves. It is crowned with a pediment, which is too high for its span. Yet, on the whole, it is the most pleasing piece of architecture we have. The Palace is not handsome without: but it is spacious and commodious within, is prettily situated, and, with the grounds annexed to it, is capable of being made an elegant seat. The College and Hospital are rude, mis-shapen piles, which, but that they have roofs, would be taken for brick-kilns. There are no other public buildings but churches and court-houses, in which no attempts are made at elegance.

Indeed it would not be easy to execute such an attempt, as a workman could scarcely be found here capable of drawing an order. The genius of architecture seems to have shed its maledictions over this land. Buildings are often erected, by individuals, of considerable expence. To give these symmetry and taste would not increase their cost. It would only change the arrangement of the materials, the form and combination of the members. This would often cost less than the burthen of barbarous ornaments with which these buildings are sometimes charged. But the first principles of the art are unknown, and there exists scarcely a model among us sufficiently chaste to give an idea of them. Architecture being one of the fine arts, and as such within the department of a professor of the college, according to the new arrangement, perhaps a spark may fall on some young subjects of natural taste, kindle up their genius, and produce a reformation in this elegant and useful art. But all we shall do in this way will produce no permanent improvement to our country, while the unhappy prejudice prevails that houses of brick or stone are less wholesome than those of wood. [...]

The inhabitants of Europe, who dwell chiefly in houses of stone or brick, are surely as healthy as those of Virginia. These houses have the advantage too of being warmer in winter and cooler in summer than those of wood, of being cheaper in their first construction, where lime is convenient, and infinitely more durable. The latter consideration renders it of great importance to eradicate this prejudice from the minds of our countrymen. A country whose buildings are of wood, can never increase in its improvements to any considerable degree. Their duration is highly estimated at 50 years. Every half century then our country becomes a tabula rasa, whereon we have to set out anew, as in the first moment of seating it. Whereas when buildings are of durable materials, every new

n actual and permanent acquisition to the state, adding to its
ell as to its ornament.

[pp. 253–258]

Start____

Critical approaches

3.6 Thomas DaCosta Kaufmann, 'Painting of the Kingdoms: A global view of the cultural field', in M. Gutiérrez Haces (ed.), *Pintura de los Reinos: Identidades compartidas* (Mexico City, 2008), vol. 1, pp. 87–135

This essay was written as a contribution to a research project
that culminated in an exhibition of paintings produced between
the sixteenth and eighteenth centuries in territories ruled by
Spain across Europe and the Americas, which was held in Madrid
and Mexico City in 2010–2011. The text builds on Thomas
DaCosta Kaufmann's earlier work on the geography of art (see
Section 1, 1.3a). In the opening section (omitted here), Kaufmann
outlines the universalist ideology of the Spanish monarchy, which
laid claim to the status of a global empire on the basis of its
commitment to the worldwide propagation of the Roman Catholic
faith. Kaufmann goes on to consider the various interpretative
approaches that have been applied to Ibero-American art since
the early twentieth century, up to and including the viceregal
model, which underlay the research project, but concludes that
none is wholly adequate to the task of comprehending the great
diversity of art produced in the Spanish realms. In a final section
(omitted here), Kaufmann characterises the Spanish empire as
a 'cultural field', extending across the globe and intersecting with
many other such fields (Indigenous, Asian, Italianate, Nether-
landish, etc.). The references are presented here in the form in
which they appear in the original publication, without full publica-
tion details. [Emma Barker]

Encompassing the Global: Interpretive Approaches
Several distinctive perspectives on art and the Spanish empire may be
found in the historiography of Iberian and Ibero-American art (and
architecture, as always implied in this discussion).

They represent a variety of hermeneutic approaches or interpretive
strategies. These are derived from different premises, respond to various
aspects of larger issues, and have offered diverse contributions. These

approaches suggest that different views of geographical (and anthropological processes) are inherent in the conceptualization of cultural transfer, although there is not always a simple match between the historiographic approach and the geographical or anthropological assumptions involved. However, each also runs into difficulties. In any case, although several perspectives have points in common, for the sake of clarity they may be termed the colonial model; the national, connected with the indigenous, to which may be linked the mestizo; variants of the model of center and periphery, including notions of the provincial; and the viceregal model.

Conceptions of the Colonial

One long-lasting approach is to regard art connected with the Spanish and Portuguese empires outside Europe, particularly in the Americas, as colonial. This view clearly takes into account both European and American phenomena. It corresponds to the political realities of the situation, by implicitly treating art in Iberia as dominant, since the European 'mother countries' occupied a hegemonic position, both in regard to their American dependencies and to those they controlled in Africa and Asia as well.

This approach also corresponds to the economic realities of what is often designated as a classic colonial situation, whereby raw materials— most significantly silver—were sent to the dominant mother country, and finished or luxury goods, including paintings and prints, less often sculpture, and of course what may be called objets d'art, were shipped to the colonies. Exports of works of art were indeed noteworthy. Although comprehensive data are not available, it has been estimated that 24,000 paintings were shipped from Seville to the Americas during the second half of the seventeenth century,[1] and many more prints, books, and manuscripts must also have been exported.

The colonial account also takes into consideration evidence for cultural transmission that would seem to be undeniable. Spanish (and Portuguese) was not spoken in the Americas (nor *mutatis mutandis* in parts of Asia or Africa) until Europeans came; Christianity did not exist; and European economic, social, and legal systems were certainly not previously present, yet became the dominant form of organization.[2] Many forms and contents of art—especially of a religious nature—certainly did not exist. Moreover, many of the sources for this art derived from Europe.

1 D. T. Kinkead, 'Juan de Luzón and the Sevillian Painting Trade with the New World in the Second Half of the Seventeenth Century', 1984, p. 305.
2 Some of these sentences repeat the observations in the critique offered in T. D. Kaufmann, 'Cultural Transfer and Arts in the Americas', 2006.

Previously historians often dealt accordingly with art in the so-called colonies as something that was subordinate to what was produced in Spain (and Portugal). One early twentieth-century art historian treated art in New Spain for example as a branch of Spanish art.[3] The important volume on the topic in the well-known Anglophone series, the Pelican History of Art, regarded the Americas similarly as dominions of Spain and Portugal.[4] In this standard work—which still has neither been revised nor replaced—the imputation is also clear that art in the Americas is second-rate, because painting is explicitly said to be lacking originality, and to imitate European sources slavishly.[5] [...]

In many of these books a common art historical heuristic, namely that of influence, is also evident: artistic forms and contents are seen to flow from a source, in this instance, mainly Iberia.[6] In other terms, this view also complements and even may directly utilize the theory of acculturation, which was developed by anthropologists who studied situations in which there was continuing contact between peoples of different traditions. The theory of acculturation depended initially upon a model in which one people or culture was militarily (or culturally) dominant.[7] Hence, this suggests the applicability of acculturation to the colonial situation, where both factors seem to be in force. Significantly, the model of acculturation has also been applied to the Spanish relation to Italy and the Low Countries.[8]

The National, the Indigenous, and the Mestizo

However, the colonial account has encountered much resistance, giving rise to other models. Scholarship in the independent states of Latin America has long resisted the imputation that art in the Americas is a colonial product of dubious quality and that art in the Americas largely results either from the import or impact of an external influence. [...]

[The] arts developed in the Americas in ways which often cannot be so clearly related to European sources. For example, there are pictures with religious subjects which may seem to depend on European sources,

3 F. Diez Barroso, *El arte en Nueva España*, 1921, p. 17.
4 G. Kudler and M. Soria, *Art and Architecture in Spain, Portugal and Their Dominions 1500–1800*, 1959.
5 Ibid. pp. 303.
6 [Discursive note omitted]
7 Lines taken from T. D. Kaufmann, 'Acculturation, Transculturation, Cultural Difference and Diffusion? Assessing the Assimilation of the Renaissance', 2007. For further discussion of these notions: Kaufmann, *Toward a Geography of Art*.
8 This idea was introduced in T. F. Glick and O. Pi-Sunyer, 'Acculturation as an Explanatory Concept in Spanish History', 1969, and has been subsequently applied to art history.

but nevertheless are distinctive products of new milieus and that treat established genres in newer ways.[9] This evidence has been taken to contradict the previous emphasis on the Iberian, which had tended to ignore or underestimate the great mass of the population of the Americas under Spanish and Portuguese rule who were either of indigenous origin, of mixed parentage or ancestry, or of African birth or parentage, as well as to answer previous lack of attention to the effect they might have had on painting and other forms or art.

Given criticism of the negative connotations and allegedly 'Eurocentric' implications of an approach that regards American culture as derivative, explanations of art in the Americas as colonial have thus increasingly given way to an emphasis on the indigenous, or the hybrid, which is described in various terms (e.g. mestizo, Creole).[10] The indigenous presence or impact is found in distinctive images which were created in new milieus, particularly in places where large settlements were founded in formerly uninhabited areas; for instance, the *Virgin Mary and the Rich Mountain of Potosí,* usually known as *Virgin of the Hill in Potosí.*[11] Mountains were worshiped in Pre-Columbian times, especially in the Andes, and such an image is often thought to have evoked the pre-Hispanic earth goddess, Pachamama.[12] It has been remarked that such interpretations

9 This theme is a familiar topic in regard to New Spain, and is handled by other essays in this volume, such as the one by Juana Gutiérrez Haces. The creation of a distinctive imagery for painting in the Andean region that developed in relation to earlier indigenous traditions has been a recurrent theme in the work of Teresa Gisbert, whose essay may be consulted in the present series of volumes; see further T. Gisbert, *Iconografía y mitos indígenas en el arte,* 1980; *El paraíso de los pájaros parlantes. La imagen del otro en la cultura andina* 1999; 'La identidad étnica de los artistas del Virreinato del Perú', 2002; also the essays by other authors in *El barroco peruano,* 2002.

10 There are of course many other explanations for the change in emphases, including tendencies toward globalization. For a useful and stimulating introduction to the large question of cultural hybridity in relation to cultural exchange: P. Burke, *Hibridismo cultural,* 2003.

11 Versions of this theme have been frequently illustrated, discussed, and exhibited. For a preliminary orientation, see the catalogue entry by Teresa Gisbert in E. Phipps, J. Hecht, and C. Esteras Martín, eds., *Tin Colonial Andes. Tapestries and Silverwork 1530–1830,* 2004, pp. 259ff, cat. no. 80, and later in J. J. Rishel and S. Stratton-Pruitt, eds., *The Arts in Latin America,* p. 447, cat. no. VI-97.

12 For this interpretation in addition to the works cited in the previous note: C. Damian, *The Virgin of the Andes. Art and Ritual in Colonial Cuzco,* 1995, pp. 50–57. See also the following by Gisbert, *Iconografía y mitos indígenas,* pp. 17–22; by the same author, 'Het Inheemse in de Koloniale Kunst', 1992, fig. 96; 'Potosí: Urbanism, Architecture, and the Sacred Image of the Environment', 1997, pp. 37–39; and her essay in the present series of volumes. For a parallel phenomenon: V. Salles-Reese, *From Viracocha to the Virgin of Copacahana. Representation of the Sacred at Lake Titicaca,* 1997.

indicate that the study of art history has been opened to the benefits of Pre-Columbian archaeology and cultural anthropology, resulting in new understandings of the importance of indigenous contributions.[13]

This shift in understanding corresponds to and often results from the positive reappraisal of the hybridity of the Americas. Manifestations of what are regarded as hybrid forms have been related to the appearance of indigenous elements or ideas through recurrence, survival, and differences in the reception of European derived art and architecture in New Spain before independence.[14] Even when such terms have not been employed, monuments such as atrium crosses have been thought to be bearers of multiple meanings and the synthesis of multiple sources [...].[15] In New Spain such hybrids have been called *tequitqui* in the past, and more recently labeled *arte indocristiano*, but the most general and widespread term used both in reference to New Spain and Peru to describe such forms is *mestizo* (with the related noun *mestizaje*); this term was of course first applied to people of mixed race, most often indigenous and European, and consequently to cultural products, among them works of art, that seem to present similar mixtures.[16]

[...]

It is believed that among the consequences of the establishment of a global empire came the creation of a distinctive art in the Americas which was neither indigenous in nature, nor solely of European derivation, but a mixture of various components, including the local, in addition to

13 This apt remark is made by Burke, 'The Parallel Course of Latin American and European Art', p. 71.
14 P. M. Watts, 'Languages of Gesture in Sixteenth-Century Mexico: Some Antecedents and Transmutations', 1995; T. Cummins, 'From Lies to Truth: Colonial Ekphrasis and the Act of Crosscultural Translation', 1995: C. F. Klein, 'Wild Woman in Colonial Mexico: An Encounter of European and Aztec Concepts of the Other', 1995; D. Leibsohn, 'Colony and Cartography: Shifting Signs on Indigenous Maps of New Spain', 1995; and T. Cummins and E. H. Boone, eds., *Native Traditions in the Postconquest World*, 1998. For a balanced review of the historiography of the question in regard to architecture in Mexico: C. Bargellini, 'Representations of Conversion: Sixteenth-Century Architecture in New Spain', 1998.
15 S.Y. Edgerton, Jr., 'Christian Cross as Indigenous "World Tree" in Sixteenth-Century Mexico: The "Atrio" Cross in the Frederick and Jan Mayer Collection', 2005.
16 For the notion of Indo-Christian art: C. Reyes-Valerio, *Arte indocristiano. Escultura del siglo XVI en México*, 1978. For use of the word *mestizo* in regard to art in New Spain Mexican art: S. Gruzinski, *The Mestizo Mind. The Intellectual Dynamics of Colonization and Globalization*, 2002, and by the same author, *Les quatre parties du monde. Histoire d'une mondialisation*, 2004. Also H. Wethey, *Colonial Architecture and Sculpture in Peru*, 1949, pp. 155–175, and by the same author, 'Mestizo Architecture in Bolivia', 1951, introduced the term in reference to artistic styles in the viceroyalty of Peru. See further T. Gisbert, 'El estilo mestizo en la arquitectura virreinal boliviana', vol. IV, 1955, pp. 9–56ff.

various forms of the European. Art historians have long noticed that forms of art and artists came to the Americas from European lands outside Iberia.[17] More attention is now also paid to art and artists who, along with peoples, came to the Americas from Asia and Africa.[18]

Hybridity has thus been proposed as one of the processes affecting art throughout the Americas.[19] Local expressions of hybridity are seen as features of a general process found in various media and places throughout the western hemisphere.[20] More recently theories of hybridity have been elaborated that also apply these notions to contemporary art and society.[21]

Serge Gruzinski has argued specifically that the concept of mestizo fits situations such as that created in New Spain, where he had earlier recounted evidence for mixed forms of art; he avers that mestizaje in its American cultural manifestations may be further linked with current and past tendencies toward globalization in general.[22] [...] In a recent book Gruzinski has incorporated art history into a discussion of how globalization was effected throughout the world by Spanish Empire. Here he uses the term mestizo to apply to the mixture of indigenous and local hands involved in the process of making works and to the materials used, but expands the notion to characterize all kinds of cultural productions. [...].[23] This coincides with a study of art on the Jesuit missions, which suggests that a worldwide process manifested itself in various forms of adoption, adaptation, and assimilation which affected cultural exchange.[24]

However, seen from the global perspective Gruzinski himself proposes, the problems with the emphasis on the indigenous or mestizo become apparent. In the first place [...] the emphasis upon local expressions of the indigenous or mestizo, hardly seem adequate descriptions of phenomena

17 Attention was raised early, e.g. by F. A. Plattner, *Deutsche Meister des Barock in Südamerika im 17. und 18. Jahrhundert*, 1960 and G. Kubler, 'El problema de los aportes europeos no ibéricos en la arquitectura colonial latinoamericana', 1968.

18 E. J. Sullivan, 'The Black Hand: Notes on the African Presence in the Visual Arts of Brazil and the Caribbean', 2006, and G. A. Bailey, 'Asia in the Arts of Colonial Latin America', 2006; and by the same author, *Art of Colonial Latin America*, 2005, pp. 357–374.

19 Burke, 'The Parallel Course of Latin American and European Art', p. 72.

20 Farago and Pierce, eds., *Transforming Images*; J. F. Peterson, *The Paradise Garden Murals of Malinalco. Utopia and Empire in Sixteenth-Century Mexico*, 1993, pp. 6–9.

21 N. García Canclini, *Hybrid Cultures. Strategies for Entering and Exiting Modernity*, 2005.

22 Gruzinski, *The Mestizo Mind*, 2002.

23 Gruzinski, *Les quatre parties du monde*, pp. 309–338.

24 G. A. Bailey, *Art on the Jesuit Missions in Asia and Latin America 1542–1773*, 1999.

that are more widely encountered in circumstances where these terms do not immediately apply. Furthermore, many forms of art and architecture were derived from, copied after, or based upon European sources which were not transformed, and which thus do not reveal any evidence of indigenous or mixed hands, as Gruzinski himself recognizes. On the contrary: evidence used to support the idea of mestizaje often seems rather to substantiate other sorts of interpretation.[25] The basic functions which paintings, sculpture, and architecture were meant to serve were often not driven by indigenous interests, but by the hegemonic or dominant groups,[26] even if their reception or interpretation may have been otherwise—although the evidence for distinctive local reactions is often as much anthropological as visual or historical. Moreover, as has also been recently said, 'there is a danger in assuming that micro-cultural developments in the early period may be taken to stand for colonial culture as a whole over the entire range of three centuries'.[27] In any event, interactions with the indigenous in local situations can hardly be taken to stand for a worldwide, global situation.

Beyond that, abundant problems remain inherent in the use of the terminology of mestizaje. [...]. Moreover, whether or not distinctions with the biological are made as such, to the extent that the idea of the mestizo relies on genetic or biological vocabulary and presuppositions, this expression of the concept of hybridity still evokes racialist conceptions, implicit or explicit; an underlying assumption is that some authentic local stock exists, onto which something else is grafted, or with which it is combined, so that a hybrid results.

The concept of mestizo was already criticized five decades ago precisely because of its racist origins, as well as for its inadequate expression of the resultant cultural mix.[28] The ideological implications of the notion of mestizo have also more recently been devastatingly exposed and undermined as in fact excluding, rather than including, indigenous contributions and groups.[29] One important recent discussion of the question has argued that mestizo and mestizaje are inappropriate because

25 V. Fraser, *The Architecture of Conquest. Building in the Viceroyalty of Peru 1535–1635*, 1990, and Kaufmann, *Toward a Geography of Art*, pp. 272–299.

26 See especially the arguments in Fraser, *The Architecture of Conquest*.

27 Burke, 'The Parallel Course of Latin American and European Art', p. 71.

28 G. Kubler, 'Indianismo y mestizaje como tradiciones americanas medievales y clásicas', 1966, reprinted in *Studies in Ancient American and European Art*, 1985, pp. 75–80.

29 R. Stutzmann, '*El Mestizaje:* An All-inclusive Ideology of Exclusion', 1981. For another critique of mestizaje: M. Weismantel, *Cholos and Pishtacos*, 2001. These issues are discussed in Kaufmann, *Toward a Geography of Art*, pp. 272–299.

they conflate 'cultural production with racial content: the transmission of cultural traditions is not a genetic trait', and instead offered much more sophisticated and complex accounts of such phenomena.[30] To continue to use mestizo as a category of analysis just because the 'racial' character of the hands involved was supposedly mixed seems therefore to relapse into racialist categories, with little gain for art historical or historical insight. This critique may also be kept in mind when one considers whether the notion of 'hybridity', even when the biological metaphor is disavowed, may also continue to serve as an explanatory concept without much further qualification and reflection.

Regardless of the terms used, changes in emphasis away from the colonial model have accompanied modifications of the theory of cultural reception. The theory of acculturation has for example been modified to allow for a more active role for the recipient. Influences, it is now often thought, can be adapted selectively. Cultural transmission is seen in this light much more as a matter of accommodation, assimilation, and adaptation to different circumstances; as mentioned above, numerous conceptions for the resulting artistic styles (and contents) have come to be utilized.[31]

Yet this usage remains problematic, because the theory of acculturation, even with its variants, still assigns too passive a role to reception. Even in its revised forms, this theory retains a model related to that of influence, and thus still evokes an image of a dominant donor and a passive recipient. For by definition acculturation assumes that a cultural change occurs which is brought about through one culture's interaction with another culture, but in such a way that a dominant culture continues to cause this cultural change. The foreign is thereby valued, and the local is dismissed or downplayed.

The discourse of cultural exchange, or cultural transfer,[32] has taken up this problem, and alternatives to acculturation theory have been advanced. [...]

Transculturation theory has gained favor in more recent decades, probably because it deals more equally with both sides of the equation, and because it emphasizes the importance of the indigenous more than

30 Farago and Pierce, eds., *Transforming Images;* the paraphrase and quotation are from p. 161.
31 These are well summarized in the discussion of 'acculturation and the mestizo style' in Bailey, *Art on the Jesuit Missions,* pp. 22–35, and in García Canclini, *Hybrid Cultures,* 2005, pp. xxxiv–xxxvii.
32 P. Burke, *Kultureller Austausch,* 2000, pp. 14–24; also W. Schmale, ed., *Kulturtransfer. Kulturelle Praxis im 16. Jahrhundert,* 2003.

does acculturation.[33] Clearly it has the merit of dealing with phenomena described by the notion of mestizo without employing racially charged language. It also seems to fit some of those elements of cultural exchange that existed not only between Spain and the Americas, but between the Low Countries and Italy and the Americas as well. While Flemish and to a degree Italian art and artists went westwards, objects from the Americas came eastwards from an early date [...]. Depictions of America and Amerindians are found in Netherlandish painting, and American creatures also appear in Italian grotesques. An iconography of conquest and of the continents also developed.[34]

The question is how fully or adequately the concept of transculturation accounts for the complexity of interactions. In the Netherlandish and Italian examples, the exchange, such as it was, seems to have been largely one-sided: in fact one aspect of Netherlandish image-making involving the Americas supported the construction of an ideology of European superiority.[35] Furthermore, transculturation in these terms does not in any case explain what is specific about the nature of the Flemish or Italian presence in the Americas, to which the phenomena mentioned here are only tangentially related.

Processes of exchange and interchange were considerably more complicated. It is for instance well known that the cult of the Guadalupe, which originated in Spain, acquired a new form in the Americas, and then spread back to Europe, whence in turn images of the American Guadalupana were created which then were sent to the Americas, where they helped spread this cult further [...].[36] Images or ideas of the 'exotic' originating in European depictions of the American 'other' were transported to the Americas, where they appear in what has been described as a form

33 For instance the essays in K. J. Andrien and R. Adorno, eds. *Transatlantic Encounters. Europeans and Andeans in the Sixteenth Century,* 1991.

34 E. Van Den Boogaart, 'Keizerin Europa en haar drie zusters. De Nederlandse uitbeelding van de Europese superioriteitsclaim, 1570–1655', 1992, and B. J. Bucher, 'De *Grands Voyages van* De Bry (1590–1634). Europa's eerste uitgebreide reportage over America', 1992; F. B. Polleross et al., eds., *Federschmuck und Kaiserkrone: das barocke Amerikabild in den habsburgischen Ländern,* 1992. For a more general discussion see H. Honour, *The New Golden Land. European Images of America from the Discoveries to the Present Time,* 1975.

35 Van Den Boogaart, 'Keizerin Europa en haar drie zusters'.

36 J. Cuadriello, *Maravilla americana: Variantes de la iconografía guadalupana, s. XVII–XIX,* 1989, and for the image illustrated here J. F. Peterson, 'The Reproducibility of the Sacred: Simulacra of the Virgin of Guadalupe', 2005, pp. 61–64.

of 'inverted exoticism'.[37] For such processes a better description might therefore be the older geographical notion of circulation.[38]

Centers, Peripheries, and the Provincial

Another model related to the theory of diffusion has in many respects taken the place of acculturation and transculturation in some accounts of cultural exchange. Diffusion is defined as the process of spreading, distributing, or scattering of something away from its locality of original occurrence over a period of time. This approach has the merit of making more neutral assumptions, since diffusion does not necessarily imply that one culture is superior to another, merely that materials or ideas are spread.

This model of diffusion is for example explicitly employed in Gruzinski's latest book. In his and similar accounts, artistic forms and content are said to be diffused throughout the world through the Spanish Empire and the social, religious, and political conditions which it caused to come to be. As a general theory, this might explain the similarities, the shared identities, found throughout the Empire, inasmuch as why the same identity or features related to it were so diffused.

This concept of diffusion is furthermore related to another familiar model of cultural history. This is the model of center and periphery, according to which a center or core is described as related to provinces which are dependent upon it, with a further periphery located beyond these provinces. [...] Among its advantages is that it supplies a general framework for relating artistic products which may be found in various parts of the world in a coherent manner. It functions more fully than other sorts of supranational syntheses which remain bounded by regional, or even hemispheric limits, for example like those seemingly broader-based accounts which, eschewing more limited national approaches, have either encompassed the South American continent,[39] or Iberoamerica as a whole.[40] Consequently it has been applied to an empire like that of Spain, which extended to more than one hemisphere.

37 H. Okada, 'Inverted Exoticism? Monkeys, Parrots, and Mermaids in Andean Colonial Art', 2006.

38 For some aspects of the applications of this concept to Latin America: Kaufmann, *Toward a Geography of Art*, pp. 239–271.

39 D. Bayón and M. Marx, eds., *History of South, American Colonial Art and Architecture*, 1992.

40 R. Gutiérrez, *Arquitectura y urbanismo en Iberoamérica*. 1992, and R. Gutiérrez, ed., *Pintura, escultura y artes útiles en Iberoamérica, 1500–1825*, 1995; G. Gasparini, ed., *Arquitectura colonial iberoamericana*, 1997.

This model lies behind some efforts to incorporate painting in New Spain into the history of Spanish baroque painting. Spanish painting, more precisely art from Spanish centers such as Seville in particular, is thereby said to be related to sites in the Americas; similarly, art in Spanish centers is related to that in supposedly less important sites within Spain itself. Painting in Mexico City is thus said to stand in relation to that in the major Spanish centers, Seville, Madrid, and Valencia, as does painting in Valladolid, Salamanca, and Murcia to them.[41]

A further inference to be read out of this argument, however, is that while the lesser Iberian sites are provincial, those in New Spain are peripheral. It has been explicitly stated that painting in what was the capital of the viceroyalty, Mexico City, occurred on the western frontier of the monarchy, i.e. in a peripheral location. Artists in New Spain are thus considered to be much like any other artists who worked on the periphery of the Spanish Empire. They accordingly occupied a different 'artistic time' than did artists in Spain, or elsewhere in Europe.[42] This does not seem intended as a negative evaluation, since it is said that these artists inherited European models, but sought to create something more than a pure copy, and that even when they clearly seem to have followed Sevillian models, or followed print sources, they created their own distinctive variants, which were in turn replicated.[43] [...]

A related interpretation holds that there are local centers in the Americas themselves. For instance, these were places, sometimes also centers of political power or administration, which also served as centers of art, for schools of painting or sculpture. Such are the well-known schools of painting associated within New Spain not only with Mexico City, but with Puebla, or with Cuzco, Lima, and Quito, where there was also a school of sculpture, and even with Popayan or Bogotá, in the viceroyalty of Peru.[44] These schools of art are thought to have developed independent of hybrid forms or content (although indigenous artists contributed to them) and to have gradually diverged from Spanish models.

Gruzinski himself has however doubted that the singularity of art in New Spain is to be credited to its eccentricity (*excentrement*) or its retardation, and many further objections may be made to the center-periphery

41 J. Brown, 'Cristóbal de Villalpando y la pintura barroca española', 1997.

42 J. G. Victoria, *Un pintor en su tiempo. Baltasar de Echave Orio*, 1994, p. 24.

43 Ibid.; for further discussion of painting types in New Spain of images: M. Burke, *Treasures of Mexican Colonial Painting. The Davenport Museum of Art Collection*, 1998, pp. 29–37; L. Bantel and M. Burke, *Spain and New Spain. Mexican Colonial Arts in their European Context*, 1979, pp. 30–36.

44 For an extensive bibliography for these schools, e.g. Gutiérrez, ed., *Arquitectura y urbanismo en Iberoamérica*.

model. It may well be asked where real centers are located, and where province and periphery lie. The presence of Italian and Italian-inspired art evinces the diffusion of the Italianate, a familiar phenomenon.[45] Many European forms found in both Spain and in the New World did not come from Spain, but from Italy, and from the Spanish viceroyalties there. [...]

Flemish artists and art were also important in viceregal America, as has been increasingly recognized.[46] [...]

Hence both Italy and the Low Countries might be seen as centers of production and diffusion, from which not only the Western Hemisphere but also Spain received impulses. In this sense Spain itself might be regarded as provincial and the Americas as peripheral. Accordingly a place like Seville might be regarded as an artistic *entrepôt*, rather than a center. In fact, it has been recognized that many leading Spanish painters, including those active in Seville and elsewhere in Andalusia who shipped works to the Americas, like Zurbarán, also themselves employed prints as the sources for their compositions; in this regard they worked much as did those painters in the Americas who also copied or emulated other sources.[47]

What is more, recent interpretations of art in New Spain have challenged assumptions that primacy in invention resides in the center, e.g. the Valley of Mexico or of Puebla, and dependence and belatedness on the periphery. Instead it has been demonstrated that innovative iconography appeared in frontier areas of New Spain and was not diffused from the Mexican metropolis; art associated with the missionary activity of the Jesuits thus contradicts the expectations of center-periphery studies, here as elsewhere.[48] Likewise a recent study of Santos in New Mexico has suggested that this region was far from being isolated, and that in any

45 For an introduction to this issue, also in regard to the Americas: Kaufmann, *Toward a Geography of Art*, pp. 187–216, [... .] revising the same author's 'Italian Sculptors and Sculpture outside Italy (Chiefly in Central Europe): Problems of Approach, Possibilities of Reception', 1995.

46 As will be fully considered in an exhibition in planning on Flemish Art in the New World; an essay by the present author 'Flanders in the Americas: Problems of Interpretation', to be published in the exhibition catalogue, is the source of some of these remarks.

47 This is a familiar feature of the art of Zurbarán: e.g., J. Brown, *Francisco de Zurbarán*, 1991, pp. 8ff. Brown, *Painting in Spain 1500–1700*, 1999, p. 1, comments on how Spain may he regarded as peripheral in relation to developments in European art history, considering the 'waves of influence' from Italy and Flanders that 'periodically washed over the country'.

48 C. Bargellini, 'At the Center on the Frontier: The Jesuit Tarahumara Missions of New Spain', 2005.

event it was creating distinctive forms which responded and resulted from much more input than those from a supposedly remote center.[49]

Other revisions have pushed even further the general critiques of theories of both diffusion and of center-periphery. The use of a center-periphery model has been criticized above all because this model itself can be decried as presenting the 'colonizer's model of the world',[50] This critique is particularly relevant for interpretations of the Americas, because regardless of whether or not Italy, Flanders, or Spain is taken to be the center, the Americas (and other parts of the world) are regarded as recipients. The problem obviously is that this particular diffusionist view remains in effect Eurocentric. This critique thus coincides with a more general realization that interpretations of cultural phenomena as the results of diffusion implicitly rely on hierarchical notions of value.[51] In the application of diffusionist or center-periphery models familiar patterns of the colonial and of acculturation thus seem to recur: the Americas still appear to be granted merely a second-rate status at best.

The Viceregal Model

The processes of cultural interchange between Europe and the Americas have consequently been discussed in another manner, which addresses some of these problems. In this view the arts in the Americas are treated not merely as an extension of Spain, but situated in a much larger context, specifically that of the universal Spanish monarchy. In one catalogue and exhibition, cultural interchange is related to the political structures of the Spanish empire.[52] In another similarly large presentation, Asian, African, indigenous, and European elements are treated together as forming a productive amalgam within the empire.[53] Yet another recent survey also emphasizes the global aspects of cultural transfer and production as they are met, in what, however, is still called colonial Latin America.[54]

49 Farago and Pierce, eds., *Transforming Images,* especially D. Pierce, 'The Active Reception of International Artistic Sources in New Mexico', pp. 44–57.

50 J. M. Blaut, *The Colonizer's Model of the World. Geographical Diffusionism and Eurocentric History,* 1993.

51 On diffusion and art history/geography: Kaufmann, *Toward a Geography of Art,* pp. 187–216. The assignment of art in the Americas to a different 'time' also expresses a 'provincialized' European historicist view which has also been criticized: D. Chakrabarty, *Provincializing Europe. Postcolonial Thought and Historical Difference,* 2000.

52 This is the underlying premise of *Los siglos de oro en los virreinatos de América,* made explicit in J. Brown, 'La antigua monarquía española como área cultural', 1999.

53 Rishel and Stratton-Pruitt, eds., *The Arts in Latin America.*

54 Bailey, *Art of Colonial Latin America.*

Nevertheless, since this approach was first divulgated in an exhibition and catalogue devoted to the viceroyalties of America[55] and refers more broadly to them, it is here called 'viceregal'. According to an initial articulation of this perspective, which explicitly acknowledges the global nature of the Spanish Empire, artistic transmission from other realms ruled by the monarchy, such as Flanders, to Spain were replicated in a process of retransmission from Spain to America. The Spanish monarchy with all its constituent parts is seen to constitute a cultural area.[56]

As it has been subsequently elaborated, this approach to the monarchy as a cultural area offers a more elaborate explication of the interrelation of the parts of the empire, and the reception, transmission, and transformation of artistic impulses within it. Specifically, New Spain has subsequently been described as belonging to a political and cultural area formed by a monarchy with global dimensions. However, unlike other cultural empires, in which the center nourished the periphery, Spain is now described as sharing received impulses from its European territories, then reworking them, and then projecting them onto the Americas, which are now described as an important part of the Hispanic cultural area. In the Americas sources are said once again to have been transformed. Following an interpretation suggested by the present author, this phenomenon is described as a process of active transformation.[57]

Although it does not take into account further aspects of circulation, this more sophisticated interpretation of the viceroyalties as a cultural area deals both with what might be called local centers and with local differences, while it allows for the expression of creative potential in all areas considered. [...]

Cultural areas may be identified in various parts of the world. One such area is constituted by the Mediterranean, as illuminated by Fernand Braudel in a famous book. Braudel treated the history and geography of the Mediterranean and the lands around it as interrelated: certain established patterns and conditions existed in the *longue durée*, the long run, against which the history of discrete events, *histoire événementielle* occurred.[58] In a posthumous work Braudel traced the historical course of cultural developments even more directly against the geography of

55 *Los Siglos de Oro en los Virreinatos de América, 1550–1700.*
56 Brown 'La antigua monarquía española como área cultural'.
57 Brown, 'Introduction. Spanish Painting and New Spanish Painting', pp. 17, 271 note 1, where the author refers to Kaufmann, 'Italian Sculptors and Sculpture outside Italy'.
58 F. Braudel, *The Mediterranean and the Mediterranean World in the Age of Philip II*, 1973.

the Mediterranean lands.[59] This approach suggests that the Mediterranean may be considered as a cultural area.

[...]

But the Spanish monarchy would be a different sort of cultural area. Hence, even though the approach to the Spanish Empire as a cultural area may avoid the pitfalls of earlier chauvinistic approaches, and provide a broader conceptual framework comparable to that used for other regions, this interpretation runs into several difficulties. In the first place, this conception does not correspond to the definition of cultural area which has been formulated in geography, and applied in cultural and art history in other instances, because it depends primarily on political, not geographical parameters. It thus artificially delimits the range and impact of some of the important cultural vectors involved.

As much scholarship has demonstrated, Italy and Italianate influences were obviously not limited to the Hispanic world.[60] The same is true for the Flemish impact throughout the world; Netherlandish artists and works of art were ubiquitous. Most important, effects or qualities of the Netherlandish often resemble each other wherever they were to be found. The shared identities they reveal are not particular to the Spanish Empire; since the Italian situation is more familiar, we may elaborate the Netherlandish a bit.

Like Latinate culture in the form of Italian humanism and works of art of an Italianate character, already by the late sixteenth century Netherlandish art and artists enjoyed global expansion. During the sixteenth and seventeenth centuries, paintings and sculpture from many places in the Low Countries, many of them from Antwerp, went to the New World and to other places where Spanish and Portuguese were in contact, and were spread from Macao to Narva. Prints in particular carried art made in Antwerp not only to the Americas, but throughout Europe, and to Asia, also to areas under Dutch control.[61] Significantly, they thus reached many areas which were not under Spanish domination, and had an impact on the making of various forms of art and architecture throughout Europe—not only in Spain—but in many places in the world. Flemish artists (like their Dutch cousins) were indistinguishable in this regard,

59 F. Braudel, *Memory and the Mediterranean*, 2001.
60 A review of these questions was offered initially in Kaufmann, 'Italian Sculptors and Sculpture'.
61 T. D. Kaufmann, 'Antwerpen als künstlerisches Zentnum und sein Einfhuß auf Europa und die Welt', 2002. Also as 'De Kunstmetropool Antwerpen en haar Wereldwijde Invloed', in *Tussen Stadspaleizen* en *Luchtkastelen. Hans Vredeman de Vries en de Renaissance*, 2002, pp. 41–50.

and were involved in painting, drawing, sculpture, and printmaking, and especially in designing and making ornaments, fortifications, fountains, gardens, buildings in many European countries, and on many other continents as well.[62]

[...] In the light of such evidence, there are many reasons to question a primary emphasis on Spain, or rather the Spanish Empire, in dealing with Flemish art in the Americas, as elsewhere. What then makes the borders of the Spanish realm especially significant in regard to the Flemish, or for that matter the Italianate?

This problem has a wider purchase. Even though it has been admitted that the political dimensions of the Spanish Empire exceeded its cultural dimensions,[63] these dimensions do not circumscribe the impact of the Italianate or Flemish and they do not adequately account for the impact of many artists and works of art from other areas that lie outside the bounds of the Spanish Empire. Obviously the impact of Chinese and Japanese art and artifacts (rarely artists) in the Americas or Europe cannot be laid to the hands of the mediation of the Spanish Empire alone. This is especially so, since the Dutch, who gained their independence from Spain, were the sole Europeans with trading privileges in Japan from the mid-seventeenth century; they took Malacca and also had established a strong presence in Formosa (Taiwan), the Pescadores (Sri Lanka), and in India. A similar observation applies to the impact of art from other parts of Europe as well.

[...]

3.7 Benjamin Schmidt, 'Mapping an Exotic World: The Global Project of Dutch Cartography, circa 1700', in Felicity A. Nussbaum (ed.), *The Global Eighteenth Century* (Baltimore, MD and London: Johns Hopkins University Press, 2003), pp. 21–37

In this essay, the historian Benjamin Schmidt offers a preliminary account of a research project that culminated in the publication

62 This is the topic of a research project organized by Michael North, the present author, and others. For the expansion of Dutch architecture, see the massive study by C. L. Temminck Groll, in cooperation with W. Van Alphen, *The Dutch Overseas. Architectural Survey. Mutual Heritage of Four Centuries in Three Continents*, 2002. This is also the subject of a project organized by Krista de Jonge and Konrad Ottenheym.

63 Brown, 'Introduction. Spanish Painting and New Spanish Painting', p. 17.

of his book, *Inventing Exoticism: Geography, Globalism and Europe's Early Modern World* (2015). His work is of art-historical interest because of the importance that he accords to visual as well as verbal representations in his account of the emergence, during the late seventeenth and early eighteenth centuries, of a new conception of the 'exotic world' in relation to which European identity was defined. In arguing that these novel forms of exoticism were largely produced by the Dutch at the time when the Netherlands ceased to be a major player in Europe's colonial expansion, Schmidt revises standard postcolonial analyses that posit a more straightforward connection between knowledge and power. Compare, for example, Edward Said on Orientalism (Section 1, 1.1a). [Emma Barker]

[...] By the later decades of the seventeenth century (and this goes for the early eighteenth century, as well), the Dutch were fast becoming the leading geographers of Europe—prolific authors of literary and cartographic texts, producers of tropical paintings and colorful prints, promoters of exotic rarities and imported *naturalia*—while at the same time assuming a less active role in the theater of European expansion. Or, put another way, the Republic was becoming less and less engaged in conquering the world as it became more and more vested in describing it. [...] Why would the Dutch role as geographers of Europe expand at the very moment that their role in the expansion of Europe contracted? How, furthermore, did the Dutch describe a world that they had a diminished stake in possessing? And—to frame the issue in starkly Foucauldian terms—what shape did knowledge take as it became increasingly disengaged from power?[1]

This essay explores the production of geography in the Netherlands and its impressive dissemination and consumption throughout Europe

1 See Michel Foucault, *The Order of Things: An Archeology of the Human Sciences* (New York: Pantheon, 1970); and *Power/Knowledge: Selected Interviews and Other Writings*, ed. Colin Gordon, trans. Colin Gordon et al. (New York: Pantheon, 1980). The project of Dutch geography ca. 1700 also complicates the classic (and reflexively invoked) thesis of Edward Said's *Orientalism* (New York: Pantheon, 1978) by suggesting that the Dutch described the colonial world not so much to control it as to market it—albeit to others with a vested imperial interest. Said, it is worth adding, derives his source material mostly from the later eighteenth and nineteenth centuries—a period that follows, by half a century at least, the geographic moment described in this essay. See further David N. Livingstone and Charles W. J. Withers, eds., *Geography and Enlightenment* (Chicago: University of Chicago Press, 1999); and G. S. Rousseau and Roy Porter, eds., *Exoticism in the Enlightenment* (Manchester: Manchester University Press, 1990).

circa 1700. As the global eighteenth century got underway, a remarkable profusion of geographic materials issued from the Dutch Republic—an explosion of books, maps, prints, paintings, curiosities, and other objects pertaining to the representation of the non-European world—effectively mapping for the rest of Europe the shape of the expanding globe. Yet both the intense production and the avid consumption of Dutch geography should give pause to students of culture and empire. For geography in early modern (no less than late modern) Europe was a highly interested, generally contested, and idiosyncratically 'national' endeavor not easily transplanted abroad. [...] Yet this habit of tactical—call it 'local'—geography appears to change by the final decades of the seventeenth century, at which time the Dutch appear also to recede from the battleground of global empire. Indeed, what is most striking about this later corpus of Dutch geography is, first, how broadly accessible, attractive, and appealing it is (this, to be sure, from a European perspective); and second, how strikingly unpolemical, apolitical, and disinterested it seems—at least relative to earlier patterns of Dutch geography and, for that matter, competing European traditions of geography. [...]

This chapter probes the very foundations of the global eighteenth century by examining the production of European images of the world circa 1700 and by considering the forms and purposes of those images at this critical moment of history. After briefly reviewing the patterns and traditions of geography in the Netherlands, it outlines the extraordinary expansion of geography in the Dutch Republic in the decades surrounding 1700, and then explores some of the methods and meanings of these sources. By way of conclusion, I wish to propose a very specific Dutch strategy of representing the world at this time, a broadly appealing mode of mimetic engagement that may be termed—to pose the issue as provocatively as possible—*exoticism.*

Making Maps and Other Geographies

Some background: The miracle of Holland, as the phenomenal political, economic, and social expansion of the Northern Netherlands was dubbed even by contemporaries, occurred largely over the first two thirds of the seventeenth century. It is less essential to detail here the astonishing growth of Dutch resources and power—military and diplomatic, commercial and demographic, literary and artistic—than it is to emphasize the timing of the Dutch Republic's meteoric rise from the late sixteenth century and underscore its exceptionally wide-reaching economic and cultural attainments by the middle of the seventeenth century. More pertinent to the subject of geography is the republic's expansion overseas, which likewise took off spectacularly in the earlier seventeenth century,

only to level off or regress thereafter. Trade to Asia began around 1600, with significant conquests (largely at the expense of Portugal) through the middle of the century. After that, though, the Dutch East India Company (Verenigde Oostindische Compagnie, or VOC) gave ground to the English and French; and, if the VOC still turned a profit, it did so increasingly as middleman in inter-Asian trade rather than as master of pan-Asian domains. The story of the Dutch in America presents a still starker model of rise and fall, with conquests in Brazil (again at Portugal's expense) and settlement in New Netherland taking place in the 1620s through 1640s. These gains, however, were followed by the catastrophic loss of Brazil in 1654 and of New Netherland in 1664. The Dutch Atlantic slave trade may have followed a slightly different pattern than other American commerce, in that contracts for slaves increased in the second half of the seventeenth century when the Republic could deliver cargoes for their former Iberian enemies. Yet this traffic was relatively marginal compared to the slaving activities of the English, French, and Portuguese; in Africa more generally, Dutch colonial reversals date from the 1660s and 1670s, when Dutch trading forts fell to superior French and English forces. By the final third of the century, in all events, the Dutch filled the role, in the West no less than the East, of middlemen. Much as they moved colonial goods, they had a minimal stake in colonies per se.[2]

The world according to the Dutch had a lot to do with those events that coincided with its articulation of geography, since the Dutch world view took shape as the Dutch *became* Dutch—as the Netherlands waged its epic struggle against Habsburg Spain, the searing Eighty Years' War that culminated in the Republic's foundation in 1648. Geography played a crucial role in this campaign, though it played a very particular role—by which is meant a provincial and idiosyncratic role—in expressing a new

2 On the East, see Femme S. Gaastra, *De geschiedenis van de VOC* (Zutphen: Walburg, 1991) and Jaap R. Bruijn and Femme S. Gaastra, 'The Dutch East India Company's Shipping, 1602–1795, in a Comparative Perspective,' in *Ships, Sailors and Spices: East India Companies and their Shipping in the Sixteenth, Seventeenth, and Eighteenth Century*, ed. Jaap R. Bruijn and Femme S. Gaastra, NEHA-Series III, no. 20 (Amsterdam: NEHA, 1993), pp. 177–208, which makes a persuasive case for the relative decline, from the late seventeenth century, of the Dutch in Asia. On the West, see Henk den Heijer, *De geschiedenis van de WIC* (Zutphen: Walburg, 1994); and Pieter Emmer and Wim Klooster, 'The Dutch Atlantic, 1600–1800: Expansion without Empire,' *Itinerario* 23, no. 2 (1999), pp. 48–69, which dates the republic's Atlantic decline quite precisely to the final decades of the seventeenth century. The Atlantic slave trade is surveyed in Johannes Menna Postma, *The Dutch in the Atlantic Slave Trade, 1600–1815* (Cambridge: Cambridge University Press, 1990); and see more generally Pieter Emmer, *The Dutch in the Atlantic Economy: Trade, Slavery and Emancipation* (Aldershot: Ashgate, 1998).

Dutch identity to match the new Dutch state. Over the course of the revolt, that is, cultural geographers in the Netherlands fashioned a version of the globe that suited the struggles of the Republic. This applies less for Asia and Africa, in which the Dutch initially showed less interest, than for America, whose 'discovery' and conquest coincided (more or less) with the Dutch revolt. America was the site of Spanish 'tyrannies', which the Dutch pronounced to be parallel to tyrannies committed in the Netherlands. The Indians were construed as allies, fellow sufferers of colonial oppression and brothers-in-arms in the war against Habsburg universal monarchy. 'Colonialism' itself took on an Old World no less than New World meaning: the duke of Alba's subjection of Dutch rebels was habitually juxtaposed with the Habsburg subjection of Indian comrades. This comparison, of course, was an exaggeration, but it was an exaggeration that worked and one that encouraged copious descriptions of 'cruelties' in America, the 'destruction of the Indies', and the tragedy of the *Conquista*—all of which were related to events back in the Netherlands. (It was in this period—the 1570s through 1620s—that the Dutch produced scores of editions of Bartolomé de Las Casas's catalogue of atrocities, *The Mirror of Spanish Tyrannies in the West Indies,* sometimes slyly published with a pendant volume, *The Mirror of Spanish Tyrannies in the Netherlands*). [...]

[...] Once the precarious moment of foundation had passed, however, such meaningful representations of the world lost their purpose. By the later decades of the century, the Dutch abandoned the topos of 'Spanish tyranny in America', quit their publication of Las Casas and other polemical tracts, and generally reoriented their geography away from their distinctly provincial image of America. Yet they did not abandon the project of geography altogether. Quite the contrary, they began to produce in these years more works, in more forms, than ever before. The sparkling maps, dazzling globes, and exceptionally well-regarded atlases produced in the Netherlands were coveted across the continent. Dutch-made prints, tropical paintings, and rare curiosa were traded among European princes, merchants, and scholars; while Dutch natural histories, protoethnographies, and accomplished geographies, in multiple editions and translations, became the standards throughout Europe. In presenting these materials, moreover, the Dutch adopted a distinct strategy of exoticism in order to market a version of the world that, rather than remaining peculiarly Netherlandic, was rendered more widely attractive to the whole of Europe. No longer as invested in the race to colonialize, the Dutch could afford to step aside and operate the concession stand, as it were, of European expansion, offering images of the world to those fast entering the competition.

The materials produced by the Dutch are unusually bountiful and strikingly beautiful. They are notably broad-ranging as well, both in their impressive attention to the vast baroque world and in their remarkable span of genres, media, and objects enlisted to represent that world. They comprise, most basically, 'traditional', printed geographies which, in the humanist mode gave broad outline to the cosmos. [...] Slightly less global in their focus, regional geographies took the form of fabulous folio works, which were sometimes called 'atlases' and were always chock-full of foldout maps, engravings, and the like [. ...] Exotic travel narratives, a more peripatetic genre, likewise streamed off Dutch presses at a torrential pace [. ...] A final category that falls under the rubric of literary text is the Dutch 'books of wonders'—a genre approximating printed *Wunderkammer*—which jumbled together the multiple marvels, mores, and curiosities of the world; arranged these with happy disregard for context or place; and then packaged them with such come-on titles as 'The Great Cabinet of Curiosities' 'The Wonder-Filled World', or, more prosaically, 'The Warehouse of Wonders'.[3]

Most of these works included maps, an indication that the Republic by this time had become the unrivaled capital of cartography. [...] This applies, moreover, to a remarkably wide range of products and consumers, for the Dutch cartographic industry served both ends of market. It churned out cheap sheet maps, topical news reports, and copious city views for the less affluent buyer; while also manufacturing premiere globes, watercolor topographies, and opulent wall maps—such as [Joan] Blaeu's stupendous, three-meter wide *mappa mundi* (a copy of which reached the court of the shogun in Edo) and his brilliant map of Brazil, decorated with extensive 'local' scenery engraved by the artist Frans Post [...].[4]

Post's name is associated chiefly with a whole other class of images—tropical landscapes—that rightfully belong to the field of geography. The Dutch invented and then abundantly produced the tropical landscape, a new genre that developed in the final half of the seventeenth century—not, that is, in the Golden Age of Dutch painting, when landscapes were dedicated almost exclusively to domestic, or perhaps Italian, scenes. Now, however, the expanding colonial world could be viewed on canvas in bright and vivid color [... .] Post himself concentrated on Brazilian scenes and pastoral settings, his lush foregrounds overflowing with the rich *naturalia* of the tropics. Other regions attracted other painters. Dirk

3 [Bibliographical note omitted].
4 [Bibliographical note omitted].

Valkenburg cornered the market on Suriname; Andries Beeckman covered the East Indies; Reinier 'Seaman' Nooms portrayed northern Africa; and Gerard van Edema applied his brush to that urban jungle lately known as New York, which he painted almost exclusively for English patrons. Dutch artists also undertook various still lifes of foreign flora, fauna, and indigenous peoples. [...] All of these images, finally, could be recycled in tapestries—the Gobelins series for Louis XIV being among the most famous example—or in earthenware or other decorative arts, produced largely in Delft though sold throughout the continent.[5]

The objects shown in the paintings and decorative arts were sorted out more meticulously in natural histories, of which the Dutch produced, once again, the most impressive samples. [...] Actual specimens could be handled or even purchased from Dutch *Kunst-* and *Wunderkammern*, which swelled in number during these years. Shells were the best preserved and therefore most popular items, though a wide variety of *naturalia, artificialia,* and hybrid items bridging the two categories—finely painted shells, artfully crafted fossils, ingeniously worked coral—could be had from Dutch dealers. Finally, paintings of collectibles also sold briskly: still lifes of rare flowers, exotic shells, or other imports from the Indies; or paintings of the very cabinets themselves—sometimes real though often imagined—like the fabulous renditions of connoisseurs' cabinets from the hand of Jan van Kessel. [...]

The commerce in collectibles (and in geography more generally) highlights the impressive migration of these products, and it is important to stress just how far and wide Dutch geography dispersed and how influential the Dutch version of the world consequently became. Though not all of these sources can be readily traced, certain patterns of patronage can be reconstructed, especially as they pertain to Europe's most prominent consumers. German, French, and English aristocrats, among others, avidly collected Dutch tropical landscapes, for example, Louis XIV acquired a spectacular trove of Americana in 1679, including twenty-seven canvases by Frans Post. Maps and globes also circulated in the finest studies and drawing rooms of Europe. Queen Christina of Sweden assembled a collection of stunning cartographic watercolors, the so-called Vingboons atlas, illustrating nearly every port of interest in the non-European world. Peter the Great came to Amsterdam to buy, among other things, every *Wunderkammer* he could lay his hands on, following in the steps of Grand Duke Cosímo III de' Medici, who had raided Dutch collections only a few years earlier. Less is known about consumption at less elevated levels

5 [Bibliographical note omitted].

3.3 Jan van Kessel, *America* (centre panel), 1666

because fewer traces remain, though it is apparent that Dutch prints and sheet maps scattered widely and that their images were recycled aggressively across the continent. The circulation of published geographies makes a still deeper impression. Printers in Paris and London—Ogilby being a prime example—poached, pirated, and otherwise published Dutch texts, and sources originating in Holland spread from Stockholm to Naples and from Dublin to Dresden. Readers of German, Latin, English, French, Swedish, and Spanish all had access, in one form or another, to the bounty of Dutch geography. Consumers of books and prints, maps and paintings, rarities, and other mimetic forms of the world as imagined circa 1700—the dawn, that is, of the global eighteenth century—could avail themselves of the flood of products that streamed so impressively from the Dutch Republic.

Mapping an Exotic World

Why the universal attraction of Dutch geography? How (to frame the issue from the perspective of the producer) did these materials win such a wide following? Consider the fantasy cabinet of Jan van Kessel, which purports to portray a collector's ideal—and thus the allure of this brand of geography (Figure 3.3). Whatever the panel's many charms, one is hard pressed to identify a single theme, or a signal object, that draws the

viewer into this undeniably compelling collection. On the contrary, one is struck by the abundance and variety of stuff and by the shapeless bric-a-brac quality of its arrangement. The painting is labeled *Americque*, though it would seem to lack a tightly focused American theme. One of a number of Indians sits in the foreground, though she is coupled with a dark-skinned African clad in feathers. To the woman's left stands a cherubic Indian boy, also decked in feathers and armed with an iconic bow and arrows; yet at her feet kneels another child—naked and less fair than the 'Indian'—who plays with a set of Javanese gamelan gongs. The woman dancing through the door, meanwhile, wears *East* Indian costume, and to the right is a depiction of a Hindu suttee. Numerous other visual devices, in much the same manner, point to the subtle blending of races and the nonchalant bleeding of regions that occur throughout the panel. Next to the Javanese drummer boy struts an African crowned crane whose curving neck guides the viewer's eye toward a perched macaw and a toucan—two birds closely associated with Brazil. Between these glamorously tropical fowl, a whiskered opossum heads toward a sturdy anteater—we are, once again, in the landscape of America—yet the framed (and framing) insects and butterflies (top and bottom right) derive from both Old and New World habitats. The background statuary bracketing the open door features Tapuya Indians (modeled closely on drawings by the Dutch painter Albert Eckhout), while the niches on the right display a pair of Brahmins. Between these stone figures, in the corner, rests a suit of Japanese armor whose sword points plainly toward a Brazilian agouti and a centrally placed armadillo—the latter belonging to the standard allegorical representation of America, as codified earlier in the century in Cesare Ripa's *Iconologia*.[6] In place of specificity—the strategy that had characterized Dutch geography at the height of its struggle against Spain, when images of America resolutely stressed the theme of Habsburg tyranny abroad—the panel conveys a remarkable sense of indeterminacy. Rather than the New World per se (let alone a Dutch

6 See P. J. P. Whitehead and M. Boeseman, *A Portrait of Dutch Seventeenth-Century Brazil: Animals, Plants and People by the Artists of John Maurits of Nassau*, Royal Dutch Academy of Sciences, Natural History Monographs, 2d ser., vol. 87 (Amsterdam: North Holland, 1989, 90–94, which offers a superb reading of the paintings' naturalia; cf. the armadillo-riding 'America' in Cesare Ripa, *Iconologia* (p. 605 in the 1644 Amsterdam edition of this standard text, which first appeared with the American allegory in 1603 [Rome] and then in countless editions throughout the century). Note that while van Kessel, technically speaking, was not a 'Dutch' painter—his workshop was based in Antwerp—the painting *Americque* very clearly derives from Dutch iconographic sources, as is meticulously detailed by Whitehead and Boeseman.

New World), one gets an almost haphazard assembly of exotica from around the globe. Objects are in disarray and, in a crucial sense, decentered. Why title the work 'America' at all, if it comprises so much more of the generically non-European world?

This sort of indeterminacy characterizes many of the sources emanating from the Republic circa 1700. There is a mix-and-match quality to Dutch geography of this period that stands in sharp contrast to the more sharply focused view propagated earlier in the century. When Johannes de Laet, a director of the Dutch West India Company, published Willem Piso's natural history of Brazil in 1648, he made clear in his prefatory materials the vital place of the Dutch in America—where they still retained, after all, important colonies. A number of years later (by which time those colonies had been lost), the work was reissued by an Amsterdam publisher with the patriotic preface excised, replaced by a poem in praise of wonders. A study of nature in the East Indies had also been added, along with a wholly new frontispiece that casually blends a heraldic Brazilian figure with a vaguely Persian one.[7] The same process also transformed a chronicle of the Brazilian travels of Johan Nieuhof, which originally lauded the Republic's rise in the West. When they later appeared in print in 1682, however, Western adventures merged with Eastern tales (Nieuhof's visit to China and Persia), the frontispiece once again inviting the reader to join in a more dizzying spin of the globe. The text itself does present two separate sets of travels in the order they took place, yet the illustration program is less fussy. Facing a description of Jewish merchants in Brazil is an otherwise incongruous engraving of a Malay couple, intoxicated with tobacco (a subtle allusion to international commerce?). An image of a Malabar snake charmer turns up in a chapter on indigenous Brazilians allied with the Dutch, leaving readers to ponder the relation between New World Indians and Old World enchanters, and the far-fetched correlation of the two [...].[8]

Relative to earlier models, then, the new geography promoted a freshly decontextualized, vertiginously decentered world. It offered sundry bric-a-brac—*admirabilia mundi,* as one writer put it—intended for a vast and

7 Willem Piso et al., *Historia naturalis Brasiliae* (Leiden and Amsterdam, 1648); and cf. *De Indiae utriusque re naturali et medica libri quatuordecim* (Amsterdam, 1658).

8 Johan Nieuhof, *Gedenkweerdige Brasiliaense zee- en lantreize door de voornaemste landschappen van West en Oostindien,* 2 pts. (Amsterdam, 1682). Nieuhof's volume contained dozens of similarly engraved illustrations of exotic 'races,' which endeavored to show the reader not only the look of local inhabitants but also the 'mores' and 'habits' of the region. It was not uncommon for these plates to be confused in the process of printing—misnumbered, misplaced, mislabeled—especially in non-Dutch language editions of the book.

cluttered mental cabinet of curiosities. Dutch sources of this period expressly do not develop the sort of polemical themes of the earlier literature, choosing instead to highlight the collectively admired, if indistinctly located, rarities of the world. One best-selling author states his strategy as purposeful discursiveness. He confesses to offering no more than quick 'morsels' of exotica, since variety, surely, was the spice of geographic life. Spain's colonial record, so central for his predecessors, is briefly considered and mildly commended, even, for the manner in which God had been delivered to the tropics. For another writer, Simon de Vries, Spain's greatest imperial sin was its lack of *curiosity* in its colonies—an appalling lapse for this author of tens of thousands of pages of 'curious observations' of the Indies. Rarity is de rigueur in de Vries's *Great Cabinet of Curiosities;* the reader is invited to rummage through the strangeness, otherness, and oddities of the world. This volume amounts to a two-thousand-page descriptive tour de force that skims nimbly over events and habits, objects and creatures, scattered across the globe. Wampum in New York and wantonness in Brazil, dragons in India and drachmas in Attica, cabalism of the Jews and matrimony of the Lapps: all are deposited into a single 'warehouse of wonders' (the title of another de Vries vehicle) from which readers could pick and choose the curiosa of their choice.[9]

These volumes' marvelous eclecticism, stunning breadth, and formidable vastness suggest a whole new order of geography. The Dutch had repackaged the world and transformed it into gargantuan, sprawling compendia of 'curiosities'. Like the exuberantly cluttered foregrounds of Frans Post's tropical landscapes, they teemed with lush description and dense detail of the late baroque world. Rather than restricting attention to Dutch deeds and Dutch settlements, they explored with encyclopedic interest *all* of the savage creatures, unusual inhabitants, and unknown landscapes of the globe. Rather than following the familiar tropes of earlier Dutch narratives, these works celebrated precisely the unfamiliar and indeterminate 'strangeness' of the Indies. Dutch geography tolerated—encouraged even—variety. It cultivated chaos, and it reveled in randomness. Most importantly, it declined to play to a specific audience or perspective; it did not promote a particular place or purpose; it targeted no contested

9 P. de Lange, *Wonderen des werelds* (Amsterdam, 1671), 'Aen de Leser,' sig. A2 (on exotic 'morsels' and 'admirabilia mundi'); Simon de Vries, *D'edelste tijdkortingh der weet-geerige verstanden: of De groote historische rariteit-kamer,* 3 vols. (Amsterdam, 1682); *Wonderen soo aen also in, en wonder-gevallen soo op als ontrent de zeeën, rivieren, meiren, poelen en fonteynen* (Amsterdam, 1687), 266 (on lack of Spanish curiosity); cf. *Curieuse aenmerckingen der bysonderste Oosten West Indische verwonderens-waerdige dingen,* 4 pts. (Utrecht, 1682); and *Historisch magazijn* (Amsterdam, 1686).

region or rival. It pursued, rather, what one magnificent tome of Asiana pronounced the 'pleasures' of the exotic: *Amoenitates exoticae*.[10]

Along with the metaphor of the warehouse and commerce, the cabinet and collecting, Dutch geography also adopted the metaphor of the theater and stage—as in Petrus Nylandt's *Schouw-toneel der aertsche schepselen* (Theater of the World's Creatures, 1672), a printed performance of global marvels that spanned everything from the feathered American turkey to the turbaned Ottoman Turk—both shown on its splendidly jumbled title page [...].[11] [...] He emphasizes the pleasure of wonder and the diversity of culture in a rich and plentiful world; his broad-ranging tour of the extra-European universe deliberately strips that world of all geopolitical specificity. Nylandt purges his 'theater' of polemics; he makes no mention of colonial contests; he favors delight over didacticism. Or rather, Nylandt's message, like that of so many other practitioners of Dutch geography, eschews the pugnacious and political in favor of a generically appealing version of the globe that seemed to sell. Nylandt made the world palatable to all by offending none—in Europe, at least.

The global dramas staged by Nylandt and his contemporaries—the immense stock of geography, cartography, natural history, tropical painting, and travel literature produced in the Dutch Republic—was indeed an 'embarrassment of riches'. Yet they were riches meant to be moved from the shop, atelier, and merchant ship to the shelf, study, and *Kunstkammer* of consumers across Europe. To do so, the Dutch created an image—pursued a marketing strategy, as it were—that presented the increasingly contested globe as a decontextualized, decentered repository of bountiful curiosities and compelling collectibles. Less and less involved themselves in colonizing overseas, the Dutch could now afford to present a neutral, widely agreeable, perhaps even bland image of the world. Rather than the local and provincial, they now strove for the global and universal—at least, it merits reiterating, from the colonial European perspective—in projecting a world of alluring, enticing, spectacular richness. By the opening of the global eighteenth century, that world had become simply exotic.

10 Engelbert Kaempfer, *Amoenitatum exoticarum politico-physico-medicarum fasciculi V, quibus contineutur variae relationes, observationes & descriptiones rerum Persicarum & Ulterioris Asiae* (Lemgo, 1712).

11 Petrus Nylandt, *Het schouw-toneel der aertsche schepselen, afbeeldende allerhande menschen, beesten, vogelen, visschen, &c.* (Amsterdam, 1672).

3.8 David Porter, 'A Wanton Chase in a Foreign Place: Hogarth and the Gendering of Exoticism in the Eighteenth-Century Interior', in Dena Goodman and Kathryn Norberg (eds), *Furnishing the Eighteenth Century: What Furniture can tell us about the European and American Past* (New York and London: Routledge, 2007), pp. 49–60

This extract is taken from a collection of essays which focus on the interactions between people and things in European and colonial interiors, examining the place of furniture in eighteenth-century social and cultural life. In his essay, David Porter, a leading scholar of European responses to Chinese culture, unpicks the craze for Chinese furnishings in eighteenth-century Britain and the gendering of this taste through the lens of William Hogarth's *The Analysis of Beauty*. Porter argues that imported Chinese wares embodied many of the aesthetic values Hogarth espoused, examining the goods which were 'colonising' eighteenth-century interiors, focusing on tea-drinking and porcelain. However, the Chinese style was rejected by Hogarth (despite Hogarth's ownership of chinoiserie goods) and Porter argues that it was not only the style's rejection of naturalism and its challenge to aesthetic nationalism which underlay this, but also fears around female aesthetic agency which left male participants as passive observers. [Clare Taylor]

Once the exclusive domain of collectors and connoisseurs, the furnishings that adorned the eighteenth-century interior have begun [...] to attract the interest and admiration of scholars intrigued by the rich and varied contexts of their production and consumption. The eighteenth century has proven especially fertile ground for a cultural history of domestic objects in part, of course, because there were many more such objects in circulation than there had been in any earlier period, thanks to expanding consumer markets and the ever-increasing allure of novelty and fashion across all social strata. But these card tables and writing desks, candelabras and cellarets also acquired layers of meaning—and hence interest for cultural historians—from the ideas and debates that circulated alongside them. In eighteenth-century Britain, two of the most important of these discursive contexts were a fascination with the foreign and the exotic, on the one hand, and with philosophical questions regarding the nature of taste and beauty on the other. The intersection of these two concerns can be seen nowhere more clearly than in the craze for Chinese furnishings—including lacquerware chests and fire screens, but also

wallpapers, porcelain vases and statues, and of course tea wares—that made a 'Chinese room' de rigueur among fashionable households of the mid-eighteenth century. The emergence of the Chinese taste in furnishings within the space of these intersecting concerns stamped Chinese objects with a set of profoundly gendered meanings that have persisted, in some degree, to this day. This chapter will examine this gendering of the Chinese taste through the works of one of the most prominent artists and aesthetic theorists of the eighteenth century, William Hogarth.

Popular conceptions of beauty today most clearly betray their eighteenth-century origins in their emphatic insistence on disinterestedness as a precondition of artistic value. Theorists from Shaftesbury to Kant argued that a pure experience of the beautiful required a state of transcendent aloofness from the yearnings of the flesh and the pull of ideological attachments.[1] Aesthetic experience is meant to be a chaste, strictly nonpartisan affair; the depth of pleasure it can afford is owing precisely to the freedom it offers from the merely contingent and material. [...]

The line from Shaftesbury to Kant, however, is not without its serpentine twists and detours. Edmund Burke struggles mightily, in his *Philosophical Enquiry into the Origin of our Ideas of the Sublime and Beautiful,* to sustain a clear distinction between a pure aesthetic love for beauty and an animal lust for the attractive women in whom he clearly found beauty most frequently incarnate. One reason, however, that we hear so much less about his account of the beautiful in the *Enquiry* than about his theory of the sublime is that he is embarrassingly unsuccessful at sustaining this distinction. Whereas Kant has the good sense to limit his examples of beauty to such unproblematic objects as flowers and arabesque designs, Burke severely compromises his credibility as an impartial arbiter of aesthetic value by basing his catalog of the empirical attributes of beauty on his close observation of sexually attractive young women, invoking their lisps, tottering steps, and even feigned distresses as emblems of a universal aesthetic ideal. In his discussion of the importance of 'gradual variation' as a formal quality of beauty, for example, he writes with the air of a seasoned connoisseur,

> Observe that part of a beautiful woman where she is perhaps the most beautiful, about the neck and breasts; the smoothness, the softness; the

1 On the history and implications of disinterestedness as a component of the aesthetic attitude, see Jerome Stolnitz, 'On the Origin of Aesthetic Disinterestedness,' *Journal of Aesthetics and Art Criticism* 20 (1961), pp. 131–43, and Elizabeth Bohls, 'Disinterestedness and the Denial of the Particular: Locke, Smith, and the Subject of Aesthetics,' in *Eighteenth-Century Aesthetics and the Reconstruction of Art,* ed. Paul Mattick (New York: Cambridge University Press, 1993).

easy and insensible swell; the variety of the surface, which is never for the smallest space the same; the deceitful maze, through which the unsteady eye slides giddily, without knowing where to fix, or whither it is carried.[2]

To corroborate his argument, Burke cites the opinion of 'the very ingenious Mr. Hogarth', pointing to Hogarth's famous line of beauty—an elongated S-shaped curve that was meant to represent the highest aesthetic ideal— as if to vindicate his otherwise perhaps too obvious delectation of the female form.[3] But Burke's more important debt to Hogarth goes conspicuously unacknowledged, and that is precisely the invocation of the beautiful, living woman as the cornerstone of an empiricist aesthetic theory. Hogarth's *Analysis of Beauty* (1753), more than any other aesthetic treatise of the period, rejects the Shaftesburian requirement of disin- terestedness as a precondition of the experience of beauty, and indeed revels in the possibilities of sensuality and eroticism as components of aesthetic pleasure. According to Ronald Paulson, 'Hogarth is attempting to create an aesthetics that acknowledges that if we place a beautiful woman on a pedestal we will inevitably and appropriately desire her and may discover, moreover, that she is not strictly virtuous'. It is an aesthetics of 'novelty, variety, intricacy, [and] curiosity' that foregrounds the pleasures of the chase and the tantalizing deferral of discovery, an 'aesthetics of seeing under or into' that vindicates the natural wantonness of the wandering gaze.[4]

[...] The *Oxford English Dictionary* quotes Shakespeare, Arbuthnot, and Samuel Johnson, among others, using the word *wanton* in the sense of lascivious or given to amorous dalliance. And the intricate objects that most frequently catch the eye, in Hogarth's account, are not ornamental carvings, but beautiful women. Nor are these the idealized beauties of classical statuary, held safely aloof from the realm of earthly desire by their transcendence of the particularities of actual bodies, but rather the living women of Southwark Fair and Covent Garden. 'Who but a bigot', Hogarth famously asks, 'will say that he has not seen faces and necks, hands and arms in living women, that even the Grecian Venus doth but coarsely imitate?' These women, moreover, are consistently presented as the objects of an explicitly eroticized gaze. Like the wanton ringlets adorning the fair head of Milton's Eve, 'the many waving and contrasted

2 Edmund Burke, *A Philosophical Enquiry into the Origin of our Ideas of the Sublime and Beautiful*, ed. James T. Boulton (Notre Dame, IN: University of Notre Dame Press, 1968), p. 115.
3 Ibid.
4 Ronald Paulson, Introduction to William Hogarth, *The Analysis of Beauty*, ed. Paulson (New Haven, CT: Yale University Press, 1997), pp. xxxiii, xxxvii, xlix.

turns of [their] naturally intermingling locks ravish the eye with the pleasure of pursuit'. The fashionable adornments of Eve's postlapsarian progeny serve only to heighten the effect: while a naked body soon satiates the eye, Hogarth says, 'when it is artfully cloath'd and decorated, the mind at every turn resumes its imaginary pursuits concerning it'.[5]

The unabashed eroticism that informs Hogarth's conception of aesthetic experience poses a problem for those who would preserve the phenomenology of beauty from the tyranny of desire. Within the context of Hogarth's text, however, it also presents a second, less frequently considered conundrum. Not the least of Hogarth's radical departures from the established norms of contemporary aesthetic theory is his insistence on the universal accessibility of the aesthetic experience he describes. Whereas Shaftesbury and later Hume depict a sanctified realm of high art whose full enjoyment is limited to an elite cadre of cultivated men of taste, Hogarth insists 'that no one may be deterr'd, by the want of ... previous knowledge, from entering into this enquiry'. This antiacademic, populist gesture is clearly intended primarily to undercut the monopoly on taste held by that wealthy class of connoisseurs that was the consistent object of Hogarth's disdain. But Hogarth appears sensitive to the exclusions of gender as well as class implicit in the received ideal of the man of taste: he holds out the promise of aesthetic edification to all readers of his book, 'ladies, as well as gentlemen'.[6] Given this conspicuous commitment to inclusiveness, it is striking that women are entirely absent as aesthetic subjects throughout the remainder of the text. When the gaze is gendered in the *Analysis*, it is inevitably gendered male. And when a human body figures as the object of aesthetic contemplation, it is, without exception, female. The hegemony of the male gaze is, obviously, an all-too-familiar dynamic in any number of historical contexts. Within the specific context of an iconoclastic work, however, that claims to present a universally valid theory of beauty to readers of both sexes, an aesthetic so closely modeled on the dynamics of an exclusively heterosexual male desire seems especially problematic. Where, we are left to wonder, do the eyes of Hogarth's women turn in their own pursuit of aesthetic pleasure? And how can one account for Hogarth's silence on this point?

Though the well-documented excesses of male foppery in the eighteenth century suggest that the beaux of the period expected a certain reciprocity in aesthetic desire between the sexes, Hogarth's adjudication of the human physique according to the serpentine line of beauty rules out a strict

5 Hogarth, *Analysis*, ed. Paulson, pp. 59, 34–35, 40.
6 Ibid., p. 18.

equivalency of pleasure. A simple comparison of the relative appeal of a series of increasingly curvaceous lines illustrated in one of the two plates accompanying the text proves for Hogarth 'how much the form of a woman's body surpasses in beauty that of a man'.[7] Should the female reader be disheartened by this revelation, she will find in the same plates no shortage of suitably curvaceous alternatives—including corsets, table legs, candlesticks, fingers, and leg bones—provided for her delectation [...]. As captivating as some of these emblems of the line of beauty surely are, one can't escape the conclusion that those readers who don't share Hogarth's lusty delight in the spectacle of a consummately attractive woman are somehow getting the short end of the stick.

If Hogarth is silent on the question of women's aesthetic proclivities in *The Analysis of Beauty*, a review of his visual oeuvre suggests that it is not for a lack of information. Not surprisingly, the attractive woman figures prominently as an aesthetic object in many of his paintings and engravings. What is surprising is the number of women Hogarth depicts as aesthetic agents and the uniformity, in one crucial respect, of their aesthetic preferences. The most important literary source for popular conceptions of female taste in the early eighteenth century is, without a doubt, Alexander Pope's poem, *The Rape of the Lock*. Hogarth's early illustration of the poem, showing a distracted Belinda seated with her companions at tea, reminds us that the taste of wealthy women, at least, tended toward the foreign and the exotic. Within the poem, Belinda's tea-drinking habit is associated with vanity, extravagance, and luxury, to be sure, but it is also the mark of a particular aesthetic sensibility privileging rare foreign commodities that tend, according to Pope, to glitter, glow, and shine. The historical context of the reference to tea drinking is the rapidly expanding China trade of the East India Company, a trade that by the 1720s had established the tea party as the preeminent site for the conspicuous display of a woman's taste and social status.[8] Hogarth's early conversation pieces conspicuously illustrate the importance both of tea drinking as a social ritual and of the tea service itself as a marker of wealth and refinement. But imported porcelains and other examples of the fashionable Chinese taste crop up regularly in the satirical works as well, most frequently as a symbol of corrupted taste and, by implication, debauched morality, as in the second plate *of Marriage à la*

7 Ibid., p. 49.
8 See the chapters on tea in Elizabeth Kowaleski-Wallace, *Consuming Subjects:Women, Shopping, and Business in the Eighteenth Century* (NewYork: Columbia University Press, 1997), pp. 19–72; and James Walvin, *The Fruits of Empire: Exotic Produce and British Taste, 1660–1800* (NewYork: NewYork University Press, 1997), pp. 9–31.

Mode (which I discuss below), or as an exemplar of the absurd excesses of modern fashion, as in *Taste in High Life*.

So, if Hogarth was clearly aware of a widely held belief in the affinity of female taste for a particular class of exotic commodities, why is there no mention of this taste in *The Analysis of Beauty?* One might have thought that a shapely Chinese vase or teapot would have provided a more visually appealing exemplar of the formal principles he describes than a human leg bone, and that it would have offered the added advantage of being a familiar object that many of his readers would have readily recognized as reflecting their own decorative tastes.

Indeed, Chinese import wares of the period perfectly exemplify many of the aesthetic values Hogarth champions in the *Analysis*. The unique qualities of porcelain itself—purity, smoothness, translucence, delicacy—bespeak the refined elegance and gentility that, as Paulson argues, are at the very center of Hogarth's creed. Many of the shapely objects into which Chinese potters fashioned this magical material likewise demonstrated the truth of Hogarth's claims for the visual power of the serpentine line of beauty. Even the imaginative exercise he advocates as a means of recognizing the lines of beauty in complex three-dimensional objects would seem to be modeled on the visual experience of a thin, translucent porcelain vessel: 'let every object under our consideration, be imagined to have its inward contents scoop'd out so nicely, as to have nothing of it left but a thin shell, exactly corresponding both in its inner and outer surface, to the shape of the object itself'.[9]

One might expect, moreover, that as a champion of the rococo style, Hogarth would have found in chinoiserie more generally a set of decorative principles much in accord with his own. The designers of the Chinese and Chinese-styled silks, fire screens, wall hangings, furniture, and even garden buildings that were colonizing contemporary English sitting rooms and country gardens adhered fastidiously to the rules of intricacy, variety, asymmetry, and nonlinearity he would promote in the *Analysis*. While these compositional attributes guaranteed the formal complexity necessary to engage the eye in its wanton wanderings, Chinese goods in their inescapable exoticism also invited imaginative play on another level entirely. The radical unfamiliarity of their visual language, the obscurity of their local meanings and cultural points of reference would have presented to the Hogarthian viewer an occasion for imaginative pleasure every bit as alluring as its surface design. For Hogarth, after all, it is not only the eye that seeks diversion in art but the mind as well.

9 Hogarth, *Analysis,* ed. Paulson, p. 21.

The active mind is ever bent to be employ'd. Pursuing is the business of our lives; and even abstracted from any other view, gives pleasure. Every arising difficulty, that for a while attends and interrupts the pursuit, gives a sort of spring to the mind, enhances the pleasure, and makes what would else be toil and labour, become sport and recreation.[10]

The essence of exoticism as an aesthetic attribute, I would argue, is that it erects precisely such a pleasing barrier to the immediate assimilation of a visual spectacle, a teasing sense of alienation from the familiar every bit as captivating as the wanton ringlets of a lover's flowing hair.

For a whole host of reasons, then, one would reasonably expect Hogarth to recognize and acknowledge the considerable aesthetic appeal of the Chinese goods his readers purchased and admired. And indeed, scholars have established that he owned a number of decidedly chinoiserie pieces himself.[11] Yet in *The Analysis of Beauty*, when the Chinese style is mentioned at all, it is summarily dismissed as an absurd and foolish taste unworthy of the least serious consideration. In a passage about the ubiquity of his line of beauty in depictions of the deities of classical civilizations, Hogarth remarks on the contrast presented by the Chinese case. 'How absolutely void of these turns are the pagodas of China, and what a mean taste runs through most of their attempts in painting and sculpture, notwithstanding they finish with such excessive neatness'.[12] Hogarth's manuscript notes on academies and the Society of Arts confirm this disparaging view of Chinese artistic production: in a discussion of the appropriate education for young artists, he praises English fabric designers for copying 'the objects they introduce from nature; a much surer guide than all the childish and ridiculous absurdities of temples, dragons, pagodas, and other fantastic fripperies, which have been imported from China'.[13]

In light both of these seemingly compelling reasons that Hogarth should have looked more kindly on these fantastic fripperies, and the circumstantial evidence that, in fact, he sometimes did, why does he lash out with such uncompromising fury against the popularity of the Chinese taste? A number of possible explanations immediately suggest themselves. To begin with, Hogarth's criticism of Chinese art on the grounds that it did not adhere to conventions of naturalistic representation was a commonplace one at the time. Although Hogarth rejected a classicist

10 Ibid., p. 32.
11 Lars Tharp, *Hogarth's China: Hogarth's Paintings and Eighteenth-Century Ceramics* (London: Merrell Hoberton, 1997), p. 49.
12 Hogarth, *Analysis*, ed. Paulson, p. 12.
13 William Hogarth, *Anecdotes*, ed. J.B. Nichols (London: Jones and Co., 1833), p. 37.

conception of nature as idealized form, he believed strongly that nature in its infinite variety was the artist's most trustworthy guide. To the extent, then, that Chinese art seemed to flout any standard of verisimilitude, it was beyond the pale of even Hogarth's postclassicist sensibilities. Furthermore, the popularity of the Chinese style surely grated on Hogarth's keenly developed sense of aesthetic nationalism. While perhaps weakening the claims of the highbrow connoisseurs to being the sole arbiters of fashionable taste, Chinese imports, like old Italian paintings, nonetheless threatened the livelihood of the native-born English artists Hogarth saw it as his mission to promote. To the extent that Chinese art seemed to replicate the rococo stylistics he espoused, there was all the more reason to repudiate it forcefully as a foreign usurper of English artistic glory.

I am more intrigued, however, by a third, less immediately obvious explanation for his disdain—an explanation that returns to the problem in the *Analysis* I raised at the beginning of this essay. Hogarth's repeated insistence on the worthlessness of the Chinese style, I would like to suggest, is intimately bound up with his perplexing silence on the question of female aesthetic agency. A closer look at some of the many contemporary literary and visual representations of Chinese goods and their domestic consumption will help to elaborate this connection. As in *The Rape of the Lock,* Chinese import goods figure prominently in these works as emblems of female vanity and extravagance. More intriguingly, though, their physical qualities are often compared to those of the women who collect them. Both fine ladies and fine porcelain, the familiar simile goes, are prized for their smooth surfaces and radiant splendor, but they are equally fragile as well, and are soon despised for the appearance of a crack or flaw. The analogy could, at times, appear so compelling as to elide any remaining differences between them. In *Royalty, Episcopacy, and Law,* for example, Hogarth imagines a courtly lady as a pastiche of exotic commodities, including a fan for a body and a teapot for a head [...]; in a contemporary poem entitled 'Tea, or Ladies into China-Cups', the anonymous poet effects a like transmutation of English women into the porcelain vessels of which they are so enamored.[14]

From the perspective of female aesthetic agency, the implications of an imagined identity between female consumers and the objects of their consumption are suggestive, to say the least. If women, in their pursuit of beauty, turn to objects that either resemble or are understood as synecdochical extensions of themselves, the result is an entirely self-contained, self-reflexive economy of female desire. Whether this economy

14 *Tea, A Poem or Ladies into China-Cups; A Metamorphosis* (London, 1729).

is figured as narcissistic or homoerotic, it inevitably leaves male participants in the drama in the unaccustomed role of passive, powerless spectators. And indeed, those writers who imaginatively pursue the consequences of women's infatuation with Chinese goods invariably figure men as frustrated and jealous rivals, deprived by porcelain vases and teapots of attentions that might otherwise have been theirs. An enigma-solving contest in an issue of the *Woman's Almanack* of 1741 features an intricate, rhymed riddle about a Chinese teapot. 'Here the fair Nymphs with each becoming Grace, And studied Art, my varied Charms embrace; Oh! what wou'd Lovers give, cou'd they command So warm a Pressure from their fair one's Hand'. John Gay's poem, 'To a Lady on her Passion for Old China', similarly laments a lover's displacement by imported exotica: 'What ecstasies her bosom fire! How her eyes languish with desire! How blessed, how happy should I be, Were that fond glance bestowed on me! New doubts and fears within me war: What rival's near? A China jar'.[15]

[...]

A more familiar and genteel locus of male anxiety about the wantonness of women's taste and power was the tea table itself. In an engraving called *The Tea Table (1710)*, the social consumption of tea is depicted as a site of viciously malignant female gossip. The theme here is homosocial rather than autoerotic self-indulgence, but the iconography is familiar: just as in *The Chinese Tale*, male observers appear only as exiled, marginal figures, while a prominent display of Chinese porcelain suggests the aesthetic context of the women's transgression. The porcelain cabinet also draws our eyes to the devilish figure chasing Justice from the room. Justice appears to have dropped her sword, which lies broken on the floor next to a curiously intact china teacup. This pair of objects conspicuously inverts the iconic cliché of feminine china meeting its ruin at the hands of an impetuously phallic masculinity and provides a striking commentary on the reversal of roles enacted in this scene.

The same pair of icons appears again in the second plate of Hogarth's *Marriage à la Mode* (Figure 3.4). The broken sword on the floor at the husband's feet figures all the more obviously here as a sign of languid, frustrated masculinity; the wife's tea service, elevated and intact, provides a contrasting echo of her own wantonness and excess. It echoes as well the debauched taste revealed by the collection of Chinese figures on the mantelpiece above her head. Here Hogarth graphically illustrates his principal charges against the Chinese taste: that it is absurd, inelegant,

15 'The Prize Aenigma,' in *The Woman's Almanack* (London, 1741), 20; John Gay, *To a Lady on Her Passion for Old China* (London, 1725).

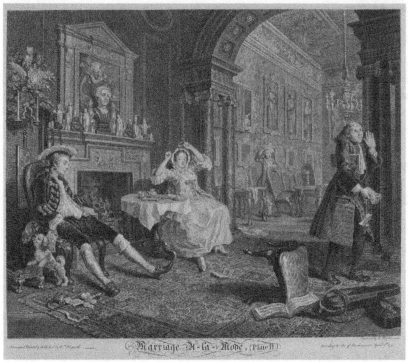

3.4 Bernard Baron after William Hogarth, *Marriage A-la-Mode*, 1745

and unnatural. But this plate, read in the context of the period's rampant associations between Chinese goods and an extravagant, wanton femininity also suggests an answer to the question of female aesthetic agency in the *Analysis* with which we began. Hogarth rejected the Chinese style as an alternative to classicism, I would propose, not so much out of a considered repudiation of its underlying aesthetic values, but rather out of a sobering recognition that to grant the validity of the Chinese taste would be to legitimate a regime not only of female aesthetic self-determination, but also of the autonomy of female desire more generally conceived. As a theorist of art, Hogarth radically asserted the emancipatory power of a spontaneous aesthetic experience unconstrained by classicist pieties. But his gestures of inclusiveness notwithstanding, he stopped short of extending this freedom to women. While beauty could henceforth be safely admired in English as well as Italian paintings, it was still to remain the exclusive preserve of European artists and of a predominantly masculine gaze. To accommodate the errant wanderings of the wanton female eye would have been to invite a wholesale defection from the Western artistic tradition and from the social and sexual order of which it was a well-established

part. And this was a travesty that our hero, canon-busting iconoclast and aesthetic libertine though he surely was, finally proved unable to countenance.

3.9 Daniel Maudlin and Bernard L. Herman, 'Introduction', in *Building the British Atlantic World: Spaces, Places, and Material Culture, 1600–1850* (Chapel Hill, NC: University of North Carolina Press, 2016), pp. 1–9

This extract is taken from an essay collection, which is the first publication to address the notion of transatlantic cultural exchange with specific reference to architecture. The 'Introduction' provides an excellent outline of eighteenth-century Atlantic studies more broadly. The 'British Atlantic World' is a term which historians have coined in the last few decades to encompass the commonalities of trade, culture and identity shared by the British diaspora situated around the Atlantic. As the editors note, such studies display an inherently interdisciplinary approach; one of the great strengths of the publication is in bringing to bear insights from a wide range of subject areas to material culture. This 'Introduction' stresses the provisional and pioneering nature of the work and highlights important omissions such as the interface with other European colonists in America or any discussion of the 'inner empire', covering the fraught relationships between the four nations of the British Isles in the eighteenth century. [Elizabeth McKellar]

[...]

Driven by imperial expansion, religion, trade and migration from Canada to the Caribbean, from West Africa to the thirteen colonies, and the passage back to Britain, the cultural space of the British Atlantic world was mapped onto the landscapes of the northern Atlantic oceanic rim. Through periods of discovery and establishment in the seventeenth century, maintenance in the eighteenth century, and eventual dismantlement and decline in the nineteenth century, this world was made, seen, and experienced through its buildings: those built in distant, different lands and those built at 'home'. Today, across the vast expanse of this former Atlantic empire, buildings and towns remain as highly visible reminders of British colonial rule. Equally, throughout England, Scotland, Ireland, and Wales, other buildings stand today as monuments to the impact of the Atlantic colonies on Britain. Whether forts in Bermuda, churches in New England, plantation houses in South Carolina, or farms

in Canada, historic buildings are markers of a historic British presence, artifacts of a coherent but complex Atlantic culture. While individual buildings and urban centers were fundamentally made in order to facilitate functions and activities—defense, prayer, shelter—they also served as important communicators of meaning and of the values and ideals held by that culture, which we can interpret in the attempt to understand that world better. Buildings were expressions of power, authority, dominion, oppression, resistance, and rebellion; of concepts such as religious faith; of *ethoi* such as modernity, progress, identity, and improvement; or expressions of social concerns such as self-fashioning, status, wealth, taste, social conformity, familiarity, belonging, and exclusion. For both colonists and the colonized, for good or ill, British-looking buildings were clear signs of a British presence across many different landscapes and climates. Abstracted from the local environment, carefully constructed, decorated, and furnished interior spaces provided the dressed stage for the repeated performance of British Atlantic society's rituals—from the extraordinary (such as court appearances) to the everyday (such as afternoon tea)—where consistency of design, dominated by neoclassicism, provided a consistent social space: whether the decorated parlor of a Canadian farmhouse, the dining room of Thomas Jefferson's villa, Monticello, the interior of a shop in downtown Falmouth, Jamaica, or even the new parlors of post-Fire London.

The British Atlantic world was driven by, and dependent upon, shipping and the various transatlantic trade networks between British ports, such as Southampton, Plymouth, Bristol, and Glasgow; North American ports, such as Boston, Charleston, Philadelphia, or Halifax in British Canada; and beyond to the Caribbean and West Africa: the transatlantic traffic in 'goods, persons, books and ideas' [...].[1] It was this transatlantic trade that 'disseminated a common culture' identified through furniture, paint, paintings, cloth, clothes, and books as well as people (from traders to emigrants and slaves).[2] In terms of buildings this meant building components such as house frames, tools, nails, window glass, books on building, and, of course, the knowledge held by migrant builders and house carpenters. The 'conversational' pathways that maintained this British

1 John Clive and Bernard Bailyn, 'England's Cultural Provinces: Scotland and America,' *William and Mary Quarterly* 11, no. 2 (1954), p. 207.
2 Fiona A. Black, 'Advent'rous Merchants and Atlantic Waves: A Preliminary Study of the Scottish Contribution to Book Availability in Halifax, 1752–1810,' in *Myth, Migration and the Making of Memory: Scotia and Nova Scotia, c. 1700–1990*, ed. Marjory Harper and Michael E. Vance (Edinburgh: John Donald Publishers, 2000), pp. 157–89.

Atlantic culture and subverted and denied it were not straightforward. What emerges from *Building the British Atlantic World* is not only the history of direct exchange between Britain and her colonies but also exchanges between the so-called peripheries—the Atlantic regions and British provinces—either as part of trade networks with and within Britain, picking up and dropping off *en route,* or directly and exclusively between each other. This approach emphasizes that the colonized changed the colonizer as much as the colonizer changed the colonized and that cultural hybridity is more characteristic than a dichotomy of them and us. It also acknowledges that 'colonization' was as much an import as an export. The origins of this model lie in postcolonial theory in cultural studies.[3] Postcolonial theory recognizes that Atlantic regions influence each other as much as they take their lead from the central 'parent culture'.[4] This 'transnational' model of interrelated networks of exchange transcends the 'nation' as the primary narrative and has largely replaced the 'outward ripple' or center-periphery model in cultural studies. The application of postcolonial theory to the wider cultural history of early modern America has been assessed by Robert St. George in *Possible Pasts: Becoming Colonial in Early America* (2000).[5] *Building the British Atlantic World* interrogates these ideas through the shared experience of architecture; identifying buildings and settlement patterns that support a model of overlapping spheres of influence, such as the New England houses built by Scottish emigrants in Canada, and buildings that on close examination deny a transatlantic influence where one has been assumed, such as the plain churches of the English naval dockyard. Through this process of architectural analysis the Atlantic world emerges as a place rather than a series of wars and trades across the Atlantic map, where place is understood not as a fixed geographic site or locus but as an enlivening process of settlement and belonging between people with common values and a shared identity.[6]

3 See Homi K. Bhabha, 'DissemiNation: Time, Narrative, and the Margins of the Modern Nation,' in *Nation and Narration,* ed. H. K. Bhabha (Oxford: Routledge, 1990), pp. 291–332.
4 Elizabeth McKellar, 'Preface,' in *Articulating British Classicism: New Approaches to Eighteenth-Century Architecture (Reinterpreting Classicism: Culture, Reaction and Appropriation),* ed. Elizabeth McKellar and Barbara Arciszewska (Oxford: Ashgate, 2004), pp. ix–xxv.
5 Robert St. George, *Possible Pasts: Becoming Colonial in Early America* (Ithaca: Cornell University Press, 2000).
6 This view of place, as tied to the relativity of people rather than the fixed geography of site, stems from human geography and writers such as Edward Relph, *Place and Placelessness* (London: Pion Press, 1976) and, more recently, Doreen Massey, *For Space* (London: SAGE, 2005).

But who were these people? The answer is that the Atlantic world was home, by birth or migration, to the full spectrum of British society as well as those indigenous peoples whose cultures were encountered and permanently altered by the British imperial project: men, women, and children from every social rank and every possible occupation, from 'gentlemen' to government officials, soldiers, clerics, doctors, lawyers, merchants, farmers, skilled artisans (including builders), unskilled laborers, servants, indentured laborers, and slaves. In the early modern period most of these recorded occupations are attributed to men; however, women and their spaces and activities must also be accounted for even if they are hidden behind the name of a male 'head of household'. The subject of gender and material culture in the Atlantic World is more widely considered in John Styles and Amanda Vickery's *Gender, Taste, and Material Culture in Britain and North America*, 1700–1830 (2007). Add to these dynamic cross-cultural interactions the experiences, contributions, and legacies of the American Indians and enslaved Africans.

The presence of a historic building, designed for a specific function—whether physical or symbolic—denotes the presence of its consumers—both intended and unintended—such as indicating their membership in a specific ethnic or social group, and can shed light on what they did, how they lived, and what they believed or valued—not infrequently through contradictory actions. For example, military forts indicate the mostly male presence of soldiers; farms the presence of farmers or farming families. The ordering and decoration of the spaces within a farmhouse provides information on the daily lives of its inhabitants including, importantly, women.[7] Non-residential buildings such as stores, churches, and courthouses provide insight into public life, its exchanges, rituals, and ceremonies. These were often mixed gender spaces occupied or used by both men and women, though perhaps in different ways. Courthouses, for instance, indicate the presence of male government officials but also of a mixed and porous civil society of male and female would-be plaintiffs, witnesses, and criminals who passed through their chambers. Moreover, the presence of cognate buildings, the familiar spaces, throughout the Atlantic world suggests the common culture that made a single place, though constantly changing, out of multiple geographic sites. Buildings were an important cultural asset for Britain's Atlantic empire because they gave visual, experiential, and spatial coherence to a geographically

7 Bernard L. Herman, 'Tabletop Conversations: Material Culture and Everyday Life in the Eighteenth-Century Atlantic World,' in *Gender, Taste, and Material Culture in Britain and North America, 1700–1830*. ed. John Styles and Amanda Vickery (New Haven: The Yale Center for British Art, 2007), p. 44.

diffused culture. While the weather and landscape were very different, things experientially felt reassuringly familiar coming into port in late eighteenth-century Jamaica, Bristol, or Charleston. Equally, you could be politely conversing in a well-furnished parlor, where communities of place yielded to communities of sensibility, and not know whether you were in the Caribbean, England, or the Carolinas without looking out the window. Architecture, therefore, accorded resonance to a divergent array of sites. That resonance emanated from a common spatial and decorative language—classicism—universally used by builders, carpenters, homeowners, and architects by the later eighteenth century. (Throughout the British Atlantic world regional vernacular forms that were commonplace in the seventeenth century were gradually straightened out, given symmetry, and codified through the eighteenth century).

Within an Atlantic colonial theatre shared with the French, Dutch, Portuguese, and Spanish, British classicism in building design in the early modern period was by no means unique. Nonetheless, it was a preeminent signifier of British Atlantic culture to those living within the dominions of the British Atlantic Empire, recognized and identified as British by soldiers, traders, and emigrants. What did this pervasive architectural style, this sameness, mean to the consumer of buildings within that British Atlantic world? Sameness, in any style or form of building, communicated familiarity, projected identity, and mapped the contours of belonging, but, more than this ready reassurance, in the early modern period classicism in particular also manifested a profound and widely understood symbolism. Of course, it was accepted as the best possible taste in fashionable design, driving consumer markets and maintaining social conventions, but more than that, to the early modern British mind, it was also a visual articulation of belonging to European civilization, of notions of morality and godliness as well as a range of other positive values drawn from Roman culture, such as learning or good imperial governance (although these associations are problematic in light of the transatlantic slave trade that paid for many expensive building programs on both sides of the Atlantic). On the ground, therefore, through this commonly understood architectural language, while implicitly if not consciously engaged on the British colonial project, a farmer in New England or a merchant in the Caribbean were both able to demonstrate directly and relatively easily through the material *lingua franca* of their social affiliations, their good taste, and their moral virtue. Although, while a common British transatlantic culture can be identified, it is important to note that most likely both the farmer and the merchant would have primarily acted and thought locally, responding first to their immediate circumstances. As such, while architectural coherence across

the British Atlantic world was a manifestation of a common culture maintained through the circulation of goods, books, and design, a true overview of this transatlantic spatial and decorative *sensus communis* would only have been experienced in person by a small number of mobile groups such as migrants, merchant seamen, military personnel, and the wealthy traveler.

By the later eighteenth century, neoclassicism in European architecture was not just a tendency to bilateral symmetry and some applied classical ornament but involved the strict observation of established design principles. Classicism across the British Atlantic world was characterized by precise observation of codified spatial proportions that dictated the relationship between height and width in all elements of a building, from walls to windows, and the interrelationships between those elements. At the level of everyday craft production, the eighteenth-century shorthand for this precision was simply 'neat' and 'regular'. Making classical buildings in the British Atlantic world was a preindustrial craft process practiced by highly skilled craftsmen and, therefore, was also dependent upon the migration of both skilled labor and knowledge. Consequently, the successful execution of a classical building—whether church, courthouse, merchant's dwelling, or colonist's farm—required the work of craftsmen familiar with bookish classical principles who were adept at modeling and manipulating classical ornament and who were familiar with building materials and the principles of construction. Stone masonry and house carpentry were well-established craft traditions in eighteenth-century Britain and British North America with interlinked international, national, and regional organizations and practices. While regional and subregional craft centers emerged throughout the British Atlantic world, craftsmen were also highly mobile, traveling between Atlantic regions in pursuit of changing demands for their skills (and were therefore not only the producers of Atlantic architecture but also among the few to experience it in more than one geographic site). Craftsmen were also highly responsive to the forward impulse of modernity and the consumer drive for fashionable good taste that was facilitated by the dissemination of ideas through migration (of craftsmen and connoisseurs), trade (the transatlantic shipping of books about buildings and supplies of building components), and through a high level of personal correspondence and visits between friends and family. In this way seemingly similar buildings were built contemporaneously throughout the British Atlantic.

And yet, as soon as this common culture is identified it is challenged and reinterpreted: from Atlantic region to region, climate to climate, social group to social group we see myriad adaptations and differences in building form, ornament, materials, and construction. The apparent

176

sameness of buildings belied their many structural differences; and it demanded competence to inflect the international with a local accent and to adapt universal conventions to local circumstances. Whether timber, stone, brick, or coral block, building materials and construction methods varied regionally giving rise to localized craft subcultures, each with its own practitioners, trade bodies, customs, and educational traditions. Conversely, regional construction methods, often hidden behind a classical veneer by the later eighteenth century, also pointed to the persistence of historic craft practices associated with particular British regional traditions and the settlements of emigrants from those regions. If we look at housing design, for example, we can see that a universal ideal was constantly challenged by practical regional adaptations. White symmetrical boxes with pitched roofs and neatly arranged windows flanking a central doorway can be found in Scotland, the Caribbean, the Carolinas, and Canada. But this uniformity hides—often behind white surface finishes—a range of different building materials and construction as well as regional responses to climate, labor, sociability, and economics. In a wider geographic context, the British Atlantic world existed in parallel and geographic overlay with those of other European colonial Atlantic powers—including the Spanish and Portuguese to the south and the French in both Canada and Louisiana; Germans in Pennsylvania, Maryland, and Virginia; and Dutch in New York—and each home-nation exported its own architectural traditions, practices, and practitioners. At points of colonial intersection, as in Canada or West Africa, builders from one European nation rubbed shoulders with builders from another. Building contracts in British America consistently bear a polyglot of surnames representing British, Scandinavian, German, and other nationalities. And then there were the individuals wielding trowels, planes, hammers, and brushes. Atlantic architectures, therefore, are not defined by a monocultural process of imposition and reproduction but by hybridity, where different colonial cultures meet at the fringes and traditions intermingle or are overlaid, where one colonial power replaces another (such as the British replacing the French Acadians in Nova Scotia), or where peoples and architectures of noncolonial nations take root in the colonies of other nations (for instance, German settlers in North America or Scandinavians in the Caribbean).[8]

Complexities in building production were not only geographic. The top-down hierarchical model for the dissemination of knowledge and design from an aristocratic, architect-and-patron design culture down

8 See, for example, William Chapman, 'Irreconcilable Differences: Urban Residences in the Danish West Indies, 1700–1900,' *Winterthur Portfolio* 30 (Summer–Autumn 1995), pp. 129–172.

to the everyday builder has been repeatedly challenged and discredited as we find vernacular classicism coexisting alongside, and independent of, the small, elite transatlantic world of professional architects and their wealthy patrons, as discussed by Peter Guillery in the context of English churches. This social distinction itself has a regional character as everyday craft traditions were based, or took root, in specific geographic contexts while the 'high culture' of professional design maintained a higher degree of exchange and mobility as wealthy patrons maintained cultural, social, and economic transatlantic links. As Elizabeth McKellar has observed of building in eighteenth-century Britain, 'the reception and spread of classicism in the eighteenth century suggests not a top-down model but rather overlapping spheres of influence between the national and the provincial, the classical and the non-classical, the elite and the everyday'.[9]

Sameness also obscured differences in the cultural reception of that universal architectural language—or what its users thought of a particular building—from one region to the next and from one social group to the next. Similar-looking buildings could mean different things in different places and to different people: national, social, and racial identities; political, cultural, and economic agendas; public, commercial, and private lives. A stone artillery fortress overlooking a bustling harbor in seventeenth-century Bermuda may have been a comforting symbol of authority and security for English merchants, but it was also a clear message of well-armed intent to other European colonial powers. A large house with classical columns may have represented the same image of money and social success to a gentleman landowner in England as it did to a plantation owner in South Carolina, but it meant something very different to the enslaved Africans on that plantation (though both may have been built on the profits of slavery). Or to look at differences over time, the pediments and columns of North America's early public buildings have represented both British imperial authority and American republicanism—and the politics of embrace and resistance to both. What emerges most clearly through the transatlantic architectural histories presented here is the tension between the apparent coherence of a historic transatlantic culture and the multiple and complex forces that continually interrogated and subverted that coherence.

[...]

9 Elizabeth McKellar, 'Preface,' pp. ix–xxv.

4

Empire and art: British India

Renate Dohmen

Introduction

The selection of texts in this section examines the seminal role art, design, photography and architecture played in British India, and offers perspectives on how British colonial ideology was applied, appropriated and re-envisaged in relation to the arts.

A key underlying issue that connects these sources is the central role art and art history played in legitimating the British imperial project in terms of a 'civilising mission'. This was based on the nineteenth-century belief that Europe represented the peak of cultural development and translated into the conviction that the rationale for Britain's colonial presence in India was to impart 'civilisational uplift'. Such ideas were premised on an assumed stable cultural core of inalienable and hence 'essential' racial and national characteristics that were believed to be directly expressed in the arts, and were deemed to be especially apparent in architecture: historical monuments were seen to transparently display the civilisational development of any given culture and could be hierarchically mapped according to a developmental scale.

This model has long been debunked yet its influence lingers, for example, in art history's emphasis on national schools. A transcultural, global perspective in contrast acknowledges that 'national' characteristics were developed over time, reflect history and culture rather than nature, and recognises that processes of transculturation are constitutional to cultural formations.

A critical re-examination of aesthetic interactions in colonial India from a global perspective is thus interested in the new, often hybrid and rebellious art forms spawned by the processes of transculturation that ensued when European notions of fine art as separate from applied art were introduced in India. It examines the dynamics of these exchanges

179

in relation to issues of power, market forces and ideology, drawing attention to the enduring influence of the first histories of Indian art and architecture written by Europeans that were based on European aesthetics yet became foundational for Indian art, architecture and design history. These texts, for the most part, certainly in the nineteenth century, denied the existence of a true and 'purely' Indian fine-art tradition and lauded Indian design. This praise, however, was not a compliment: according to Victorian reasoning, design was considered indicative of a lower level of cultural development since higher civilisations were thought to lose the instinctual surety in colouring and design.

Such largely negative assessments of Indian cultural achievements were rooted in the norms of classicism and its emphasis on order, symmetry, naturalism and restraint. But as aesthetic preferences in nineteenth-century Britain shifted towards the Gothic, and then, at the end of the century, towards the modern, perceptions of Indian aesthetic traditions were reframed and Indian art began to be seen in a more positive light. Furthermore, in the second half of the nineteenth century, a growing critical response by English educated Indian critics and scholars began to emerge who grappled with colonial ideology, in part accepting and in part challenging its frameworks. This initiated a new wave of counter-narratives by Indian nationalists that became central to the Indian independence movement, turning racial conceptions such as Aryanism and essentialist conceptions of Indian culture to their advantage. The so-called Neo-Orientalist nationalist school for example adopted the essential East–West divide posited by European Orientalism, and claimed spirituality as their true Indian essence. It expanded the notion of the 'East' to the whole of Asia and claimed the role of Asian master culture for a re-valorised India that now was declared a conduit of a uniquely 'Eastern' spiritual civilisation. This had political implications as Indian nationalists now refuted the need for a European civilising presence. They singled out aspects of high-cultural brahmanical Hindu philosophy as representative of 'pure' traditions in order to rekindle a 'truly' Indian art untainted by foreign influence. This nationalist emphasis on Hinduism as representative of a uniquely Indian cultural essence thus mirrored colonial ideology and sidelined India's other religious traditions.

The group of primary source texts presented here has been selected to examine how the 'colonising of the mind' unfolded in British India. It presents a sampling of texts that demonstrates the shifts in colonial perceptions of Indian art during the time of the Raj as the seemingly self-evident role of classicism as benchmark for universal artistic achievement was increasingly challenged even from within the colonial

establishment. Counter-narratives and propositions of how an Indian aesthetics might be conceived, however, undermined the narrative of 'cultural uplift' and benevolent paternal guidance supposedly imparted by the British colonial presence.

From 1858, when the crown took over colonial rule in British India, the status and development of India's visual culture became intricately intertwined with colonial power and notions of authentic Indianness acquired immediate and potent political dimensions. Whether supporting colonialism, the struggle for independence or adopting positions in between, all sides readily roped in art, architecture and design to provide key and often contested evidence, with photography as a supporting act. Seemingly insignificant and 'hair-splitting' scholarly debates about the status of Indian art and culture therefore took on a much larger significance than immediately apparent.

The texts in the critical approaches section of this section offer further context to the history of aesthetic interaction in British India. They reflect on methodological debates, critically review and situate colonial models of thought, and examine the entanglements of art, race and empire in British India. As part of this remit they elaborate how race was used to maintain colonial control by positing an essential difference which upheld an illusion of distance as the English-educated Indian elite, also called 'brown Englishmen', or 'mimic men' in the words of Homi K. Bhabha, threatened to close the gap. The texts also draw attention to the agency of the visual in shaping a new British imperial identity through depictions of far-flung regions, and examine the rise of a rationalised mode of vision evident in the ordered display of Indian objects at international world fairs and museums across the globe. The role of technologies of reproduction in the commodification and refashioning of the world is also examined and constitutes processes that were often pioneered in the imperial realm before they arrived in Britain.

Primary source texts

4.1 Did India have an authentic, truly Indian a 'truly Indian' tradition of fine art? The contentious issue of Gandharan art

A key bone of contention in the latter half of the nineteenth century was the question whether the fourth- to mid-fifth-century CE Buddhist sculptures of Gandhara in today's north-west Pakistan which showed evidence of Greek stylistic influences demonstrated a formative influence of Greek art on Indian culture. This point

of view was adopted by the army-engineer turned key government field-archaeologist Alexander Cunningham as well as indigo planter turned founding scholar of Indian architecture James Fergusson. Rajendralal Mitra, India's first British-educated Indian archaeologist, however, took issue with this assumption and argued for a developed Indian art tradition prior to Gandhara, a theory that by implication challenged India's need for civilizational help from Europe. This was well understood by Fergusson who attacked Mitra's arguments. Both are sampled in this collection. But in the early twentieth century a pan-Asianist theory also evolved which claimed Gandharan art as an exclusively Asian tradition. This view was based on the pan-Asian notion of a single unified entity of Asian art that purportedly combined the heritage of India, China and Japan, with India taking the position of religious Asian master tradition. This view is represented here by Sister Nivedita, a follower of Swami Vivekananda and an outspoken Indian nationalist of Irish extraction, who actively participated in these debates. [Renate Dohmen]

a) **Alexander Cunningham,** *Archaeological Survey of India. Report for the Year 1871–72*, vol. 3 **(Simla: Government Central Press, 1873), p. 100**
[...] [T]he Indians derived the art of sculpture from the Greeks. It is a fact, which receives fresh proofs every day, that the art of sculpture, or certainly of good sculpture, appeared suddenly in India at the very time that the Greeks were masters of the Kabul valley, that it retained its superiority during the period of the Greek and half-Greek rule of the Indo-Scythians, and that it deteriorated more and more the further it receded from the Greek age, until its degradation culminated in the wooden inanities and bestial obscenities of the Brahmanical temples.

b) **Raja Rajendralal Mitra, 'Origin of Indian Architecture', in** *Indo-Aryans: Contributions Towards the Elucidation of Their Ancient and Mediaeval History* **(London: E. Stanford and Calcutta: W. Newman, 1881), pp. i–ii, 4, 32–34, 46–47**
[...]
The essay on the origin of Indian Architecture was written in 1870 by way of a protest against the opinion which was then getting very common to the effect that the Hindus had first learnt the art of building in stone from their Greek conquerors. Mr. Fergusson criticised it in 1871,

in the pages of the 'Indian Antiquary'. It subsequently appeared as the first chapter of my work on the 'Antiquities of Orissa'; and a second criticism followed in Mr. Fergusson's 'History of Indian and Eastern Architecture'. My rejoinder appeared in my work on Buddha-Gaya [...].

[pp. i–ii]

[...] It would be foreign to the subject of this essay to discuss at length the history of architecture among the Aryans from the time they issued forth from the plateau of central Asia to people India, Persia, and diverse parts of Europe, but certain it is that one branch of them, the colonists in Greece, attained a higher pitch of excellence [...] in [...] perfection of artistic beauty [...] than the Semites, or the Turanians, ever did [...].

The Grecians may have borrowed the idea of large edifices from the Egyptians, or the Pelasgians, and the most successful building tribes among them may have had some Pelasgic blood in their veins as supposed by Mr. Fergusson, but as a nation they were Aryans, and, having once got the idea, they worked it out in their own way, independently of their teachers. The Aryans who came to India had the same intellectual capacity [...].

[p. 4]

[...]

The question may be here raised as to how far the ancient Aryans were indebted to the Tamulians [Tamil people] for their knowledge of stone architecture? [...] [T]he remains of Tamulian architecture existing in the present day, are more voluminous, more extensive, and more elaborate than Aryan remains. And all these tend to show the superiority of the Tamulians in architecture, and the likelihood of their having been the first teachers in the art to the Aryans. On the other hand, the oldest Indian specimens of the art are not Tamulian, but Buddhist; and they do not bear a close family resemblance to the Tamulian specimens now available; and the relative positions of the Aryans and the Tamulians in the scale of civilization were such as not by any means to warrant the assumption that the latter were the teachers and the former the taught, in so essential a civilizing art as architecture. [...]

But whatever the origin or the age of ancient Indian architecture, looking to it as a whole it appears perfectly self-evolved, self-contained, and independent of all extraneous admixture. It has its peculiar rules, its proportions, its particular features, —all bearing impress of a style that has grown from within, —a style which expresses in itself what the people, for whom, and by whom, it was designed, thought, and felt, and meant, and not what was supplied to them by aliens in creed, colour and race. A few insignificant ornaments apart, its merits and its defects are all its own, and the different forms it has assumed in different provinces are all

modifications, or adaptations to local circumstances, of one primitive idea. It may, therefore, be treated by itself without reference to foreign art.

[...]

[pp. 32–34]

[...] He [Fergusson] has, however, made an important concession. While persisting in the statement that Indian architecture before the time of As'oka was entirely of wood, he admits, 'stone in those days seems to have been employed only for the foundations of buildings, or in engineering works, such as city walls and gates, or bridges or embankments'; [...].

[...] The admission [...] throws on the author the onus of proving that men, who could, and did, build stone walls, confined their talent to city-walls and embankments, but could not, or did not, extend it to the superstructure of their houses; that having built a brick or stone foundation as high as the plinth, they encountered some obstacle, intellectual, material, or artistic, to push it higher, and bring it to the level of the ceiling until taught to surmount it by Greek adventurers or their half-caste descendants. [...] Such an inference is unjust to a nation whose inventive and intellectual faculties were second to those of no other race on earth, and which in the domain of philosophy attained an altitude which none has yet surpassed.

[...]

[pp. 46–47]

c) **James Fergusson, *Archaeology in India, with Special Reference to the Works of Babu Rajendralal Mitra* (1884), pp. 4–6, 13, 55, 58–59, 87–88, 97, 99**

[...] Though Indian Archaeology may be considered as beneath the attention of the English public, the Ilbert Bill is certainly not so, and no means of bringing it home, and rendering it intelligible to the masses, appears to me so appropriate as examining a typical specimen of one of the proposed class of governors, and seeing what stuff they are made of. For this purpose there is probably no example so suitable as Babu Rajendralala. He has written in English more, and under more favourable circumstances, than any native of Bengal, and has consequently, laid his aspirations his mode of attaining them more bare than any of his *confreres*, so that out of his own mouth it will be easy to judge how far the class to which he belongs are worthy of the confidence it is proposed to repose in them.

No one who has resided long in Bengal, or has been in familiar intercourse with the educated classes of the natives of that country, but must have been struck with the marvellous facility with which they acquire our language, and at least a superficial familiarity with the principal

features of our arts and sciences. The truth of the matter is, their powers of memory are prodigious. No other nation in the world could have handed down their earliest literature from primaeval times to the present day without the intervention of any kind of writing. But it seems an established fact, that till nearly the Christian era, the Vedas were transmitted from generation to generation by oral recitation only, and that even now Brahmins can be found who can commit the whole to memory, and repeat it consecutively, without the aid of any written text. Memory is, in fact, the Indian's forte; but knowledge acquired by its aid only, is apt to be superficial, and sadly wanting in depth and earnestness. [...]

Perhaps, however, the most glaring defect of this easily acquired knowledge is the inevitable conceit it engenders. A man who by his powers of memory alone has become familiar with a great mass of scientific facts, is apt to consider himself quite equal to those who, by long study and careful reasoning, have assimilated the great truths of scientific knowledge. Without any previous study or preparation, he does not see why he should not 'profess' any science he may take a fancy to, and pronounce dogmatically on any series of facts that may come before him. [...]

[pp. 4–6]

[...] No one can look at any cave of the Mauryan era, and not see that every feature and every detail is copied from a wooden original, and that the people who used these forms did not build in stone, and had never used stone architecture in any ornamental building, though in mere 'building' or engineering works, of course stone or brick was generally if not always employed.[1]

[...]

[p. 13]

1 As I have been so voluminous a writer on architectural subjects, it hardly seems necessary that I should be called upon to define what I mean by the term, which I have always used in one sense and one only. Architecture I have always understood to apply to the *fine* art of ornamental building, either in wood or stone, or other materials, as contradistinguished from the *useful* art of building or civil engineering. I have written a good many works on architecture but none on building, and I might, I fancy, be allowed to understand the term. But the Babu has looked up his dictionary, and says, 'I have always used the word architecture in the ordinary dictionary meaning of it, "art or science of building", and not in the aesthetic sense, of the ornamentation of buildings as distinct from the mere mechanical engineering art of piling stones or bricks for making houses' (preface to 'Indo-Aryans', p. v). On the contrary, in all I have ever written on the subject I have made the most marked distinction between the two branches of the art of building, and as it is my works the Babu is criticising, he is bound to accept my definition of the subject; but nine-tenths of the misunderstandings and objections in his book arise from his inability to see, or unwillingness to admit, this perfectly obvious distinction.

[...]

There is of course in the 'Antiquities of Orissa' [by Rajendralal Mitra]
no attempt to arrange the temples in any order, either chronologically
or even as to form [...].

[p. 55]

[...]

Throughout his work on Orissa the Babu persists in calling this temple
Vaitala Deül — which certainly is not the name by which it is known to
the Brahmins or any one else. If, however, he had called it Kapila Devi,
or Kapileswara, or any such name, he would have been obliged to
acknowledge that he had seen the plate I published of it in 1846, and to
confess that in the few hours I passed at Bhuvaneswara, I had done more
to convey to outsiders a correct notion of this temple and its peculiarities
than he had done after a long sojourn there, with all his array of draftsmen
and casters. [...]

[...]

It would be as tedious as unprofitable to attempt to criticise the
plates of detail given in the Babu's first volume. They were selected
without the guidance of any fixed principle, and are arranged on no
intelligible system. [...] In like manner it would be easy, if worth while,
to criticise the selection of photographs of temples in the second volume.
They are all too much of one type, and not the best or most interesting
of their class. There are others, as the Gauri Devi [...] which are as
exceptional in form as the Vaitala Deül, and consequently as suggestive
of foreign relationship, [...] but which remain in this collection entirely
unrepresented. From my own collection of photographs I fancy I could
have made a very much better and more typical selection; but, as the
Babu had no system and no story to tell, one photograph in his eyes
was as good as another, and we must be grateful for what we have
got. [...]

[pp. 58–59]

[...] The fact of the matter is, that nine-tenths of the difficulties and
discrepancies that occur, both in this book and in the 'Antiquities of
Orissa', arise from the total want of education of the eye, which is every-
where apparent. This arises apparently from his never learning to draw
in his youth, or never at least practising it in his mature age, which was
a fatal deficiency when he undertook to enlighten the world on matters
of art and archaeology.

[pp. 87–88]

[...]

It is one of the most curious and interesting facts that recent
archaeological researches have revealed to us, that there did exist in the

north-west of India, especially beyond the Indus, a school of sculpture which undoubtedly owes its origin to the Greek colonists in Bactria, [...].

[p. 97]

[...]

Is it that the Babu's eye is so uneducated, that he cannot perceive the obvious distinction between Classical and Native art in India? Or is it that he is so satisfied by his own superficial knowledge, that he has not cared to follow the recent developments of Indian archaeology, and cannot consequently state them with intelligible clearness? The latter can hardly be pleaded as an explanation of the phenomena [...], the mode of reasoning and the English in which it is expressed are wonderfully correct for a man writing in a foreign tongue, and dealing with a subject with which he had no previous acquaintance. Given the data, and assuming the conclusion, the logic is irreproachable, though the result is, notwithstanding, feeble and foolish.

[...]

[p. 99]

d) Sister Nivedita (1903), 'Introduction', in Kakuzo Okakura (ed.), *The Ideals of the East with Special Reference to the Art of Japan* (New York: E.P. Dutton and Company, 1920), pp. xiii–xiv

[...] [It] is very reassuring to be told by a competent authority that [...] she [India] evidently led the whole East, impressing her thought and taste upon the innumerable Chinese pilgrims who visited her universities and cave-temples, and by their means influencing the development of sculpture, painting, and architecture in China itself, and through China in Japan.

Only those who are already deep in the problems peculiar to Indian archaeology, however, will realise the striking value of Mr. Okakura's suggestions regarding the alleged influence of the Greeks on Indian sculpture. Representing, as he does, the great alternative art-lineage of the world — namely, the Chinese — Mr. Okakura is able to show the absurdity of the Hellenic theory. He points out that the actual affinities of the Indian development are largely Chinese, but that the reason of this is probably to be sought in the existence of a common early Asiatic art [...]. In such a theory, a fitting truce is called to all degrading disputes about priority, and Greece falls into her proper place, as but a province of that ancient Asia [...].

[...]

4.2 Neo-Orientalism, Nationalism and Pan-Asianism

The defence of a national Indian culture was ironically increasingly based on the Orientalist notion of an essential difference between a spiritual 'East' and a materialistic 'West', and has earned the highly influential school of Indian nationalist thought at the turn of the century the designation 'Neo-Orientalist'. Key players associated with this movement were the British superintendent of the art school in Calcutta, Ernest Binfield Havell, the artist Abanindranath Tagore, who was championed as harbinger of a rekindled spirit of a true Indian art, and the Anglo-Sinhalese art critic Ananada Coomaraswamy. The latter had grown up in Britain and was, like Havell and other prominent movers and shakers in the Indian art education and craft scene, influenced by the Arts and Crafts movement and approached his influential theorising of Indian art from this perspective. As an avid collector of Indian miniature painting and curator of the Indian section of the Boston Museum of Fine Arts from 1917, his Orientalist Hindu-centric approach to Indian art became foundational for the conception of the field for most of the twentieth century. [Renate Dohmen]

a) E.B. Havell, 'The New Indian School of Painting', in *The Studio* 44 (1908), pp. 107–117: 107–116

[...]

Modern school text-books foolishly teach the young Briton that his ancestors were savages, and that the civilisation of England began with the Roman invasion. [...]

The fact that the Britons left few traces of their civilisation behind is easily explained. The methods of barbarism which the Romans employed to extirpate it were much the same as those we use at the present day. Probably some previous incarnation of Macaulay suggested it to them. They crammed the young Britons with Greek and Latin [...] until they almost forgot that they had a language of their own; they brought artists from Italy to teach them that all art came from Greece and Rome, [...]

We have been civilising India in the same way for more than fifty years, and have succeeded in persuading educated Indians that they have no art of their own, [...]

188

About twelve years ago I took over charge of the Calcutta Art Gallery, one of the institutions established by a benevolent government for the purpose of revealing to Indians the superiority of European art. [...] I [...] proposed that we should start an Indian section of the gallery, [...].

At the same time I abolished the 'antique' class in the school of art, and revised the whole course of instruction in that institution, making Indian art the basis of the teaching. The effect of this revolution was startling. The Bengali is constitutionally conservative, and the *Swadeshi*, or national cult was not then so popular with Indians as it is now. The students left the school in a body, held mass meetings on the Calcutta *maidan*, and presented petitions to Government, while the 'advanced' chapter of the Bengali press raged furiously against me, However, [...] the wandering sheep returned to the fold.

[...] After some years, [...] I ventured to propose that the old collection of European pictures should be sold, and that the funds realised should be devoted to purchases of Indian art. This proposal was eventually accepted, though not without raising another violent storm in the Bengali press; the principal journal of *Swadeshi* politics seeing nothing in it but a sinister attempt to discourage 'high' art in Bengal.

With the proceeds of the sales of some of these works of 'high' art, the Gallery increased its Indian collection largely [...].

[...]

The re-organisation of the Calcutta Art Gallery in 1896 was the starting-point in Mr. Tagore's career as an artist of New India; for the masterpieces of Mogul painting [...] were as much a revelation to Mr. Tagore as they were to the great majority of Anglo-Indians. Up to that time he, like all other Indian art students, had looked to Europe for guidance in technique, and followed purely European ideas of artistic expression. Henceforth all his efforts were directed towards the endeavour to pick up the lost threads of Indian tradition.

[...]

[...] [T]he Bengalis have hitherto had the reputation among Europeans of being the least artistic of the Indian races. [...] but the best Bengali students have that rarest of artistic gifts—the one in which the Anglo-Saxon is generally most deficient—imagination, a faculty for suppressing which our departmental system of education seems to be specially designed. [...]

The academic methods of the New School of Indian Art are really a return to the artistic principles on which all true Oriental art practice is based [...]. The Oriental artist develops his imitative skill mainly by the

exercise of his creative powers; his first and last aim is to cultivate a habit of mind-seeing. The modern European practice of dressing up a series of living models, or lay-figures, in costume and then painting them one by one as a piece of still-life, would seem to the Oriental artist a most feeble and inartistic method of creation. He will sit down for an hour, a day, or a week, and create the picture in his own mind; and not until the mind-image is complete will he set to work to transfer it to paper or canvas. [...] In a student's training, therefore, memory work takes a much more important place than mere copying from nature, and a habit of intense mental concentration is developed from the earliest stage of his artistic career. I venture to think that the usual Western academic methods would be immensely improved if we tried to learn a little more of the Eastern.

The Oriental student is of course greatly indebted to the traditional art practice which is handed down from generation to generation. In India, unfortunately, the too exclusive reliance on traditional practice has led to a mental stagnation which deprives Indian art of much of its former vitality. But our approved departmental methods, instead of reviving original creative activity, have done everything possible to suppress it [...].

The appearance of this new school, small though it is at present, is an indication that India still retains some of her old creative intellect. The great traditions of Indian architecture, sculpture, and painting are still alive, and if our educational system infused the right kind of mental stimulus into them, instead of crushing them out with the purblind pedantry of the Macaulay school of pedagogics, India might before long recover its former place as the artistic leader of Asia.

[...]

b) Ananda K. Coomaraswamy, 'The Aim of Indian Art',
Modern Review, **vol. 3, no. 1 (1908), pp. 15–21: 15–17**

[...] Indian art like every other aspect of Indian culture is informed with religious ideas; it has sought always first the kingdom of God and His righteousness, – and in my view, all else has been added to it. [...]

[...]

Thus whether in decorative or substantive art, the consistent Indian aim has been to represent the Ideal, to express in the language of form and colour the *logos* or Idea underlying phenomenal appearance.

The aim of the trained scientific or artistic imagination is to conceive (*con-cipio* to take hold of) or invent (*in-venio* to light upon) some unifying

truth otherwise unsuspected. The fact already exists; the creative genius discovers it. The theory of evolution, [...] the rapid discovery by a mathematical genius of the answer to an abstruse calculation; the conception that flashes into the artist's mind, all these represent some true vision of the Idea underlying phenomenal experiences. Ideal art is thus rather a spiritual discovery, than a creation.

The mere imitation of nature is not attempted, because not desired. The revelation of the idea underlying each sensuous appearance has more concerned the Indian artist, than has appearance itself. He embodies the vision arrived at by inward contemplation, in the language of art, which is based on natural forms. [...]

[...] [I]n India [...] the same idealism pervades it all, is as conspicuous in 18th century Sinhalese art (representing Indian art reduced to the level of a great beautiful scheme of peasant decoration), as it is in Early Indian, Ajantayan, or 16th century Dravidian. It is this fact which gives so much dignity and value to the lesser arts of India, and separates them so entirely in spirit from the 'pagan' art of the Western renaissance, or the merely imitative decorative art of modern Europe.

[...]

c) **Ananda K. Coomaraswamy, 'Art of the East and of the West', *Modern Review*, vol. 3, no. 5 (1908), pp. 397–399: 397–398**

It is impossible to understand Indian Art, without understanding the whole culture and historical tradition of which it is the direct expression. It is useless to treat art as an isolated phenomenon apart from the life of the people who made it. Neither can Indian art and culture be really comprehended without sympathy; and sympathy for Indian culture is a rare thing. The orthodox Christian, the Materialists, and the Imperialists are all, in so far as they are what I have called them, constitutionally unable to sympathise with the ideals of Indian civilization. Add to this the strong temperamental difference between Oriental and European, and it is easy to understand that lovers of India art have been few.

I give a typical example of the ordinary attitude, a quotation from Mr. Maskell's book on Ivories:

'There is a sameness, a repetition, and overloading, a crowding and elaboration of detail which become wearisome before we have gone very far. We are spoken to of things, and in a language of which we are ignorant. We regard them with a listless kind of attention. In a word we are not interested. We feel that the artist has ever been bound and enslaved by the traditions of Hindoo mythology. We are met at every turn by the

interminable processions of monstrous gods and goddesses these Buddhas and Krishnas, Vishnus and Ramas, these hideous deities with animal's heads and innumerable arms, these dancing women with expressionless faces and strange garments. In his figures the Hindu artist seems absolutely incapable – it may be reluctant – to reproduce the human form; he ignores anatomy, he appears to have no idea of giving any expression to the features. There is no distinction between the work of one man and another. Is the name of a single artist familiar? The reproduction of type is literal: one divinity resembles another, and we can only distinguish them by their attributes, or by the more or less hideous occupations in which they may be supposed to be engaged.'

I quote this ignorant and childish rhodomontade only because it is so typical. Perhaps the easiest way to show its true value would be to ask you to imagine similar words spoken by an Oriental, who should substitute the word 'Christian' for the word 'Hindoo'. 'Enslaved by the traditions of Christian mythology interminable processions of crucifixes and Madonnas' ... would not this be an idle criticism of Mediæval European art? [...]

And so we come to one serious difficulty; the Indian ideal of beauty is not the Greek to which the Western artist is accustomed; nor does it appear to us that art, to be great, need necessarily be beautiful at all. There is a higher quality in art than that of beauty. There is something in great ideal art which transcends the limited conceptions of beauty and ugliness, and makes a criticism founded on such a basis seem but idle words. [...]

And even when the representation of physical human beauty is the immediate aim, we find that the ideal of the human form is different in East and West. The robust muscularity and activity of the Greek athletic statue, or of Michael Angelo, is repugnant to the lover of the repose and the smooth and slender refinement, of the bodies and limbs of Orientals. [...] But the real decision lies deeper still. [...] The Western artist sees nature with his eyes and judges of art by intellectual and aesthetic standards. The Indian seeks truth in his inner consciousness, and judges of its expression by metaphysical and imaginative standards. We are told, for example, that Zeuxis, when commissioned to paint a figure of Helen for the people of Croton, stipulated to be allowed to use as models five of the most beautiful virgins of the city. The Indian artist, on the other hand, would have demanded opportunity for meditation and mental concentration, in order that he might visualise the idea of Helen in his inner consciousness, aiming rather at discovery than creation, desiring rather to draw back the veil from the face of Superwoman, than to combine visible perfections by a process of intellectual selection. [...]

4.3 Ravi Varma – the first modern Indian artist

The national cause had not always been associated with an assumed Indian spiritual essence even though this became the dominant narrative. Prior to the rise of Neo-Orientalism and Pan-Asianism the largely self-taught South-Indian artist Ravi Varma, who painted Indian mythological scenes in a Western academic style, was revered as the first modern artist and was seen to be engaged in the work of nation-building. As the excerpt by the art critic Balendranath Tagore attests, at this point in time the British verdict, that India lacked a developed sense of art was still accepted and was based on the preconception of an essential aesthetic difference between Britain and India.

The slightly later text by the journalist Ramananda Chatterjee presents us with a turning point in the conception of the national in relation to modern Indian art. Chatterjee still credits Varma as the greatest modern Indian painter, but already points to the work of Abanindranath Tagore as more fully 'Indian' since his work is seen to combine an Indian style with Indian subject matter. [Renate Dohmen]

a) **Balendranath Tagore, 'Ravi Varma', in Sovon Some and Anil Acharya (eds),** *Bangla Silpa Samalochanar Dhara: Shyamcharan Srimani, Balendranath Tagore, Sukumar Ray (Trends in Bengali Art Criticism: Shyamcharan Srimani, Balendranath Tagore, Sukumar Ray)* **(Calcutta: Anustup, 1986 [1893]), pp. 60–65 [translation Priyanka Basu]**
There has been little progress in this country from the primitive barbaric ways of applying colours. The English-educated [Indians] are familiar with renowned European painters like Raphael, Titian and other artists are also not unknown [...] however, we imbibe the greatness of Raphael-Titian more through speculation than through sensitivity. Firstly, our senses have not fully flowered towards art appreciation due to the lack of cultivation of painting as an art form; secondly our indigenous imaginations, senses and the understanding of mythological ornateness are not reflected in European art—hence, it does not appeal to our hearts. It is therefore absolutely necessary to have someone who is talented enough to bring our mythological imaginations into life with the strokes of the brush.
[...]
I believe our art-studios in Calcutta run somewhat according to this principle. However, the numbers of mythological paintings that are

produced each year by these art studios and the scroll-paintings that come out of Kalighat have little difference between them, except for the better paper quality of the former and the countless piling of colours on top of the other; hence, viewing these paintings does not offer much hope to the mind. This is because nowhere in such diversely colourful paintings do the emotions develop fully, nor is the physiological form of the figures sufficiently pronounced nor does the painter achieve artistic expression through even the slightest hint of beauty in the assortment of colours.

[...]

Whereas one should be awe-inspired on seeing the frightfully sombre figure of the Karal Kalika [one of the many forms of goddess Durga], the paintings of the art-studio only establish the image of an impassive ugly wooden figurine in our minds which consequently provokes our vexation rather than any good feeling.

[...]

The Southern region, however, is much more fortunate than Bengal in this regard. They have received there what is truly needed—without gatherings, societies, companies, or art-studios like in Calcutta—a meaningful talent in painting, who can feel and express beauty without copying, who is able to collect the essence of beauty by roving from one flower to the other like a bee and who appeals to the heart by forming a honeycomb of exquisiteness. This talent is Ravi Varma.

[...]

There may be certain flaws in these paintings that will only be discernible to an art critic—and for us who only have the art-studios of Bengal and the Kalighat scrolls to contend with it is an audacity to offer a criticism of any sort—but the paintings have a delectable quality and that this quality has been churned out of the heart of the land of India can be ascertained without doubt. Never before have mythological paintings been painted so beautifully in this country. And though there might be some shortcomings in their details, Ravi Varma is the firstmost gifted artist of this country.

[...]

Undoubtedly Ravi Varma has entered the core of the mythological mood; this is why he can achieve such wonderful emotional states in his paintings.

[...]

However, one does not feel an inclination to offer any negative criticism on entering the indigenous gallery of paintings and is experiencing the initial joys of viewing them. We will only be in a position to offer detailed criticism when there will be an abundance of painters in India and the

treasures of our artwork will be prodigious. Right now, whatever little we achieve seems to be a mighty gain.

b) Ramananda Chatterjee, 'Ravi Varma', *Modern Review,*
vol. 1, no. 1 (1907), pp. 84–90: 84, 86–88
The art of a country epitomizes the whole development of the people that produced it. [...] In modern India, [...] it is called upon to exercise [...] the function of nation-building. [...] India is inhabited by various races, speaking more than a hundred and fifty languages. To make the situation still more difficult, they profess many different religions. To build up all these races into one nation is a work of the greatest difficulty.
 [...]
 But the language of form and colour appeals to all. [...] Ravi Varma, the greatest painter of modern India [...] painted for the most part scenes from the religious and classical literature of India. In this way [...] he helped in the work of nation-building, at least so far as Hindu India is concerned. [...]

[p. 84]

Of late years, mainly through the efforts of Messrs. Havell and Aban-indro Nath Tagore, public attention has been drawn to the Indian style of painting. If a man of Ravi Varma's originality and feeling for beauty had in youth followed the Indian style, we do not know how much greater his success would have been; [...]
 With the exception of his style, every thing [*sic*] else in the pictures is Indian. But his foreign style [...] does not detract from the usefulness of his paintings as sources of enjoyment [...] or as influence that makes for nationality. From the Himalayas to Cape Cormorin, however much our languages, dress, manners and customs may differ, the social organization and national character are much the same everywhere. This is due to no small extent to the influence of our national epics, the Ramayana and the Mahabharata. Ravi Varma's pictures taken from these epics appeal to all Hindus, at any rate, thoroughout India. May we not hope that hereafter a gifted artist will be born who will speak in the inspiring language of form and colour to all Indians alike irrespective of race or creed?
 The most ancient Indian ideal was one of healthy activity and healthy enjoyment. Even in the Ajanta caves, which served as retreats for Buddhist monks, whose ideal was renunciation, we find an indication of this feature of the national character, taking delight in all natural forms and activities. [...] May we not hope that the advent and popularity of a painter like Ravi Varma are artistic indications of the returning interest of the nation's mundane existence?

[pp. 86–88]

4.4 The Modern, Internal Primitivism and Hinduisation

A further factor in this history of encounter was the changing aesthetic preferences in Britain from Classicism to the Gothic to modern art. As pointed out by the British art critic Roger Fry, this transformed the interactions with Indian art and culture. The approach of the historian of Indian art Vincent Smith who in 1911 revised his earlier championing of the theory of Grecian influence in Gandharan art published in 1889, is a case in point. It is however foremost the arrival of the modern which opened up new vistas, ushering in a sea change in the appreciation of India's visual culture: India was now credited with fine art, albeit under the remit of Primitivism, a deeply problematic legacy of modern art implicated in imperialism. The internal Primitivism of the Neo-Orientalist Indian national school of art represents a lesser known yet complex part of this trajectory and reflects the downgrading of India's other aesthetic traditions by the high-cultural literary emphasis and Hinduisation of the national sphere of Indian art. Smith is critical of this neglect and stresses the prevalence of multifarious subaltern art traditions which he sees as key, yet unacknowledged, national traditions of Indian art. [Renate Dohmen]

a) **Roger Fry, 'Oriental Art', *Quarterly* Review, 212 (1910), pp. 225–239: 226**
[…] Scarcely more than a hundred years ago art meant for a cultivated European, Graeco-Roman sculpture and the art of the high Renaissance, with acceptance of a few Chinese lacquers and porcelains as curious decorative trifles. Then came the admission that Gothic art was not barbarous, that the Primitives must be reckoned with, and the discovery of early Greek art. The acceptance of Gothic and Byzantine art as great and noble expressions of human feeling, which was due in no small degree to Ruskin's teaching, made a breach in the well-arranged scheme of our aesthetics, a breach through which ever new claimants to our admiring recognition have poured.

When once we have admitted that the Graeco-Roman and high Renaissance views of art – and for our purposes we may conceive these as practically identical – are not the only right ones, we have admitted that artistic expression need not necessarily take effect through scientifically complete representation of natural appearances, and the painting of China and Japan, the drawings of Persian potters and illuminators, the ivories,

bronzes and textiles of the early Mohammedan craftsmen, all claim a right to serious consideration. And now, finally, the claim is being brought forward on behalf of the sculptures of India, Java and Ceylon. These claims have got to be faced; we can no longer hide behind the Elgin marbles and refuse to look; we have no longer any system of ascetics which can rule out, *a priori*, even the most fantastic and unreal aesthetic forms. They must be judged in themselves and by their own standards.
[...]

b) Vincent A. Smith, *A History of Fine Art in India & Ceylon*, 2nd edn (Oxford: Clarendon Press, 1930 [1911]), pp. 1–3, 5, 7
[...] India is multiple; neither geographically, ethnologically, nor culturally can it be considered a unity. This being so, I am led to suspect that the India of many writers is more imagination than fact, existing rather in pictorial expression than in reality.

[...] The opposition of Eastern spirituality to Western materialism is a generalization without support, while the postulation of a metaphysical basis for any art is equally as sterile, and in fact as inconsequential, as the postulation of the existence of eternal, immutable classical standards.
[...]

[pp. 1–3]

[...] Nor can I accept as sound criticism a discourse which shifts the foundations of a true understanding of art from the visual into the literary or historical or metaphysical. [...]

The popularization of Indian art has been mainly the work of Dr. Coomaraswamy and Mr. E. B. Havell. To a certain extent their methods of exposition agree, the vein being interpretational, with a stressing of the literary. For Dr. Coomaraswamy 'all that India can offer to the world proceeds from her philosophy',[1] a state of 'mental concentration' (*yoga*)[2] on the part of the artist and the enactment of a certain amount of ritual being postulated as the source of the 'spirituality' of Indian art. The weakness of this attitude lies in its interweaving of distinct lines of criticism, form being dressed out in the purely literary with the consequent confusion of aesthetic appreciation with religious and other impulses. It is also historically ill-founded, for the sentiment and philosophy out of which the web is spun are the products of medieval India, as an examination

1 A. Coomaraswamy, 'What Has India Contributed to Human Welfare?', *Athenaeum*, October 2, 1915.
2 A. Coomaraswamy, *The Dance of Sive* (New York: New York Sunwise Turn, 1918), p. 21.

of the texts quoted will show; many of the southern authorities quoted can only be classed as modern.

[...]

[p. 5]

[...]

The Vedas, in spite of their antiquity, cannot be accepted as the sole source of religious thought in India, or as anything but a critical and highly selective representation of this unvoiced and necessarily formless background [of the primitive]. This relationship between Brahmanism and the primitive, between the formulated philosophy of the schools and the worship and propitiation born of the vague fears and desires of savages, is present throughout the history of India, both religious and political. [...] Vedic thaumaturgy and theosophy were never the faith of India. The countless Mother-Goddesses and village guardians of the South lie closer to the real heart of Indian religion, a numberless pantheon, superficially identified with Brahmanism but radically distinct and unchanged.

[...]

[p. 7]

4.5 'Authentic' Indian designs

Parallel to the civilisational argument that revolved around the perceived lack of an Indian fine-art tradition, the question of authentic Indian design also exercised the minds of British colonial officials. As exemplified by the writing of the influential colonial arts administrator George Birdwood who romanticised the Indian village, they often endorsed Arts and Crafts ideals. In his view artisanal traditions, which had flourished unadulterated for centuries in India's village communities now needed to be saved from the corruption of Western modernisation. The general colonial approach to this task was to seek to keep India's heritage 'pure' through art education (which Birdwood however did not support) and the display of approved Indian artefacts in Indian craft museums (which he backed and was deeply involved in). The collection arranged by the medical officer and prolific art enthusiast Thomas Holbein Hendley in Jaipur's Albert Hall Museum is a case in point and aimed to teach Indian artisans about 'correct' Indian artisanal traditions. The irony of defining and teaching Indian aesthetic traditions from an assumed superior 'scientific' vantage point was lost on colonial officials. [Renate Dohmen]

a) George Birdwood, *The Industrial Arts of India* (London: Chapman & Hall Ltd., 1884), Part I, pp. 125–126, 150–152
[...]

Evil Influence of the Puranas on Indian Art

The mythology of the Puranas is not an essential element in Hindu art, which, however, it has profoundly influenced. It lends itself happily enough to decorative art; but has had a fatal effect in blighting the growth of true pictorial and plastic art in India. The monstrous shapes of the Puranic deities are unsuitable for the higher forms of artistic representation; and this is possibly why sculpture and painting are unknown, as fine arts, in India. Where the Indian artist is left free from the trammels of the Puranic mythology he has frequently shewn an instinctive capacity for fine art. The ancient Buddhist sculptures of Sanchi, Bharhut, and Amravati display no mean skill, and some of the scenes from Buddha's life, in which he is represented in purely human shape without any ritualistic disfigurement, are of great beauty. Many also of the more popular scenes of the Ramayana and Mahabharata, [...] are free from the intrusion of the Puranic gods, and the common bazaar paintings of them often approach the ideal expression of true pictorial art. They shew little knowledge of perspective, but tell their story naturally [...].

 [...] [T]he unnatural figures of the Puranic gods, derived from the Dravidian and Indo-Chinese races of India, sometimes shew indetailed [*sic*] ornamentation, yet their employment for this purpose is in direct defection from the use of the lovelier, nobler forms of trees and flowers. The latter forms were introduced in the decorative arts by the Aryan race wherever it went; and after being comparatively suppressed for centuries in India, as they still are in the South, were again brought into fashion by the Afghans and Mongols [Turkomans] from Persia; where this charming style of religious symbolism, springing from the love and worship of nature intuitive in the Aryas, has prevailed [...].

[pp. 125–126]

 [...] At present the industries of India are carried on all over the country, although hand-weaving is everywhere languishing in the unequal competition with Manchester and the Presidency Mills. But in every Indian village all the traditional handicrafts are still to be found at work.

 Outside the entrance of the single village street, on an exposed rise of ground, the hereditary potter sits by his wheel moulding the swift revolving clay by the natural curves of his hands. At the back of the houses, which form the low irregular street, there are two or three looms at work in blue and scarlet and gold, the frames hanging between the acacia trees, the yellow flowers of which drop fast on the webs as they

are being woven. In the street the brass and copper smiths are hammering away at their pots and pans; and further down, in the verandah of the rich man's house, is the jeweller working rupees and gold mohrs into fair jewelry, gold and silver earrings, and round tires like the moon, bracelets and tablets and nose rings, and tinkling ornaments for the feet, taking his designs from the fruits and flowers around him, or from the traditional forms represented in the paintings and carvings of the great temple, which rises over the grove of mangoes and palms at the end of the street above the lotus-covered village tank. At half-past three or four in the afternoon the whole street is lighted up by the moving robes of the women going down to draw water from the tank, each with two or three water jars on her head: and so, while they are going and returning in single file, the scene glows like Titian's canvas, and moves like the stately procession of the Panathenaic frieze. Later the men drive in the mild grey kine[1] from the moaning plain, the looms are folded up, the coppersmiths are silent, the elders gather in the gate, the lights begin to glimmer in the fast-falling darkness, the feasting and the music are heard on every side, and late into the night the songs are sung from the Ramayana or Mahabharata. The next morning with sunrise, after the simple ablutions and adorations performed in the open air before the houses, the same day begins again. This is the daily life going on all over Western India in the village communities of the Dakhan,[2] among a people happy in their simple manners and frugal way of life, and in the culture derived from the grand epics of a religion in which they live and move and have their daily being, and in which the highest expression of their literature, art, and civilisation has been stereotyped for 3,000 years.

But of late years these handicraftsmen, for the sake of whose works the whole world has been ceaselessly pouring its bullion for 3,000 years into India, and who, for all the marvellous tissues and embroidery they have wrought, have polluted no rivers, deformed no pleasing prospects, nor poisoned any air; whose skill and individuality the training of countless generations has developed to the highest perfection; these hereditary handicraftsmen are being everywhere gathered from their democratic village communities in hundreds and thousands into the colossal mills of Bombay, to drudge in gangs, for tempting wages, at manufacturing piece goods, in competition with Manchester, in the production of which they are no more intellectually and morally concerned than the grinder of a barrel organ in the tunes turned out from it.

1 Kine – cow.
2 Dakhan – the Deccan.

I do not mean to depreciate the proper functions of machines in modern civilisation, but machinery should be the servant and never the master of men. It cannot minister to the beauty and pleasure of life, it can only be the slave of life's drudgery; and it should be kept rigorously in its place, in India as well as England. When in England machinery is, by the force of cultivated taste, and opinion, no longer allowed to intrude into the domain of art manufactures, which belongs exclusively to the trained mind and hand of individual workmen, wealth will become more equally diffused throughout society; and the working classes, through the elevating influence of their daily work, and the growing respect for their talent and skill and culture, will rise at once in social, civil, and political position, raising the whole country, to the highest classes, with them; and Europe will learn to taste of some of that content and happiness in life which is to be still found in the pagan East, as it was once found in pagan Greece and Rome.

The village communities have been the stronghold of the traditionary arts of India; and where these arts have passed out of the villages into the wide world beyond, the caste system of the Code of Manu has still been their best defence against the taint and degradation of foreign fashions. [...]

[pp. 150–152]

b) George Birdwood, *The Industrial Arts of India* (London: Chapman & Hall Ltd., 1884), Part 2, pp. 302–303

Clay Figures

[...]

It is very surprising that a people who possess, as their ivory and stone carvings and clay figures incontestably prove, so great a facility in the appreciation and delineation of natural forms should have failed to develop the art of figure sculpture. Nowhere does their figure sculpture shew the inspiration of true art. They seem to have no feeling for it. They only attempt a literal transcript of the human form, and of the forms of animals, for the purpose of making toys and curiosities, almost exclusively for sale to English people. Otherwise they use these sculptured forms only in architecture, and their tendency is to subordinate them strictly to the architecture. The treatment of them rapidly becomes decorative and conventional. Their very gods are distinguished only by their attributes and symbolical monstrosities of body, and never by any expression of individual and personal character.

So foreign to the Hindus is the idea of figure sculpture in the aesthetic sense, that in the noblest temples the idol is often found to be some obscene or monstrous symbol. [...]

c) **Thomas Holbein Hendley, 'Decorative Arts in Rajputana',** *The Journal of Indian Art and Industry*, **vol. 2, no. 21 (1888), pp. 45–49: 45**

[...] [P]lastic and receptive as is the mind of the Hindu, beneath all his apparent ready susceptibility to the external impressions with which he is for the moment in contact, there is a deep underlying current of obstinate adherence to old traditions and to rule, which is always making itself felt, and is revealed in quite unexpected manners and places. He absorbs everything, though often without understanding, or with an interpretation of his own, which completely disguises the origin and true meaning of what he is attempting when his more recent ideas lead him to a new departure.

d) **Thomas Holbein Hendley, 'The Opening of the Albert Hall and Museum in Jeypore',** *The Journal of Indian Art and* **Industry, vol. 3, no. 19 (1888), pp. 21–22**

[...] [T]he building is a successful adaptation of the Indo-Saracenic style to a modern public building and, it might be added, to the peculiar uses of a museum. [...] Although, however, the exterior of the building is so worthy of admiration, it is to the decoration of the interior that the palm must be awarded. Almost every pillar and every inch of wall space is a copy of, or an adaptation from some well-known and admired native building. For many years Colonel Jacob has employed a number of youths, trained in their first instance under Dr. De Fabeck at the Jeypore School of Art, in copying the ornament on the palaces, tombs, and other important edifices at Delhi, Agra, or Fatehpore Sikri, till at last his pupils, who, it should be observed, were sons of Jeypore masons, were so imbued with the spirit of the Indo-Saracenic style that they could produce works which were no longer copies but creations. Much of the internal decoration of the hall is therefore original: there are, however, reproductions from the palaces of Agra, the tombs near Delhi, and the walls of Amber, the ancient capital of Jeypore. [...] Most of the carving with which the doors and windows is enriched, whether in wood or metal, is the work of men who have been settled for many centuries in the north of the State, and who adorned the great gates and screens of the Jeypore courts, which stood at the entrance of the Indian section of the London Exhibition of 1886. [...]

The collection in the larger rooms [...] arranged in cases of the South Kensington Museum pattern are made by Mr. Wimbridge of Bombay. [...] [I]t is hoped you will find [...] ere long a very complete illustration of the condition of industrial art in the East. [...] Although no interference is attempted in the art progress of the people where it proceeds on ancient and indigenous lines, still it is admissible and desirable that the artists and inhabitants of Jeypore should have opportunities of seeing what is recognised by all nations as art work of the highest type. To this end a few original specimens and a number of electrotypes of some of the best examples of metal and other work form the great national collections of Europe have been purchased and displayed in the Museum. [...]

Critical approaches

4.6 Tim Barringer, Geoff Quilley and Douglas Fordham, 'Introduction', in Barringer, Quilley and Fordham (eds), *Art and the British Empire* (Manchester: Manchester University Press, 2007), pp. 1–19: 3–6

Tim Barringer is Paul Mellon Professor of the History of Art, Yale University, with a specialism in British art and empire and a long-standing background in curation; Geoff Quilley, Professor of Art History at Sussex University and former curator at the National Maritime Museum in Greenwich, works on the British Empire, maritime history and the colonial; and Douglas Fordham is Associate Professor of Art History at the University of Virginia and is interested in the interface between politics, empire and eighteenth-century visual culture. In this extract they note an intrinsic schism between British art and empire which they argue fundamentally misrepresents nineteenth-century British art, and eclipses the formative role played by the visual in Britain's forging of an imperial identity. [Renate Dohmen]

Art and the history of empire
The central premise of the essays collected here is that the concept of *empire* belongs at the centre, rather than in the margins, of the history of British art. This is contrary to virtually the entire existing historiography of the subject. In texts from Ellis Waterhouse's 1953 survey for the Pelican 'History of Art' series and Nikolaus Pevsner's Reith lectures *The Englishness of English Art*, delivered in 1955, to more recent synthetic volumes by Andrew Graham-Dixon, Andrew Wilton and William Vaughan, British

art has been conceived as work produced in Britain and overwhelmingly representing subjects in the British Isles.[1] The visual arts, in these accounts, played a fundamental role in the expression, celebration and (it has more recently been added) the construction, of *Britishness*. This term, in turn, has often been subsumed by *Englishness*, reflecting the unequal balance of power within the component parts of Britain.[2] Until very recently the major collections of British painting at institutions such as the Tate Gallery (whose British collections from 2000 formed a self-contained museum, named Tate Britain) and the Yale Centre for British Art, chose largely to keep the issue of empire away from public view, despite the overwhelming dominance of empire in the historical development of Britain as a global economic and political power from the mid-eighteenth to the mid-twentieth century.[3] Even at the Victoria and Albert Museum, where a substantial proportion of the collection derives from imperial endeavours, the narrative of 'British Art and Design' was, until recently, held to be separate from those of galleries representing the Indian and South-East Asian, Far-Eastern and Islamic collections.[4] In these metropolitan narratives, the imperial occupies a peripheral position or is simply ignored. This spectacular act of erasure has resulted in histories that are partial in coverage, and they are ideologically partial too. This book aims to reinsert empire as a fundamental category for the analysis of British art.

1 E. Waterhouse, *Painting in Britain, 1530–1790*, new edn with an Introduction by Michael Kitson (New Haven: Yale University Press, 1994 [1953]); N. Pevsner, *The Englishness of English Art* (London: Architectural Press, 1956); A. Graham-Dixon, *History of British Art* (London: BBC Books, 1996); W. Vaughan, *British Painting: The Golden Age from Hogarth to Turner* (London: Thames & Hudson, 1999); A. Wilton, *Five Centuries of British Painting* (London: Thames & Hudson, 2001). Even when the term is acknowledged (as in Wilton's chapter 7, 'The Apogee of Empire'), questions of empire are brushed aside. Sir Frank Swettenham, in Sargent's portrait of 1904 (London: National Portrait Gallery), is described by Wilton as 'evoking Britishness as personified in the aristocratic official of a distant dominion'; the 'cheerful' nature of Sargent's image is explained as follows: 'Not being British, Sargent may have been happier to take the burdens of empire lightly' (p. 191).

2 L. Colley, *Britons: Forging the Nation* (New Haven and London: Yale University Press, 1992); W. Vaughan, 'The Englishness of British Art', *Oxford Art Journal*, 13:2 (1990), 11–23.

3 Even recent publications, such as Martin Myrone, *Representing Britain 1500–2000* (London: Tate, 2000), make only the slightest gestures in the direction of empire as a theme in British art, despite the claim of Stephen Deuchar, Director of Tate Britain, to be 'applying the best of new scholarship'. The major preoccupation of Tate Britain lies with 'art's contribution to varying kinds of national identity' (p. 8).

4 For a full discussion, see M. Snodin and J. Styles (eds), *Design and the Decorative Arts: Britain, 1500–1900* (London: V&A Publications, 2001); and M. Baker and B. Richardson (eds), *A Grand Design: The Art of the Victoria and Albert Museum* (New York: Harry N. Abrams, 1997).

Despite the silence of many scholars and curators, empire remains an unspoken presence, stalking the museums' picture stores and haunting the footnotes of journals and monographs. The chronological development of British art, as narrated by survey texts and museums, uncannily replicates the contours of imperial history, following a path from sixteenth-century roots, through a first major efflorescence in the mid-eighteenth century and an opulent, and perhaps increasingly troubled, climax between Waterloo and the Boer War, to crisis and metamorphosis in the twentieth century. To pursue such a parallel could be deemed deterministic – reducing art merely to a function of imperialism [...]. The contributors to this book argue for a more complex account of the relationship between art and empire. We contend that culture and, in particular, the visual image play a formative as well as a reflective role in the course of empire. In making this claim we are mindful of William Blake's telling epithet 'Empire follows Art & not Vice Versa as Englishmen suppose.' Even more broadly we take up Blake's dictum 'The Foundation of Empire is Art and Science'.[5]

During the post-war period of decolonisation, scholarship in British social history, literary studies and art history was notable for its near silence on the subject of empire – a silence which speaks eloquently of the psychological impact of the loss of imperial power. [...]

[...] Imperial history's definition of empire as a monolithic political and economic project has been replaced across the humanities by an idea of empire as a complex and contested process, mediated materially and imaginatively by multifarious forms of culture. In the field of literary studies and the history of ideas, Edward Said's seminal *Orientalism* of 1978 served to draw attention to the continuing existence of imperialist 'habits of mind' in constructing binary distinctions, primarily that between East and West, which served as an apologetics for imperialism. Though this sweeping polemical text has since been the subject of effective critiques, notably from historians of empire, Said's magisterial *Culture and Imperialism* (1993) offered a broader and more balanced account: 'I do not believe that authors are mechanically determined by ideology, class, or economic history, but authors are, I also believe, very much in the history of their societies, shaping and shaped by that history and their social experience in different measure. Culture and the aesthetic forms it contains derive from historical experience ... '.[6] Once again, however, Said's analysis

5 William Blake, 'Annotations to Reynolds's *Discourses*', in Joshua Reynolds, *Discourses on Art*, ed. Robert R. Wark (New Haven: Yale University Press, 1975), p. 285.

6 E. Said, *Culture and Imperialism* (New York: Vintage Books, 1994), p. xxii; for a critique of Said's work by an imperial historian, see J. M. MacKenzie, *Orientalism: History, Theory and the Arts* (Manchester: Manchester University Press, 1995).

relied primarily on canonical literary sources and completely ignored the visual field.

[...]

The critical equipment and the cultural conditions exist for a radical re-reading of cultural production in the British empire. Yet despite Said's pioneering work and the extensive reassessment of official and literary imperial texts, the visual archive has not yet been subjected to the same rigorous analysis. The burgeoning historiography of the British empire includes specialised studies in almost every imaginable area – from gender and sexuality to hunting and the environment, from exploration and religion to science and communications – except that of art. [...]

4.7 Theodore Koditschek, 'Race Struggles', in Theodore Koditschek, Sundiata Keita Cha-Jua and Helen A. Neville (eds), *Race Struggles* (Urbana, IL: University of Illinois Press, 2009), pp. 48–79: 64–79

Theodore Koditschek is Professor of History at the University of Missouri, Columbia and works on nineteenth-century British history and empire. He argues that the hardening of racial attitudes in the second half of the nineteenth century was not caused by the parallel rise of 'scientific racism' as is commonly assumed. In his view, as outlined in the excerpt below, these new racial theories rather were opportunistically adopted in response to the socio-economic shifts from the previous protectionist mercantilist system based on slave labour to a free-trade economy. He argues that race offered the benefit of a new and flexible 'labour management system' that kept colonial peoples firmly in their lowly place. It provided a racialised distancing mechanism to intellectually contain the blurring of boundaries between the metropolitan centre and the colonial periphery as geographical distance shrank due to the nineteenth-century transport and communication revolutions epitomised by steam power, the railways and the telegraph. But, as Koditschek develops, even this harsher view of race was not as black and white as is often assumed, and rather constituted a 'palette of power' which offered many shades of grey. He also explores the central role of race in the colonial rhetoric of a civilising mission. This combined the paradox of a paternalistic fostering of the advance of wayward, childlike, inferior races, while at the same time fixing them in 'evolutionary amber', as otherwise the claimed mission would be obsolete. He notes

that this racial model was also applied to the British underclass, and draws attention to the central role of Aryanism in the divergent and malleable colonial paradigm that later was taken up by Indian nationalists and spun in their favour. [Renate Dohmen]

[...] It is important to distinguish the evolutionary theories of the post-1859 period from those that had been proposed before the Victorian age. In the eighteenth century, evolutionary theory had tended to downplay biology, focusing primarily on processes of social evolution in which environment reigned supreme. Tracing a logical trajectory from hunting (savagery) to pastoralism (barbarism) to agriculture (early civilization) to commerce (advanced civilization), such theories hypothesized that all human societies had passed through these same four stages, albeit with varying success and at differing rates.[1]

On one level, the post-Darwinian theories of racial evolution were not really so different from those of the earlier period. Both took a historical approach to the question of racial formation, in contrast to the absolutist and ahistorical doctrines of Knox and Hunt.[2] There were, however, two crucial innovations in the new evolutionary theories that not only rendered them scientifically respectable but also fitted them for the imperial challenges of the day. The first, of course, was Darwin's theory of natural selection. Yet the influence of this theory is easily overstated. Most biologists and ethnologists, including Darwin himself, still believed that some acquired characteristics could also be inherited—thus leaving open the door to the possibility that environmental changes could become encoded in hereditary bloodlines and that cultural improvement could continue to alter the biology of race.[3]

A more fundamental change was the shift from the six thousand-year time line of Genesis to the almost limitless expanse of geological time that the new paleontological discoveries implied. In terms of the old eighteenth-century categories, the fossils indicated that the earliest

1 James Cowles Prichard, *Researches into the Physical History of Man* (Chicago: University of Chicago Press, 1973). The classic studies of eighteenth- and nineteenth-century social evolutionary theories are Ronald Meek, *Social Science and the Ignoble Savage* (Cambridge: Cambridge University Press, 1976); John Burrow, *Evolution and Society: A Study in Victorian Social Theory* (Cambridge: Cambridge University Press, 1966); and George W. Stocking, *Victorian Anthropology* (New York: The Free Press, 1987).

2 This is a key point that is ignored in most of the existing literature on 'scientific racism'—for example, Nancy Stepan, *The Idea of Race in Science: Great Britain 1800–1960* (London: Macmillan, 1982); and Christine Bolt, *Victorian Attitudes to Race* (Abingdon: Routledge, 1971), I develop it more fully in my *Liberalism, Imperialism, and the Historical Imagination* (Cambridge: Cambridge University Press, 2011).

3 Peter J. Bowler, *The Eclipse of Darwinism* (Baltimore: Johns Hopkins University Press, 1983).

stage of hunting had been vastly elongated, and that most humans, and prehumans, had subsisted in a state of protracted savagery throughout their development. Indeed, savagery was now divided into a number of substages, based on archaeological and paleontological evidence. [...] The fact that so much of human history had been passed in various stages of savagery was oddly reassuring, as it explained why 'savages,' of one kind or another, still predominated in most portions of the globe. [...]

In his book *Cave Hunting*, amateur paleontologist Boyd Dawkins purported to demonstrate, from fossil evidence, that only the severest pressure of Darwinian selection had enabled British Anglo-Saxons to achieve their uniquely elevated civilizational pinnacle. European history, he hypothesized, had been driven by successive waves of invasion, in which a superior race, with a more advanced technology, supplanted its more primitive predecessor. [...] In Asia, Africa, and indigenous America, where selection had been less rigorous, primitive dark men still subsisted in a Stone or Bronze Age mentality. By contrast, British history had been a Darwinian proving ground where the weaker (darker, lower tech) had repeatedly perished and only the strongest (blondest, highest tech) had survived.

The problem with this theory (as Dawkins himself half-realized) was that, even in Britain, none of his 'unfit' races (except perhaps the Neanderthal) had been entirely wiped out.[4] To the less dogmatic ethnologists and race commentators, this evidence showed that cultural exchange and biological miscegenation had always been an important motor of evolutionary progress. Instead of denying the evidence of biological and cultural miscegenation, they preferred to concentrate on the ways in which the imperial infusion of superior culture into backward regions might enable inferior races to improve their bloodlines—very gradually— albeit at some risk of a weakening and dilution of the superiority of the master race.[5]

A good example of this kind of historicized thinking can be found in Sir John Lubbock's enormously influential treatise *Pre-historic Times* (1865). To Lubbock, the scientific interest of the modern savage was that his culture had preserved in evolutionary amber the same kind of primitive social structures and cultural belief systems that had prevailed

4 Boyd Dawkins, *Cave Hunting: Researches on the Evidence of Caves Respecting the Early Inhabitants of Europe* (London: Macmillan, 1974).

5 See, for example, Herman Merivale, *Lectures on Colonization and Colonies* (London: Longman & c., 1841), 535–40; James Bryce, *The Relations of the Advanced and the Backward Races of Mankind* (Oxford: Oxford University Press, 1903); and Charles W. Dilke, *Greater Britain: A Record of Travel in English Speaking Countries* (New York: Harper Bros., [1868]), 41–43.

in Britain during the Neolithic and Paleolithic epochs. Yet if the modern savage represented the past of the modern Briton, modern British industrial capitalism represented the future to which the modern savage had to adjust. Where the earlier generation of abolitionists had figured the savage or slave as a shackled suffering brother, Lubbock refigured him as a wayward refractory child. The adult savage, Lubbock repeatedly argued, exhibited the same behavior as a typical English child. He was moody, undisciplined, attracted to baubles, and mired in dirty habits and gross, superstitious beliefs. Lubbock's analogy was by no means original, and many other ethnologists repeated the observation that although colored children might be as intelligent as their English counterparts, from adolescence onward their development was arrested, and they became fixed as mental children for the remainder of their lives.[6]

Among those savages (like those children) that were destined for survival, childish behavior manifested itself in several ways.[7] Some children were obedient, and some were naughty. Some had to be punished, corrected, and disciplined, whereas others were responsive to incentives and rewards. The important thing was to be patient, purposeful, and paternalistic, without any illusions that those whom one held in a state of wardship could instantly develop, advance, or progress. At some distant point in the *longue durée* of racial evolution, self-control, and even self-government, might become a possibility. This time, however, lay far away in an unknown hereafter. For the present, and the foreseeable future, imperial rule had to be the order of the day.[8]

[...] It was, rather, the interaction of evolutionary theory with three other racialized discourses that made it possible to identify the precise cultural coordinates of any given ethnic group or colonized people, and the exact pace at which they could be allowed or encouraged to progress.

In the remainder of this chapter I will examine the way in which the new post-Darwinian evolutionism played itself out in connection with two of these other racial discourses—Aryanism and racial degeneration—to produce a new body of racial and ethnological knowledge designed to help British metropolitan elites and colonial managers in realizing their

6 John Lubbock, *Pre-historic Times, as Illustrated by Ancient Remains and Modern Savages*, 2d ed. (London: Williams and Norgate, 1869).
7 Merivale, *Lectures on Colonies*, 524–553.
8 Dilke, *Greater Britain*, 475–534. The most succinct and powerful statement of this position is Rudyard Kipling's famous poem 'The White Man's Burden'.

projects of capitalist integration and colonial control.[9] In fact, because there was never complete agreement among these elites, who came with divergent goals and agendas, these racial and evolutionary discourses became sites of ambiguity and contestation, as rival interpretations turned them in different directions at once. Moreover, by the 1880s and 1890s, some of these discourses themselves were being appropriated by colonial others, who had figured out how to use them to question white metropolitan domination and to assert insurgent objectives of their own.

'Aryanism' and the Evolution of Victorian Races

The 'Aryan' hypothesis had been first formulated by the Anglo-Indian jurist Sir William Jones in 1786. Noticing striking resemblances between Sanskrit and the major European languages, he hypothesized that these languages were all remotely descended from a common 'Aryan' root. Because Irish and native Indian languages were almost all Aryan, Jones's theory had obvious imperial implications. Not surprisingly, from the 1840s onward, these arguments about the descent of language, culture, and mythology were transmuted into debates about the descent of blood and race.[10] Clearly, not all Aryan speakers were racially Aryan, so attention had to be paid to physical attributes such as skin color, behavior, and physiognomy. [...] The point was to come up with a scenario in which the British stood at the top, as pure Aryans. Favored others would be cast as more or less adulterated admixtures, while the laboring masses would be identified as lesser breeds entirely.[11]

The place where the Aryan hypothesis was developed most fruitfully was in India, for there it offered a comprehensive explanation of the existing caste system as well as an Anglo-friendly rendering of Indian

9 Limitations of space prevent me from considering several other important Victorian discourses of racial evolution, those of miscegenation, Anglo-Saxonism, and arrested development. I hope to repair this deficiency in future work.

10 J. Marshall, ed., *The British Discovery of Hinduism in the Eighteenth Century* (Cambridge: Cambridge University Press, 1970). Sir William Jones himself never used the word *Aryan*, which was coined by German philologists in the early nineteenth century. Once the leap had been made from language to race, the doctrine became an important classificatory tool in identifying groups with claims (however attenuated) to racial superiority. Indeed, some ethnologists and sociologists, with more imperial enthusiasm than scientific skepticism, tried to apply it to the 'higher races' of South Asia and Oceana. See Tony Ballantine, *Orientalism and Race: Aryanism in the British Empire* (New York: Palgrave, 2002).

11 Thomas B. Trautmann, *Aryans and British India* (Berkeley and Los Angeles: University of California Press, 1997). See also Martin Bernal, *Black Athena: The Afroasiatic Roots of Classical Civilization*, vol. 1, *Fabrication of Ancient Greece* (New Brunswick: Rutgers University Press, 1987).

history. According to this analysis, caste distinctions had been created by the original light-skinned Aryan invaders (ca. 1500 BC[E]) in a partially abortive effort to preserve their racial purity. To this end, the black 'Dravidian' indigenes, whom they conquered, were corralled into the lowest, most menial castes. When miscegenation blurred these racial boundaries, the resultant half-breeds were assigned to intermediate castes, which grew ever more numerous, specialized, and complex. Eventually, as classical Indian civilization faltered, even the highest-caste Brahmans began to darken, as their ranks were adulterated with tainted blood. From this perspective, the British could regard themselves as the new Aryan master caste, destined to advance a stagnant Indian civilization by bracing infusions of their fresh Aryan culture (if not blood).[12] Inasmuch as caste had originally developed as a system of social and labor management, the British could now refurbish it to secure their own aims.

Given the speculative nature of this tenuously grounded historical argumentation, it could be molded to support almost any racial or caste hierarchy that one chose. Thus, a liberal like Friedrich Max Müller, who minimized the significance of skin color, might urge the British to regard nearly all Indians as at least distant racial cousins. Conservatives, like H. H. Risley, on the other hand, would reserve Aryan honors for the highest castes alone. Those in the market for cheap indentured labor often tended to favor the darkest, least-Aryan Dhangars, or 'Hill Coolies,' who were deemed especially suited to plantation work. [...]

By far, the most urgent concern for the British in India was to find collaborators among indigenous elites who would help them in the day-to-day running of the subcontinental empire. Initially, they fastened on the Bengali Brahmans, whose Western educations made them the most likely candidates for the job of diffusing British civilization to the masses below.[13] After the 1857 revolt, as we have seen, this strategy began to change. The 'Bengali Babu' had now become too Westernized and independent to be trusted. Increasingly, he was caricatured as garrulous, overrefined, deceptive, and effeminate. He was compared unfavorably

12 Thomas Metcalf, *Ideologies of the Raj* (Cambridge: Cambridge University Press, 1994); H. H. Risley, *The Tribes and Castes of Bengal: An Ethnographic Glossary, in Two Volumes* (Calcutta: Bengal Secretariat, 1891).

13 David Kopf, *British Orientalism and the Bengali Renaissance: The Dynamics of Indian Modernization* (Berkeley and Los Angeles: University of California Press, 1969); David Kopf, *The Brahmo Samaj and the Shaping of the Modern Indian Mind* (Princeton: Princeton University Press, 1979); Nicholas Dirks, *Castes of Mind: Colonialism and the Making of Modern India* (Princeton: Princeton University Press, 2001), 127–228.

not only with the 'manly Englishman' but also with the traditional Maharajas and northwest frontier 'martial castes,' which were now increasingly favored as the bulwarks of British rule.[14] Given the importance of race in imperial thinking, however, it was necessary to drain the Aryan blood that had formerly coursed in the Bengali Brahman. Somehow it had to be transfused into those Gurkha or Sikh tribesmen, who had previously been dismissed as borderland pests. [...]

The utility of this kind of racial and evolutionary classification lay in the way it articulated a graduated hierarchy in which every group in Indian society could be assigned a British place. Radiating the appearance of solidity, inexorability, and biological predestination, such racial classifications were, in reality, highly fluid, transmutable, and easily adapted to whatever racial promotions or demotions the imperatives of capitalist and imperial rule might require. Such malleability was acceptable, however, only when it corresponded to the agenda of British imperial elites. When it was taken up by colored peoples to advance their own interests, it met with concerted hostility and opposition.

In the end, however, the Bengali Babu did get his revenge. Like other rising middle-class colonial groups—prosperous Catholics in Ireland or mulattoes in the West Indies—he began to learn how to formulate Aryan claims of his own. In the hands of creative intellectuals, like Bankimchandra Chattopadhyay, Swami Vivekananda, or the Irishmen Ulick Bourke and W. B. Yeats, an argument was crafted along the following lines: The ancient Celts and Hindus, no less than the ancient Anglo-Saxons, had once been in the vanguard of the Aryan race. In ancient times, the great Aryan family had split up into eastern and western branches. The western Anglo-Saxons had achieved mastery in the realms of war and government, and in these arenas they had become the undisputed masters of the world. By contrast, the eastern branches (somehow mysteriously including the Celts) had become avatars of the spiritual realm. In the British Empire, these two great Aryan branches had rediscovered one another. Rather than squabbling over superior status, they ought to establish a working division of labor in which the British would retain the powers

14 Mrinalini Sinha, *Colonial Masculinity: The "Manly Englishman" and the "Effeminate Bengali" in the Later Nineteenth Century* (Manchester: Manchester University Press, 1995); Indira Chowdhuri, *The Frail Hero and Virile History: Gender and the Politics of Culture in Colonial Bengal* (Delhi: Oxford University Press, 1998); Linda Colley, *Britons: Forging the Nation, 1707–1837* (New Haven: Yale University Press, 1992); Metcalf, *Ideologies of the Raj*, 125–127.

of government but would recognize the supremacy of Irish and Indian intellectuals in the realms of literature, religion, and morality.[15]

'Racial Degeneration' and Victorian Society

Given the way in which Aryanism was providing unexpected openings for the racial self-promotion of nonwhite others, it is not surprising that the discourses of demotion, exclusion, and limitation were increasingly shifting to ideologies of racial degeneration during the last few decades of the nineteenth century. Given the general evolutionary framework, it was, of course, quite logical to assume that a race could degenerate as well as advance. As we have seen, racial degeneration (often associated with miscegenation) had often been invoked to explain the deterioration of India's or Ireland's Aryans and to justify why they needed the benefits of British rule.[16] When connected to discourses on 'savagery,' the discourse of degeneration would play an even more critical role in addressing the problems of 'third world' labor control, discussed earlier in this chapter. According to this way of thinking, labor in distant mines or tropical plantations was deemed a civilizing experience for black savages, who would otherwise have remained mired in primitive misery. According to this view, slavery—for all its undoubted horrors—had been a civilizing force for the Afro-Americans and Afro-Caribbeans who had been involuntarily dragooned into it. Abolition had been a practical and ethical inevitability, but it had left the incompletely civilized freedmen to lapse back into their 'natural' condition of backwardness and savagery. [...]

By the 1870s, the discourse of racial degeneration began to be turned on the metropolis itself, as urban industrial Britain showed a new and increasingly savage underside. During the 1840s, when the metropolitan language of class division and class conflict was pervasive, the notion that certain sectors of the Anglo-Saxon proletariat might be racially degenerating would not have been taken seriously. There were simply too many poor people, too obviously impoverished by circumstances beyond their control, for economic failure to be interpreted in racial

15 Tapan Raychaudhuri, *Europe Reconsidered: Perceptions of the West in Nineteenth Century Bengal* (Delhi: OUP India, 2002); R. F. Foster, *W. B. Yeats, a Life: The Apprentice Mage, 1865–1914* (Oxford: Oxford University Press, 1997); W. B. Yeats, *Celtic Twilight* (London: Bullen, 1912); Ulick Bourke, *The Aryan Origins of the Gaelic Race and History* (London: Longmans, 1875). See also Ernest Renan, *Poetry of the Celtic Races, and Other Essays* (London: Scott, 1896); and Matthew Arnold, *Mixed Essays, Irish Essays, and Others* (New York: Macmillan, 1924).

16 Daniel Argov, *Moderates and Extremists in the Indian National Movement, 1883–1920* (New Delhi: Asia Publishing, 1967); David George Boyce, *Nationalism in Ireland* (Abingdon: Routledge, 2003), 144–227.

terms. In the 1860s, however, social investigator Henry Mayhew began to suggest that there might be a racial element to the dysfunctions of the British poor. Over the generations, their behavior was growing more feckless, their lifestyle was becoming more 'Irish,' and their vigor was diminishing. Even their skin color seemed to darken, as they came to constitute a permanently inferior underclass.[17] [...]

From the 1870s onward, this racialization of the English lower classes became more common, as the language of race became increasingly pervasive, and as the incorporation of respectable workers into the political system made it easier to isolate a degraded underclass. Whether this racialization was taken in a liberal or a reactionary direction depended in large measure on the evolutionary vision in which it was framed.[18] [...]

Needless to say, the preferred solution to this problem of domestic racial degeneration varied, depending on one's political point of view. For evangelicals like Booth, the solution was home missionaries, Christian conversion, and labor colonies. For conservatives like J. A. Froude or Cecil Rhodes, the solution was more emigration to Australia, New Zealand, and South Africa, where the Saxon yeoman could renew his hereditary vigor and reclaim his racial supremacist legacy.[19] For the New Liberals of the 1890s, racial regeneration became the pretext for the kind of progressive social reform and environmental improvement that would have been couched, fifty years earlier, in the language of class ameliora-tion.[20] [...]

Conclusion

In this chapter, I have tried to show how the racialized discourses that proliferated rapidly in the post-1850 British Empire were products of material transformations occurring in the capitalist and imperial political economy. This was a period of profound structural change, when Greater Britain was integrated by a transportation and communication revolution,

17 Henry Mayhew, *London Labour and the London Poor, in Four Volumes* (London: Griffin, Bohn, 1861–1862), III–II7, 4:23–27.

18 Gareth Stedman Jones, *Outcast London: A Study in the Relationship between the Classes in Victorian Society* (New York: Pantheon, 1971); Gertrude Himmelfarb, *Poverty and Compassion: The Moral Imagination of the Late Victorians* (New York: Vintage, 1991).

19 Ibid.; James Anthony Proude, *Oceana; or, England and Her Colonies* (New York: Scribner's, 1886); Vladimir I. Lenin, *Imperialism: The Highest Stage of Capitalism* (Moscow: Foreign Languages Publishing, 1947), 79.

20 Anna Davin, 'Imperialism and Motherhood,' *History Workshop* (May 1978): 1–65; Bernard Semmel, *Imperialism and Social Reform: English Social-Imperial Thought, 1895–1914* (London: Allen and Unwin, 1960).

while the imperatives of free-market capitalism made deep inroads into traditional social relations all around the globe. With the abolition of fixed ranks (that is, in mercantilism and slavery), it was necessary to find another way of regulating proletarianization. With the increasing ability of colored others to demand the civic rights that were accruing to white middle- and respectable working-class groups in the imperial metropolis, it was necessary to devise some alternative framework for justifying political exclusion and naturalizing the larger imperial social hierarchy.

The new discourses on race, I have argued, performed these functions. [...] When conjoined with the older racial and historical discourses of savagery, Aryanism, and degenerationism, it provided a flexible and malleable framework onto which hierarchies of natural superiority or inferiority could be mapped.

Understood in this manner, race was no stark black-and-white bifurcation but an almost infinitely graded array of mixed color shadings. It was a palette of power from which the rulers of Greater Britain could paint new designs of social containment, or labor mobilization, and devise new strategies of 'divide and rule'. [...]

[...] By manipulating the evolutionary discourses of savagery, degeneration, Aryanism, and Anglo-Saxonism, these rulers were able to demote, or promote, supposedly fixed racial groups in ways that can be seen, in retrospect, as extraordinarily opportunistic. But this ability to manipulate racial discourses to serve pragmatic interests could also be taken up by racial others. Here the languages of savagery, degeneration, and Aryanism could be reoriented to contest exclusionary judgments, and to mount new demands for political inclusion, in a shifting Greater British constitutional frame. Yet so long as such inclusionary movements were couched in the racialized language of the imperial masters, they too entailed the exclusion of other others, such as Africans, African Americans, and those Asians who could not invoke the badge of Aryan ancestry. In this manner, the Victorian racial discourses outlined in this chapter would continue to cast their toxic shadow over the twentieth century.

4.8 Lee Lawrence, 'The Other Half of Indian Art History: A Study of Photographic Illustrations in Orientalist and Nationalist Texts', *Visual Resources,* vol. XX, no. 4 (December 2004), pp. 287–314: 288–289, 291, 294–299

The writer and art critic Lee Lawrence adds photography to Gyan Prakash's notion of enframing technologies such as irrigation, railways and telegraphs which reorganise the world and turn it

into an exploitable resource. She examines the lens-based medium in analogous terms, and discusses its central role in implementing a new scientific form of knowledge that made India collectable and knowable. She also analyses how the specificity of photographic conventions employed, for example, in the photography of architecture underscored its assumed factuality, and how the European penchant for studying figurative remains of ancient buildings replaced an indigenous value system. In the part of the text that is omitted here she furthermore explores an alternative mode of photographing Indian sculpture employed by the Neo-Orientalist nationalist historian of Indian art Ananda K. Coomaraswamy. [Renate Dohmen]

[...]

Photography in India

[...] Gyan Prakash looks at technology as 'an enframing that acts upon and organizes the world so as to make it available as a resource'. [...] In the decades following the 1857 mutiny-rebellion, Prakash states, 'the British planned and put into place one project after another to shore up the foundations of their rule, the operation of the colonial state became deeply enmeshed in a network of technological apparatuses, institutions and practices'.[1] Irrigation systems, for example, set upon the land and ordered it into agricultural fields, just as engineering projects set upon a mountainside and ordered it into layers of extractable mineral deposits.

To Prakash's list of enframing technologies I would add photography, which entered India just months after its 1839 unveiling in Europe. As an essential tool in the state's programmatic quest for knowledge, photography can be said to have set upon India's people and cultural heritage.[2] The aim was both to extract wealth and to create 'a new form of knowledge' about India, one based on science.[3] To this end, the government surveyed and mapped the territory, fingerprinted the population, and named and classified a broad range of items from grains to antiquities as well as people. The state ordered Indians into a compendium of regional, ethnic

1 Gyan Prakash, *Another Reason: Science and the Imagination of Modern India* (Princeton, NJ: Princeton University Press, 1999), 159, 161.

2 Many scholars have chronicled this quest for knowledge – see relevant chapters in Nicholas Dirks, *Castes of Mind* (Princeton, NJ: Princeton University Press, 2001); Bernard Cohn, 'The Command of Language and the Language of Command', in *Colonialism and Its Forms of Knowledge* (Princeton, NJ: Princeton University Press, 1996), 16–56.

3 Prakash, *Another Reason*, p. 21.

and caste categories, just as Orientalist scholars ordered India's architecture, sculpture and painting into religious, regional and evolutionary categories. Both projects aimed to establish European superiority, justify British rule and exert more effective control over the colony.

Integral to the implementation of this agenda was photography. The state compiled images for a massive ethnologic and ethnographic project entitled *The People of India: A Series of Photographic Illustrations with Descriptive Letter Press of the Races and Tribes of India.*[4] Its efforts were similarly energetic in the realm of antiquities. Within a decade of photography's development, Calcutta surveyor Josiah Rowe was assembling what would become a substantial collection of photographic images and, by 1855, the East India Company had directed its officers to 'discontinue the employment of draftsmen in the recording of antiquities in Western India, and to employ photographers instead'. [...]

[...]

pp. 288–289

Photography and Indian Art History

The photographing of Indian art began almost as soon as the technology was available on the subcontinent [...]. With the establishment in 1870 of ASI [Archaeological Society of India], the photographing of art became increasingly systematic, with the result that the first fifty years of photography in India created a vast, unparalleled body of work.

The first to apply photography to the analysis of Indian art was Fergusson [...]. [...]

The 'knowledge' Fergusson extracted from photographs was a narrative of decay that, in a nutshell, began with a glorious, highly artistic Buddhist past and degenerated into a present characterized by Hindu chaos and Muslim despotism. It was a knowledge that justified and bolstered the British colonial mission, to be sure, but it was also a knowledge that established the category of 'Indian Art'.[5] By so doing, it safeguarded its future, for now there was a recognized artistic heritage to protect.

[...]

pp. 294–299

4 *The People* was published serially between 1868 and 1875, and its eight volumes contained more than 500 photographs depicting India's 'races' and 'types'.

5 John Tagg, in *Burden of Representation: Essays on Photographies and Histories* (Minneapolis, MN: University of Minnesota Press, 1993), p. 87, argues persuasively that: 'We must cease once and for all to describe the effects of power in negative terms – as exclusion, repression, censorship, concealment, eradication. In fact, power produces. It produces reality. It produces domains of objects, institutions of language, rituals of truth.'

Photographic Illustrations: Encoded Knowledge

[...]

Let us briefly review how Europeans had visually represented India prior to photography. In general, seventeenth-century Europeans regarded Indian temples and carvings as places of such greatness, power and obscurity that they found themselves at once slack-jawed with admiration and weak-kneed with fear.[6] This mixture of awe and terror associated India with notions of 'the sublime,' an association that at first fueled exploration. As Britain sought to consolidate its political and economic hold on the subcontinent, however, this association became counter-productive. In order to extract India's riches, 'India the sublime' had to be reconfigured into an India that Europeans could tame and control, still desirable and 'other' to be sure, but also inferior enough to be fully knowable and exploited.[7] The 'picturesque,' a style that was popular in Europe for the treatment of landscapes, accomplished this. No longer conceived as awe-inspiring carvings mysteriously emerging from monumental rocks, India's visual past appeared in the late eighteenth and early nineteenth centuries as picturesque scenes riddled with crumbling walls and fissured carvings. [...]

Created through the camera's viewfinder, picturesque scenes gained the added cachet of veracity, at once reifying earlier views and replacing them with images that could stand alongside maps, statistics and charts as tools with which the British Empire was bringing order to the chaos of India.[8] By virtue of their imputed veracity, photographs reconfigured the vast and sublime nature of India's art into portable, controllable fragments, just as the picturesque imagery on their surfaces encoded a concept of a tamed, knowable India, a land that had once produced great art (witness the majestic temple structures) but had since fallen into a deplorable state of decay (witness the neglected, crumbling walls).[9] This

6 See Partha Mitter's description of Burke's 'sublime' in *Much Maligned Monsters: A History of European Reactions to Indian Art* (Chicago, IL: University of Chicago Press, 1977), 121–122; and Sara Suleri's interpretations in *The Rhetoric of English India* (Chicago, IL: University of Chicago Press, 1992), pp. 24–48, 103–110.

7 Suleri, *Rhetoric of English India*, pp. 24–48.

8 'India, now as ever static, timeless, and exotic, was increasingly available not only for plunder but for science, as photography and statistics replaced and at the same time reified older forms of representation' (Nicholas Dirks, Foreword to Bernard Cohn, 'Command of Language', p. xv).

9 Susan Sontag speaks to this point in *On Photography* (New York: Picador, 1973) (p. 156): 'Reality as such is redefined as an item for exhibition, as a record for scrutiny, as a target for surveillance. The photographic exploration and duplication of the world fragments continuities and feeds pieces into an interminable dossier, thereby providing possibilities of control that could not even be dreamed of under the earlier system of recording information: writing.'

was an India in need of rescue, since its very own people ignored its antiquities and failed to appreciate their value – unlike the European, who not only recognized their value, but had the means, knowledge and will to preserve them. [...]

[...]

Photographic Conventions: Encoding Orientalist Values

[...] [P]hotographs, [...] however, required a shift in practice. Unlike painters, photographers could not add, eliminate or merge elements at will [...]. [...]

A [...] convention that virtually all photographers of Indian sculpture and architecture followed [...] demanded that all vertical lines remain parallel, and so familiar has this view of architecture become that we assume it to be the most accurate and therefore the inevitable choice for photographers. [...] [T]he right-angle view is the convention that has held sway in Europe since the Renaissance, and in the late 1800s it found favor in India among surveyors, scholars and commercial photographers catering to the European market. It was not only familiar to Europeans, but it had the added advantage of presenting objects as a compilation of their constitutive elements. This view of a building, for example, visually enumerated the 'facts' of the structure: from bottom to top, viewers read plinth, doorway, columnade, frieze, another set of columns. ... At a time when the British sought to take inventory of India, it is no surprise that photographers adopted this right-angle view [...].

As a shorthand I refer to this approach as 'factual/documentary' photography – or simply 'factual' – and I read in such images a colonial desire for clarity, directness and rationality as well as objective, one might even say statistical, information.[10] Just as Fergusson's text aimed to explain India as much as to salvage her, so did many of his photographic illustrations move beyond the picturesque toward a factual style that rendered Indian monuments 'historically and architecturally legible'.[11]

Typical of this style is a photograph of the eastern gateway of Sanchi by the Calcutta firm, Johnston & Hoffman (Figure 4.1). It shows that

10 For a discussion on the priorities of the photographer in colonial India, see Richard Pare, *Photography and Architecture, 1839–1939* (Montreal: Centre Canadien d'Architecture, 1982).

11 For a detailed study of Fergusson's imagery, see T. Guha-Thakurta, 'The Compulsion of Visual Representation in Colonial India', in A. A. Pelizzari (ed.), *Traces of India: Photography, Architecture, and the Politics of Representation 1850–1900* (Montreal: Canadian Center for Architecture and New Haven: Yale Center for British Art, 2003) pp. 108–139. Guha-Thakurta places Fergusson at 'a critical crossroad between the earlier genre of "picturesque" landscape painting and a later genre of scholarly documentation'.

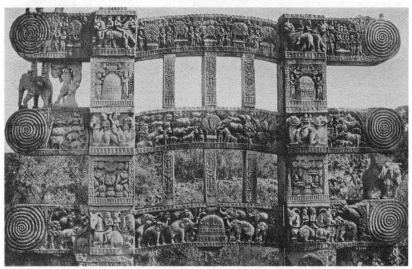

4.1 Sanchi Gateway in Havell, *A Handbook of Indian Art*

the photographer stood at enough distance and sufficiently elevated his camera to position the lens at a right angle to the gateway; he then waited for the light to fall evenly on the relief to ensure that the carvings on the gateway lay, as it were, flatly across the surface of the film. [...]

[...]

Photographs of sculpture, however, differed somewhat in that they included elements of what would become hallmarks of modernism: defining and appreciating objects as artworks divorced from their original use and context. Illustrations frequently presented fragments (Figure 4.2), the kind of objects that museums and individuals collected and exhibited – idols with missing limbs, disembodied heads of Buddha and Vishnu, portions of friezes in isolation.

Before the European-led search for antiquities began, Indians had judged the value of architecture and statuary according to practical and religious concerns. Devotees and priests deemed a damaged temple an unfit habitation for a god and abandoned it, letting villagers use it as a source of building materials. Similarly, an idol missing its arms or head could no longer serve as a vehicle for divine presence, and priests disposed of it ritually in accordance with the dictates of Sanskrit texts.[12] By presenting temples and idols in a state of disrepair, such photographs effectively

12 See Richard H. Davis, *Lives of Indian Images* (Princeton, NJ: Princeton University Press, 1997) pp. 252–253.

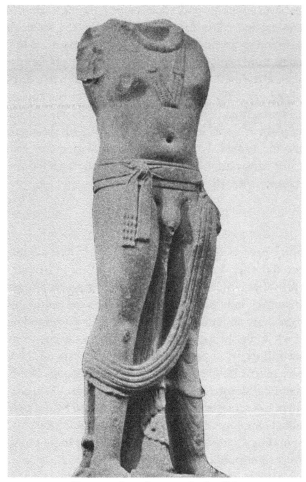

4.2 Damaged sculpture of a bodhisattva

replaced an indigenous value system with a European concept of Indian works as art and antiquities.

[...]

4.9 Carol A. Breckenridge, 'The Aesthetics and Politics of Colonial Collecting: India at World Fairs', *Comparative Studies in Society and History*, vol. 31, no. 2 (1989), pp. 197–203, 205–213

Anthropologist and Associate Professor of History at the New School for Social Research, Professor Carol Breckenridge (1942–2009) began her career as historian of colonial South India

and was a prominent voice that shaped the emerging field of transnational and cultural studies. In this text she shows that the rise of Britain as an imperial power was accompanied by a shift in visuality, from 'wonder', presented by popular public entertainment such as the panorama of Tipu Sultan's defeat, to a disciplined rationalised gaze. The latter was paramount in the collecting of the world presented in international exhibitions where India took pride of place as 'jewel in the British crown'. This discussion also highlights the formative role played by technologies of reproduction in not just illustrating but fashioning the new global world of British imperiality. [Renate Dohmen]

[...]

II

In the century preceding the first world fair in 1851, Londoners were being prepared for the shift that was about to occur in Britain's romance with the things of distant lands. In this pre-cinema age, before photography and the illustrated daily newspaper, Londoners led culturally insulated lives. Their curiosity about the world beyond their tiny island was severely circumscribed, arguably due to disinterest.[1] Even the eighteenth-century Grand Tour of Europe, in part made difficult by wars on the Continent, ceased to be a means for expanding the cultural horizons of the cultivated upper class of English men and women.[2] This climate of cultural insularity frustrated men like Charles Grant, who—motivated by the need to renew the East India Company charter in 1813 and again in 1833, and to affirm the ever expanding Company *raj*—sought to bring India to the attention of the metropolitan public.

The parochialism of Londoners, and their reliance on vicarious rather than actual travel, was encouraged and reinforced by two constellations of activities: the one revolving around the latent entertainment industry, and the other, around the wonder cabinets of enterprising private collectors. These two modes of experiencing the 'world' required a specialized gaze that was non-analytic, non-judgmental, and undiscerning, while being shaped by the experience of wonder. Neither mode offered the refined and constrained training in visual literacy that was to develop later in the century.

1 Richard D. Altick, *The Shows of London* (Cambridge: The Belknap Press of Harvard University Press, 1978), pp. 457, 482.
2 Elizabeth Holt, *The Triumph of Art for the Public, 1785–1848* (Princeton: Princeton University Press, 1983).

At the turn of the eighteenth century, the London entertainment industry was beginning to appear in such quarters as Leicester Square. The theater had fallen into disfavor with families of respectability, who turned instead to new forms of amusement including the panorama (literally 'all-embracing view'). This new entertainment form, housed in rotunda-shaped rooms and buildings, encouraged Londoners to cast a transient gaze on their own world as well as on the world beyond them. This gaze, not yet groomed by authoritative expectations and standards of beauty, fixed the eyes of the beholder on views of distant lands, as well as on imported natives and their objects, that, when placed on stage, were elevated to the position of disoriented commodities.

India was regularly featured in a new form of mercantile realism on panoramic canvases. In 1800, a young and promising painter named Robert Ker Porter stretched a canvas over two hundred feet long on a semicircular (some sources say three-quarter circle) plane; and in six weeks painted the *Taking of Seringapatam,* a pictorial reconstruction of the fourth Mysore war fought the previous year to defeat the indefatigable South Indian king named Tipu Sultan. This victory, more than any other on the Indian subcontinent, offered a symbol of hope and promise to Londoners, and inspired confidence and certainty that a new imperial ecumene was about to be put in place. Displayed at Somerset House, this representation (of the war that technically brought about the British East India Company's final mastery over southwestern India and ultimately the rest of the subcontinent) launched a euphoric season in London's entertainment quarters.

This panorama did more than create a desire for victory; it transported viewers to the scene of the defeat. One spectator noted that 'you seemed to be listening to the groans of the wounded and the dying', whose 'red hot blood' was spilled all over the canvas.[3] The realism of the scene, and its large scale, fostered a fantasy that overwhelmed and encompassed the observer, and thereby produced 'a sight that was altogether as marvelous as it was novel. You carried it home, and did nothing but think of it, talk of it, and dream of it', our observer reflected.[4]

The *Taking of Seringapatam* was the first of several noteworthy India panoramas that turned the attention of London viewers to the subcontinent where their countrymen were systematically domesticating life to the rule of the British East India Company. As late as 1858, in the waning years of panoramas, and one year after the now famous 1857 uprisings

3 Quoted in Altick, *The Shows of London,* p. 135.
4 Altick, *The Shows of London,* p. 135.

in North India that stunned and outraged the English at home and in India, two shows respectively entitled the *Fall of Delhi* and the *City of Lucknow* could be seen at Burford's on Leicester Square. This scene (and the reality it depicted) presented a shocking reversal of the overwhelming English victory at Seringapatam celebrated panoramically fifty-eight years earlier. Like the Seringapatam painting, the 1857 challenge to British rule was an experience, both as reality and as entertainment, that was to become indelibly embedded in the memory of English men and women, and was to contribute indirectly to the escalation and expansion of British rule in India.

[...]

Thus, British imperium was advanced in India: What was soon to be experienced in India as political domination, was first experienced in London as entertainment. The mode of this experience, already seen in the workings of the panorama, can be more closely examined by looking at the wonder cabinet.

Wonder had long been the sensation provoked by the sight of select and unrelated objects randomly collected from around the world, and placed in glass cabinets, known variously as *wonder cabinets* or as *cabinets of curiosities*. Thus, while Londoners were accumulating collective experiences of India at the panorama, they were also continuing to patronize older forms of acknowledging other cultures. [...] In 1808, objects taken as booty from Seringapatam (Tipu's impressive South Indian capital) were brought to London to be housed along with other artifacts in an 'Oriental repository' kept by the East India Company. Londoners flocked to gaze and gawk at Tipu's regalia displayed at an exhibit thought by some to have been one of the most popular of all time. This Oriental repository (in effect a wonder cabinet) staged objects without framing them visually, conceptually, or theoretically.[5] Minimally labelled and uncluttered by such modern devices as classification systems, selective thematic displays, and retrieval concerns, such cabinets and repositories represented an eclectic aesthetic of mercantilism soon to be displaced by one of imperialism in which collecting served as a sign of connoisseurship, and hence, of control. Value in wonder cabinets was derived less from an object's aesthetic associations, and more from its uniqueness that was the product of its decontextualized presentation. Guided by

5 E.g. James Bunn, 'The Aesthetics of British Mercantilism'. *New Literary History*, 11:2 (Winter, 1980), pp. 303–321; Steven Mullaney, 'Strange Things, Gross Terms, Curious Customs: The Rehearsal of Cultures in the Late Renaissance'. *Representations*, 3 (Summer, 1983), 4, pp. 1–67.

a *laissez faire* ethic, the eclecticism of wonder cabinets promoted an aesthetic of randomness: no exacting standards existed to judge a particular object; specialization was unheard of; and the fabrication of meaning was unexpected.

[...]

The object in a wonder cabinet celebrated nothing but itself as rare, sensational, and unusual. Neither beauty nor history appear to have been promoted as a value by which to behold the housed object. Objects were judged according to the amazement they aroused largely because they were rare, uncommon, and even unthought of creations. Intrigue and allure clearly motivated collectors who maintained such cabinets. The enticement of the hunt was associated less with the artifice of a world perceived to be exotic, and more with one perceived to be awe inspiring because of its incredible qualities.

Cabinets of curiosities were on the wane on the Continent in the late seventeenth century when they were becoming fashionable in Britain—first in Oxford and subsequently in London. Compared to her continental rivals, Britain had been a latecomer in the world of collecting in general, and with respect to India in particular. This changed during the course of the nineteenth century when English royal collections were developed specifically to house art objects. At his 1821 coronation George IV renewed his commitment to 'do more for ... every refined pursuit, than any monarch that ever sat on the British throne'.[6] Generating and pursuing such refined pursuits, including the collection of art, were among the innumerable modern practices of the imperial crown being shaped then. These activities anticipated the enthronement of objects that was to follow at world fairs.

III

[...]

The reach of imperialism was facilitated by other changes which came to have global implications. In the 1850s, the modern entertainment industry began to take shape in European urban centers. Trains, the latest in transport inventions, facilitated the temporary movement of people for leisure, and advanced the idea of the excursion as a sign of an accomplished middle-class person. Developments in photography 'enormously expanded the scope of the commodity trade' [...].[7] Advertising,

6 Quoted in Altick, *The Shows of London*, p. 404.
7 Walter Benjamin, *Reflections: Essays, Aphorisms, Autobiographical Writings* (New York: Harcourt Brace Jovanovich, 1978), p. 151.

a term coined at this time, enlarged and recontextualized the world of the object [...].

Such changes marked capitalist societies, conditioned urban life, and encouraged the development around the world of modern publics. Of all these changes, the world fair anticipated and helped shape both the form and the content of public life in respect to global issues. [...] Fairs, for example, enthroned merchandise in an 'aura of amusement', thus making them special 'sites of the commodity fetish' emerging at that time.[8] [...]

The Crystal Palace Exhibition of 1851 was the unsurpassed founding spectacle of the world fair genre.[9] The legacy of Crystal Palace launched a period of exhibition mania in emporia and metropoles around the globe. Scores of exhibitions followed, but only some of them approached its impressive scope. [...]

India was represented at all the major world exhibitions—a process that continues today. Colonial officials also hosted their own exhibitions throughout the Indian countryside, usually in association with a visit from a member of the British royal family. At some fairs, illustrative collections of India's objects were framed and shaped in the India court or the India pavilion by traders, and at other fairs by professionals and/or officials in government service. India was also well represented by contractors who negotiated for space in the amusement zones of fairs. Native village- or street-scenes were constructed on the midway, complete with foreign vendors and dancing girls imported especially for the entertainment of fairgoers.

At world fairs, Asian lands other than India could also be seen in the courts and pavilions that graced the aisles and thoroughfares of fair grounds. [...] More than spectacles featuring prominent people, or

8 Benjamin, *Reflections*, p. 151.
9 The most comprehensive historical study of this (or any) fair is Utz Haltern, *Die Londoner Weltausstellung von 1851: eine Beitrag zur Geschichte der bürgerlich-industriellen Gesellschaft im 19. jahrhundert.* (Munster: Aschendorff, 1971). Other fine studies include John Allwood, *The Great Exhibitions* (London: Studio Vista, 1977), Werner Plum, *World Fairs in the 19th Century: Pageants of Social and Cultural Change* (Bonn: Friedrich-Ebert-Stiftung, 1977), Burton Benedict (ed.), *The Anthropology of World's Fairs: San Francisco's Panama Pacific International Exposition of 1915* (Berkeley: University of California Press, 1983), Robert Rydell, *All the World's a Fair: Visions of Empire at American International Expositions, 1876–1916* (Chicago: University of Chicago Press, 1984) and Debora Silverman, 'The 1889 Exhibition: The Crisis of Bourgeois Individualism', in *City and Ideology: Paris under the Academy,* Anthony Vidler, ed., special issue of *Oppositions, A Journal for Ideas and Criticism in Architecture,* 8 (Spring, 1977), pp. 71–91.

occasions to display goods from all nations, world fairs were venues that (through selective representation) reduced cultures to their objects. [...]

IV

Although its official title was 'The Great Exhibition of the Industry of All Nations', the first world fair was popularly known as the Crystal Palace Exhibition, an apt description of the enormous, even humorous, iron and glass structure housing the exhibition on an eighteen-acre plot of London's Hyde Park. Like Cinderella, whose life was transformed by a glass slipper, Britain's glass greenhouse foreshadowed modern twentieth-century architecture and transformed the landscape and discourse of images and objects available to modern publics. It was this transformative power of world fairs that quickly made them a ubiquitous and unavoidable part of the decor of modern metropoles.

The Crystal Palace, and its associated rituals and amusements, titillated and delighted more than six million sightseers. Wide-eyed and open-mouthed, they gaped at its displays, romped through its amusements, and marvelled over its objects. [...] The British East India Company, at short notice, crated and shipped a 'noble' display of Indian objects to the exhibition, thus confirming the growing suspicion that India was a wellspring of 'Oriental' splendor and luster. Occupying several courts, the Indian display considerably outstripped (in size and floor space) the courts designated for the other twenty-eight places represented at the extravaganza.

[...]

[...] Her sumptuous objects made a splash. They inspired favorable comment from most viewers (notwithstanding the criticisms of Wornum, Ruskin and others). Her 'curiosities', positioned alongside a veritable empire of things (including machinery, inventions, scientific instruments, raw minerals, and processed materials), were acclaimed as a new-found well of art. India's well-designed objects were a fresh source of inspiration to viewers, who sensed that England was on the verge of a second industrial revolution this time featuring refinement in the design of objects, rather than mere utility.

[...]

V

Objects on display do *not* provide their own narrative. Displayed objects must be textualized, and, therefore, require verbal and written explication in the form of signs, guides, and catalogues—if they are to be anything other than a mere accumulation of disoriented curios and wondrous artifacts. As world fairs progressed, such explication became embedded

in the discursive languages of history, ethnography, archaeology, and eventually art. These emergent forms of knowledge and colonial rule were dialectically tied; their emergence was dependent on a colonial presence in India (and in other parts of the world), while, at the same time, their development facilitated colonial modes of governance.

India was imprinted on the minds of viewers in numerous illustrated publications, lecture series, and scholarly debates spawned by the Crystal Palace Exhibition. At the exhibition, men such as the novelist Gustave Flaubert, the architect M. Digby Wyatt, and the renowned Henry Cole saw an assemblage of India's objects for the first time. Until then, they had encountered India largely piecemeal through lithographs, manuscripts, panoramas, verbal accounts, and the stray object from which they generated their own mental images of India. In the Crystal Palace, an India constructed by colonial rulers was on public view. India's material culture, denuded of social context and natural environment, was choreographed and displayed to impress the world with the talent, skill, and splendor of the subcontinent.

This seminal experience of seeing India through her objects inspired viewers to textualize objects in identities they created for them. Wyatt, for example, printed a monumental publication of chromolithographs featuring select exhibition objects. Indian artifacts (more than half were textiles) were seen in twenty of his 157 lavishly colored plates. This glamorous publication implemented a reproductive process then in its infancy [...].

In reproductions, the object was highlighted on its own, where it inevitably called attention to itself, rather than to the other objects brought together to address one another in the display. [...]

The India court at Crystal Palace, and at exhibitions that followed, bred antiquarians, publishers, and chromolithographers of indomitable industry, keen intelligence, and lively imagination. These men, most of whom were either medical practitioners or botanists, struggled with the knotty and intractable problems of arrangement, classification and reproduction (a logical extension of their training in science, that, as a field of knowledge, had not yet been fully and decisively separated from art). Their experiments, publications and influence enabled private as well as public collections of Indian objects to acquire an aura of authenticity. In their endless displays and publications, they identified, organized, and codified Indian objects according to a variety of schemes, including the *place of origin* (e.g., from Kancipuram), the *time of origin* (e.g., Chola period), the *nature of its raw material* (e.g., bronzes), and *style* (e.g., Chaluykan). [...]

[...]

VI

An astonishing surge of interest in collecting Indian objects occurred in the post-Crystal Palace period. This surge inaugurated a new era in which collecting, like culture itself, became institutionalized and internationalized. Numerous discreet but public settings for this phenomenon emerged. There were exhibitions, museums, royal receptions (*durbars*), archives, libraries, and surveys of a variety of materials, including archaeology, epigraphy, zoology and geology. Each of these forms of generating and controlling knowledge had a discrete set of associated practices that formed a field of action within which the acceptable and unacceptable could be defined and continuously shaped.

Government officials, Indian princes and British royalty all collected (as did connoisseurs on the Continent). Many collected while on their India Tour (that came to replace the Grand Tour of the eighteenth century). [...]

[...]

Collecting satisfied several desires at once for a civil servant like Rivett-Carnac. A collection ordered India's unruly and disorderly *past,* at the same time that it pointed towards India's present by ordering her unruly and disorderly *practices.* Coins, serving as they did as a 'landmark of a particular period', ordered the past for Rivett-Carnac, just as his collection of metal Hindu ritual objects ordered India's practices. Such a collection created an illusion of control—in this case, over 'the mysteries of the Hindu pantheon' with its endless 'curious and often grotesque' gods who belonged to a 'polluted faith'. Mastery over these multi-armed gods was brought about with Linnaean tenacity, if not obsessiveness. The collector collected them, grouped them, photographed them, and even published them.

Unsatisfied with mere ownership (that permitted all of these manipulations), the collector's journey continued. Rivett-Carnac felt compelled to fabricate histories and identities for the individual objects in his collection, and for the collection as a whole. In addition to reading select reference works, including E. Moore's *The Hindu Pantheon* (1809) and G. Birdwood's *The Industrial Arts of India* (1880), he quizzed and queried Indians who entered his official and unofficial world. He searched for a usable past that he then (rightly or wrongly) called a tradition.[10] This usable past sustained him and his collection. It was always a partial and ambiguous past made up of some admixture of genealogy, observed

10 Edward Moor, *The Hindu Pantheon* (London: J. Johnson, 1807); George C. M. Birdwood, *The Industrial Arts of India* (London: Chapman and Hall, 1880) 2 vols.

practice and hearsay. The usability of this past, as Homi Bhabha has pointed out in another context, presumed India 'as a fixed reality which [is] entirely knowable and visible'.[11]

In constructing a tradition in which to place the object, Rivett-Carnac came to possess a body of knowledge (to accompany his objects) that purported to represent a recognizable reality called India. [...] But it is India only in a very special sense. The collected object distances itself from its origin, and in doing so, substitutes classification for use value and thus, for history. The collection is self-contained, and the 'world is accounted for by the elements of the collection'.[12] [...]

[...]

[...] For individual colonial officials, the act of collecting and the building of a collection created an illusion of cognitive control over their experience in India—an experience that might otherwise have been disturbingly chaotic. Since many officials collected, it can be argued that collections promoted a sense of moral and material control over the Indian environment. At the same time, collected objects could be fed into the two growing institutions of the second half of the nineteenth century, the exhibition and the museum, thus allowing this sense of knowledge and control to be repatriated to the metropolis. In the metropole, fairs and museums could serve, over time, as reminders of the orderliness of empire as well as the exoticism of distant parts of the Victorian ecumene.

Unlike the wonder cabinet, such colonial collections, whether private or otherwise, were clearly anything but the static abode of disoriented objects. The birth of the international exhibition (and its handmaiden, the modern museum) changed all that in the second half of the nineteenth century. World fairs generated the practical and ideological apparatus necessary for modern collectors, such as Mr. and Mrs. Rivett-Carnac, to transform objects by lifting them out of their everyday contexts and by placing them within reach of institutions such as exhibitions and museums. In these contexts, textualized objects acquired a new discursive value, and by contrast helped to create a new, object-centered mythology of rule in the imagined ecumene of Victoria.

11 Homi K. Bhabba, 'The Other Question: Difference, Discrimination and the Discourses of Colonialism', in *Literature, Politics and Theory: Papers from The Essex Conference,* Frances Parker *et al.* (eds.) (London: Methuen 1986), p. 156.
12 Susan Stewart, *On Longing: Narratives of the Miniature, The Gigantic, The Souvenir and The Collection* (Baltimore: The Johns Hopkins University Press, 1984), p. 162.

VII

As should be clear by now, world fairs were more than merchandizing ventures. [...] Fairs expanded the world of commodities by transforming all objects into merchandise available for consumption, if only visually. They facilitated long-distance contracts between traders, and inspired the development in a city like London of display oriented department stores such as Liberty's, and mail-order suppliers such as the Army and Navy store and Harrods. They even transformed people into quasi-commodities. Natives were brought to stage re-enactments of their everyday lives, a phenomenon that reached its epitome at the 1904 Saint Louis fair where, in the building earmarked the Hall of Anthropology, one could view scantily-clad (Philippine) Ilongots in one corner, and giants from Patagonia in another.

If the task of the world fair had ended there, it could be dismissed easily as a spectacle of modern commerce that placed art in the service of merchandising. But it did not end there. The world fair mixed commerce with culture in a mode that was then innovative, even radical. As I have hinted, world fairs were lively fora for experimentation with systems of classification and presentation for assembled objects [...].

This surge of interest in classification challenged the pre-eminence of emotive, nonverbal forms of experiencing objects, as was the case with the wonder cabinets, and favored the more disciplinary languages concerned with authenticity, connoisseurship, provenance and patronage that drew some closure on knowledge. These were discursive languages eminently suited to politics and control. [...]

[...] That 'transient gaze', guided by what some have called unfruitful wonder, that was employed by spectators of panoramas and curiosity cabinets, was soon reshaped as an aesthetic gaze. This new gaze was directed by detailed and rule-bound standards, styles, and classificatory protocols associated with such institutions as exhibitions and, later, with museums.

Creating social distinctions between individuals and classes largely on the basis of *taste* has no longer or deeper history in India than it does in Britain, as might be expected. The imperial encounter that spawned the institutionalization of culture was a late nineteenth-century phenomenon anticipated earlier in the century. In 1835, in a now famous government memo, Lord Macaulay, an early architect of a colonial policy on education in India, advanced taste as an agent for the construction of a class of new Indian subjects. These new subjects were to be interpreters between 'us and the millions whom we govern—a class of persons Indian in blood and colour, but English in tastes, in opinions, in morals and in

intellect'.[13] Most interpretations of this well-known quote emphasize the position rather than the nature of the new Indian subject envisioned by Macaulay: He was the man-in-between. Equally important was the nature of the new Indian subjects as *English in taste*. The task of delineating taste remained with a host of culture-makers, such as colonial archaeologists, ethnographers, photographers, publishers, and inadvertently policymakers. These brokers of culture were central to the institutionalization of new cultural forms, as well as to the collection and canonization of cultural content.

[...]

4.10 Christopher Pinney, 'The Material and Visual Culture of British India', in Douglas M. Peers and Nandini Gooptu (eds), *India and the British Empire* (Oxford, Oxford University Press, 2012), pp. 231–261: 231–237, 241–254, 258–261

Christopher Pinney is Professor of Anthropology and Visual Culture at University College London. He draws attention to the agency of the visual which remains marginal in the largely text-based explorations of empire and is considered illustrative at best, proposing visual and material culture as an alternative mode of historiography. Building on Said's *Orientalism* and its critiques, he also suggests the 'dance of transculturation and purification' and the notion of the autonomous as an alternative critical framework to explore the complex aesthetic interactions between India and Britain, and rehearses this proposition by discussing key moments of this history. [Renate Dohmen]

'Empire follows Art and Not Vice Versa as Englishmen suppose'

William Blake

[...]

An old duality is at the point of exhaustion. This offered an impoverished menu of affirmation or negation to the question of culture's relation to power. Dramatized most starkly in Edward Said's work and in an Indian context in more fruitful ways through the Cohnian school (that is the work initiated by Bernard Cohn and developed by Ronald Inden, Nicholas

13 Richard Lannoy, *The Speaking Tree: A Study of Indian Culture and Society* (London: Oxford University Press, 1971), p. 238.

Dirks, and Arjun Appadurai),[1] this historiography has sought narratives of connectivity between colonial interest and cultural practice. Pitched in a battle against other historiographies deemed to be complicit with colonialism by virtue of the alibi they grant colonial knowledge, Saidian and Cohnian historiography has little room for 'disinterest' and disconnection. Although Said gestures to the complex desires that underlay orientalist knowledge production ('a battery of desires, repressions, investments, and projections'), the bulk of his analysis advances a confident systematicity—a world of 'racial, ideological and imperialist stereotypes'— apparently devoid of self-doubt and contradiction.[2]

Here I will outline a different way of viewing the relationship between power and cultural practice which I hope can more adequately engage its complexity. However, mine is not a wholesale rejection of the paradigm invoked above. Indeed there is one central aspect of it that I wish to amplify: the Nietzschean/Foucauldian stress on the elision of knowledge and power, and the possibility that art (or more properly, the visual and material) may constitute a primary form of 'knowledge'. One of my key concerns is the need to engage material and visual practices not as 'superstructure' (as an *after*-effect of what has already been achieved socially or politically) but as a formative zone of debate. This idea lies explicitly at the heart of Said's work, for the phantasmatic entities of the Orient and the Occident are essentially works of the *imagination*. [...]

Until recently the historiography of Empire has had little time for questions of materiality. Empire was discussed largely in the absence of the visual art, statuary, public architecture, costume, and interior decor that have sustained all empires. Ideologies seemed to originate and find sustenance in minds which appeared not to engage with paintings, theatrical performances, photography, or film. If one assumes that this domain of 'representation' was simply a secondary elaboration of what had already been determined in a more important sphere of 'politics', 'society', or 'culture', the omission would be minor, and of little consequence. However, if one sees the 'material history' of the British empire as more than simply a 'supplement' to—or a set of illustrative embodiments of—a history with which we are already familiar, we face not an omission so much as

1 Arjun Appadurai, *Modernity at Large: Cultural Dimensions of Globalization* (Minneapolis, 1997); B. S. Cohn, *Colonialism and Its Forms of Knowledge: The British in India* (Princeton, 1996); Ronald Inden, *Imagining India* (Oxford, 1990); Edward Said, *Orientalism* (London, 1985 1st pub. 1978); Edward Said, 'Orientalism Reconsidered', *Cultural Critique*, 1 (1985), 89–107; Edward Said, *Culture and Imperialism* (London, 1992).
2 Edward Said, *Orientalism* (London: Penguin, 1978), pp. 8, 328.

the deletion of an alternative mode of historiography. We can approach this question through the following formulation: does the visual serve simply as an illustration of what we already know, or can a history be written through the visual and material [...]?[3]

[...]

With respect to this question of the possibility of a 'visual history' we can identify an unexpected alliance between orthodox histories and many postcolonial critiques, since although the latter are likely to be of a more culturalist persuasion and preoccupied with representation, they share with the former the Platonic assumption that these are essentially reflections of something, more important, happening elsewhere. Representations are in this way deemed to be representations 'of' something and it is that something, that Idea, which is endowed with primary explanatory power. This is one further reason to see Edward Said's *Orientalism* as a challenge to engagement and supersession rather than simply as negation. The binary choice that usually characterizes the debate around *Orientalism* can be sidestepped by a different analytic strategy that invokes the notions of 'transculturation', 'purification', and 'autonomy'. These terms are chosen as potentials of specific moments and spaces, and reflect a desire to avoid having to be *tout court* for or against a particular paradigmatic approach.

'Transculturation' is derived from its usage by Mary Louise Pratt and James Clifford to signify a 'contact zone'[4] characterized by co-presence and interaction. This exchange can flow in both directions (from colonizer to colonized and vice versa) as is the case with the bungalow's dissemination as a global architectural form, and Indians' enthusiasm for the technology of photography.

'Purification' takes its character from Bruno Latour's use of the term. This is purification in the sense of titration: the creation of two putatively 'entirely distinct ontological zones'.[5] This purification is also characterized by a bi-directionality: at times it involves a purification towards European idioms (as with the prevalence of Palladian civic architecture) and at others, purification serves to essentialize Indianness as with certain aesthetic styles associated with chromolithography which derived part of their cachet from their rejection of European conventions, the pan-Asian

3 Carlo Ginzburg, 'From Aby Warburg to E. H. Gombrich: A Problem of Method', in his *Clues, Myths and the Historical Method* (Baltimore, 1989), p. 35.

4 Mary Louise Pratt, *Imperial Eyes: Travel Writing and Transculturation* (London, 1992), p. 6; see also James Clifford, *Routes: Travel and Translation in the Late Twentieth Century* (Cambridge, Mass., 1997), p. 192.

5 B. Latour, *We Have Never Been Modern* (Cambridge, Mass., 1993), p. 10.

aesthetic associated with Abanindranath Tagore,[6] or the musicological Hindu purism of Vishnu Narayan Bhatkhande.[7] However, aspects of visual and material culture frequently embody aspects of both the transcultural and the purificatory (as with, for instance, the bungalow which became a central element in exclusionary enclave settlement patterns, or Gandhian anti-industrialism which was indebted to John Ruskin and Lockwood Kipling, but was mobilized in the cause of an essentialized India).

'Autonomy' is a provisional and unsatisfactory term intended to mark the limits of the above two terms through a recognition that vast swathes of the visual and material culture of British India stemmed from enduring traditions and developed in ways that were not significantly impacted by colonialism. The recognition of this domain, which, if not quite autonomous, was largely independent of empire, is intended as a recognition that Indian cultural production was vast and complex and much of it was capable of creating its own history free from the shadow of colonialism.

Image Flows

[...]

The genre which has become known as 'Company Painting' stands in stark contrast, for these are images produced in a very intimate space of hybrid transculturation. Described by Mildred Archer as 'an attempt by Indian artists to work in a mixed Indo-European style which would appeal to Europeans',[8] many of the images within this diverse genre (especially those from Murshidabad and Calcutta) manifest their desire to mediate an Indian reality with a European aesthetic expectation through the marked use of shadowing to produce an illusion of depth. [...]

In late eighteenth-century Bengal, Lucknow, and Arcot, conversely, Mughal and British aesthetic schemata engaged in a complex dance of transculturation and purification. We can see in the European longing for Mughal miniatures a transculturating desire, and in Indian ambivalence about British portraiture we can trace a purificatory strategy of distance. Natasha Eaton alerts us to the complex politics and aesthetics of the commissioning and prestation of, and payment for, portraits in late

6 See Partha Mitter, *Art and Nationalism in Colonial India,* 1850–1922: *Occidental Orientations* (Cambridge, 1995), pp. 283–314.

7 Janaki Bakhle, *Two Men and Music: Nationalism in the Making of an Indian Classical Tradition* (New York, 2005).

8 Mildred Archer, *Company Paintings: Indian Paintings of the British Period* (London, 1992), p. 11.

eighteenth-century Indian courts. She describes the East India Company's attempt to replace Mughal gifts of rulers' robes *(khil'at)* and tribute money *(nazar)* with 'symbolically potent portraits'.[9] Both *khil'at* and painted portraits 'aimed to transmit the "presence" of the donor to the recipient',[10] but they were aspects of aesthetic regimes which misunderstood and misrecognized each other. Warren Hastings's enthusiastic patronage of portraitists such as Tilly Kettle[11] and Johan Zoffany, and his dissemination of his own likeness as 'image-gifts' was in part designed to negotiate the strictures of the Regulating Act of 1773 which had prohibited the acceptance of money, land, and jewels from Indians.[12] But British and Indian expectations of portraiture were often opposed: Eaton cites the case of the Scottish artist James Wales in the Maratha court in Pune in the 1790s whose idea of how to depict Shinde conflicted with the sitter's own. Shinde himself, as reported by the Resident Charles Malet, 'expressed a desire that, his picture may be drawn on horseback, observing that every man's character and way of life should be painted in his picture and that his whole life bad been present in the field'.[13] Wales, by contrast, was intent on depicting a man who was 'of mean appearance and rather low stature, fat and lame of one leg'.[14]

[...]

<div align="right">pp. 231–237</div>

[...]

'The Museum Gone Wild'

Visualization, objectification, and categorization undoubtedly played an important role in rendering an India that was 'consumable' and governable. The elision of knowledge and power is fundamental to the Foucauldian and Saidian paradigms. However, it is not necessary to concur with every element of those paradigms to concede that from the late eighteenth century India was the focus of an immense project of visualization, driven by a desire to make what was 'pictured' knowable. Popular panoramas, history paintings treating of the death of Tipu Sultan, a profusion of lithographs, aquatints and engravings, exhibitions, and photography,

9 Natasha Eaton, 'Between Mimesis and Alterity: Art, Gift and Diplomacy in Colonial India, 1770–1800', *Comparative Studies in Society and History*, 46 (2004), p. 818.
10 Ibid.
11 H. De Almeida and G. H. Gilpin, *Indian Renaissance: British Romantic Art and the Prospect of India* (Aldershot, 2005), p. 68.
12 Eaton, 'Between Mimesis and Alterity', p. 820.
13 Cited ibid. p. 836.
14 Cited ibid. p. 837.

constructed a new India—one that was graspable by distant viewers—and gave birth to new classes of artists, curators, archaeologists, and photographers 'whose careers were sustained by manipulating objects in their various, categorical incarnations'.[15] The Archaeological Survey of India, for example, was founded in 1861 with Alexander Cunningham as director. These categorical incarnations were also exported to India, through various pedagogical devices such as the museum, but in the process of translation museological hierarchies and separations were frequently transformed. [...]

A similar hybridization of a colonial space and taxonomy is elucidated by Gyan Prakash in his discussion of the museum 'gone wild'. India here becomes the site of 'inappropriate' translations as a European museology and classification is imported into India. [...] Prakash documents a wondrous subaltern curiosity that converted the museum into the *ajaib-ghar* and the *jadu-ghar* (house of wonder and house of magic) and had the Allahabad Exhibition of 1910–11 resounding to cries of 'Kolossal!, Jya ajib! [how amazing], Bápre báp [akin to O my God], Wah! [splendid]'.[16] The museum, evolved from the Renaissance *wunderkammer*, was imported into India as part of a technology of pedagogic disenchantment: many subaltern viewers reconstructed it as a cabinet of marvels.[17]

In the eighteenth century, little thought had been given to what form British architecture in India should take: the prevailing classical models that prevailed in Britain were simply imported with pragmatic adjustments made for climatic difference. The enthusiasm for Greece and Rome, which gripped Europe, formed the basic template for many buildings in Madras and Calcutta. The painter William Hodges, arriving in Madras in 1780, noted that the buildings arising from Fort St George with their long colonnades and open porticoes 'offer to the eye an appearance familiar to what we may conceive of a Grecian city in the age of Alexander'.[18] This neoclassical aesthetic would be ramped up for key edifices of British power such as Lord Wellesley's Government House in Calcutta (Figure 4.3)—a swollen copy of Robert Adams's Kedleston Hall in

15 Carol A. Breckenridge, 'The Aesthetics and Politics of Colonial Collecting: India at World Fairs', *Comparative Studies in Society and History*, 31 (1989), p. 206.
16 An account in the *Pioneer* cited ibid. 163. Parentheses by Prakash.
17 Prakash notes that the Indian National Congress began to hold exhibitions from 1901. For Prakash this was the natural co-option by an Indian elite of elite colonial practices. See also Lisa N. Trivedi, 'Visually Mapping the "Nation": Swadeshi Politics in Nationalist India, 1920–1930', *Journal of Asian Studies*, 62 (2003), p. 11–41.
18 William Hodges, *Travels in India During the Years 1780, 1781, 1782 & 1783* (London, 1893), p. 2.

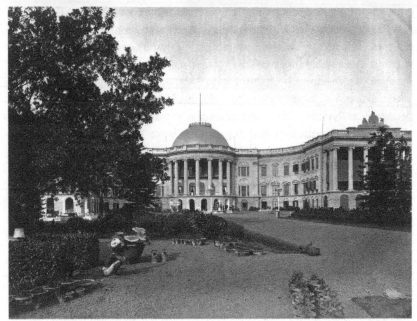

4.3 Unknown photographer, Government House, Calcutta, c. 1870

Derbyshire—which embodied in the opulence and scale of their conception the idea that India would henceforth be ruled 'from a palace, not a counting house; with the ideas of a Prince, not with those of a retail dealer in muslins and indigo'.[19] Bombay's somewhat later urban development has left it with a predominantly Gothic architecture, reflecting the dominance of Gothic in Britain at that time.

Following the Revolt of 1857 and the subsequent consolidation of British rule, a debate emerged about the appropriate architectural form of the new imperialism. [...] The 'Saracenic' aesthetic drew upon what were deemed to be the architectural forms produced by the various Muslim dynasties which had ruled in India and came to be understood—given its association with the empire that preceded the British—as 'simply [...] the most suited for the representation of empire'.[20] It was, as Thomas

19 Cited in Thomas R. Metcalf, Architecture and the Representation of Empire: India, 1860–1910', *Representations*, 6 (1984), p. 40. See also Thomas R. Metcalf, *An Imperial Vision: Indian Architecture and Britain's Raj* (Delhi, 2002), p. 12–14.

20 Ibid. p. 42. The art historian Shivaji Panikkar has recently traced how the early temples built by Gujarati followers of Swaminarayan were 'marked by Victorian arches, Corinthian columns, and gigantic clock towers in the Indo-Saracenic style'. In the late 20th century these structures were 'purified' and made to exemplify the 11th-century Solanki style (see Atreyee Gupta at www.matttersofart.com/Featurese83.html).

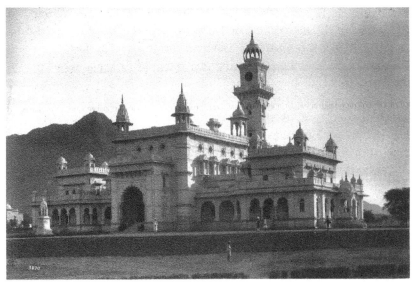

4.4 Mayo College, Ajmer, c. 1880s

Metcalf has argued, no coincidence that museums would in the 1870s become the site for the canonization of the Indo-Saracenic, a hybrid architectural style which, after much conflict, had emerged as one of the solutions to the question as to 'how Empire ought best to be translated into stone'.[21] It was appropriate that museums—in which India's past was classified—would be given a form that reflected a 'museological' understanding of its past architecture.[22]

Drawing on the hybrid styles of buildings in Agra and Fatehpur Sikri, and reconceptualized as the 'Indo-Saracenic', this style would leave its impress on many key buildings in the later nineteenth century such as Major C. Mant's Mayo College in Ajmer (1877–85) (Figure 4.4) and Swinton Jacob's Albert Hall Museum in Jaipur (1878–86). Fusing British engineering with a 'native' aesthetic, these buildings and others would be criticized (in 1913) by the art school director E. B. Havell for the manner in which they clothed structures with 'external paper-designed adornments borrowed from ancient buildings which were made for purposes totally foreign'.[23]

21 Metcalf, 'Architecture', 46.
22 Ibid. p. 50.
23 Cited in Metcalf, 'Architecture', p. 60.

The ornate fusion of Jacob's Indo-Saracenic was largely rejected in the design of the new capital at Delhi.[24] Herbert Baker, who would be brought in to counterbalance Luytens, writing to *The Times* in 1912, declared the desirability of putting the 'stamp of British sovereignty' on the new capital and opined that the Indo-Saracenic 'has not the constructive and geometrical qualities necessary to embody the idea of law and order which has been produced out of chaos by the British Administration'.[25] His Secretariat Buildings fused the classical colonnades which he had used earlier in the Union Buildings in Pretoria with 'Indian' features such as *chattris* (canopied turrets) and *jaalis* (pierced stone screens) whose presence was largely justified functionally and climatically.[26]

Lutyens's Viceroy's House placed a massive dome, modelled on the Buddhist stupa at Sanchi (compete with railing) on top of huge colonnades from which protruded a stone cornice, all of this scattered with sundry *chattris* of his own austere design. [...]

Metcalf reads the history of British colonial architecture in India in a highly 'Cohnian'[27] manner, seeing the form given to stone as reflecting British desires and claims to have 'mastered' India: 'they asserted a claim to knowledge, and hence to power, from within'.[28] This history can also be refigured as an oscillation between purification and transculturation. We can see in the form of the bungalow a transculturation of form, and in the cantonment culture, which usually accompanied it, a purification of space. In early Calcutta's neo-Palladianism we can see purification, in Swinton Jacob we can see an enthusiastic transculturation, in Luytens, an ambivalence in which Sanchi appears as a *deus ex machina,* providing escape from a history which has become simply too complex to mediate, but which as Metcalf rightly notes, is headed nowhere.[29]

24 Swinton Jacob was appointed architect of New Delhi, along with Luytens and Baker in Mar. 1913, largely to counterbalance what Hardinge saw as Luytens's unwillingness to 'Indianize' his designs. Jacob resigned six months later. See Metcalf, *Imperial Vision*, 229.

25 Ibid. p. 222.

26 Ibid. p. 224.

27 I do not say 'pre-Saidian' although it is this too, since Bernard Cohn's work prefigures much of the nexus of colonial knowledge and power which Said would later formalize. However, Cohn's work presents a much more detailed and powerful account of the material mechanism of power. See Christopher Pinney, 'Colonialism and Culture', in Tony Bennett and John Frow (eds), *A Handbook of Cultural Analysis* (London, 2007).

28 Metcalf, 'Architecture', p. 62.

29 Metcalf, *Imperial Vision*, p. 239.

Pedagogy, Performance, and Technology

We can see parallel essentializations and their introduction into Indian society in the work of colonial art schools and museums. Art schools in Bombay, Madras, and Calcutta were started with a variety of motives but were quickly co-opted by the colonial state as instruments of an optimistic strategy to alter an Indian sensibility[30] and to preserve what were perceived to be threatened artisanal skills. [...] For some such as Richard Temple, art education was at the vanguard of a colonial 'perceptual' revolution ('which constantly corrects the initial formula by means of observation')[31] designed to supersede a 'conceptual' mode of India art dependent on hierarchical inculcation. Through the inculcation of new modes of perception, its aim was a latter-day Baconian colonial empirical revolution. Art schools, Temple opined, 'will teach them one thing, which through all the preceding ages they have never learnt, namely drawing objects correctly, whether figures, landscape or architecture'.[32] This mimetic perfection would serve to transform a broader perception, for 'Such drawing tends to rectify some of their mental faults, to intensify their powers of observation, and to make them understand analytically the glories of nature which they love so well'.[33]

However, colonial art pedagogy was fractured from the start: although some sought an aesthetic imperialism through the mimicking of European art forms, key figures like Henry Cole and George Birdwood looked to Indian craft production for the sustenance and revival of 'traditional' forms which they perceived were threatened by colonialism's transnational commodity flows. Birdwood (who returned permanently to Britain in 1868) sought the continuance of a purified Indian craft practice in which although everything is 'more or less a work of art', nothing attained the status of fine art.[34] Later figures associated with the art schools such as E. B. Havell and W. E. Gladstone Solomon saw their task as the rescue of an Indian 'fine art' from the contamination of Western illusionism. These seemingly opposed options shared certain ideas in common: Birdwood deprecated the 'evil' polluting transculturation in Indian artisanal

30 Partha Mitter, *Art and Nationalism in Colonial India, 1850–1922: Occidental Orientations* (Cambridge, 1995), p. 29.
31 Ibid. p. 30.
32 Cited ibid. p. 32.
33 Ibid.
34 The spirit of fine art is everywhere latent in India, but it has yet to be quickened into creative operation. George Birdwood, *Paris Universal Exhibition of 1878: Handbook to the British Indian Chapter* (London, 1878), p. 56.

manufacture; Havell disparaged the corruption of a pan-Asian aesthetic by colonial illusionism.

Outside the art schools a vibrant popular visual culture thrived. In the mid to late nineteenth century, Kalighat *pats,* characterized by strong and fluid draughtsmanship, catered to a popular market seeking devotional pilgrimage souvenirs, and subsequently, visual commentary on Bengal's colonial modernity. In Kalighat *pats* we can see copious evidence of a society in flux: women enter a new public visibility, the pretensions of anglicized *babus* are mocked, and the sense of a dangerous and new upside-down world is attested to by many images depicting women beating their husbands. These images invoke an inversion of appropriate gendered behaviour, an inversion which conjures the *kaliyug,* the present base epoch which in Hindu cosmology signifies a degenerate modernity. The colonial dimension of this decay and disorder is made explicit in a small number of images such as one depicting the Jackal Raja's Court (Figure 4.5). According to W. G. Archer's exegesis, this is a visualization of the Bengali proverb that 'In the jungle even a jackal is king'. The image depicts a jackal seated on a royal *gaddi* and smoking a hookah, and in the lower half of the image the same jackal 'now seated in a Western-style chair, [pronouncing] judgement on two tied and bound animals which are led before him by a jack tailor, dressed in black top-hat and midshipman's uniform'.[35]

[...] Jain stresses the inter-visuality within which Kalighat *pats* were enmeshed and relates the frontality and symmetry apparent in certain Kalighat images to the formation of new kinds of subjects pictured in the act of 'looking at' a camera or an audience that lay on the other side of the proscenium stage. Jain stresses the circularity of influence: painted styles influence photographic conventions which in turn fed back into photographic aesthetics, this all occurring against the burgeoning of photographic studios in Calcutta: by 1860 there were nearly 130 Bengali photographers in Calcutta, and a further 200 European ones.[36]

The early fruits of lithography, as practised by graduates of the School of Art in Calcutta, were highly transculturated: Nala and Damayanti were exiled in a European pastoral; Shiv meditated in a Himalayas forested with European trees. However, this new technology would soon be used in powerfully purifying strategies. [...]

In the same year (1878), Vishnu Shastri Chiplunkar, an associate of B. G. Tilak, founded the Chitrashala Press in Poona. Its rationale was

35 W. G. Archer, *Kalighat Paintings: A Catalogue and Introduction* (London, 1971), p. 55.

36 Jyotindra Jain, *Kalighat Painting: Images from a Changing World* (Middletown, NJ, 1999), p. 113.

4.5 *The Jackal Raja's Court,* Kalighat painting, c. 1870

overtly political—indeed its own official history boasts that it was on its premises that the first bomb in the Deccan was assembled—and sought mass political mobilization through image circulation as a complement to Tilak's interventions. Chitrashala evoked a historical past of resistance and political power, through Shivaji and the Peshwas, whose allegorical intent was obvious to Maharashtrian consumers.

The Calcutta Art Studio's aesthetic experiments and Chitrashala's political aspirations found a complex repose in the work of the painter Ravi Varma who was persuaded to start mass-reproducing his work

in the early 1890s. Declared the 'first modern Indian painter' by his supporters—a 'stealer of fire' because of his appropriation of oil as medium—Ravi Varma was the first individual cultural producer in India capable of bearing the sign of gentleman 'artist'. Undoubtedly important for his role in nationalizing a popular aesthetic, his work owed much more to his Calcutta and Chitrashala forebears than is commonly accepted, and his legacy was far less permanent than many commentators assume. However, together with the film-maker D. G. Phalke, he occupies centre stage in the articulation of popular media practices with a new cultural nationalism. What Abanindranath Tagore and his circle enacted at an elite level in Bengal, the Ravi Varma aesthetic and the rise of mythological film would do for a popular pan-Indian imaginary.

[...]

Phalke's sense that new representational technologies could be co-opted in the service of a particular 'national' and ideological cause had been long ago prefigured in relation to photography. This is most clearly evident in the architectural historian James Fergusson's extraordinary rebuke of the Bengali antiquarian, and founder member of the Bengal Photographic Society, Rajendralal Mitra, in which the 'proper' use of photography becomes an idiom for a larger—and politically charged—debate about protocols of evidence. In 1884 Fergusson published an astonishing *ad hominem* attack on Mitra in a book entitled *Archaeology in India with Especial Reference to the Works of Babu Rajendralal Mitra*.[37] Fergusson had first gone to India as an indigo planter and had made such an enormous fortune that he was able to retire after ten years.[38] Fergusson's indebtedness to the exploitation of the rural poor of Bengal and Bihar and Mitra's outspoken statements against the suffering inflicted by the indigo system[39] clearly inform the antagonism between the two, but it is the use of the photograph as evidence, the ability to read photographs, and the very nature of 'being there' through which this conflict is articulated. Fergusson was a great enthusiast for the inviolable nature of photographic evidence and used photographs extensively in his publications, but being no

37 James Fergusson, *Archaeology in India, With Special Reference to the Works of Babu Rajendralal Mitra* (London, 1884).
38 Major-Gen. Sir Frederic Goldsmid, obituary in *Proceedings of the Royal Geographical Society* (Feb. 1886), 114.
39 Which had led to his expulsion from the Bengal Photographic Society in 1857. See Malavika Karlekar, *Re-Visioning the Past: Early Photography in Bengal 1875–1915* (Delhi, 2005), 136–48.

photographer himself he relied on Gill, Burgess, Pigou, and others. Mitra by contrast was a competent photographer.[40] [...]

One point of dispute between Fergusson and Mitra concerned whether Indians (having initially built in wood) had copied stone techniques from the Bactrian Greeks. However, Fergusson focuses on the methodological uses of photographs. Fergusson's problem was how to retain the authority of the photograph as index (and as a proof for his own argument) when faced with a photographic counter-practice. His solution was not to challenge Mitra's photographs, but to question his ability to 'see' them properly. At the heart of Fergusson's complaint is the claim that Mitra's eye was 'uneducated'. He may have been a good photographer but he could not see what was really in his photographs, he muddled his locations, and claimed to have been to places that he had never in fact visited. Mitra's work was, Fergusson claimed in a resonant metaphor, 'an attempt to throw dust in the eyes of the public'.[41] Mitra—like other Indians—Fergusson suggested, excelled in the arts of memory, but could not see properly. 'I perfectly understand the uneducated eye of the Babu not perceiving' a particular detail, he writes, and concludes that since 'the Babu had no system and no story to tell, one photograph in his eyes was as good as another'—even with a photograph 'staring him in the face' his 'uneducated eye' prevents him from seeing what he really should see, Fergusson claims.[42]

[...]

This astonishing dispute permits us to see how technologies of representation entered into and structured broader debates. It also reveals the key role that Indians played in the development of photography in the subcontinent. News of photography reached India within a few months of its announcement in Europe: in October 1839 William O'Shaughnessy (who, significantly was also the originator of India's telegraphic network) reported to a meeting of the Asiatic Society in Calcutta on his experiments with 'photogenic drawing'. However, it was not until the 1850s that photography was practised in any systematic manner in India. In 1855

40 An anonymous writer in a pamphlet entitled 'A member To the Members of the Photographic Society of Bengal', 28 July 1857, conceded that the President of the Society had said that he was 'one of the few practical Photographers of whom the Society could boast' and 'had worked well for the Society, and had done so when Europeans had hung back'.
41 Fergusson, *Archaeology in India*, 99.
42 Ibid. 56, 59.

the Elphinstone Institution opened a photography class which attracted forty pupils including Hurrychund Chintamon who would soon open his own commercial studio. In the same year the Bombay Photographic Society had already attracted over 250 members.

Indians demonstrated a very early enthusiasm for photography's potential for what has been called 'sentimental realism': the British in India shared this desire but also invested much in photography's potential for an 'instrumental realism'. [...][43]

pp. 241–254

[...]

Art and Empire

The material and visual dimensions of British India have heretofore been marginalized in accounts which privileged politics, economics, and culture. The prevailing assumption has been that the material and visual was a secondary reflection of something else more important. This expectation was variously incarnated as a distinction between infrastructure and superstructure, and a sociological consensus that representation was a kind of screen onto which more primal determinants were projected. Why study the monkey, when one could engage the organ grinder? In concluding this account we might note how representation—material and visual artefacts and practices—is increasingly understood as much more than mere secondary reflection. Ample evidence of its causative potential has already been invoked above, but here I will merely mention three strong instances in which the material and visual serve as motors of change or agents of transformation.

[...]

Consider also the role of aesthetic practice in the constitution of Gandhi's highly efficacious political 'somatics' and political theorization. A complex network connects John Ruskin, William Morris, John Lockwood Kipling, and the aesthetician Ananda K. Coomaraswamy to Gandhi. Lockwood Kipling (inspired in part by George Birdwood) and Coomaraswamy both articulated within the sphere of art pedagogy and aesthetic theory, positions that prefigured Gandhi's own essentialization of the village, of artisanal—as opposed to industrial—production, and of a political ethic rooted in a civilizational 'craft'. But this flow of ideas—triangulating India, Britain, and South Africa—would form the basis of a much more significant aesthetic 'intervention' in the form of Gandhi's somaticization of a political theology. His increasingly naked body became

43 The terms are Leslie Sheddon's, cited in Geoffrey Batchen, *Burning with Desire: The Conception of Photography* (Cambridge, Mass., 1997), p. 9.

an aesthetic surface which exemplified the ethics of anti-colonial practice, and when this body was in turn positioned next to the *chakra* (the spinning wheel which symbolized the self-production of *swadeshi*), it made visible the performative dimensions of his politics.

A similar aesthetic excess can be seen in a genre of mass-produced images—motors of 'national feeling'—whose popularity mirrored Gandhi's ascendancy in the 1920s and 1930s. Produced by Brahman artists from the Pushtimarg pilgrimage centre of Nathdvara in Rajasthan, these images foregrounded deities in fecund landscapes. Pictorially animating the lush topography of Krishna's Braj, these images depicted landscape as an emanation of the gods. Waterfalls cascaded, parrots and peacocks festooned every tree, and a melancholic moon shone an unearthly light.[44] Reproduced in their millions these ubiquitous images manifested a utopian 'else-where'—making itself present in a flash of recognition—which paralleled Gandhi's pastoral utopia. Much more than mere illustrations of a yearning that had already been resolved in 'society', these images constituted their own immensely powerful and affective force-field. Empire and anti-Empire did indeed follow Art.

<div align="right">pp. 258–261</div>

44 See Christopher Pinney, *'Photos of the Gods': The Printed Image and Political Struggle in India* (London, 2004), 92–103.

5

Art after empire: from colonialism to globalisation

Warren Carter

Introduction

The texts in this section begin in the early twentieth century in the period leading up to the First World War. This was the high point of European imperialism when the colonial territories formerly administered by commercial interests had been taken over by national governments. Indeed it was this inter-imperialist rivalry and the scramble over the carving up of the rest of the world that largely produced the conditions for the war itself. Artists and intellectuals were appalled by the ensuing carnage and it led to radical manifestations in both spheres. It was in neutral Zurich in 1916 that the Cabaret Voltaire opened as the venue for the radical avant-garde activities of the Dadaists and also where Lenin wrote his influential tract on imperialism as the highest stage of capitalism. The section ends with a series of critical texts that attempt to unpick the relationship between art and politics in the contemporary moment of globalisation.

The first two source texts in this section are a product of this imperialist moment when the sculptures of non-Western cultures – principally from Africa and Oceania – made their way back to Europe and were deposited in anthropological collections. It was the fascination with the non-mimetic representational strategies in such works that would spur what was termed at the time as 'primitivism'. Modernist artists such as Maurice de Vlaminck and Emil Nolde appropriated the formal techniques of these works to reinvigorate their painting practices in a further challenge to traditional bourgeois conventions that would be further repudiated after the onset of the imperialist war.

This relationship between European modernism and non-Western sculpture was the subject of an important exhibition, '"Primitivism" in 20th Century Art', at the Museum of Modern Art (MoMA) in 1984,

which sought to demonstrate the 'affinities' between the two traditions. But in the wake of Said's critique of orientalism and the emergence of postcolonialism the show generated controversy and became the subject of a withering critique by Hal Foster in his essay 'The "Primitive" Unconscious of Modern Art, or White Skin Black Masks' (1985). If here Foster makes the point that this encounter between European artists and African art was also complicit with colonialism, he also importantly pointed to a counterpractice of avant-garde artists who had a more radical response. This is the context for the third source text by the Surrealists in Paris. Carrying on where the Dadaists left off, they combined avant-garde aesthetics with a radical political stance that included a withering critique of imperialism.

This imperialist moment was not just limited to Europe however. The United States had strong corporate interests in Mexico. Indeed the dictator Porfirio Díaz had been installed in 1876 with North American backing, and under his 35-year rule US companies amassed massive landholdings and access to subsoil resources, such as oil, for export. The last two source texts relate to the Mexican Revolution of 1910–20 which one historian has referred to as the first 'Third World' revolt against imperialism. The post-revolutionary governments that took power used massive state-sponsored murals as propaganda and the manifesto reprinted here is a statement of intent by the radicalised artists that would go on to paint many of the walls in Mexico City and beyond. The interview with Alberto Hijar, a close friend of David Alfaro Siqueiros who penned the manifesto, takes the muralists as its focus and then builds outwards to a general discussion of revolutionary Mexican art and politics in the period.

The Mexican Revolution was followed by a whole swathe of national liberation struggles, especially in the period following the Second World War. The post-war dominance of the United States and its implacable opposition to the Soviet Union meant that these anti-imperialist struggles were often polarised along Cold War lines. The influence of the Mexican avant-garde which was associated with large-scale figurative murals waned in the period as modernism took hold in the United States. The rise of both Nazism and Stalinism had forced the avant-garde (importantly including many of the key Surrealists) into exile across the Atlantic to New York which had by then superseded Paris as the home of modern art. It is the centrality of New York within the art world and its relation to Australian art on a centre/periphery model that is the subject of Terry Smith's essay on provincialism. Here he argues that the prominence of New York is a product of North American cultural imperialism more generally and it therefore sits fully in line with its foreign policy – the

international programme of MoMA, which showcased US artists in Europe, South America and Australia amongst other places, being a case in point.

In 1977, when Smith wrote his essay, neo-liberalism had only been tested in Chile and Thatcher and Reagan were still a couple of years away from power. With the election of the latter to the White House relations with the Soviet Union took a turn for the worse and Cold War tensions escalated. With the fall of the Berlin Wall in 1989 and the incorporation of the former Soviet bloc, China and a whole host of now independent former colonies into a fully globalised neo-liberal world market, everything changed and the centre/periphery model supposedly collapsed. The remainder of the texts in this section assess the impact of these transformations on the global art market, challenging the democratic and postcolonial claims made for contemporary art. They look at institutional displays and the biennials circuit and point to the ways in which the international market in art is actually complicit with the existing economic inequalities in the global economy as a whole.

Stuart Hall takes as his subject the role of the modern art museum in the twenty-first century. His paper first took form as a keynote to a conference at the Tate Gallery in 1999 when the curators were thinking about how to hang the twentieth-century collection when it was moved the following year to its new site on London's South Bank. As such his essay was a call for institutions like the Tate to think reflectively in the wake of postcolonialism and the emergence of the deeply unequal forces of globalisation that have displaced the centre/periphery model outlined by Smith. The extent to which this was achieved at Tate Modern is then taken up by Okwui Enwezor in a critique of the curatorial overview when it opened in 2000 and the traditional chronological hang was changed to one based upon genre, subject matter and formal affinities. Like Foster, Enwezor argues that modern art history has its roots in imperial discourse and, furthermore, that the pressures of postcolonialism were largely ignored with the opening of Tate Modern so that the institution is in fact the heir to the modernist appropriation of African art under primitivism.

The dramatic increase in biennials and major international exhibitions over the last few decades is often cited as evidence of a more porous and globalised art world. In an important empirical study Chin-Tao Wu challenges the extent of these changes by looking at where the international community of artists who have participated in nine international exhibitions between 1968 and 2007 actually live and work. While the presence of artists from all over the world at these international events is seen as proof that the centre/periphery model is now redundant, she offers

compelling evidence that the art world remains firmly concentric and hierarchical. And finally, Hito Steyerl argues in a scathing polemical piece that contemporary art has become little more than the cultural veneer for a whole host of despotic regimes that openly flout democracy. For her, institutional critique is no longer critical and the role of the artist has become analogous to that of the urban pimps and hoodlums who were hired as mercenaries and exploiters under colonialism.

What these essays suggest, then, is that the grand claims that are made for the globalisation of the art world or the progressive nature of contemporary art practices may well be, at the very least, overstated. And furthermore that, despite the cogent critique of Western culture provided by postcolonialism, the art market and art institutions, as well as art history as a discipline, are all still marked to some degree or other by histories and geographies that are rooted in imperialism. In this sense the emphasis upon diversity in the contemporary art world, and the biennials circuit that underpins it, perhaps provide little more than a smokescreen for the deep-rooted economic inequalities that continue to persist in a fully globalised world. [Warren Carter]

Primary sources

5.1 Modernism and Primitivism

Maurice de Vlaminck (1876–1958) was one of the Fauve painters whose use of intense colours in a post-impressionistic style caused a scandal at the Salon d'Automne in 1905. Alongside fellow Fauve painters Henri Matisse and André Derain he claimed to be one of the first to 'discover' the aesthetic importance of African sculpture. Emil Nolde (1857–1956) was a member of Die Brücke from 1906 to 1908 and is central to German Expressionism. In the paintings for which he is most celebrated he deploys the human figure with a range of distortions influenced by his encounter with non-Western art. In this way he sought to endow his paintings with emotional and even spiritual qualities that for him transcended the limited horizon of dominant German bourgeois culture at the time. The original Surrealists were essentially poets and writers based in Paris in the early 1920s and centred around the figure of André Breton. Having their roots in Dadaism they were an avant-garde group radicalised by the First World War who sought to fuse Freud and Marx in a critique of bourgeois culture. Their militant anti-imperialism was

originally forged in 1925 with their support of the Rif uprising against French colonialism in Morocco. The article printed here is an extension of this critique and the first example of what has been termed 'black surrealism' which would go on to influence the Négritude movement in Martinique. [Warren Carter]

a) Maurice de Vlaminck, 'Discovery of African Art' [1906], in
***Portraits avant décès* (Paris: Flammarion, 1943), pp. 105–107**
One afternoon in 1905 I found myself at Argenteuil. I had just finished painting the Seine, [...] I packed up my canvas and went into a bistro. [...] I noticed, on the shelf behind the bar, three Negro sculptures. Two were statuettes from Dahomey, daubed in red ochre, yellow ochre, and white, and the third, from the Ivory Coast, was completely black.

Was it because I had just been working in the bright sun for two or three hours? Or was it the particular state of mind I was in that day? Or did it just confirm some thoughts that were preoccupying me at that time? These three sculptures really struck me. I intuitively sensed their power. They revealed Negro Art to me.

Derain and I had explored the Trocadero Museum several times. [...] But neither Derain nor I viewed the works on display there as anything other than barbarous fetishes. The notion that these were the expressions of an instinctive art had always eluded us.

These three Negro statuettes in the Argenteuil bistro were showing me something of a very different order entirely! I was moved to the depths of my being.

[...] Shortly afterward, I showed my acquisition to a friend of my father's. [...] I went to his place, and I took a large white mask and two superb Ivory Coast statues.

I hung the white mask over my bed. I was at once entranced and disturbed:

Negro Art was revealed to me in all its primitivism and all its grandeur. When Derain visited and saw the white mask he was speechless. [...] When Picasso and Matisse saw it at Derain's they were absolutely thunderstruck. From that day on, Negro Art became all the rage!

It was Picasso who first understood the lessons one could learn from the sculptural conceptions of African and Oceanic art and progressively incorporated these into his painting. He stretched the forms, lengthened, flattened and re-composed them on his canvas. He colored assemblages with red, ochre, black, or yellow ochre, just as the Negroes did for their idols and fetishes.

[...]

**b) Emil Nolde, 'On Primitive Art' [1912], in Charles Harrison
and Paul Wood (eds),** *Art in Theory: 1900–2000* **(Oxford:
Blackwell Publishers, 1992), pp. 101–102**

1. 'The most perfect art was Greek art. Raphael is the greatest of all
 masters in painting.' Such were the doctrines of every art teacher only
 twenty or thirty years ago.
2. Since then, much has changed. We do not care for Raphael, and are
 less enthusiastic about the statues of the so-called golden age of Greece.
 Our predecessors' ideals are not ours. Works signed by great names
 over the centuries appeal to us less. In the hurry and bustle of their
 times, worldly-wise artists created works for Popes and palaces. It is
 the ordinary people who laboured in their workshops and of whose
 lives scarcely anything is now known, whose very names have not
 come down to us, that we love and respect today in their plain, large-
 scale carvings in the cathedrals of Naumburg, Magdeburg and Bamberg.
3. Our museums are getting large and crammed and are growing rapidly.
 I am not keen on these vast collections, deadening by virtue of their
 sheer mass. A reaction against such excess must surely come soon.
4. Not long ago only a few artistic periods were thought suitable for
 museums. Then they were joined by exhibitions of Coptic and early
 Christian art, Greek terracottas and vases, Persian and Islamic art.
 But why is Indian, Chinese and Javanese art still classified under
 ethnology or anthropology? And why is the art of primitive peoples
 not considered art at all?
5. What is it about these primitive forms of expression that appeals so
 much to us artists?
6. In our own time, every earthenware vessel or piece of jewellery, every
 utensil or garment, has to be designed on paper before it is made.
 Primitive peoples, however, create their works with the material itself
 in the artist's hand, held in his fingers. They aspire to express delight
 in form and the love of creating it. Absolute originality, the intense
 and often grotesque expression of power and life in very simple forms
 – that may be why we like these works of native art.

c) André Breton *et al.,* **'Murderous Humanitarianism' [1934],
in Nancy Cunard (ed.),** *Negro: An Anthology* **(New York and
London: Continuum Books, 2002), pp. 352–353**

For centuries the soldiers, priests and civil agents of imperialism, in a
welter of looting, outrage and wholesale murder, have with impunity
grown fat off the coloured races. Now it is the turn of the demagogues,
with their counterfeit liberalism.

But the proletariat of today, whether metropolitan or colonial, is no longer to be fooled by fine words as to the real end in view, which is still, as it always was, the exploitation of the greatest number for the benefit of a few slavers. Now these slavers, knowing their days to be numbered and reading the doom of their system in the world crisis, fall back on a gospel of mercy, whereas in reality they rely more than ever on their traditional methods of slaughter to enforce their tyranny.

No great penetration is required to read between the lines of the news, whether in print or on the screen: punitive expeditions, blacks lynched in America, the white scourge devastating town and country in our parliamentary kingdoms and bourgeois republics.

War, that reliable colonial endemic, receives fresh impulse in the name of 'pacification'. France may well be proud of having launched this godsent euphemism at the precise moment when, in throes of pacifism, she sent forth her tried and trusty thugs with instructions to plunder all those distant and defenceless peoples from whom the intercapitalistic butchery had distracted her attentions for a space.

The most scandalous of these wars, that against the Riffains in 1925, stimulated a number of intellectuals, investors in militarism, to assert their complicity with the hangmen of jingo and capital.

Responding to the appeal of the Communist Party, we protested against the war in Morocco and made our declaration in *Revolution First and Always!*

In a France hideously inflated from having dismembered Europe, made mincemeat of Africa, polluted Oceania and ravaged whole tracts of Asia, we Surréalistes pronounced ourselves in favour of changing the imperialist war, in its chronic and colonial form, into a civil war. Thus we placed our energies at the disposal of the revolution, of the proletariat and its struggles, and defined our attitude towards the colonial problem, and hence towards the colour question.

Gone were the days when the delegates of this snivelling capitalism might screen themselves in those abstractions which, in both secular and religious mode, were invariably inspired by the christian ignominy and which strove on the most grossly interested grounds to masochise whatever peoples had not yet been contaminated by the sordid moral and religious codes in which men feign to find authority for the exploitation of their fellows.

When whole peoples had been decimated with fire and sword it became necessary to round up the survivors and domesticate them in such a cult of labour as could only proceed from the notions of original sin and atonement. The clergy and professional philanthropists have always collaborated with the army in this bloody exploitation. The colonial machinery

that extracts the last penny from natural advantages hammers away with the joyful regularity of a poleaxe. The white man preaches, doses, vaccinates, assassinates and (from himself) receives absolution. With his psalms, his speeches, his guarantees of liberty, equality and fraternity, he seeks to drown the noise of his machine guns.

It is no good objecting that these periods of rapine are only a necessary phase and pave the way, in the words of the time-honoured formula, 'for an era of prosperity founded on a close and intelligent collaboration between the natives and the metropolis'! It is no good trying to palliate collective outrage and butchery by jury in the new colonies by inviting us to consider the old, and the peace and prosperity they have so long enjoyed. It is no good blustering about the Antilles and the 'happy evolution' that has enabled them to be assimilated, or very nearly, by France.

In the Antilles, as in America, the fun began with the total extermination of the natives, in spite of their having extended a most cordial reception to the Christopher Columbian invaders. Were they now, in the hour of triumph, and having come so far, to set out empty-handed for home? Never! So they sailed on to Africa and stole men. These were in due course promoted by our humanists to the ranks of slavery, but were more or less exempted from the sadism of their masters in virtue of the fact that they represented a capital which had to be safeguarded like any other capital. Their descendants, long since reduced to destitution (in the French Antilles they live on vegetables and salt cod and are dependent in the matter of clothing on whatever old guano sacks they are lucky enough to steal), constitute a black proletariat whose conditions of life are even more wretched than those of its European equivalent and which is exploited by a coloured bourgeoisie quite as ferocious as any other. This bourgeoisie, covered by the machine-guns of culture, 'elects' such perfectly adequate representatives as 'Hard Labour' Diagne and 'Twister' Delmont.

The intellectuals of this new bourgeoisie, though they may not all be specialists in parliamentary abuse, are no better than the experts when they proclaim their devotion to the Spirit. The value of this idealism is precisely given by the manoeuvres of its doctrinaires who, in their paradise of comfortable iniquity, have organized a system of poltroonery proof against all the necessities of life and the urgent consequences of dream. These gentlemen, votaries of corpses and theosophies, go to ground in the past, vanish down the warrens of Himalayan monasteries. Even for those whom a few last shreds of shame and intelligence dissuade from invoking those current religions whose God is too frankly a God of cash, there is the call of some 'mystic Orient' or other. Our gallant sailors, policemen and agents of imperialist thought, in labour with opium and

literature, have swamped us with their irretentions of nostalgia; the function of all these idyllic alarums among the dead and gone being to distract our thoughts from the present, the abominations of the present.

A Holy-Saint-Faced *International* of hypocrites deprecates the material progress foisted on the blacks, protests, courteously, against the importation not only of alcohol, syphilis and field-artillery but also of railways and printing. This comes well after the former rejoicings of its evangelical spirit at the idea that the 'spiritual values' current in capitalist societies, and notably the respect for human life and property, would devolve naturally from enforced familiarity with fermented drinks, firearms and disease. It is scarcely necessary to add that the colonist demands this respect for property without reciprocity.

Those blacks who have merely been compelled to distort in terms of fashionable jazz the natural expression of their joy at finding themselves partakers of a universe from which western peoples have wilfully withdrawn may consider themselves lucky to have suffered no worse thing than degradation. The 18th century derived nothing from China except a repertory of frivolities to grace the alcove. In the same way the whole object of our romantic exoticism and modern travel-lust is of use only in entertaining that class of blasé client sly enough to see an interest in deflecting to his own advantage the torrent of those energies which soon, sooner than he thinks, will close over his head.

André Breton, Roger Caillois, René Char, René Crevel, Paul Eluard, J.-M. Monnerot, Benjamin Péret, Yves Tanguy, André Thirion, Pierre Unik, Pierre Yoyotte

5.2 Mexican muralism

The Syndicate of Technical Workers, Painters and Sculptors was established in Mexico City in 1923 with David Alfaro Siqueiros (1896–1974) as its Secretary General. In the same year Adolfo de la Huerta was installed as the provisional president of Mexico by General Guadalupe Suárez, against the legitimate government of General Alvaro Obregón. As a response to this attempted coup Siqueiros wrote the manifesto and it was signed by Diego Rivera, José Clemente Orozco, Jean Charlot, Ignacio Asunsolo, Xavier Guerrero, Fermín Revueltas, Roberto Montenegro and Charles Merrida, amongst others.

Alberto Hijar (b. 1935) is a philosopher, teacher and activist from Mexico. A labour organiser during the 1970s, he was imprisoned as a result of his political activities and later pardoned.

In addition to teaching at the National Autonomous University of Mexico (UNAM) from the 1960s onwards, he was also the co-ordinator of the David Alfaro Siqueiros Foundation between 1974 and 1987, and since 1996 has been a Research Fellow at the Instituto Nacional de Bellas Artes. The interview between him and Warren Carter was conducted in Mexico City in September 1916 and is printed here for the first time. While his friend and fellow activist David Alfaro Siqueiros is the main subject of the exchange, Hijar ranges widely over Mexican politics and culture from the Mexican Revolution through to the present day. [Warren Carter]

a) David Alfaro Siqueiros, 'A Declaration of Social, Political and Aesthetic Principles' [1922], in *Art and Revolution* (London: Lawrence & Wishart, 1975), pp. 24–25

The Syndicate of Technical Workers, Painters and Sculptors directs itself to the native races humiliated for centuries; to the soldiers made into hangmen by their officers; to the workers and peasants scourged by the rich; and to the intellectuals who do not flatter the bourgeoisie.

We side with those who demand the disappearance of an ancient, cruel system in which the farm worker produces food for the loud-mouthed politicians and bosses, while he starves; in which the industrial workers in the factories who weave cloth and by the work of their hands make life comfortable for the pimps and prostitutes, while they crawl and freeze; in which the Indian soldier heroically leaves the land he has tilled and eternally sacrifices his life in a vain attempt to destroy the misery which has lain on his face for centuries.

The noble work of our race, down to its most insignificant spiritual and physical expressions, is native (and essentially Indian) in origin. With their admirable and extraordinary *talent to create beauty, peculiar to themselves, the art of the Mexican people is the most wholesome spiritual expression in the world* and this tradition is our greatest treasure. Great because it belongs collectively to the people and this is why our fundamental aesthetic goal must be to socialise artistic expression and wipe out bourgeois individualism.

We *repudiate* so-called easel painting and every kind of art favoured by ultra-intellectual circles, because it is aristocratic, and we praise monumental art in all its forms, because it is public property.

We *proclaim* that at this time of social change from a decrepit order to a new one, the creators of beauty must use their best efforts to produce ideological works of art for the people; art must no longer be the expression

of individual satisfaction which it is today, but should aim to become a fighting, educative art for all.

b) Interview with Alberto Hijar Serrano, Researcher of Plastic Arts of the National Institute of Fine Arts, Mexico; Interviewer Warren Carter, 10 October 2016

INTERVIEWER: You were close to Siqueiros during his lifetime. Could you could talk a little about your relationship?

[ALBERTO]Hijar: Our relationship solidified when the Workers University of Mexico called for a debate on the Sino-Soviet conflict. This was planned for one session but ended up continuing for a week. This discussion between very distinguished artists, researchers and war journalists was sometimes aggressive but Siqueiros impressed me with his eloquence. I had previously seen him talk to railroad workers in the public square which ultimately cost him his longest term in prison in 1960–64. Anyhow, in that debate I discovered that I learned more from listening to Siqueiros or Antonio Rodriguez, a very combative Portuguese journalist, than in any lectures at the Faculty of Philosophy at UNAM where I was enrolled. From then on our relationship became constant and endearing even if prison interrupted this. Once out his health had deteriorated badly but we could still converse, discuss a little of what was happening – his release from prison with his acceptance of the presidential pardon. This was my intellectual formation in aesthetics and politics and their relationship to changing the world.

INTERVIEWER: After his death in 1974 you were coordinator of the Siqueiros foundation until 1987. Could you tell us something about the kind of work that this entailed?

ALBERTO: It was a trust fund with the Bank of Mexico providing the money to sustain what Siqueiros left to the people of Mexico – including his house in the elegant Polanco neighbourhood which was called the 'Sala Public Art Siqueiros'. I was responsible for the cultural programme, for the curation of the gallery that we had transformed, and what was published to document Siqueiros' life. The question was how to do justice to such a full life with the surviving documents, photographs, manuscripts, medals, and trophies? How best to bring together his artwork with his radical political activism. This made the 'Sala Public Art Siqueiros' an important centre of discussing political problems, at least until the Bank of Mexico withdrew its support and we had to dissolve the trust. The house needed urgent repair as it was full of leaks. He also left a small but very important library and as we processed the documentation in

those years we had to ensure that they did not deteriorate or were destroyed. Anyway the dissolution of the fund did not prevent me continuing doing our 'Siqueiranious' work.

INTERVIEWER: Siqueiros was a committed communist all his life and led the first assassination attempt on Trotsky. Yet his artistic avant-gardism had more in common with that of the former Bolshevik leader than it did with Soviet socialist realism. How did Siqueiros negotiate these contradictions?

ALBERTO: He handled it with a militancy that was not always in keeping with the Mexican Communist Party line, which resulted in his expulsion. However he always found a way to express his radical militancy in ways even outside of the Communist Party. He had an international prestige enhanced by the prize that he would later win in the 1950s at the Venice Biennale. That international prestige was partly built during his participation in the defence of the Spanish Republic. He went with a delegation of artists after a conference in New York. Others participated in the famous congress in Valencia but, not content with this, he went back with Antonio Pujol and they presented themselves as would-be participants in the armed struggle. Siqueiros revelled in his first role as a mailman to test his daring military effectiveness. Before that he had participated in the Mexican Revolution in the famous 'Battalion Bebé' made up of minors under the instruction of General Manuel M. Diéguez who was leader of the strike at Cananea that preceded the Mexican Revolution. In Spain Siqueiros rose to commissar in the International Brigades. He was one of those responsible for bringing the political ideology of the Soviet Union and Stalinism to anyone who was not suitably caderised. Siqueiros built relationships in Spain with those who were then shocked when the Mexican government received Trotsky as a political refugee under Cárdenas. Stalin had ordered the physical elimination of Trotsky whilst the Moscow trials were in their pomp. Stalin had already caused thousands of deaths, disappearances, poisonings, shootings and all sorts of atrocities against all those who had a different political position to that of building socialism in one country and Trotsky was pursued by his henchmen the world over. Siqueiros could not admit this to himself as he believed that socialism in Mexico could not arrive until we had industrialized every member of working class. Then we could start to think about socialist revolution – no? Rivera was expelled from the Communist Party as a Trotskyist and Siqueiros was a radical Stalinist who agreed to the assassination attempt against Trotsky. Siqueiros alleged that the attempt was not to kill Trotsky but merely to demonstrate that all the guards at the house where Trotsky had taken refuge were actually

North American which was in principle illegal. Curious eh – a Communist worried about the legal position of the Mexican state? Other artists like Antonio Pujol also participated, as I have already mentioned. I mention him especially because he was very young when he left Spain and, like Siqueiros, he returned wounded. Both became lieutenant colonels in the International Brigades. The attack on Trotsky consisted of a shootout inside the house and this forced Siqueiros to flee. It is very curious because his desire for anonymity led him to Hostotipaquillo in Altos de Jalisco where he had worked with the Cuban Communist Julio Antonio Mella to consolidate the project of the Trade Union Confederation of Mexico. I say it is very curious to take refuge there because he had a photo taken with a stetson hat and a great jorongo so that he basically looked identical to any indigenous peasant that one could see around those parts. Yet walking side by side with him was Blanca Luz Brum, who I think was going with him at that time, richly attired in a silk shawl. As such they were hardly inconspicuous. But, as I have said, in Siqueiros' defence he insisted that he was not trying to kill Trotsky. Although we will never know what really happened because the truth is that his sectarian indiscipline did not prevent him being a Stalinist who could commit political acts of this scale.

INTERVIEWER: You wrote 'Diego Rivera: His Political Contribution' in 1986. You have already touched on this in your answer to the previous question, but what were the essential differences between Rivera and Siqueiros, who are usually grouped together as 'The Big Three'?

ALBERTO: The differences between Siqueiros and Rivera, as with them and Orozco, began very early in the history of Mexican muralism, after the murals done at the National Preparatory School which the Mexican bourgeoisie in power like to call the School of San Ildefonso, after its colonial name. José Vasconcelos, Secretary of Public Education and promoter of that spiritualist nationalism: 'Through my race speaks the spirit' – which is the abominable slogan of the University of Mexico – agreed the project with Rivera who was given the job of coordinating the mural programme. Rivera did well out of this with his subsequent commission at the Ministry of Education whilst, with the ongoing repression of Communists, Siqueiros has to flee to Guadalajara where he was looked after by a wealthy political leader José Guadalupe Zuno, an important character in the national liberation movement, understudied if studied at all. Rivera then left the Communist Party in 1924 with the big spoon, as the Mexicans say, i.e. with the commission to paint all of the Ministry of Education. This generates great unrest among the other muralists. Siqueiros argues against what Rivera is doing as he considers

him to be an accomplice of the Mexican state in its repression of the Communist painters who then left for the United States to study or put on exhibitions there. This resulted in the launch of *The Machete* which was conceived in 1924 as the paper of the Union of Technical Workers, Painters and Sculptors. *The Machete*, said Siqueiros, had to be a transportable mural, a revolutionary medium par excellence because it had a national circulation at a time when there was no internet. With reports on popular struggles, etchings and poems by the likes of Gachita Amador it became, within a year, a vital tool of the Mexican Communist Party. The differences between Rivera and Siqueiros increased after the invitation for both to meet in the Soviet Union in 1927 to celebrate the tenth anniversary of the triumph of the Russian Revolution. Rivera is an artist first and Communist second; Siqueiros is a worker representative on the central committee of the Communist Party. In 1927 the Moscow trials had already started and Rivera and Siqueiros can see the opposition to Stalinism, and the importance of Bukharin, Kamenev, Zinoviev and Trotsky himself. So began the construction of socialism in one country and the brutal elimination of all opposition to Stalin's work. They both returned to Mexico: Siqueiros insisted Rivera was welcomed with honours in Veracruz; in contrast he was met by the police. The differences would continue to grow until 1929, a year of global crisis with the crash in New York, the dictatorships in South and Central America, the murder of Álvaro Obregón and the end of his second presidency of the republic. With the killing of Obregón came the persecution of Communists with Siqueiros going to jail in 1929 with most of them. Conversely Rivera asks a member of the central committee of the party for permission to withdraw from his own role on it and be considered as a collaborator of the party so he can paint, because he had a lot of work on with his commissions at Chapingo, then the Ministry of Education, and then at National Palace. This resulted in his expulsion from the Communist Party and then the poisonous relationship between Rivera and the North American ambassador Dwight Morrow, a perverse and terrible proconsul who saw the opportunity to build artistic relations between the United States and Mexico via an imperialist peace promoted by United States. Rivera is sponsored to paint a mural in Cuernavaca and this is scandalous. Morrow pays for the mural, introduces him to Edsel Ford and they make arrangements for him to paint in Detroit. He meets with Nelson Rockefeller, Jr., and agrees to paint in the Rockefeller Centre in New York as well as receiving an important exhibition at the Rockefeller-owned Museum of Modern Art beforehand. In the United States Rivera enjoys the accolade of corporate patronage without ever once losing the appearance of being a worker. A witty poet and member of the group of contemporaries,

Salvador Novo, wrote 'The Diegada' to mock him – lampooning his unionism and his peasantness. Rivera wears blue worker overalls, mining boots, a cowboy hat and is accompanied by Frida Kahlo dressed as an indigenous peasant and this is a scandal, especially in United States. Yet his capacity for scandal never seemed to undermine his anti-imperialist credentials. The fight between the two continues in 1934 in *New Masses*, the journal of the Communist Party of the United States. In an article entitled 'The Counter-Revolutionary Way of Rivera' Siqueiros conjured up more than ten nicknames for Rivera, such as 'mental tourist', 'Picasso in Aztecland', and 'Esthete of imperialism' and Rivera responded a year later in the Trotskyist magazine 'Key' published in Buenos Aires. In stylish third person he wrote: 'Rivera is the most famous painter and the most sold in the United States', which is intolerable to Siqueiros and the Communist Party. Then the last sentence of his letter ends with 'Siqueiros talking, Rivera painting'. Trotskyism also divides them. Trotsky eventually quarreled with Rivera despite him being the one who pleaded for his political asylum and who took him in with his wife in the famous Blue House in Coyoacán where he lived with Frida. So there was an ongoing battle but they eventually rebuilt their friendship. Pablo Neruda had an important part to play in this because they both end up in the 1950s working with him so they both had to sit at a table together. Orozco could no longer participate in the illustration of 'Canto General' by Neruda. At a conference of American educational organizations their enmity erupted once more and Siqueiros insulted Rivera at the School of Fine Arts. Again the League of Revolutionary Writers and Artists (LEAR) forced them to sit at a table and talk again. They sat down and produced a sensational document and founded a School of Plastic Arts which preceded the Taller de Gráfica Popular. And in the document it is acknowledged that the murals did not reach the desired public as they were in government buildings – they had to do something else.

INTERVIEWER: In my opinion *Portrait of the Bourgeoisie* is one of the most important works of the interwar period. Where do you place this mural in the works of Siqueiros?

ALBERTO: The mural was originally a project designed to glorify the headquarters of the Union of Electricians, a union fighting for its place within the theatre of proletarian struggle and which represented the most important constituent of the labour movement in support of the government of Cárdenas. I agree that this mural is the most significant for several important reasons. One, it is a truly collective mural. Siqueiros was very busy planning the attack on Trotsky, therefore he got together a team of participants in the defence of the defeated Spanish Republic

and each had a part to play in the painting. Those who were not muralists painted at the base of the stairwell where one could move along following the boards and minutely detail the worker's clothing, etc. Anyway, the academic painters did what they did best and it ended excellently. José Renau, a prominent militant of the Spanish Republic and who was the head of culture in Spain and therefore responsible for the rescue of Picasso's *Guernica*, did the optical study in the staircase, to centre the crosshairs for each part of the mural painted. So first and foremost it is a truly collective mural. In fact I cannot emphasise this enough. Renau painted the fire on the aircraft-carrier platform and was very satisfied with the smoke that he had painted. Siqueiros arrived in the afternoon and sees what he has done and throws a few brushstrokes here and there and Renault gathers his things, leaves and is on the point of suicide. Well, not really, but ... Anyhow, after 15 days he eventually relented and said: 'Well yes, Siqueiros was right, that smoke I painted, it was like the kind of smoke in a fairy tale.' Siqueiros comes in does his changes and we are left with what Siqueiros called 'the drama of war' – no? So it is with these incidents that the mural ends up as the *Portrait of the Bourgeoisie*. There are influences I think proposed by Renau in the construction of the central figure with the gas mask, with the bodies of the hanged black man, and the anti-fascist and anti-Nazi European details. So the mural builds a full portrait of the bourgeoisie whilst overcoming a very difficult space in a stairwell and in which the small windows are painted with red fire, as in the burning of the Reichstag which was attributed to the Communists to justify their persecution in Nazi Germany. The figure of the parakeet with violets in his hand as the great demagogue completes the vision for the spectator going from top to bottom up and a strip on the lintel gives credit to all those who participated in the mural and demonstrates its position in the struggle against the imperialist war. All this makes the wall very important. I would like to add also that the building in which it stands was designed by the architect Enrique Yáñez who was part of a group called the 'Socialist Architects' which was integrated into LEAR. He won a competition to construct the building and he designed on the model of Soviet structures with their large auditoriums for assemblies for entertainment. The first modern dance show directed by Magda Montoya and the early work of avant-garde theatre director of Seki Sano, an American chased out by McCarthyism, were performed there. It had a library, a kindergarten, and a club for workers to meet and discuss politics. Inside the corridor connecting the two bodies of the building they built peepholes in which they could put gun barrels in case they had to defend both the building and the syndicate. Subsequently the illiterate and abominable beasts of Mexican unionism

covered the front of the building with plastic and it lost all its charm and was no longer the symbol of what it was in the 1930s and 40s to the Mexican labour movement. All this comes together in the mural. And in order to highlight the extraordinary dynamic composition, which might have ended up looking a little stiff if Siqueiros had not come along and painted the figure of a fighter with a rifle in his hands at the top of the mural and the towers and then above him the red flag with the hammer and sickle.

INTERVIEWER: You mentioned that Siqueiros dominated the process of painting the mural yet he would always argue that it was a collective process. Was this not a deeply contradictory position?

ALBERTO: The contradictions of working collectively to produce murals are summarised in a short sentence by the man who was his foreman in almost all of Siqueiros' projects – Arenal, his brother in law – who collaborated with him on murals from those in Los Angeles in 1932 through to the Polyforum. Arenal said: 'In reality we were actually assistants, we were not the collaborators, he told us where to fill in blue and then he would come and correct.' This summarizes the problem and naturally the endeavours he made in industrial technique ensured that Siqueiros abhorred what he called 'the hair, brush and stick'. So he had very clear ideas about what needed be done and I think he formed no less than ten collectives wherever he painted a mural. None of these collectives prospered after the mural was completed.

INTERVIEWER: Exiled after the attempted assassination of Trotsky, the mural was completed by the Spaniard Renau. Does this in some sense complicate the attribution of the work to Siqueiros?

ALBERTO: No, and he made this very clear in the lintel where he put the credits. The main responsibility undoubtedly goes to Siqueiros because it was him that organised the contributions from everyone else. The figure of Renau was very important because he provided his experience of graphics and plastics, he made the outline of geometric points of view of the mural – but no, the mural is by Siqueiros – he is the main culprit.

INTERVIEWER: The dominant conception of the avant-garde art is Dada, Constructivism and Surrealism. Is this not Eurocentric and, furthermore, do the Mexican muralists not deserve to be considered alongside these artistic formations?

ALBERTO: Without doubt the muralists deserve the same status but with a dimension that the European avant-garde lacks – that is, the insistence on the need to give significance to public space. Indeed the so called Mexican School of Painting is a movement in which there is

a kinship between those who paint and sculpt and its other participants. In an aesthetic sense this binds them to a project involving the importance of architectonic space with all that this entails. The exception being in 1922 when Siqueiros puts together a single issue of the journal *American Life* in Barcelona with three appeals for the 'Plastics of America'. The first appeal is against bijou and chic art, such as that in the Palace of Fine Arts in Mexico. Second is the call to live our marvellous dynamic age under the influence of Futurism, especially the Italian and Soviet variants, and by taking control of urban architecture as well the prehispanic ceremonial centres and large colonial convents in Mexico and North America. He also opposes what he calls the influence of 'faux fas' – that is to say the imitation of European painting and the pandering to gallery owners. The last call was to not take the poets seriously, i.e. those who set themselves up as art critics and as cultural promoters such as Octavio Paz, who was a servant of the power of the Mexican state and flirted with American sponsorship to promote culture and tourism favourable to the penetration of large North American corporations. All this builds a school, one I think that is comparable to any other avant-garde, whether this be in Europe or Uruguay, such as the southern workshop of Torres García.

INTERVIEWER: There has been a trend in recent years of treating Mexican muralism as complicit in the construction of the bourgeois state after 1920. What do you think is the political significance of the murals today?

ALBERTO: Those are two questions. The first is answered in the convenient phrase: 'that the mural paintings are the left of the cultural project of building the Mexican state'. Since the nineteenth century in Mexico there has been a constant struggle between the conservative and liberal positivist republican trend within the Mexican Revolution. This leads to the emergence of a crisis due to the fact that the peasant and incipient labour movements were represented by organisations with anarchist roots with the participation of communist cadre within them. This gave rise to at least three major nationalist tendencies. The Cristero War incorporated numerous peasant masses who did not know either way what they were fighting for, but the priests said that they should go to fight against the federal army and they did. They are continuing to do so in a very violent and combative manner even today in that they are filling the cities with marches against civil liberties such as gay marriage or abortion. This is a nationalism that has the Virgin of Guadalupe as its symbol, an inescapably Mexican one. Fermín Revueltas, who signed his murals with the hammer and sickle, painted her at the National Preparatory School and the

comrades complained and he replied: 'Have you noticed the shape of the Virgin, the colour?' It is obviously a rather pre-Hispanic monolith painted in peasant colours. This is important but the Virgin of Guadalupe also generates huge profits and is the shrine that raises the most money for the Catholic Church after the Vatican. That is one kind of nationalism. Another nationalism is that of the state, and there was certainly a corrupt clique of painters, sculptors, and architects to aggrandise the Mexican state. At the forefront of many of these murals there appear figures of politicians at different levels. If the mural is paid for by a municipal president then the president is there in it, often with his wife and his assistants too. This projects the Mexican state as something that it has not been for decades, i.e. one that sides with the peasants as a result of the Mexican Revolution. Certainly this trend remained prevalent until they discovered that it is better to build nationalism with non-figurative sculptures of the sort that now plague Mexico City and the entrances of some cities which been decorated with these hideous geometric figures. But there continues to exist a school of Mexican muralism which is why I insist on the importance of the mural by Rafael Cauduro and, in particular, his *En Plena Suprema Corte de Justicia* which points to the state-sanctioned violence that prevents justice in Mexico. A mural without even one single portrait other than his daughters, and no specific references to any government minister, nor any Messiah, nor any sponsor – that is very important. The mural by Cauduro seems to me a fundamental act made in the Centennial of the Mexican Revolution. This is now fuelled by the movement against the criminal government of Ulises Ruiz in Oaxaca in 2006 and specifically an organization called Assembly of Revolutionary Artists of Oaxaca (ASARO) who have discovered the importance of the stencil which, by the way, Siqueiros used for the first time in the mural of the Mexican Union of Electricians – those soldiers marching identically were done by stencil. This then gives something contemporary to the tradition of Mexican muralism – a dimension that Siqueiros envisaged. And of course the use of stencils can result in murals that are six square meters or more.

INTERVIEWER: How important are 'The Big Three' to contemporary Mexican art?

ALBERTO: Well they are the most prominent in terms of professional accomplishment, certainly. But those committed to contemporary political art do not like to use the term 'The Big Three' because it devalues the very important work of those who did not participate in the armed struggle and who contributed publications, schools, workshops, or those who founded the group ¡30-30! – sometimes known as the second

generation who were a little younger. Anyway the name does not appeal much to those of us invested in these other aspects as well. But their input is, I think, fundamental. In his book scandalously titled: *There Is No Road But Ours* Siqueiros argued for the importance of Rivera as the first professional, the first who knew how to masterfully paint in fresco. It was Orozco who first brought to mural painting the expressionism, the burlesque, and the sarcasm necessary to mock the powers that be. And then there was Siqueiros with all his efforts to incorporate industrial materials and methods in monumental mural painting. The synthesis of all this with the ongoing need to construct a historical and revolutionary social subject with feelings, sensations, perceptions, and critical reflections that integrate the proposals of 'The Big Three' is work in progress.

Critical approaches

5.3 Terry Smith, 'The Provincialism Problem', *Artforum*, XIII, no. 1 (September 1974), pp. 54–59

In 1974, after spending the previous two years in New York city on a prestigious scholarship, the art historian Terry Smith wrote 'The Provincialism Problem' for the art journal *Artforum*. Written as a polemic of sorts, and at an early and formative stage of his career, this essay gained notoriety for its critical stance on the dichotomies of the 'centre/margin' or 'metropolitan/provincialism' dyad through the case study of his home country, Australia and the then accepted centre of the art world, New York. Smith's essay can be situated within a broader terrain of debates as articulated by his fellow Art and Language colleague, Ian Burn. This essay outlines the relation between the 'leaders' and 'followers' of the art world with that of the histories of colonialism, dependence and power. Rather than render the provincial pejoratively, however, he seeks to unpack the mutual dependency and innovation between assumed parochial 'hinterlands' and metropolitan 'powerhouses'. [Amy Charlesworth]

Provincialism appears primarily as an attitude of subservience to an externally imposed hierarchy of cultural values. It is not simply the product of a colonialist history; nor is it merely a function of geographic location. Most New York artists, critics, collectors, dealers, and gallery-goers are provincialist in their work, attitudes and positions within the system. Members of art worlds outside New York—on every continent, including North America—are likewise provincial, although in different ways. The

projection of the New York art world as the metropolitan center for art by every other art world is symptomatic of the provincialism of each of them.

Most of us treat this projection as if it were a construction of reality—and it is, in the sense that it is almost universally shared. However, those who are able to live adequately within the framework of respect for the essential differentness of diverse yet related cultures recognize that the projection does not have the force of 'natural law'. It is rather, a viewpoint that, while effectively governing majority behaviour, is as culturally relative as any other. That is, it is one among many ways of defining the (different) situations we are in.

Yet, whatever one's approach, the complex of metropolitan/provincial interrelationships persistently impinges. While they are obviously denoted in some (perhaps most) artworks, they are connoted by all. Shelving the questions they raise as insoluble or trivial is irresponsible. Awareness of these questions has consequences for action throughout the art system. They set a problematic relevant to all of us.

I propose to begin to deal with this problematic by exploring the patterns of provincialism in Australian art. These quickly expose, by contrast and comparison, a range of similar patterns in American art. Much of my method will consist in stating the obvious—a somewhat unusual procedure in this area of debate.

Like its political history, the development of Australian art is typified by variations on the theme of dependence. Although all variations were not responses to changes in British art, they were for the most part until the 1950s.[1] British art itself has rarely been innovative since the mid-nineteenth century. It, too, progressed largely in terms of its capacity to absorb the weaker—or if you prefer, the more subtle—aspects of succeeding waves of French art movements. Australian artists, therefore, got their stimulation at second remove. Indeed when Abstract Expressionism became prominent in the early 1950s, Australian painters tended to respond to the European responses to it—that is, to *l'art informel,* the Cobra group, the Spanish texture painters, etc.[2]

But this is hardly a mechanical process. Australian artists have not responded to each and every European movement. Nineteenth-century Realism, Dada and Pop art, for example, found few followers. All the

1 The classic study of these patterns is Bernard Smith, *Australian Painting 1788–1970* (Melbourne: rev. ed. 1971).
2 See Patrick McCaughey, 'Notes on the Centre: New York', *Quadrant,* Sydney (July–August, 1970), pp. 76–80, and my reply 'Provincialism in Art', ibid. (March–April, 1971), pp. 67–71.

other styles, however, have had small to quite large bands of advocates who devote their artistic maturity to mastering, then elaborating aspects of the initiatives of those they have imitated. This process continues unabated today, like a succession of faithful echoes, always open to replenishment at the sound of a new call from the other side of the divide.

Nor are the European/American styles adopted whole. Their character is distorted because acquaintance with them is late, usually with the mature forms of the style. The early innovative struggles are simply not available outside of the limited cultural situation in which they arise. If a visiting artist chances upon them, they are usually incomprehensible to him. Further distortions occur when works are seen only in reproduction, and are accompanied by inadequate criticism and gnomic artist's statements. In short, models and prototypes arrive in the provinces devoid of their genetic contexts. They carry, and are transformed by, the fact of their coming from the metropolitan center. They seem to issue, as it were, directly out of art, to be made by 'cultural heroes', and to take their predestined place as one of a succession of 'great moments' in art history.

Isolation gives these cultural exports a connotation perhaps unsuspected by their makers—they can hardly fail to reinforce a vicious circle of conservatism. Ian Milliss puts his point succinctly:

> In Australia where the cultural roots of the dominant white society are geographically on the other side of the world, 'official culture' with its distortions of history is accepted almost universally, because the physical evidence that would contradict it is lacking. This dissolution is particularly telling amongst political radicals; they either accept 'official culture' unquestioningly, as the Labor Party has in its formation of the Council for the Arts, or unthinkingly reject culture in its entirety for pure politics. Either way they render the social change they seek impossible.[3]

But geographic isolation is only one measure of cultural distancing from metropolitan centers. It is inescapably obvious that most artists the world over live in art communities that are formed by a relentless provincialism. Their worlds are replete with tensions between two antithetical terms: a defiant urge to localism (a claim for the possibility and validity of 'making good, original art right here') and a reluctant recognition that the generative innovations in art, and the criteria for standards of 'quality', 'originality', 'interest', 'forcefulness', etc., are determined externally. Far from encouraging innocent art of naive purity, untainted by 'too much

3 Catalogue essay, *Object and Idea*, National Gallery of Victoria, Melbourne, 1973.

history and too much thinking', provincialism, in fact, produces highly self-conscious art 'obsessed with the problem of what its identity ought to be'.[4]

In this provincialist bind, it is surprising that Australian artists have created as much 'interesting' work as they have. They now exhibit all over the world with unexceptional regularity, put on 'strong showings' in international exhibitions, are written about in the magazines, etc. That is to say, within the last 20 years we have learned to [do] what everybody else does in art, and do it as well as most. But so has almost everybody else: the European-North and South American art circuit is studded with artists from everywhere making competent art within current categories. The art fairs have become condemned to insufferable dullness by their own success in promoting international sameness.

New York remains the metropolitan center for the visual arts, to which artists living in rest of America, in Holland, Germany, Brazil, England, France, Japan, Australia, etc. stand in a provincial relationship. They are making art indistinguishable from that of the majority of New York artists but their art needs to funnel through New York before it has a chance to significantly 'change the culture', even the culture back home. New York, of course, depends essentially on these inputs from foreign artists.

[...]

A cruel irony of provincialism is that while the artist pays exaggerated homage to the conceptions of art history and the standards for judging 'quality', 'significance', 'interest', etc., of the metropolitan center, he has, by definition of his situation, no way of (from his distance) affecting those conceptions and standards. He may satisfy his local audience, but to the international audience he is mostly invisible, sometimes amusingly exotic.

The cultural transmission is one-way: whereas both Jackson Pollock and Sidney Nolan are seen as 'great artists' by the art audience in Australia, it is inconceivable that Nolan should be so regarded in New York. And in Australia, Nolan's 'greatness' is of a different order from Pollock's. Nolan is admired as a great *Australian* artist, while Pollock is taken to be a great artist—his Americanness accepted as a secondary aspect of his achievement qua artist. In such circumstances, the most to which the provincial artist can aspire is to be considered second-rate. Thus, the superficial plausibility of the remark that while provincial societies have

4 Robert Hughes, *The Art of Australia* (Harmondsworth, rev. ed.,1970), p. 314.

produced many fine artists, they have, at least in this century, produced no great ones.[5]

Clearly, a bad case of double standards operates here. Whole concepts of art are being formed on the basis of imperfectly assimilated international (i.e., for recent art, New York art world) criteria. Estimations of the achievement of local artists are based sometimes on these, sometimes on determinants that acknowledge the inherent limitations of the local scene. Under the first the artist invariably loses, under the second he might win too easily. If the local artist and his audience take the metropolitan/provincial dichotomy as fundamental, it often seems that nothing but this shuttling between standards can go on until, by some miracle, the local art world itself becomes a metropolitan center.

[...]

The stylistic diversity of international art during the past 15 years reverberates throughout recent Australian art. The last local movement of any strength was colour painting following Noland, Olitski, Stella and others, centering around Central Street Gallery, Sydney, during the latter 1960s, and enshrined in a major exhibition, 'The Field', at the National Gallery of Victoria, Melbourne, in 1968.[6] [...]

In recent years, however, an inventiveness encouraged by open form sculpture, process, environmental, and performance art has marked Australian art. This ranges from the restraint of Nigel Lendon's systematically arranged metal sculpture to the documentation of interpersonal social situations by Tim Johnson, Peter Kennedy and Mike Parr.[7]

[...]

Can the provincial bind be broken? Waves of hope recur cyclically. In the 1920s 'nativeness' was celebrated. In the mid 1940s a number of painters (later called the 'Antipodeans') placed their faith in a localism pursued with sharp awareness of European traditions. During the '50s

5 George Steiner, in a recent discussion of the demise of European classical humanist culture in America, notes a second-rate quality throughout current American culture—with, he adds, the 'challenging' exception of recent visual art, *In Bluebeard's Castle, some notes towards the re-definition of culture* (London, Faber, 1971).

6 See my 'Color-form painting: Sydney 1965–70', *Other Voices*, Sydney (June–July, 1970), pp. 6–17.

7 These tendencies emerged in exhibitions at (primarily) Pinacotheca artists' cooperative gallery, Melbourne, and at Inhibodress and Watters galleries, Sydney. They were explored in the following exhibitions: 'The Situation Now: Object and Post-Object Art', Contemporary Art Society Gallery, Sydney, 1971; 'Sculpturescape', Mildura Art Gallery; 'Object and Idea', National Gallery of Victoria, Melbourne; and 'Recent Australian Art', Art Gallery of New South Wales, Sydney, all 1973.

and '60s, following the influence of Abstract Expressionism, hope grew for the possibility of an avant-garde 'breakthrough'. By the end of the decade, with the rise of art centers throughout Europe and in various American cities, it seemed that the time of a liberating 'global village internationalism' had arrived. In the last year (a relatively) large and (generally speaking) enlightened funding of the arts by the new Labor government has aroused even greater confidence.

These pleadings for rescue to external forces most clearly attest to provincialism's relentless entrapment. There seems no way around the fact that as long as strong metropolitan centers like New York continue to define the state of play, and other centers continue to accept the rules of the game, all the other centers will be provincial, ipso facto. *As the situation stands, the provincial artist cannot choose not to be provincial.* The complex history of the 'expatriates', most of whom eventually return, highlights this dilemma.

With variations, the pattern of expatriation is this: As soon as he is able the young provincial artist leaves for the metropolitan center, where he picks up competencies for art-making in terms of the most obviously 'advanced' style, along with a taste for at least some aspects of the center's community dynamism (for example, the ready availability of a number of active audiences). Returning home, he proselytizes his new vision of artwork and art world around Sydney and Melbourne, often winning converts, throwing others into the position of reactionaries, and competing with acolytes of different metropolitan avant-gardisms until his initiative runs aground.

Having at no point been 'in on' the seminal impulses which generated his adopted style, he no longer knows how to continue within its framework; and the local art world is incapable of acting as a dynamic audience. He might then return to the metropolitan center only to discover that the style to which he has committed himself has changed in incomprehensible or unbridgeable ways. Also, its authority will probably have diminished, the singularity of its energy and confidence abated, its proponents engaged in the futile rear guard actions against the newest avant-gardism. The provincial artist returns home to find to his dismay, the same crisis building up for him. Most artists are flexible enough to go one or two rounds in this circus, but after that it becomes increasingly debilitating.

This pattern may well account for the curious fact that the 'history' of a provincial art, as it is experienced locally, is mostly written by younger artists, whereas what tends to be valued by overseas visitors are the unique-looking compromises of older artists. What, in their anthropological romanticism, the visitors fail to see is that the 'native' accents are often

the result of efforts to wed local traditionalisms to newly imported features. But, because the traditions are likewise hybrids, the mixture grows weaker. Struggling on in the hope that *the situation* will somehow change seems to be the lot of the provincial artist. The crucial point remains that, outside the metropolitan center, the individual artist is not himself the agent of significant change. Larger forces control the shape of his development as an artist.

All these remarks apply to artists in, say, Phoenix, Arizona (where, for example, Fritz Scholder's presentation of Indian themes in a light Francis Bacon style are currently causing much excitement), in San Francisco and, ultimately, in Chicago and Los Angeles as well. The only way an artist has a chance to make a 'significant' contribution, one which will have implications for 'the culture in general', seems to be to get him or herself to New York and stay here. Or, at the very least, to stay in some constant relationship to this art world. The reason being, it is here that 'significance' is determined and will continue to be as long as these determinations are accepted throughout the rest of the world.

[...]

The provincialism problem doesn't end at this unpleasant impasse—it goes deeper. Those who have broken the bind have done so largely because the system is structured so that several artists every few years *have* to break the bind. They are catalytic to the system's self-perpetuation; it forces them to come out 'on top'. How one gets to be one of these culture heroes is only partly a matter of one's planning. Nearly everyone in the New York art world takes approximately the right steps toward candidacy. The structural movements of the art world transform a few into winners, in an ad hoc, variable, irregular but nonetheless unfailing way.

As Ian Burn has pointed out, there are *responsibilities* here for American artists and their critical supporters.[8] They are the leading participants, whether wittingly or not, in a game whose rules, by which all artists must play but which can be written only by them, make it inevitable that only they can win and all others lose. This is the same kind of trick that underlies the authoritarian assumptions of superiority displayed by U.S. foreign policy. Instead, we should look to the benefits that would accrue to all from acting in a way which projects our own uncertainties and fallibilities undisguised and which value the differences of the cultures relative to ours.

8 (With Mel Ramsden), 'Provincialism', *Art Dialogue*, Melbourne, no. 1, October, 1973, 3–11; and as 'Art is what we do, culture is what we do to other artists', contribution to the Congress on Art in Its Cultural Context, Brussels, July 1973, in *Deurle II.7.73*, Deurle, Belgium, 1973.

For example, many American cultural institutions have international programs. The Museum of Modern Art is perhaps the most active—in the past 12 months it has toured exhibitions throughout Europe, South America, Australia and elsewhere. Such exhibitions may not be intended as tools of cultural imperialism, but it would be naive to believe that they do not have precisely this effect. Although they may be conceived in the spirit of making available otherwise inaccessible art so as to provide a basis for human communication at levels 'transcending' political differences (itself an astonishingly naive concept), when they emerge from the New York art world I have described, they cannot but carry the condescending implication of superiority. This is reinforced by the fact that the very urge to unity that attends any organizational job tends to give the work shown on such occasions a specious certainty of purpose and a misleading coherence as a range of cultural products.

The vicious circle of metropolitan initiative–provincial submission continues strengthened. In an important sense, such exhibitions cannot fail to be counter-productive until they are redundant, that is, until the receiving country has founded an authentic, sustaining culture of its own. Then, they would become enriching. At present, it seems that the most responsible kind of exhibition would be one that took as its aim, not the supposedly 'neutral' presentation of a selection of art-work, but the display of the very problematic which its own incursion into a provincial situation raises. This would be difficult, certainly requiring an unusual degree of reflexivity and some rethinking of the nature of exhibitions, but it is surely not impossible.

Similarly, critical articles, such as those appearing regularly in this and other magazines, which give a systematic, homogenized immutability to the development of an artist's work, do artists the world over the disservice of promoting a model of art-making which not only distorts reality but also cannot be matched. In this way, closed concepts of art are spread with an extra and unwarranted loading of authority, unnecessary confusions arise, and inventiveness is inhibited.

[...]

5.4 Stuart Hall, 'Museums of Modern Art and the End of History', in Sarah Campbell and Gilane Tawadros (eds), *Modernity and Difference (Annotations 6): Stuart Hall and Sarat Maharaj* (London: INIVA, 2001), pp. 8–23

The following extract was presented as keynote address for the 'Museums of Modern Art and the End of History' conference

held at the Tate Gallery, London, 1999 by sociologist and cultural theorist, Stuart Hall. In his talk Hall provided nuance to the 'posts' that have littered the latter third of the twentieth century through unpacking the formation of a central idea of modernism structured by western notions of history. Hall positions the institution of the museum as handmaiden to this formation and suggests, in place of 'posts' which signal a break or an end, we would be better placed to understand such changes in history as 'turns'. It is not, then, the end of modernism or indeed museums, but rather a lateral move that forces a re-examination of modernisms as they relate to, come in to contact with, make and re-make one another – a playing field that is not, if indeed it ever was, the exclusive purview of the west. [Amy Charlesworth]

[...]

[...] The idea of museums in general, but also museums of modern art, is in trouble as a result of certain deep historical shifts or 'turns': transformations of theory and consciousness, but also shifts in the actual cultural landscape itself.

This 'crisis', if we may call it that, is the cumulative effects of a rather dispersed set of developments – what I refer to as a series of turns – which constitute the end of certain ideas of the museum, of the modernity of modern art and, indeed, of history. That notion of a turn is important for me. A turn is neither an ending nor a reversal; the process continues in the direction in which it was travelling before, but with a critical break, a deflection. After the turn, all of the terms of a paradigm are not destroyed; instead, the deflection shifts the paradigm in a direction which is different from that which one might have presupposed from the previous moment. It is not an ending, but a break, and the notion of breaks – of ruptures and of turns – begins to provide us with certain broad handles with which to grasp the current crisis of modernity, and thus of the museums of the modern.

This is clearly related to the much abused notion of the 'post' [...] so I must spend a moment dogmatically reiterating what 'post' means to me. I do not use the term to mean 'after' in a sequential or chronological sense, as though one phase or epoch or set of practices has ended and an absolutely new one is beginning. Post, for me, always refers to the aftermath or the after-flow of a particular configuration. The impetus which constituted one particular historical or aesthetic moment disintegrates in the form in which we know it. Many of those impulses are resumed or reconvened in a new terrain or context, eroding some of the boundaries which made our occupation of an earlier moment seem

relatively clear, well bounded and easy to inhabit, and opening in their place new gaps, new interstices.

Let us look at three examples. The post-colonial is not the ending of colonialism but is what happens after the end of the national independence movement. All those contradictions and problems which constituted the dependency of colonial societies are reconvened, partly now within the old colonised societies, but also inside the metropolis, which was previously regarded as standing outside of this process. Similarly, post-structuralism spends all its time and energies saying how it is an advance on structuralism, and yet the first thing to recognise is that, without structuralism, post-structuralism could not exist. It continues in its bloodstream, but in a disseminated or deconstructed form, which allows the original structuralist impulse, transformed, to take on new directions. I think the term 'post-modern' is exactly the same.

[...]

There has always been something contradictory about the relationship between modernity and history, which is bound to problematise the notion of art history itself. Art history has given the museum its principles of organisation, providing the practices of curating, exhibiting, collecting and classification with a scholarly ground. The historicisation, therefore, of what was previously perceived as an entirely new historical moment inevitably leads to a sense of operating in a gap between a past which is not quite over and a future which has not yet started (and may never happen in the totalised form in which we imagine it). Writing the history of a phenomenon or of a movement or of an epoch does, in a very complex way, suggest that one can trace its genealogy – what its evolution has been, define the principal forces which will drive it forward and ask the question of whether it has a conclusion. But this historicising tendency is seen as contradictory in the context of modernity, since modernity was precisely a fundamental rupture with 'the past' in that sense. It was a break into contingency and, by contingency, I do not mean complete absence of pattern, but a break from the established continuities and connections which made artistic practice intelligible in a historical review. It focused as much on the blankness of the spaces between things as on the things itself and on the excessive refusal of continuities. It was always caught between the attempt, on the one hand, to turn the sign back to a kind of direct engagement with material reality and, on the other, to set the sign free of history in a proliferating utopia of pure forms. Writing histories of modernity is not impossible, but I think they have always been extremely difficult to suture back into the more confident historical organisation of the history of Western art, which extends roughly from the Renaissance until the modern itself. [...]

[...]

It seems that something significant has to be taken on board about the persistence of the impulse of modernity itself within post-modernism. I cite three examples. The first is what I would call modernism in the streets. I think post-modernism is best described as precisely that; it is the end of modernism in the *museum* and the penetration of the modernist ruptures into everyday life, which is closely related to my second example, the aestheticisation of daily life. This might puzzle people in this room who think of contemporary life as the very antithesis of the aesthetic, but personally I think the symbolic has never had such a wide significance as it does in contemporary life. In earlier theories, the symbolic was corralled into a narrow terrain, but it has now entirely imploded in terms of late-modern experience and we find the languages of the aesthetic as appropriate within popular culture or public television, as they are within the most *recherché* rooms of the Museum of Modern Art. There are aesthetic practices distributed by a massive cultural industry on a global scale and the aesthetic is, indeed, the bearer of some of the most powerful impulses in modern culture as a whole, including what we used to think of as its antithesis – the 'new economy' which is, par excellence, a *cultural* economy. This notion of a modernism that is to be found inscribed on the face of everyday life, in everyday fashion, in popular culture and in the popular media, in consumer culture and the visual revolution, does obviously jeopardise the whole concept of gathering together the best of all this in one place and calling it 'a museum'.

Alongside all of this is my third example, the proliferation of media or, in other words, the means of signification. I read recently that it is completely ridiculous to define modern contemporary visual art practices in terms of the media in which they are executed; instead, we must consider the proliferation of sites and places in which the modern artistic impulse is taking place, in which it is encountered and seen. This is not just a reservation about the white cube gallery space. This is an explosion of the boundaries – the symbolic as well as physical and material limits – within which the notion of art and aesthetic practices have been organised. Young intellectuals – barely able to spell intellectual, let alone call themselves that – who are working somewhere within the cultural industries, with visual languages, are as deeply and profoundly implicated in the breaking point of modern artistic practices as the most fully paid-up members of the most academic, scholarly schools of art. That they came in through the back door and went out into industry is not important. What is relevant, however, is the proliferation of these practices and the degree to which this proliferation sits most uncomfortably with the prestige attached to the process which attempts to sift, on some universal criteria

of historical value, the best that is being produced and gets it displayed inside some well-patrolled set of walls. Modernism in the streets, the aestheticisation of everyday life and the proliferation of sites and means of signification are some ways of re-reading post-modernism, or the post-modern 'turn', as the aftermath of modernism.

Post-modernism is not a new movement that kicked modernism into touch, but, instead, by building on and breaking from modernism, it transformed it by taking it out into the world. Similarly, we might talk about the post-museum – not in the sense of the necessary end of all museums, but in terms of the radical transformation of the museum as a concept. I would call it the relativisation of the museum, which can now be perceived as only one site among many in the circulation of aesthetic practices. It is certainly true that the museum remains a very privileged, well-funded site, which is still closely tied to the accumulation of cultural capital, of power and prestige, but in terms of the real understanding of how artistic practices proliferate in our society, it is only one site and no longer enjoys the privileged position that it had historically.

[...]

The next 'post' that I wanted to talk about is what I want to call post-culture. You will say there is nothing post about culture; it is the ever-present, ever-evolving signifier of our times. Everybody is interested in it, the prime minister most of all; whenever you offer him an institution which seems resilient to reform, he says we need a 'culture change'. So culture is the ground on which everybody is somehow now said to be operating. But what is entailed in this conception of culture? We can no longer inhabit a notion of culture in the old anthropological sense, as something which is clearly bounded, internally self-sufficient and relatively homogenous across its members, which sustains and regulates individual conduct within the framework that it offers. Cultures, in that anthropological sense of specifically defined ways of life, have been broken into and interrupted by cosmopolitan dispersals, by migration and displacement. I think that the collapse of that anthropological definition – culture as a way of life – has to do with the point at which the West began to universalise itself. It is connected with the attempt to construct the world as a single place, with the world market, with globalisation and with that moment when Western Europe tried to convert the rest of the world into a province of its own forms of life. From that moment onwards – the moment of modernity – we could no longer think in terms of cultures which are integral, organic, whole, which are well bounded spatially, which support us and which write the scripts of our lives from start to finish. The ending of this moment of Euro-centric closure and

its panoptic project has been a long and protracted one, but it has been increasingly prized open.

The movement from an anthropological to a signifying conception of culture does not mean that cultures become less important. Instead, we are now talking more than ever before about the domain, the importance and the proliferation of meanings by which people live their lives, understand and contest where they are and develop aesthetic and artistic forms of expression. What has disappeared is the ability to carve those forms of expressions into strictly classificatory boxes, so that the primitive and the ancient fit like two rooms inside the modern, with the modern itself boxed inside the ancient. The modern has been inside the primitive and the ancient since 1492 roughly speaking, so what is this 'new' discovery that all of a sudden there are more than one set of modernities? They have been proliferating ever since the world began, only ever tentatively, unevenly, contradictorily, to be convened under the rubric of Western time. This does not mean that we are merely moving everywhere towards a cloning of the West. Instead, those sharp distinctions which underpin our classification – that fixed notion of primordial cultural difference – between tradition and modernity simply do not explain any longer the way in which individuals and their practices are *both* embedded in certain cultural languages or repertoires and at the same time reach across any frontiers which they construct to those which lie beyond – the phenomenon of vernacular cosmopolitanism which is globalisation's accompanying shadow. This is nothing other than the shift from the notion of difference as an either/or concept to Derrida's notion of *differance*, in which you cannot make an absolute distinction between a here and a there, inside and outside.

The history of the relationship between the West and its others is a history of the transformations which have changed both out there and here. It is true that these changes are more dramatic under the conditions of modern globalisation, in which, undeniably, a lot of out there is actually in here now and vice versa. They are in here, trying to become like you, but also making you different, more like them in their *differance*.

The idea that we live in a well-bounded, well-policed, well-frontiered set of spaces, in which you can move from this room to that, tracing how that became this and how the practices governed by a particular culture evolved to become something different, simply misses the degree to which cultures can no longer be clearly categorised. With the modern and even the post-modern condition, the process of *cultural translation* means that cultural languages are not closed; they are constantly transformed from both within and outside, continuously learning from other languages and traditions, drawing them in and producing something

which is irreducible to either of the cultural elements which constituted it in the first place. The most dramatic example of how the notion of cultural translation is the only way in which the cultural process today can be properly grasped is found in the history of modernism itself. The latter has been written precisely as if modernism was a set of triumphal artistic practices, located in what you might think of as the West. However, a small number of deracinated artists out there were drawn to this pole of attraction and did relate to it, but of course, in the dominant way the history is read, they cannot be considered to have contributed in any central way to the history and evolution of modernist art practices. In reality, the world is absolutely littered by modernities and by practising artists, who never regarded modernism as the secure possession of the West, but perceived it as a language which was both open to them but which they would have to transform. The history therefore should now be rewritten as a set of cultural translations rather than as a universal movement which can be located securely within *a* culture, within a history, within *a* space, within *a* chronology and within *a* set of political and cultural relations.

The final 'post' I would like to talk about has to do with the question of the post-West. In the light of what I said earlier, we are aware that modern museums of art and other kinds of museums now function in the context of a widening and expanding process of globalisation, which is often seen from within the West as a kind of inevitable homogenisation; it is as if unfortunately everybody in the world is determined, predetermined, to end up looking like 'us'. In that sense, the process is sometimes referred to as the 'end of history', but I do not believe it is. If you think about contemporary forms of globalisation – which are of course driven by Western technology, by Western capital on a global scale and by the flows of international finance which has the capacity to undermine societies far removed from ours by the proliferation of the cultural industry – then I quite understand that a dynamic exists, which is grounded and rooted in the development and over-development of the West. However, I think that its actual impact on the rest of the world has not been simply to homogenise it, but also to expose it to differentiation. The impulse of 'difference' operating in and across the world is, to me, as powerful and as unintended a consequence of capitalist globalisation and modernity as the impulse towards the McDonaldsisation of the world. I do not believe any law of history exists which will guarantee that the one must prevail over the other, although I recognise the grim unevenness and contradictoriness of what we may call the 'global balance of social forces'.

If we look at the way in which contemporary art practices locate themselves within an awareness of the slow decentring of the West, we see the constitution of lateral relations in which the West is an absolutely pivotal, powerful, hegemonic force, but is no longer the only force within which creative energies, cultural flows and new ideas can be concerted. The world is moving outwards and can no longer be structured in terms of the centre/periphery relation. It has to be defined in terms of a set of interesting centres, which are both different from and related to one another. Inhabiting this uneven language of a more common planetary or cosmopolitan consciousness – and I know that this process of globalisation is one which has enormous inequalities built into it – is a deeply and profoundly unequal process. This does not necessarily mean that the game is already so wrapped up that we can designate it with the term 'the end of history'. Any museum which thinks it can incorporate or grasp the best texts and productions of modern artistic practice, believing the world is still organised in a centre/periphery model, simply does not understand the contradictory tensions which are in play. On the one hand are all those lines of force which continue to draw energy, resources, exhibitions and circulation to a very narrow metropolitan centre and, on the other, is the disseminating force of what is happening laterally. On the edge of our consciousness, we are aware that some of the most 'modern' artists are practising in the most 'underdeveloped' places. The account of what matters in the artistic world, from the point of view of the declining, diminishing cultural authority of the West, is expanding in its potential to gobble up everything and yet this is not happening.

If you think about where important movements are being made, sometimes they happen in the centre, but the most exciting artists are those who live simultaneously in the centre and at the periphery. In terms of the conditions of consciousness within which these people start to make artistic practices, they inhabit a world which is torn, on the one hand, by the centralising force of Western modernity, with all the goodies it entails, and, on the other, by the dissemination and proliferation of notions of what it would be like to be vernacular and modern. We are embarking on a hundred different ideas of 'the modern', not one, and therefore, of a thousand practising modern artists, who require recognition within the terms of the criteria that we have stitched into our museum space. Is that the end of the museum? I do not believe it is.

Museums have to understand their collections and their practices as what I can only call 'temporary stabilisations'. What they are – and they must be specific things or they have no interest – is as much defined by what they are not. Their identities are determined by their constitutive

outside; they are defined by what they lack and by their other. The relation to the other no longer operates as a dialogue of paternalistic apologetic disposition. It has to be aware that it is a narrative, a selection, whose purpose is not just to disturb the viewer but to itself be disturbed by what it can not be, by its necessary exclusions. It must make its own disturbance evident so that the viewer is not entrapped into the universalised logic of thinking whereby because something has been there for a long period of time and is well funded, it must be 'true' and of value in some aesthetic sense. Its purpose is to destabilise its own stabilities. Of course, it has to risk saying, 'This is what I think is worth seeing and preserving', but it has to turn its criteria of selectivity inside out so that the viewer becomes aware of both the frame and what is framed.

The viewer should be able to read a particular narrative in the context of other narratives and understand that its identity is always positional. The museum of modern art has a history, a space, a funding, a tradition; it speaks a language but knows that it is no longer the only language in the world. This is a difficult exercise because museums, in spite of what we would like to think, are deeply enmeshed in systems of power and privilege. They are locked into the narrowest circulation of art in its diminishing terms and are consequently locked into mindsets which have been institutionalised in those circuits. The process of breaking free is likely to be a long and nasty business. But it can not be long before museums of modern art come to look more and more like what the architect Cedric Price in the recent show at inIVA described as 'cultural centres', characterised by 'calculated uncertainty and conscious incompleteness'.

5.5 Okwui Enwezor, 'The Postcolonial Constellation: Contemporary Art in a State of Permanent Transition', in Terry Smith, Okwui Enwezor and Nancy Condee (eds), *Antinomies of Modern and Culture* (Durham, NC and London: Duke University Press, 2008), pp. 207–234

Okwui Enwezor (b. 1963) is a Nigerian curator, art critic, educator and writer. He is currently Director of the Haus der Kunst, Munich, Germany. He has curated many exhibitions around the world, and was the artistic director of documenta 11 in Kassel, Germany in 1998–2002. As the first non-European to hold this role, his curation is widely seen to have helped to refocus debates in contemporary art to address issues of globalisation and wider artistic representation. He also curated the 2015 Venice Biennale,

making him the first African-born curator in the 120-year history of this major international exhibition. Enwezor explores the controversial relationship of globalisation and art, arguing that decolonisation is as significant as (and related to) globalisation in art and culture. He identifies a 'postcolonial constellation' in the production, dissemination and reception of art. This extract critically explores the 'encounter' with so-called 'primitive' art as presented by Tate Modern displays in the early 2000s. [Gill Perry]

The Proper task of a history of thought is: to define the conditions in which human beings 'problematize' what they are, what they do, and the world in which they live.
 —Michel Foucault, *The History of Sexuality*, 2:10)

This flood of convergences, publishing itself in the guise of the commonplace. No longer is the latter an accepted generality, suitable and dull—no longer is it deceptively obvious, exploiting common sense—it is, rather, all that is relentlessly and endlessly reiterated by these encounters.
 —Édouard Glissant, *Poetics of Relation*, 45)

I

It is a commonplace of the current historical thinking about globalization to say there are no vantage points from which to observe any culture since the very processes of globalization have effectively abolished the temporal and spatial distance that previously separated cultures.[1] Similarly, globalization is viewed as the most developed mode, ultimate structure of singularization, standardization, and homogenization of culture in the service of instruments of advanced capitalism and neoliberalism. In the face of such totalization, what remains of the critical forces of production which, throughout the Modern era, placed strong checks on the submergence of all subjective protocols to the orders of a singular organizing ideology, be it the state or the market? If globalization has established, categorically, the proximity of cultures, can the same be said about globalization and art? When we ask such questions, we must remember that the critical division between culture and art has, for centuries, been

1 See Fernand Braudel's discussion of the structural transformation of the flow of capital and culture by distinct temporal manifestations, the paradigmatic and diagnostic attribute of historical events in relation to their duration, in his *Civilization and Capital: The Fifteenth Century to the Eighteenth Century*, Vol. 3 *The Perspective of the World* (New York: Harper and Row, 1984), esp. 3: pp. 17–18 and 3: chap. 1.

marked by art's waging of a fierce battle of independence from all cultural, social, economic, and political influences.

At the same time, the Modern Western imagination has used the apotropaic devices of containment and desublimation to perceive other cultures, in order to feed off their strange aura and hence displace their power. Today, the nearness of those cultures calls for new critical appraisals of our contemporary present and its relationship to artistic production.

I start with these observations in order to place in proper context the current conditions of production, dissemination, and reception of contemporary art. Contemporary art today is refracted, not just from the specific site of culture and history but also – in a more critical sense – from the standpoint of a complex geopolitical configuration that defines all systems of production and relations of exchange as a consequence of globalization after imperialism. It is this geopolitical configuration and its postimperial transformations, that situates what I call here 'the postcolonial constellation'. The changes wrought by transitions to new forms of governmentality and institutionality, new domains of living and belonging as people and citizens, cultures, and communities – these define the postcolonial matrix that shapes the ethics of subjectivity and creativity today. Whereas classical European thought formulated the realm of subjectivity and creativity as two domains of activity each informed by its own internal cohesion – without an outside, as it were – such thought today is consistently questioned by the constant tessellation of the outside and inside, each folding into the other, each opening out to complex communicative tremors and upheavals. Perhaps, then, to bring contemporary art into the context of the geopolitical framework that define global relations – between the so-called local and the global, center and margin, nation-state and the individual, transnational and diasporic communities, audiences and institutions – would offer a perspicacious view of the postcolonial constellation. The constellation is not, however, made up solely of the dichotomies named above. Overall, it is a set of arrangements of deeply entangled relations and forces that are founded by discourses of power. These are geopolitical in nature and, by extension, can be civilizational in their reliance on binary oppositions between cultures. In this sense, they are inimical to any transcultural understanding of the present context of cultural production. Geopolitical power arrangements appear in the artistic context along much the same Maginot line. The terrible tear at its core of these arrangements lends contact between different artistic cultures an air of civilizational distinctions predicated on the tensions between the developed and the underdeveloped, the reactionary and the progressive, the regressive and the advanced, shading

into the avant-garde and the outmoded. This type of discourse is a heritage of classical Modernity, which, through these distinctions, furnishes the dialectical and ideological agenda for competition and hegemony often found in the spaces of art and culture.

The current artistic context is constellated around the norms of the postcolonial, those based on the discontinuous, aleatory forms, on creolization, hybridization, and so forth, all of these tendencies operating with a specific cosmopolitan accent. These norms are not relativistic, despite their best efforts to displace certain stubborn values that have structured the discourse of Western Modernism and determined its power over other Modernisms elsewhere in the world. Édouard Glissant, whose classic work *Caribbean Discourse* made us aware of the tremor at the roots of the postcolonial order, interprets current understanding of global Modernity as essentially the phenomenon of creolization of cultures. He shows us that global processes of movement, resettlement, recalibration, certain changes and shifts in modalities of cultural transformations occur, changes that by necessity are neither wholly universal nor essentially particular. Contemporary culture as such, for Glissant, is cross-cultural, reconstituting itself as a 'flood of convergences publishing itself in the guise of the commonplace'.[2] In the Modern world, he intimates, all subjectivities emerge directly from the convergences and proximities wrought by imperialism. Today, they direct us to the postcolonial. The current history of Modern art, therefore, sits at the intersection between imperial and postcolonial discourses. Any critical interest in the exhibition systems of Modern or contemporary art, requires us to refer to the foundational base of Modern art history: its roots in imperial discourse, on the one hand, and, on the other, the pressures that postcolonial discourse exerts on its narratives today.

From its inception, the history of Modern art has been inextricably bound to the history of its exhibitions, both in its commodity function through collectors in the economic sphere and in its iconoclasm evidenced by the assaults on formalism by the historical avant-garde. It could, in fact, be said that no significant change in the direction of Modern art occurred outside the framework of the public controversies generated

2 Édouard Glissant, *Caribbean Discourse: Selected Essays*, A. James Arnold (ed.), Michael Dash (trans.) (Charlottesville: University of Virginia Press, CARAF Books, 1992). Much like Gilles Deleuze and Félix Guattari in their use of the idea of the rhizome, Glissant employs the metaphor of the prodigious spread of the mangrove forest to describe the processes of multiplications and mutations that for him describe the tremor of creolization as a force of historical changes and ruptures brought about by changes in the imperial order.

by its exhibitions.[3] Fundamental to the historical understanding of Modern art is the important role played through the forum and medium of exhibitions in explicating the trajectory taken by artists, their supporters, critics, and the public in identifying the great shifts that have marked all encounters with Modern art and advanced its claim for enlightened singularity among other cultural avatars. For contemporary art, this history is no less true, and the recent phenomenon of the curator in shaping this history has been remarkable. Nevertheless, a number of remarkable mutations in the growing discourse of exhibitions have occurred. At the same time, art has persistently presented as something wholly autonomous and separate from the sphere of other cultural activities. Exhibitions have evolved from being primarily the presentations of singular perspectives of certain types of artistic development to become the frightening *Gesamt-kunstwerk* evident in the global megaexhibitions that seem to have overtaken the entire field of contemporary artistic production. If we are to judge correctly the proper role of the curator in this state of affairs, the exhibition as form, genre, or medium, as a communicative, dialogical forum of conversation between heterogeneous actors, publics, objects, and so on, needs careful examination.

2

Today, most exhibitions and curatorial projects of contemporary art are falling under increasing scrutiny and attack. More specifically, they have been called into question by two types of commentary. The first type is generalist and speculative in nature. Fascinated by contemporary art as novelty, consumed by affects of reification as a pure image and object of exhibitionism, with spectacle culture, such commentary is itself sensationalist, and lacks critical purpose. It tends to equate the task of an exhibition with entertainment, fashion, and the new thrills and discoveries that seasonally top up the depleted inventory of the 'new'. It haunts the response to so-called megaexhibitions such as documenta, biennales, triennales, and festivals, as well as commercial gallery exhibitions of the

3　Admittedly, the advent of mass culture has all but made mute the ability of exhibitions to be truly seminal in a wider cultural sense manifest in the controversies around the French salons of the nineteenth century, or the Armory Show of [1913] in New York. Dada was defined as a new artistic movement primarily through its many exhibitions and happenings. Recent art world miniscandals – such as the lawsuit brought against the Contemporary Art Center of Cincinnati upon its exhibition of Robert Mapplethorpe's homoerotic photographs in 1990 or the controversy surrounding Chris Ofili's painting of a Madonna, which used elephant dung for one of her breasts, in Brooklyn Museum's exhibition 'Sensation' in 1999 – indicate the degree to which exhibitions of art remain culturally significant.

ominbus type. It easily grows bored with any exhibition that lacks the usual dosage of concocted outrage and scandal. Impatient with historical exegesis, it contents itself with the phantasmagoric transition between moments of staged disenchantment and the incessant populist renewal of art.

The second type of commentary is largely institutional, divided between academic and museological production. It is one part nostalgic and one part critical. Adopting the tone of a buttoned-up, mock severity, it is actually based on a pseudocritical disaffection with what it sees as the consummation achieved between art and spectacle, between the auguries of pop-cultural banality and an atomized avant-garde legacy. For this kind of commentary, art has meaning and cultural value only when it is seen wholly as art as autonomous. On this view, every encounter with art must be a scientific, not a cultural, one, the priority being to understand the objective conditions of the work in question. In modernity, the inner logic of the work of art is marked by art's removal from the realm of the social-life world that positions it as an object of high culture. Yet there is a price to be paid when it wins autonomy from any accreted social or ideological baggage. For such critics with this viewpoint, the task of the curator is to pay the greatest fidelity to a restrained formal diligence in artworks, one derived from values inculcated and transmitted by tradition, a flow that can only be interrupted through a necessary disjuncture, one marked by innovation. The paradox of a disjunctive innovation that simultaneously announces its allegiance and affinity to the very tradition it seeks to displace is a commonplace in the entire history of Modernism, especially in the discourse of the avant-garde.

For curators and art historians the central problematic between art and the avant-garde occurs when there is a breach in the supposed eternality of values that flow from antiquity to the present, when the autonomy of art that suddenly has to contend with the reality of the secular, democratic public sphere – itself the result of a concatenation of many traditions.[4] Even more problematic are breaches in the very conditions of artistic production. One example is what has been called elsewhere the 'Duchamp effect'; another is highlighted in Walter Benjamin's much referenced essay 'The Work of Art in the Age of Mechanical Reproduction', which famously traces the changes in the dissemination of art that transform and question traditional notions of originality and

4 The Nobel economist Amartya Sen has recently given many examples of the cross-pollination of ideas between cultures – particularly in language, mathematics, and the sciences – which has continued unabated for two millennia. See 'Civilizational Imprisonments', *New Republic* (June 10, 2002), pp. 28–33.

aura.[5] Yet another is the encounter between modern European artists and the African and Oceanic sculptures at the turn of the twentieth century, one that resulted in the birth of cubism and much else.

Of these, the Duchamp effect was the most traditional view, because what it purports to do is delineate the supremacy of the artist: the artist not only as a form giver, but a name giver. It is the artist who decides what an object of art is or what it can be, rather than the decision being a result of progressive, formal transformation of the medium of art. For Duchamp, it is not tradition, but the artist who not only decides what the work of art is but also controls its narrative of interpretation. This idea found its final culmination in the tautological exercises of conceptual art, whereby the physical fabrication of art could, ostensibly, be replaced with linguistic description. From this perspective, artistic genius emerges from a subjective critique of tradition by the artist, against all other available data, not from an objective analysis of the fallacy of tradition.

The confrontation with African and Oceanic sculptures by European artists was a striking example from the 'contact zone' of cultures.[6] This encounter transformed the pictorial and plastic language of modern European painting and sculpture, hence deeply affecting its tradition. What is astonishing is the degree to which the artistic challenges posed by so-called primitive art to twentieth-century European Modernism have subsequently been assimilated and subordinated to modernist totalization. Therein lies the fault line between imperial and postcolonial discourse, for to admit to the paradigmatic breach produced by the encounter between African sculptures and European artists would also be to question the narrative of modern art history. Nor should we forget that the non-Western objects in question were required to shed their utilitarian function and undergo a conversion from ritual objects of magic into reified objects of art. The remarkable import of this conversion is that the historical repercussion of the encounter has remained mostly confined to formal effects and thus formalist aesthetic analysis.

I cite these examples because they are material to our reading and judgment of contemporary art. The entrance into art of historically determined questions in terms of form, content, strategy, cultural difference, and so on establishes a ground from which to view art and the artists' relationship to the institutions of art today. This breach is visible, because it no longer refers to the eternal past of pure objects or to the aloofness

5 See Martha Buskirk and Mignon Nixon (eds.), *The Duchamp Effect* (Cambridge, Mass.: MIT Press, 1996) and Walter Benjamin, 'The Work of Art in the Age of Mechanical Reproduction', in Walter Benjamin, *illuminations* (1969), pp. 217–252.
6 See Mary Louise Pratt, 'Arts of the Contact Zone', *Profession* 91 (1991), pp. 33–40.

from society necessary for autonomy to have any meaning. In his *Theory of the Avant-Garde*, Peter Bürger makes this point clear: 'If the autonomy of art is defined as art's independence from society, there are several ways of understanding that definition. Conceiving of art's apartness from society as its "nature" means involuntarily adopting the *l'art pour l'art* concept of art and simultaneously making it impossible to explain this apartness as the product of a historical and social development.'[7]

The concept of *l'art pour l'art* as part of the avant-garde formulation of artistic autonomy was described by Benjamin as a *theology of art*, which 'gave rise to what might be called a negative theology in the form of the idea of "pure" art, which ... denied any social function of art'.[8] Based on this denial, Bürger's analysis advances a claim for a socially determined theory that stands at the root of two opposing traditions of art historical thought found among certain practitioners today. Not surprisingly, the two opposing traditions match the rivalry discernible in the second type of commentary on curatorial procedures mentioned above. This is the domain most struggled over by conservative (traditionalist) and liberal (progressive) groups, both of whom have increasingly come to abjure any social function of art, except when it fits certain theories.

Two recent examples will demonstrate my point here. A roundtable discussion on the state of art criticism in 2000, published in the one-hundredth issue anniversary of the influential art journal *October*, was typically reductive.[9] Although the panelists' attack against certain populist types of criticism was indeed cogent and necessary, one could not help but detect a tone of condescension in their irritation. The composition of the speakers of the roundtable is illustrative of the way in which the modes of elision and discrimination that are recurrent in most mainstream institutions and conservative academies pervade even this self-styled progressive intellectual organ. It is, of course, universally known that this journal, despite its revolutionary claims, remains staunchly and ideologically committed to a defense of Modernism as it has been historically elaborated within the European context and updated in postwar American art. There is nothing inherently wrong with such commitment, were not its elevation to the height of being the universal paradigm for the uneven, diachronic experience of modernity. There is very little acknowledgment of the radical political strategies and the social and cultural transformations developed

7 Peter Bürger, *Theory of the Avant-Garde*, Michael Shaw (trans.) (Minneapolis: University of Minnesota Press, 1984), p. 35.
8 Benjamin, 'The Work of Art in the Age of Mechanical Reproduction', p. 224.
9 See *October*, 'A Special Issue on Obsolescence', Vol 1, no. 1, spring 2002, particularly the roundtable on art criticism, pp. 200–228.

since the decolonization project of the postwar period outside the West. These have shaped the reception of Modernism in the work of artists outside of Europe and North America, as well as that of many within these spheres. To ignore or downplay this, after one hundred issues of continuous publication, is a grave error.

The second example highlights the conservatism of traditional museums of Modern art in their treatment of Modernism. For its opening in 2000, the Tate Modern museum presented an overarching curatorial overview, one that straddles over a large expanse of historical developments in Modern art. The relationships between Modern art and the European artistic tradition, and between contemporary art and its modernist heritage, were central. To demonstrate these relationships and at the same time transform the methodology for rendering them in a public display, the museum moved actively between a synchronic and diachronic ordering of its message. The press was filled with speculation about the effectiveness of the museum's 'radical' attempt to break with the outmoded chronological emphasis of modernist art history, its effort to inaugurate a far more dialectical exchange and adopt a discursive approach, above all in the display of the permanent collection, which was arranged according to genre, subject matter, and formal affinities. The goal was to present the history of Modern art and the transformations within it in a way that would be readily read by the general public, especially if, for example, a Monet landscape were demonstrated to be an immediate ancestor to the stone circle sculptures and mud wall paintings of Richard Long. What are we to make of this juxtaposition? It shows us, certainly, that both Monet and Long are deeply interested in nature as a source for their art. It could also evoke for the viewer aspects of spirituality and the metaphysical often connected to nature, as well as the conception of landscape as a genre of art from which artists have often drawn. Despite being a curatorial gimmick, these are interesting enough propositions for the average, unschooled museum visitor.

The rooms housing the permanent collection were divided into four themes: Still Life/Object/Real Life, Nude/Action/Body, History/Memory/Society, Landscape/Matter/Environment. The decisive idea was to break with a conception of modernist historiography entrenched at the Museum of Modern Art in New York since its founding more than seventy years ago. Never mind that many professional visitors, namely curators and historians, whispered that the apparent boldness owed more to the lack of depth in its collection of Modern art than to any radical attempt to redefine how the history of Modern art was to be adjudicated and read publicly. The rooms were divided, like stage sets, into the four themes, such that they read much like chapters in a textbook. The resultant sense

of Modern art's undisturbed progression – absent the contradictions, frictions, resistance, and changes that confound and challenge conventional ideas of Modernism – in itself a historical conceit. Anything that might challenge this most undialectical of approaches was sublated and absorbed into the yawning maws of the Tate Modern's self-authorizing account.

One example, and by far the most troubling, of the curatorial reasoning behind this account will suffice. The Nude/Action/Body theme suggests is a series of transformations in the manner in which the body has been used in Modern and contemporary art. The series of passages from *nude* to *action* to *body* suggest an image of contingency, internal shifts in the development and understanding of the human form and subjectivity as it moves from Modern to contemporary art. The image that presides over this shift is both corporeal and mechanical, symbolic and functional, artistic and political, from the *nude* as an ideal to the *body* as a desiring machine.

The first gallery opens out to an eclectic selection of paintings by Stanley Spencer, John Currin, Picasso, and others. This is not an auspicious introduction. The selection and arrangement of the works in the gallery is striking, but more for its formal sensibility than in authoritatively setting out any radical thesis of the nude and the body. In the second gallery two large-scale, genuinely imposing, black and white photographic works, one by Craigie Horsfield and the other by John Coplans, face each other. Horsfield's picture *E. Horsfield (1987)* (1995), is in the tradition of the classical modernist reclining nudes reminiscent of Cézanne's bathers and Matisse's odalisques. It is an outstanding, ponderous picture, heavy like fruit, with the graded tones of gray lending the mass of flesh a stately presence. Coplans's *Self Portrait (Frieze No. 2, Four Panels)* (1995) is typical of his performative and fragmentary, multipaneled, serial self-portraiture, often representing his flabby, aging body. The seriality of the depicted parts reveals a body seemingly laying claim to its own sentient properties. Formal echoes in the nude from its early modernist treatments of the nude are to be found in contemporary photography, but the difference between the two lies in the idealization of the former and the self-conscious subjectivity of the latter. Modernist photography of the nude focused on forces of nature trapped in classical culture, whereas the contemporary nude is closer in spirit to Deleuze and Guattari's notion of the desiring machine consumed by the process of expressing itself.[10]

10 See Gilles Deleuze and Félix Guattari, *Anti-Oedipus: Capitalism and Schizophrenia*, Robert Hurley, Mark Seem and Helen R. Lane (trans.) (Minneapolis: University of Minnesota Press, 1983); (London: Athlone Press, 1984).

When we enter this gallery, we find a small ethnographic vitrine embedded into one of the walls of the room. To the left of the wall is a discreetly placed LCD monitor playing extracts from two films; one by Michel Allégret and André Gide, *Voyage to the Congo*, 1928 (see Figures 5.1 and 5.2), and the other an anonymous archival film, *Manners and Customs of Senegal*, 1910. The two extracts evince a theme common to travel documentary. Although temporally and spatially separated, we can group these two films within a well-known genre, a system of knowledge that belongs to the discourse of colonial, ethnographic film studies of 'primitive' peoples. (We already know much about the Western modernist fascination with 'primitive' peoples' bodies, along with their Orientalist correlatives. We know that the concept of alterity was not only important for Western Modernism; it was also a focus of allegorical differentiation.) But Allégret and Gide's film, and the more structurally open archival footage, provide us with much to think about in regard to Modernism, spectacle, otherness, and degeneracy. In each of the two films, we see the setting of the African village and its social life: villagers self-consciously working on their everyday chores such as grinding grain, tending fires, minding children, or participating in a village festival of dance and song. Most striking about Allégret and Gide's film, however, is that it mostly highlights nakedness; the nakedness of black African bodies under imperial observation. Here, nakedness as opposed to the nude yields a structure of critical differentiation between the primitive and the Modern, between the savage and the civilized, between ideas of nature and culture.

The method of the camera work in both films appears to be objective, aiming to show 'primitive peoples' as they are, in their natural space. Nevertheless, one can detect that part of its conscious structure is to show the degree to which primitive man is not to be confused with the modern man. This differentiation lends what we are viewing a quality not of empathy exactly, but, as James Clifford puts it, 'a more disquieting quality of Modernism: its taste for appropriating or redeeming otherness, for constituting non-Western arts in its own image, for discovering universal, ahistorical "human" capacities'.[11] This observation taken *in toto* with Modernism's relationship to otherness, the primitive and the savage, bears on the distinction between the nude's formal, aesthetic status within Western modernist art and the picturing of simple nakedness with no redeeming aesthetic value commonly found in ethnographic discourse.

If the Tate Modern were an institution working beyond the smug reflex of Western museological authority it would have found right in its

11 James Clifford, *The Predicament of Culture: Twentieth-Century Ethnography, Literature, and Art* (Cambridge, Mass.: Harvard University Press, 1988), p. 193.

5.1 Still from Michel Allégret and André Gide's film *Voyage to the Congo*, 1928

own context work of artists like Rotimi Fani-Kayode, the Nigerian-British photographer whose work – formally and conceptually – involves a long, rigorous excursus into the distinction between the nude and nakedness as it concerns the African body (see Figure 5.3). The analytic content, not to say the formal and aesthetic contradictions that Fani-Kayode's

5.2 Still from Michel Allégret and André Gide's film *Voyage to the Congo*,
1928

photographic work introduces us to about the black body in contrast to
the modernist nude is quite telling. More substantial is its awareness of
the conflicted relationship the black body has to Western representation
and its museum discourse.[12] This makes the absence of works like his
in the Nude/Action/Body section of the Tate Modern the more glaring.
Many other practitioners deal with these issues, but Fani-Kayode is
important for my analysis for the more specific reason of his Africanness,
his conceptual usage of that Africanness in his imagery, and his subversion
of the fraught distinction between nakedness and the nude in his pho-
tographic representation. Fani-Kayode's pictures also conceive of the
black body (in his case the black male body with its homoerotic inferences)

12 For a thorough account and brilliant analysis of this issue, see Thelma Golden's
groundbreaking exhibition catalogue *Black Male: Representations of Masculinity in
Contemporary American Art* (New York: Whitney Museum/Abrams, 1994).

5.3 Rotimi Faye-Kayode, *Untitled*, 1987–1988

as a vessel for idealization, as a desiring and desirable subject, and as self-conscious in the face of the reduction of the black body as pure object of ethnographic spectacle. All these critical turns in his work make the Tate Modern's inattention to strong, critical work on the nude and the body by artists such as he all the more troubling, because it is precisely works like his that have brought to crisis those naturalized conventions of otherness that throughout history of modern art have been the stock-in-trade of Modernism.

Whatever its excuses for excluding some of these artists from its presentation, there are none for Tate Modern's monologue on the matter of the ethnographic films. Alongside the screen, the wall label expounds on the matter of the films' presence in the gallery, uttering its explanation in a characteristic double-speak: 'European audiences in the early 20th century gained experience of Africa through documentary films. Generally these conformed to stereotyped notions about African cultures.

An ethnographic film of 1910, for instance, concentrates on the skills and customs of the Senegalese, while *Voyage to the Congo*, by filmmaker Marc Allégret and writer André Gide perpetuates preconceptions about life in the "bush". However, the self-awareness displayed by those under scrutiny, glimpsed observing the filmmakers subverts the supposed objectivity of the film.'

These words impute both the manufacture and consumption of the stereotype to some previous era of European documentary films and audiences, which is to imply that the business of such stereotypes lies in the past, even if it has now been exhumed before a contemporary European audience for the purposes of explaining Modernism's penchant for deracinating the African subject. But if the discourse of the stereotype is now behind us, is its resuscitation an act of mimicry, or is it, as Homi Bhabha has written elsewhere, an act of anxious repetition of the stereotype that folds back into the logic for excluding African artists in the gallery arrangement as a whole?[13] Does the repetition of the stereotype caught – caught, if you will, in a discursive double-maneuver – posit an awareness of the problem of the stereotype for contemporary transnational audiences? Or does the museum's label present us with a more profound question in which the wall text causally explains and masks what is absent in the historical reorganization of the museum's memory cum history? One conclusion can be drawn from this unconvincing explanatory maneuver: more than anything, it entrenches European modernist appropriation and instrumentalization of Africa in its primitivist discourse to which the Tate Modern in the twenty-first century is a logical heir.

As we go deeper into the matter, our investigation has much to yield as we look further into the ethnographic desublimation (an uneasy conjunction, no doubt, between colonialism and Modernism) taking place in the museum. Beside the film screen, inside the vitrines, we find, casually scattered, postcards with the general title 'Postcards from West Africa', and a small, dark, figurative sculpture, untitled, undated, identified simply as *Standing Figure*. The label tells us of the sculpture's provenance: it is from the collection of Jacob Epstein, thus conveying to us the sculpture's aesthetic aura through the synechdoche of ownership. The implication is obvious: the ownership of such a sculpture by one of Britain's important modernist artists means that he must have appreciated the sculpture first and foremost as a work of art, for the important aesthetic qualities that recommend it to the modern European sculptor. But if this is so, why then is the sculpture not more properly displayed along

13 Homi K. Bhabha, 'The Other Question: Stereotype, Discrimination and the Discourse of Colonialism', in *The Location of Culture* (New York: Routledge, 1994), pp. 85–92.

with other sculptures installed in the gallery? Or does its namelessness and authorlessness disable it from entering into the domain of aesthetic judgment necessary for its inclusion as an authoritative work of art?

It is no use speaking about the lyrical beauty and artistic integrity of this powerful sculpture now so pointlessly compromised by the rest of the detritus of colonial knowledge system crammed in the vitrine. The sculpture's presence is not only remote from us, it seems to connote not art, above all not autonomous art, but merely the idea of artifact or, worse still, evidence. Nearly a hundred years after the initial venture by Western modernists (and I do not care which artist 'discovered' what qualities in African or Oceanic art first), it should have been clear enough to the curators at Tate Modern that in terms of sheer variety of styles, forms, complexity, genres, plastic distinctiveness, stylistic inventiveness and complexity of sculptural language, no region in the world approaches the depth and breadth of African sculptural traditions. In the Congo, from where Gide and Allégret gave us the deleterious impressions of their *voyage*, we find distinct traditions of sculpture such as Yombe, Luba, Mangbetu, Kuba, Teke, Lega, Songye, and Dengese. These traditions of sculpture – like many others – are as distinctively unique as they are historically different in their morphological conception of sculpture. The expressive and conceptual possibilities in the language of artists working within each group have produced sculptural forms of extraordinary anthropomorphic variety and complexity. Whether of the mask or figure, the statue or relief, that simple comparative study between them yields such an active field of artistic experimentation and invention that many a modernist recognized, understood, and appreciated. But this is not communicated at all in the lugubrious gathering at the museum. What this installation communicates is neither a history nor even a proper anthropology of Modernism. Rather, the task of this 'historical' instruction is more a repetition of what has become a convention in a variety of museums of Modern art. This type of instruction more obfuscates than enlightens. In fact, along with museum collections, most Western modernist museology is predicated on the repetition and circulation of disparate apocrypha and objects connected to this obfuscation.[14]

14 The same holds true for most museums of contemporary art in Europe and the United States. I have often found it curious how contemporary museum collections seem exactly identical, irrespective of city in which the museum is located. The unconscious repetition of the same artists, objects, and chronology in both museums and private collections should make curators sanguine about the independence of their judgment in connection with art and artists who may not fit easily in this logocentric logic of seriality.

The very idea that there might be an African conception of modernity does not even come up. Nor does the possibility that between Western modernist artists in correspondence with their African contemporaries there existed and now exists an affiliative spirit of mutual influence and recognition. Instead, the vitrines as a whole posit a mode of instruction as to what is modern and what is not. On display are Carl Einstein's well-known book *NegerPlastik*, Marcel Griaule's accounts of the Dakar-Djibouti expedition published in the journal *Minotaure*, contemporary to Michel Leiris's famous book *L'Afrique fantôme*. This is a pantomime of 'the Modern' opposed to 'the primitive', which the Tate Modern has now upgraded to the most astonishing form of ethnographic ventriloquism. Having emptied and hollowed out the space of African aesthetic traditions, the rest of the gallery was filled in – with customary care and reverence – with carefully installed 'autonomous' sculptures by Brancusi and Giacometti and paintings by the German expressionists Karl Rotluff and Ludwig Ernst Kirchner. A Kirchner painting of a cluster of nude figures with pale elongated limbs and quasi-cubist, conical, distended midsections is noteworthy and striking in its anthropomorphic resemblance and formal correspondence to both the sculpture in the vitrine and what we had been looking at in the film of the naked Congolese women and children in Gide and Allégret's film.

Given the large literature on the subject, one should take Tate Modern to task by asking whether it could have found African artists from whatever period to fit into their dialectical scheme? The evidence emphatically suggests a larger number of candidates. The reality is that they did not do so. Not because they could not, but most likely because they felt no obligation to stray from the modern museum's traditional curatorial exclusions. So much for the claim to be mounting a dialectical display, as indicated by the titles of the rooms. In fact, what was concretely conveyed was an attitude, a singular point of view, a sense of sovereign judgment.

We should, nonetheless, concede the fact that Tate Modern was merely operating on well-trodden ground. When, for example, Werner Spies reinstalled the galleries of the Centre Pompidou, Paris, in 1999, he applied a curatorial flourish to the museum's cache of modernist paintings and sculptures, mixing them with postwar and contemporary art while assigning classical African sculpture and masks a garishly lit vitrine wedged into a hallway-like room. A more serious example of this sort was the curatorially important, widely influential, and superbly scholarly exhibition 'Primitivism in Modern Art: Affinities of the Tribal and the Modern' exhibition in 1984–85 at the Museum of Modern Art, New York, which treated the African and Oceanic works as it did the most highly refined modernist

object. But even this valuing of them as autonomous sculptures was achieved through a sense of reification that all but destroyed the important symbolic power of the objects and the role they played in their social contexts.

In 1989, Jean-Hubert Martin curated 'Magiciens de la Terre' at the Centre Pompidou, an exhibition that remains controversial. It set a different course in its response to the question that has vexed the modernist museum from its earliest inception, namely the status and place of non-Western art within the history of Modern and contemporary art. To evade this conundrum, Martin elected to eliminate the word 'artist' from his exhibition – mindful of the fact that such a designation may be unduly burdened by a Western bias – choosing instead the term *magicien* as the proper name for the object and image makers invited to present their art. If the MOMA and Centre Pompidou exhibitions – in New York and Paris respectively, two bastions of the history of Modern art in the world – responded critically to the controversial and unresolved aesthetic and historical debates within modernist accounts concerning art and artists from other cultures, Tate Modern, in its own attempt to further the rewriting of modernist reception of the Other and of non-Western art, proved both unevolved and unreflexive. The entire installation was ahistorical, with no semblance of the critical content of what Habermas calls the 'the philosophical discourse of modernity'.[15] In fact, it was marked by subjugation of historical memory, a savage act of epistemological and hermeneutic violence.

5.6 Chin-Tao Wu, 'Biennials without Borders', *New Left Review,* vol. 57 (May–June 2009), pp. 107–115. Also published in *Tate Papers: Landmark Exhibitions Issue* (the Tate's Online Research Journal), no. 12 (Autumn 2009), online

Chin-Tao Wu (b. 1961) is a Research Fellow at the Institute of European and American Studies, Academia Sinica, Taiwan. She specialises in the study of contemporary art and culture, the workings of the art market, and interpretations of 'globalised'

15 See Jürgen Habermas, *The Philosophical Discourse of Modernity* (Cambridge: Polity, 1987), for an extensive treatment of the discourse of modernity and modernization, and of Modernism as their artistic and aesthetic corollary. In the chapter 'Modernity's Consciousness of Time and Its Need for Self-Reassurance', he draws attention to Max Weber's contention that the concept of modernity arose out of a peculiarly 'Occidental rationalism', in *The Philosophical Discourse of Modernity*, pp. 1–4.

art. In 2002 she published an influential book, *Privatising Culture: Corporate Art Intervention Since the 1980s*, which offers a provocative contribution to the debate on public culture in Britain and America, exploring the ways in which free-market capitalism and business values have permeated the sphere of the visual arts since the 1980s. Versions of her essay 'Biennials Without Borders?' were first published in *New Left Review*, vol. 57 (May–June 2009), and then in the Tate's online research journal *Tate Papers: Landmark Exhibitions Issue*, No. 12 (Autumn 2009). She explores the nature of artistic representation at increasingly popular 'international' art festivals, especially biennials. She argues that despite its democratic claims, the so-called 'global' art world is less 'porous' than it might seem. [Gill Perry]

[...]

It may seem odd, even retrograde, to think of contemporary art practice in terms of artists' nationality and place of birth, at a time when there is so much talk of globalisation, hybridisation, transnationalisation, world markets and so on. Nevertheless, the question of national affiliation is critical to what the biennial (or triennial, or quinquennial) has come to stand for since the 1980s. An increasingly popular institutional structure for the staging of large-scale exhibitions – some observers refer to 'the biennialisation of the contemporary art world' – the biennial is generally understood as an international festival of contemporary art occurring once every two years.[1] Here the operative words are, of course, 'international' and 'festival'. On the first of these depends the second: without the national diversity of its participants, there could be no real celebration or festivity. 'International' in this scheme of things means that artists, almost by definition, come from all four corners of the world; even events with a specific geographical focus, such as the Fukuoka Asian Art Triennale, cast their net far beyond their immediate backyard; they rightly see this as imperative not only for their legitimacy but also for their success.

Artscapes

The fact that artists from remote areas now appear centre-stage in Western events such as the Kassel *documenta* or the Venice Biennale is often taken as further proof that the distinction between centre and periphery has

1 I use biennial as a convenient generic term that can also embrace less frequent exhibitions, including the quinquennial Kassel *documenta*. Carlos Jiménez credits Gerhard Haupt for formulating the concept of 'biennialisation' in 'The Berlin Biennale: A Model for Anti-Biennialization?', *Art Nexus*, no. 53, July–September 2004.

collapsed. In his studies of global cultural flows, for example, Arjun Appadurai uses the terms 'artscape' and 'ethnoscape' to characterise the space through which uninterrupted flows of people – including artists, curators, critics – and high art criss-cross the globe, as city after city vies to establish its own biennial in order to claim membership of the international art scene.[2] Like other globalisation theorists, Appadurai emphasises the growing planetary interdependence and intensification of social relations. Nowhere, however, are we told in what directions such 'flows' flow, nor what new configurations of power relations these seemingly de-territorialising movements imply.[3]

Hence this attempt to understand the power implications of biennials by looking more closely, and empirically, at the artists themselves – a luxury in which most theorists have too little time to indulge. I am, of course, well aware of the risks that a nation-based approach may involve, including the possibility of inviting criticism from the pro-globalisation lobby in particular. I do not wish to assert that the international art scene has not undergone significant changes over the last two decades. But what ultimately is the nature of these changes, and for what reasons have they taken place? Is the much-discussed collapse of the centre and dis-solution of the periphery as irrefutable as some people would have us believe? Has the global art world really become so porous, open to all artists irrespective of their origins – even if they come from what Paris or New York would consider the most marginal places?

To attempt to answer these questions on the basis of national statistics may be unexpected. But the actual numbers of artists, and the range of countries they come from, prove to be centrally embedded in the psychol-ogy of biennial organisers and feature prominently in their marketing strategies. The 2006 Singapore Biennial boasted of '95 artists from over 38 countries', while at the Liverpool Biennial in 1999, ubiquitous banners proclaimed: '350 artists, 24 countries, 60 sites, 1 city'. In what follows, I shall take a closer look at the quantitative data underpinning such 'flat-world' claims, by establishing not only where the artists come from, but also, in the case of those who move or emigrate, which places they

2 In 1996, Appadurai identified five dimensions of global cultural flow: ethnoscapes (flows of tourists, immigrants, refugees, guest workers, etc.); mediascapes (flows of information and images); technoscapes; financescapes; and ideoscapes (flows of cultural and political ideologies). Later, he added 'artscapes' to this list. Appadurai, *Modernity at Large: Cultural Dimensions of Globalization*, Minneapolis 1996, pp. 33–7.
3 A similar comment was made by Larissa Buchholz and Ulf Wuggenig, 'Cultural Globalization between Myth and Reality: the Case of the Contemporary Visual Arts', *Art-e-fact*, no. 4, December 2005.

choose to emigrate to – in other words, the direction of the cultural flows they personify. My purpose in examining these data was, firstly, to map out the shifts that have taken place in the focus of large-scale international exhibitions, which have gone from a marked Eurocentrism to encompass the world beyond the NATO-pact countries; and secondly, to ask whether these events have become another powerful Western filter, governing the access of artists from underresourced parts of the world to the global mainstream.

In order to provide a long-term view of these developments, I shall focus here on the Kassel *documenta* exhibitions, nine in all, between 1968 and 2007; examining firstly, where the artists were born; secondly, where they are currently living; and thirdly, the relation between the two.[4] I use typical regional categories – North America, Latin America, Asia, Africa and Oceania. Europe, however, I have divided in two. For despite EU enlargement, there are still two Europes in contemporary art practice: one comprises Germany, Italy, Britain, France, Switzerland, Austria, and to a lesser degree Holland, Belgium and Spain, which supply the majority of European art figures – 'Europe A'. The remaining countries, whose artists appear only sporadically at international events, form what I call 'Europe B'.

What conclusions, then, can we tentatively draw from this mass of statistics, which seems to belong more to sociology than to art history? The first and most obvious is that until recently, the vast majority of artists exhibited at *documenta* were born in North America and Europe – well over ninety per cent in fact, reaching a record ninety-six per cent in 1972 (see Figure 5.4). Although the 1989 *Magiciens de la terre* exhibition at the Pompidou Centre is generally considered the first truly international exhibition and a trend-setter for the next decade, North Americans and Europeans were still predominant at the 1992 and 1997 *documentas*. The real change came with Okwui Enwezor's *documenta 11* in 2002, when the proportion of Western artists fell to a more respectable sixty per cent. It remained fixed at this lower level in 2007.

The figures on where artists are currently living, meanwhile (see Figure 5.5), show that a substantial number of artists have moved or emigrated from the countries where they were born. In some cases, of course, artists will divide their time, and their lives, between two or more places – their birthplace, and where their artistic careers take them (or where they have

4 The total number of artists in this survey is 1,734. The data are primarily compiled from *documenta* catalogues. There are five artists/groups whose place of birth it has not been possible to trace. The places of residence of 168 artists are unknown, while 108 artists were deceased by the time their work was exhibited.

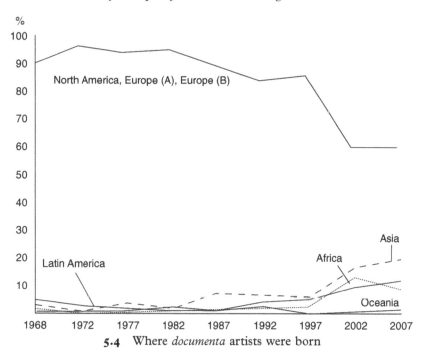

5.4 Where *documenta* artists were born

a better opportunity of succeeding). Up to and including the 1982 *documenta*, nearly one hundred per cent of participating artists lived in North America and Europe. This proportion begins to fall from 1987; for the 1992 and 1997 *documentas* it was around ninety per cent, dropping to seventy-six per cent in 2002 and sixty-one per cent in 2007.

But it is the difference between these two sets of figures – where artists were born and where they are currently living (see Figure 5.6) – that interests me most, because it shows what directions artistic 'flows' have taken. Of course, artists do not move solely because of their work: there may well be personal circumstances involved; but there is no denying that an artist from, say, Taiwan or Indonesia stands a better chance of succeeding in the international art world if she lives in New York or London. Before 1992, nearly all the artists originally from Latin America, Asia or Africa had already moved to either North America or Europe before they exhibited in *documenta*. During the 1990s, these 'flows' represented around four or five per cent of the total artists showing. By 2002, they had risen to nearly sixteen per cent.

As Figure 5.7 demonstrates, the upshot of these movements is unmistakable. For artists born in North America and Europe A, nearly ninety-three

303

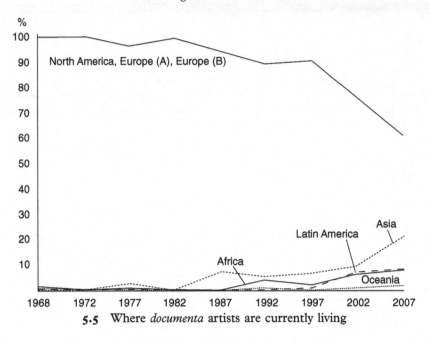

5.5 Where *documenta* artists are currently living

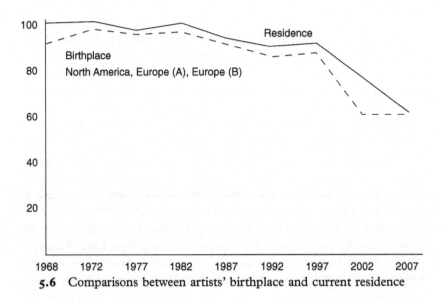

5.6 Comparisons between artists' birthplace and current residence

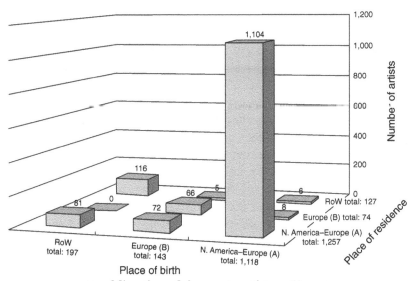

5.7 Migration of *documenta* artists 1968–2007

per cent of movements are within that region – between London and New York, for example, where the conditions for artistic production and reception may be considered more or less equal. Secondly, for artists born in Europe B, nearly eighty-nine per cent of movements are towards North America and Europe A, presumably in search of better support systems and infrastructures. Thirdly, for artists born in Latin America, Asia or Africa, the overwhelming majority of movements – over ninety-two per cent – are to North America and Europe A. They constitute a generalised one-way emigration from what I would call the periphery to the centre, or centres; that is, in the direction of the USA, UK, France and Germany. As we can see, seventy-two artists from Europe B and eighty-one artists from the rest of the world have moved to North America and Europe A, making this region the most popular place of residence for the majority of the artists who have figured in the last nine *documentas*. Rarely if ever does an artist from London or New York move to, say, Thailand or Trinidad.

Flowing uphill

There is a Chinese saying: water flows downhill, people climb uphill. If, as some critics would have us believe, centres and peripheries are a thing of the past, how are we to account for this almost exclusively one-way flow of artists? Figures like this lead us to question claims that the 2002 *documenta II* represented 'the full emergence of the margin at the

305

centre',[5] or 'the most radically conceived event in the history of postcolonial art practice', offering 'an unprecedented presence of artists from outside Europe and North America'.[6] Whatever questions may be raised by the hybrid make-up of the emigrant artists in question, there is something highly incongruous in talking about an exhibition like *documenta 11*, in which nearly seventy-eight per cent of the artists featured were living in North America or Europe, as illustrating 'the full emergence of the margin'.

Although it is forever shifting, the global art world nevertheless maintains a basic structure: concentric and hierarchical, we can imagine it as a three-dimensional spiral, not unlike the interior of the Guggenheim in New York. Concentric because there are centres, or semi-centres, and peripheries as well. To reach the centres you need to imagine an uphill journey, starting from the peripheries and passing through the semi-peripheries and semi-centres before you reach the top – though in some cases it may be possible to jump straight from a periphery to one of the centres. Hierarchical because, like all power relations, the spiral has a central core, with clusters of satellites orbiting it. Even those who champion the globalisation of the contemporary art world, and imagine the biennial to be one of its most successful manifestations, recognise a political dimension to such exhibitions. Okwui Enwezor, for instance, has advocated a 'G7 for biennials … so as not to further dilute the "cachet" of this incredibly ambiguous global brand'.[7] Global the biennial perhaps is, but global for whom and for what reasons? Whose interests are served by the 'biennialisation' of the contemporary art world?

The rise of the biennial over the last twenty years has, of course, made it easier for a few artists from less well-resourced countries to gain visibility in the art world. If, however, this is indeed part of 'globalisation', it is very different from other manifestations of that process. The agents of economic globalisation, for example, whether individuals or multinationals, have to invest substantial amounts of time and money in order to establish themselves in their new location. The people who curate most of the biennials these days, on the other hand, are constantly on the move. Jetting in and out of likely locations, they have no time to assimilate, still less to understand, the artistic production in any one place. From the viewpoint of those living and working in distant outposts, mega-curators and global artists may seem well connected; but they remain, by the very

5 Okwui Enwezor, 'The Black Box', in *documenta 11_Platform 5: Exhibition: Catalogue*, Ostfildern-Ruit 2002, p. 47.

6 Stewart Martin, 'A New World Art: Documenting documenta 11', Radical Philosophy, no. 122, November–December 2003, p. 7.

7 Enwezor, 'Mega-Exhibitions and the Antinomies of a Transnational Global Form', *MJ–Manifesta Journal*, no. 2, Winter 2003–Spring 2004, p. 19.

nature of the enterprise, more or less culturally rootless. At the same time, this deracination gives them a position of advantage, if not of privilege; for them, biennials do indeed have no frontiers. But for the majority outside the magic circle, real barriers still remain. The biennial, the most popular institutional mechanism of the last two decades for the organisation of large-scale international art exhibitions, has, despite its decolonising and democratic claims, proved still to embody the traditional power structures of the contemporary Western art world; the only difference being that 'Western' has quietly been replaced by a new buzzword, 'global'.

5.7 Hito Steyerl, 'Politics of Art: Contemporary Art and the Transition to Post-Democracy', *e-flux*, journal #21 (December 2010), pp. 1–8

Hito Steyerl (b. 1966), is a German filmmaker, writer and visual artist, with an interest in the documentary form of 'video essay'. She is currently Professor of New Media Art at Berlin University of the Arts. She is concerned with the global circulation of images and the relationship of politics to art. In her art practice she often blurs the lines between cinema and the fine arts, and artist and cultural critic. Her work has been shown in many solo and group exhibitions, including many biennials, and she is a frequent contributor to the online *e-flux journal*, from which the following is taken. In this lively essay from 2010 she explores the complicated relationship between contemporary art and geo-political power. She argues for an extension of 'institutional critique' identify- ing the political manipulation involved, yet also encourages the reader to seek out areas in which radical art can effectively intervene as a site of 'commonality, movement, energy and desire'.
[Gill Perry]

A standard way of relating politics to art assumes that art represents political issues in one way or another. But there is a much more interesting perspective: the politics of the field of art as a place of work.[1] Simply look at what it does—not what it shows.

Amongst all other forms of art, fine art has been most closely linked to post-Fordist speculation, with bling, boom, and bust. Contemporary art is no unworldly discipline nestled away in some remote ivory tower.

1 I am expanding on a notion developed by Hongjohn Lin in his curatorial statement for the Taipei Biennial 2010. Hongjohn Lin, 'Curatorial Statement', in *10TB Taipei Biennial Guidebook* (Taipei: Taipei Fine Arts Museum, 2010), pp. 10–11.

On the contrary, it is squarely placed in the neoliberal thick of things. We cannot dissociate the hype around contemporary art from the shock policies used to defibrillate slowing economies. Such hype embodies the affective dimension of global economies tied to ponzi schemes, credit addiction, and bygone bull markets. Contemporary art is a brand name without a brand, ready to be slapped onto almost anything, a quick face-lift touting the new creative imperative for places in need of an extreme makeover, the suspense of gambling combined with the stern pleasures of upper-class boarding school education, a licensed playground for a world confused and collapsed by dizzying deregulation. If contemporary art is the answer, the question is: How can capitalism be made more beautiful?

But contemporary art is not only about beauty. It is also about function. What is the function of art within disaster capitalism? Contemporary art feeds on the crumbs of a massive and widespread redistribution of wealth from the poor to the rich, conducted by means of an ongoing class struggle from above.[2] It lends primordial accumulation a whiff of post-conceptual razzmatazz. Additionally, its reach has grown much more decentralized—important hubs of art are no longer only located in the Western metropolis. Today, deconstructivist contemporary art museums pop up in any self-respecting autocracy. A country with human rights violations? Bring on the Gehry gallery!

The Global Guggenheim is a cultural refinery for a set of post-democratic oligarchies, as are the countless international biennials tasked with upgrading and reeducating the surplus population.[3] Art thus facilitates the development of a new multipolar distribution of geopolitical power

2 This has been described as a global and ongoing process of expropriation since the 1970s. See David Harvey, *A Brief History of Neoliberalism* (Oxford: Oxford University Press, 2005). As for the resulting distribution of wealth, a study by the Helsinki-based World Institute for Development Economics Research of the United Nations University (UNU-WIDER) found that in the year 2000, the richest 1 percent of adults alone owned 40 percent of global assets. The bottom half of the world's adult population owned 1 percent of global wealth. See https://www.wider.unu.edu/events.

3 For just one example of oligarch involvement, see http://www.nytimes.com/2010/04/28/nyregion/28trustee.html. While such biennials span from Moscow to Dubai to Shanghai and many of the so-called transitional countries, we shouldn't consider post-democracy to be a non-Western phenomenon. The Schengen area is a brilliant example of post-democratic rule, with a whole host of political institutions not legitimized by popular vote and a substantial section of the population excluded from citizenship (not to mention the Old World's growing fondness for democratically-elected fascists). The current exhibition 'The Potosi-Principle', organized by Alice Creischer, Andreas Siekmann, and Max Jorge Hinderer, highlights the connection between oligarchy and image production from another historically relevant perspective.

whose predatory economies are often fueled by internal oppression, class war from above, and radical shock and awe policies.

Contemporary art thus not only reflects, but actively intervenes in the transition towards a new post-Cold War world order. It is a major player in unevenly advancing semiocapitalism wherever T-Mobile plants its flag. It is involved in mining for raw materials for dual-core processors. It pollutes, gentrifies, and ravishes. It seduces and consumes, then suddenly walks off, breaking your heart. From the deserts of Mongolia to the high plains of Peru, contemporary art is everywhere. And when it is finally dragged into Gagosian dripping from head to toe with blood and dirt, it triggers off rounds and rounds of rapturous applause.

Why and for whom is contemporary art so attractive? One guess: the production of art presents a mirror image of post-democratic forms of hypercapitalism that look set to become the dominant political post-Cold War paradigm. It seems unpredictable, unaccountable, brilliant, mercurial, moody, guided by inspiration and genius. Just as any oligarch aspiring to dictatorship might want to see himself. The traditional conception of the artist's role corresponds all too well with the self-image of wannabe autocrats, who see government potentially—and dangerously—as an art form. Post-democratic government is very much related to this erratic type of male-genius-artist behavior. It is opaque, corrupt, and completely unaccountable. Both models operate within male bonding structures that are as democratic as your local mafia chapter. Rule of law? Why don't we just leave it to taste? Checks and balances? Cheques and balances! Good governance? Bad curating! You see why the contemporary oligarch loves contemporary art: it's just what works for him.

Thus, traditional art production may be a role model for the nouveaux riches created by privatization, expropriation, and speculation. But the actual production of art is simultaneously a workshop for many of the nouveaux poor, trying their luck as jpeg virtuosos and conceptual impostors, as gallerinas and overdrive content providers. Because art also means work, more precisely strike work.[4] It is produced as spectacle, on post-Fordist all-you-can-work conveyor belts. Strike or shock work is affective labor at insane speeds, enthusiastic, hyperactive, and deeply compromised.

Originally, strike workers were excess laborers in the early Soviet Union. The term is derived from the expression 'udarny trud' for 'super-productive, enthusiastic labor' (udar for 'shock, strike, blow'). Now, transferred to present-day cultural factories, strike work relates to the

4 I am drawing on a field of meaning developed by Ekaterina Degot, Cosmin Costinas, and David Riff for their 1st Ural Industrial Biennial, 2010.

sensual dimension of shock. Rather than painting, welding, and molding, artistic strike work consists of ripping, chatting, and posing. This accelerated form of artistic production creates punch and glitz, sensation and impact. Its historical origin as format for Stalinist model brigades brings an additional edge to the paradigm of hyperproductivity. Strike workers churn out feelings, perception, and distinction in all possible sizes and variations. Intensity or evacuation, sublime or crap, readymade or readymade reality—strike work supplies consumers with all they never knew they wanted.

Strike work feeds on exhaustion and tempo, on deadlines and curatorial bullshit, on small talk and fine print. It also thrives on accelerated exploitation. I'd guess that—apart from domestic and care work—art is the industry with the most unpaid labor around. It sustains itself on the time and energy of unpaid interns and self-exploiting actors on pretty much every level and in almost every function. Free labor and rampant exploitation are the invisible dark matter that keeps the cultural sector going.

Free-floating strike workers plus new (and old) elites and oligarchies equal the framework of the contemporary politics of art. While the latter manage the transition to post-democracy, the former image it. But what does this situation actually indicate? Nothing but the ways in which contemporary art is implicated in transforming global power patterns.

Contemporary art's workforce consists largely of people who, despite working constantly, do not correspond to any traditional image of labor. They stubbornly resist settling into any entity recognizable enough to be identified as a class. While the easy way out would be to classify this constituency as multitude or crowd, it might be less romantic to ask whether they are not global lumpenfreelancers, deterritorialized and ideologically free-floating: a reserve army of imagination communicating via Google Translate.

Instead of shaping up as a new class, this fragile constituency may well consist—as Hannah Arendt once spitefully formulated—of the 'refuse of all classes.' These dispossessed adventurers described by Arendt, the urban pimps and hoodlums ready to be hired as colonial mercenaries and exploiters, are faintly (and quite distortedly) mirrored in the brigades of creative strike workers propelled into the global sphere of circulation known today as the art world.[5] If we acknowledge that current strike

5 Arendt may have been wrong on the matter of taste. Taste is not necessarily a matter of the common, as she argued, following Kant. In this context, it is a matter of manufacturing consensus, engineering reputation, and other delicate machinations, which—whoops—metamorphose into art-historical bibliographies. Let's face it: the politics of taste are not about the collective, but about the collector. Not about the common but about the patron. Not about sharing but about sponsoring.

workers might inhabit similarly shifting grounds—the opaque disaster zones of shock capitalism—a decidedly un-heroic, conflicted, and ambivalent picture of artistic labor emerges.

We have to face up to the fact that there is no automatically available road to resistance and organization for artistic labor. That opportunism and competition are not a deviation of this form of labor but its inherent structure. That this workforce is not ever going to march in unison, except perhaps while dancing to a viral Lady Gaga imitation video. The international is over. Now let's get on with the global.

Here is the bad news: political art routinely shies away from discussing all these matters.[6] Addressing the intrinsic conditions of the art field, as well as the blatant corruption within it—think of bribes to get this or that large-scale biennial into one peripheral region or another—is a taboo even on the agenda of most artists who consider themselves political. Even though political art manages to represent so-called local situations from all over the globe, and routinely packages injustice and destitution, the conditions of its own production and display remain pretty much unexplored. One could even say that the politics of art are the blind spot of much contemporary political art.

Of course, institutional critique has traditionally been interested in similar issues. But today we need a quite extensive expansion of it.[7] Because in contrast to the age of an institutional criticism, which focused on art institutions, or even the sphere of representation at large, art production (consumption, distribution, marketing, etc.) takes on a different and extended role within post-democratic globalization. One example, which is a quite absurd but also common phenomenon, is that radical art is nowadays very often sponsored by the most predatory banks or arms traders and completely embedded in rhetorics of city marketing, branding, and social engineering.[8] For very obvious reasons, this condition

6 There are of course many laudable and great exceptions, and I admit that I myself may bow my head in shame, too.
7 As is also argued in the reader *Institutional Critique*, eds. Alex Alberro and Blake Stimson (Cambridge, MA: The MIT Press, 2009). See also the collected issues of the online journal *transform*: http://eipcp.net/transversal/0106/folder_contents.
8 Recently on show at Henie Onstad Kunstsenter in Oslo was 'Guggenheim Visibility Study Group', a very interesting project by Nomeda and Gediminas Urbonas that unpacked the tensions between local (and partly indigenist) art scenes and the Guggenheim franchise system, with the Guggenheim effect analyzed in detail in a case study. See http://www.vilma.cc/2G/. Also see Joseba Zulaika, *Guggenheim Bilbao Museoa: Museums, Architecture, and City Renewal* (Reno: Center for Basque Studies, University of Nevada, 2003). Another case study: Beat Weber and Therese Kaufmann, 'The Foundation, the State Secretary and the Bank – A Journey into

is rarely explored within political art, which is in many cases content to offer exotic self-ethnicization, pithy gestures, and militant nostalgia.

I am certainly not arguing for a position of innocence.[9] It is at best illusory, at worst just another selling point. Most of all it is very boring. But I do think that political artists could become more relevant if they were to confront these issues instead of safely parade as Stalinist realists, CNN situationists, or Jamie-Oliver-meets-probation-officer social engineers. It's time to kick the hammer-and-sickle souvenir art into the dustbin. If politics is thought of as the Other, happening somewhere else, always belonging to disenfranchised communities in whose name no one can speak, we end up missing what makes art intrinsically political nowadays: its function as a place for labor, conflict, and … fun—a site of condensation of the contradictions of capital and of extremely entertaining and sometimes devastating misunderstandings between the global and the local.

The art field is a space of wild contradiction and phenomenal exploitation. It is a place of power mongering, speculation, financial engineering, and massive and crooked manipulation. But it is also a site of commonality, movement, energy, and desire. In its best iterations it is a terrific cosmopolitan arena populated by mobile shock workers, itinerant salesmen of self, tech whiz kids, budget tricksters, supersonic translators, PhD interns, and other digital vagrants and day laborers. It's hard-wired, thin-skinned, plastic-fantastic. A potential commonplace where competition is ruthless and solidarity remains the only foreign expression. Peopled with charming scumbags, bully-kings, almost-beauty-queens. It's HDMI, CMYK, LGBT. Pretentious, flirtatious, mesmerizing.

This mess is kept afloat by the sheer dynamism of loads and loads of hardworking women. A hive of affective labor under close scrutiny and controlled by capital, woven tightly into its multiple contradictions. All of this makes it relevant to contemporary reality. Art affects this reality

the Cultural Policy of a Private Institution', http://transform.eipcp.net/correspondenc e/1145970626#redir. See also Martha Rosler, 'Take the Money and Run? Can Political and Socio-critical Art 'Survive'?' *e-flux journal*, issue 12, http://www.e-flux.com/journal/12/61338/take-the-money-and-run-can-political-and-socio-critical-art-survive/, and Tirdad Zolghadr, '11th Istanbul Biennial', *Frieze*, 01 Nov 2009, https://frieze.com/article/11th-istanbul-biennial.

9 This is evident from this text's placement on *e-flux* as an advertisement supplement. The situation is furthermore complicated by the fact that these ads may well flaunt my own shows. At the risk of repeating myself, I would like to emphasize that I do not consider innocence a political position, but a moral one, and thus politically irrelevant. An interesting comment on this situation can be found in Luis Camnitzer, 'The Corruption in the Arts / the Art of Corruption', published in the context of The Marco Polo Syndrome, a symposium at the House of World Cultures in April, 1995. See http://www.universes-in-universe.de/magazin/marco-polo/s-camnitzer.htm.

precisely because it is entangled into all of its aspects. It's messy, embedded, troubled, irresistible. We could try to understand its space as a political one instead of trying to represent a politics that is always happening elsewhere. Art is not outside politics, but politics resides within its production, its distribution, and its reception. If we take this on, we might surpass the plane of a politics of representation and embark on a politics that is there, in front of our eyes, ready to embrace.

Index